Michelangelo

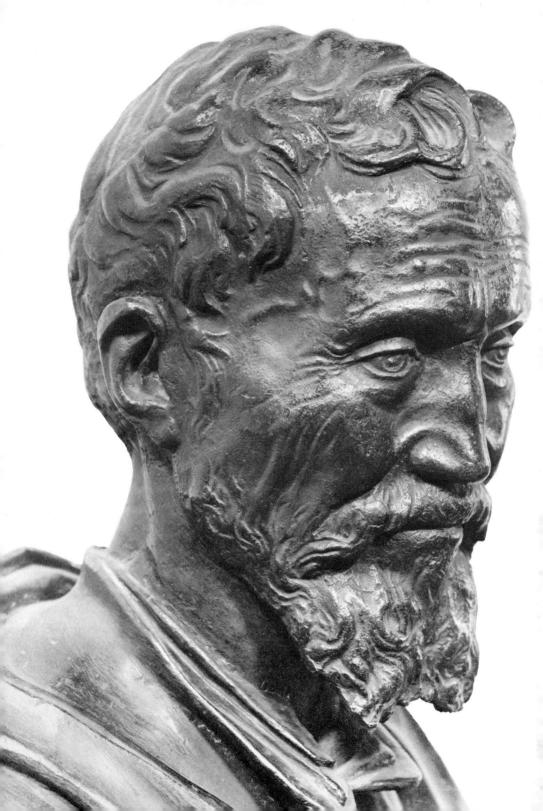

Howard Hibbard

Michelangelo

Icon Editions

Harper & Row, Publishers

New York, Evanston, San Francisco, London

MICHELANGELO Copyright © 1974 by Howard Hibbard

All rights reserved. Printed in the United States of America.

No part of this book may be used or reproduced
in any manner whatsoever without written permission except in the case
of brief quotations embodied in critical articles and reviews.

For information address Harper & Row, Publishers, Inc.,
10 East 53rd Street, New York, N.Y. 10022.

Published simultaneously in Canada by Fitzhenry & Whiteside Limited, Toronto.

FIRST U.S. EDITION

ISBN 0-06-433323-X

LIBRARY OF CONGRESS CATALOG CARD NUMBER: 74-6576

Designed by Gerald Cinamon

Preface 9 Introduction 11
I The Prodigy
 Early Years in Florence and Bologna: 1475-96 The First Roman Sojourn: 1496-1501 The High Renaissance in Florence: 1501-5 The Julius Tomb and Lesser Tragedies: 1505-8
II The Sistine Chapel and its Aftermath
 5. The Sistine Ceiling: 1508-12 6. The Julius Tomb Again and Other Failures: 1512-20 148
III Medicean Florence with a Republican Interlude: 1519–34
 7. The Medici Tombs and the Victory 177 8. Michelangelo's Medicean Architecture 209 9. Years of Turmoil: 1527-34 220
IV Rome: 1534–64
 10. The Last Judgement, a Pious Lady, and Tyrannicide: 1534-47 239 11. Figural Works of the 1540s and 1550s 267 12. The Roman Architecture 291 13. Death and Transfiguration 309
Bibliographical Note 315 Notes for Further Reading 317 Bibliography 321 List of Illustrations 326 Acknowledgements 334 Index 335

For Carla
who wanted a book
and for Claire and Susan
who may read it sooner

Preface

I have tried to write a short, reliable book that will introduce the general reader to Michelangelo's life and art on the 500th anniversary of his birth in 1475. I have selected those works by the artist, including letters and poems, that seemed most revealing of his unique qualities in the hope of giving within small compass an idea of the man and of his achievement. This is no light task, for Michelangelo's world was radically different from our own – perhaps the fact that he was an almost exact contemporary of Copernicus (1473–1543) brings this home to us most quickly.

The road to understanding Michelangelo is, for Anglo-Saxons, particularly tortuous. The year he died, 1564, Shakespeare was born. It is a symptom of the different cultures that the nude male figure, Michelangelo's lifelong artistic ideal, was for Shakespeare 'a poor, bare, forked animal.' It is also revealing that whereas we know almost everything we want to know about Michelangelo's life, our greatest writer is so elusive as a man that his works have even been attributed to others. Michelangelo, in addition to his sculpture, painting, and architecture, left almost 500 letters, some 300 poems, and hundreds of drawings; innumerable documents and other source materials cluster around his life and works. He soon becomes compellingly alive as a personality, and remains an artist of unmatched power.

In the book that follows I admit to indulging a preference for existing works over projects, and the reader will not find – I hope to his relief – an elaborate discussion of what was not carved for the tomb of Julius II. Moreover, Michelangelo's art has an amazing continuity over some sixty years - a hostile contemporary actually claimed that 'if you have seen one figure you have seen them all.' That is of course a libel; nevertheless, the pace of my discussion picks up about mid-way with the assumption that Michelangelo as a person and as an artist is by then a known quantity. James Ackerman's splendid book on Michelangelo's architecture, now available in paperback, allowed me to deal with that aspect of his achievement less fully than the rest, but I have not omitted any major works. Poetry had to be used chiefly as a biographical and esthetic tool - no fruitful discussion of it is possible without a profound knowledge of Italian and of Renaissance poetry. This aspect of his art, which is far more than a rhyming commentary on his life and sculpture, is of necessity rather slighted here.

Michelangelo is the most famous artist who ever lived and many would say the greatest. The study of his works has consequently become an industry: in 1927 an entire volume was devoted to Michelangelo bibliography, and more has been written since 1927 than in the preceding 400 years. I have tried to go back to contemporary sources and writers when possible; many quotations throughout the text signal my indebtedness to them as well as to historians of our own time. I want to arouse an interest in Michelangelo's life and art within the framework of reliable chronology and reasonable attributions. But there lies a problem: often there is no consensus on a work or on when it was created; a recent German treatise was entitled *The Chaos in Michelangelo Studies*. Michelangelo's art has become the province of specialists and super-specialists, whom I thank for their insights while having to pick my way, following now one, now another.

I am grateful to my students, who over the years have taught me at least as much as I have taught them; to John Fleming and Hugh Honour for reading the text and making many helpful suggestions; and to Creighton Gilbert for useful criticism. My wife Shirley was, as usual, an active collaborator.

Rome February 1973

Introduction

Michelangelo was a proud son of the city of Florence, and his art is the culmination of a specifically Florentine artistic tradition. That tradition, beginning with Cimabue and Giotto before 1300, came to flower in the serene architecture of Brunelleschi [119], the expressive sculpture of Donatello [8], and the weighty painting of Masaccio [3]. The works of these men are what we specifically mean when we speak of the new Renaissance style of the 1400s - the Quattrocento. The word 'Renaissance' refers to a rebirth of antique forms and ideals, and it seems at first odd that the style should have been Florentine rather than Roman. Florence (Florentia) had been merely a provincial town in Roman times: there was very little local antiquity to revive. But Rome, which was governed by the popes, was all but deserted during a crucial period when the Great Schism placed the real popes in Avignon and feeble anti-popes, or none, in Rome. Even after its restoration as the papal capital in 1420. Rome necessarily remained little more than a provincial town. It was considerably smaller than Florence, which was a rich and powerful city of some forty or fifty thousand inhabitants. Florence had produced those precocious literary giants, Dante, Petrarch, and Boccaccio, who established Tuscan as the vital literary language of all Italy. Their works in prose and verse, together with the money in the Florentine banks, may have furnished the humus needed for sustained growth of the other arts. Dante already records the fame of Cimabue and Giotto. By 1378 the painters of Florence were allowed to form a separate group within their old guild because their work was 'important for the life of the state.' This statement reflects the growing self-consciousness of the Florentines, who by 1400 had a sense of identity and uniqueness that was probably unknown in the Middle Ages, which led to an identification with the great city-states of antiquity – Athens and Rome.

Florence was also ahead of its time in the foundation of democratic institutions, but it was somewhat unstable in its government. In the mid-thirteenth century a first democracy, *il primo popolo*, was formed by the Guelphs (originally the pro-papal party), although the guilds, especially the prosperous cloth guilds, really ran the city. Florence was notable for its industry, which has been called a small-scale prototype of modern capitalism; and, as in many capitalist countries today, there was an impoverished lower class of manual workers.

Like many Florentines. Michelangelo was born to a Guelph family that cherished a republican ideal. He grew up, however, under a bureaucratic oligarchy headed by Lorenzo de' Medici. The growth of Medici power can be traced back more than a century before Michelangelo's birth. A series of disasters had struck Florence in the midfourteenth century: a flood in 1333, bank failures in 1339, and the Black Death in 1348. Out of these calamities grew a mercantile oligarchy led by two rival families, the Albizzi and the Alberti. In 1387 the Alberti were forced into exile - and so one of the brightest lights of the Florentine Renaissance, Leon Battista Alberti, was born in Genoa. Florence prospered: Florentia, the city of flowers, became the city of the florin, the local coin with an image of a lily that became an international medium of exchange. The Medici bank gradually became so rich that it could control much of Florentine life, but in general the members of the family avoided visible office, governing from behind the counter. Cosimo de' Medici, later called reverently Pater Patriae. triumphed over the Albizzi and by 1434 was exercising control through a financial stranglehold that allowed him to tax his political enemies out of existence. Medici supremacy became overt under Cosimo's son Piero (d. 1469), and Piero's son, Lorenzo il Magnifico (1449-92).

The older parts of Florence have not changed so very much since Michelangelo's day and we can still walk down cool, narrow streets that would look familiar to a man of the Renaissance. The streets are lined with the high walls of countless palaces, whose grim exteriors sometimes conceal graciously arcaded courtyards. The glory of

Florence in the Quattrocento was, at least in retrospect, her art. The artists in a sense served two masters, religious institutions and the state. But all patronage ultimately came from individuals - whether for a painted family chapel [cf. 1] or a Neoplatonic allegory of Spring. Lorenzo himself was not a great patron (he was not a prince and had no real court) but he had a splendid collection of antiquities and an even more impressive collection of intellectuals grouped around the philosopher Marsilio Ficino (1433-99). Ficino sought to reconcile antique Platonic ideas, especially those later, mystical doctrines associated with Plotinus, and Christian belief. This syncretism was not so hard a task as it sounds and the men around Lorenzo must often have been buoyed by a sense of coming ever closer to the philosophical secrets at the core of man's existence. Ficino also liked to play the part of a modern Orpheus, entertaining the Medici with his lyre; Lorenzo himself wrote poetry and acted in triumphal pageants. It was into this hedonistic humanist world that the young Michelangelo was thrust when he was about fifteen years of age. All his life he kept a Neoplatonic vocabulary, and his poetry, written years later, may sometimes reflect the diction of the Medici circle. But it was the literal humanism of these men, the new importance they gave to man himself, that most influenced Michelangelo and that differentiates him from earlier artists.

I The Prodigy

I Early Years in Florence and Bologna 1475–96

> Michelagnolo di Lodovico Buonarroti Simoni, as he was baptized, was born on 6 March 1475 in Caprese, a tiny village near Arezzo, where his father was serving a short term as mayor (podestà) – almost his first iob. Less than a month later the family moved back to a high, dank house near the church of Santa Croce in Florence. The new baby had a brother only sixteen months older, and perhaps for this reason Michelangelo was given to a wet-nurse living on the small family farm near Florence at Settignano. Wet-nurses were commonly employed among the upper classes [cf. 1], although Michelangelo's father Ludovico was poor enough. Michelangelo's nurse was the daughter of a stonemason, and married to another; years later the great sculptor jokingly said that he had taken in the hammer and chisel along with her milk. Between Michelangelo's birth in 1475 and the death of his mother Francesca in 1481 she bore three more sons. Psychoanalysts have tried to explain Michelangelo's personality and art by calling attention to his supposed rejection by his mother, but we know nothing about their relationship. We do know that Michelangelo lost her for good when he was six, a cruel blow if she had been a real mother to him. Perhaps the fact that only one of her five sons ever married tells its own psychological story.

The Buonarroti had been fairly prominent and successful up to the mid-Quattrocento, when Michelangelo's grandfather lost money. The family business had been small-scale money-changing – really, disguised lending at interest. Michelangelo grew up in a communal household that included his paternal grandmother, his father and brothers, together with his father's brother and his wife. Ludovico and his brother had inherited a house that was, apart from the small farm, their only source of wealth. Michelangelo's father was a mediocre man – too proud to work for a living, too poor to live well. The quality of his paternal influence can perhaps be judged by the cautionary words that he later sent to Michelangelo: 'Above all take care of your head, keep it moderately warm and never wash yourself; allow yourself to be rubbed but don't wash.'

Our main sources of information about Michelangelo's life and career are the Life by Giorgio Vasari published in 1550; another, by Ascanio Condivi, with new information direct from Michelangelo, published in 1553; and Vasari's greatly revised Life of 1568 (Michelangelo died in 1564). Obviously the information about Michelangelo's earlier life and work contained in these Lives, fascinating and valuable as it is, was blurred over by time and by the sometimes willful memory of their famous subject, who was seventy-five when the earliest of them was published. By then Michelangelo was a public figure, widely regarded as the greatest artist of all time, and apotheosized as 'divine.' He did not then like to think of himself as having had the normal artisan's training, and we still do not know how he learned to carve marble. We are told that at the age of ten he was sent to grammar school, but presumably he began formal schooling around 1482. We also learn that he did not like it and that he constantly ran off to draw and to watch artists at work. This story has the ring of a topos, a standard yarn told about countless artists of earlier times. The mature Michelangelo was literate, wrote a beautiful hand, and composed expressive poetry. All of this is conceivable without much formal schooling, but he must have had more than we know about. In any event, the story is essentially true: his father's desire for Michelangelo to be a man of letters was soon thwarted and, despite paternal beatings (reported by Condivi sixty-five years later), Michelangelo got his own way. His earliest artist-friend seems to have been Francesco Granacci (b. 1469). who was a modestly-endowed pupil of the painter Domenico Ghirlandaio (1449-94). Evidently through Granacci's influence, Michelangelo was himself apprenticed to Ghirlandaio on I April 1488. The thirteen-year-old, three years older than the normal beginner in an artist's shop, may already have attained some artistic skill by this time

since, instead of paying for his tuition, he himself was paid. Another explanation is suggested by the account that Benvenuto Cellini (1500–1571) gives of his own apprenticeship:

When I reached the age of fifteen, against my father's will I placed my-self in a goldsmith's shop... My father would not let me be paid like the other apprentices, in order that, as I had adopted this craft from choice, I might be able to spend as much of my time designing as I liked.

Perhaps the same option obtained in the large Ghirlandaio shop.

Michelangelo's apprenticeship lasted only a year or so, but it was fruitful. Ghirlandaio had just begun painting the high-altar chapel in Santa Maria Novella for the Tornabuoni family; Michelangelo probably received a thorough grounding in fresco technique, which was to serve him well when he painted the Sistine ceiling. He must have become conversant with Ghirlandaio's picturesquely discursive style [1], and it is possible to see in some of the other figures of the choir an

1. Domenico Ghirlandaio and assistants, The Birth of St John the Baptist. c. 1491

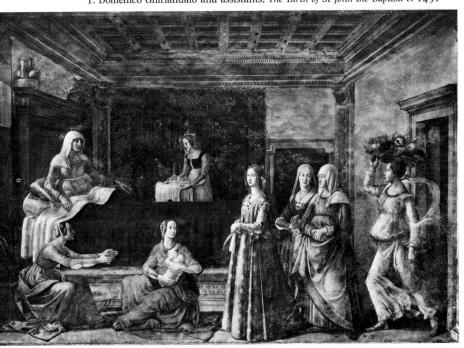

intensity and physicality that may be Michelangelo's contribution. Ghirlandaio practiced a novel method of drawing, defining forms by means of cross-hatching that could vary to indicate light and shade

(chiaroscuro). Michelangelo began to use an even more powerful cross-hatched pen line that reportedly impressed and even daunted his master, who was a connoisseur of drawings. Illustration 2, perhaps done $c.\ 1489-90$, shows Michelangelo's youthful, cross-hatched tech-

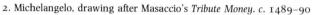

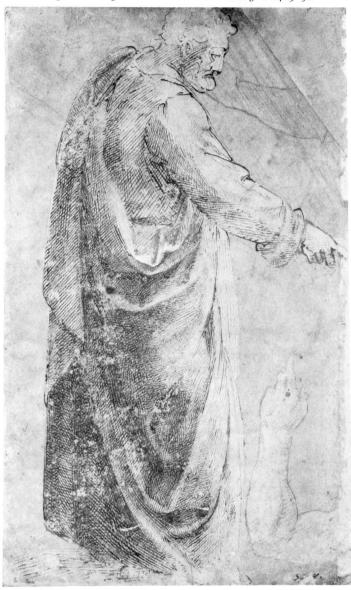

nique and also demonstrates his interest in one of the great founders of Florentine Renaissance art: it is a version of the Apostle Peter handing over a coin in Masaccio's famous fresco *The Tribute Money*, painted c. 1427 [3]. Vasari tells us that Michelangelo studied Masaccio's fres-

3. Masaccio, The Tribute Money (detail). c. 1427

coes for many months. Other drawings show that Michelangelo studied Giotto with equal care; and still others seem to be based on drawings by Ghirlandaio, whose creations the young Michelangelo even dared to correct.

Ghirlandaio was a student of antiquity and may have introduced Michelangelo to what became a lifelong passion, the study of ancient sculpture. But a new and greater opportunity arose in 1489–90 with his introduction to Lorenzo de' Medici's collection of antiquities, which was kept in a house and garden near San Marco. Vasari, writing from the point of view of the mid-sixteenth century, gives the idea that this garden was a kind of proto-academy, a school for all the brightest

and best artists of the time. This it surely was not, but Lorenzo allowed Michelangelo to study, copy, and work in the garden together with a few other promising artists. The curator of this collection was an aging pupil of Donatello's, Bertoldo di Giovanni, who had been a sculptor in bronze. By this time he was a kind of valet de chambre to Lorenzo. Condivi, who reflects the aged Michelangelo's distaste for acknowledging his masters, does not even mention Bertoldo; but Vasari tells us that Bertoldo taught another young sculptor in the garden, Pietro Torrigiano, to model figures in clay; Michelangelo must have learned too. Torrigiano, at first a friendly rival of Michelangelo's, became so jealous of the young prodigy that he hit Michelangelo in the nose, breaking it and disfiguring him for life [cf. frontispiece]. Torrigiano's own version of the incident (as Benvenuto Cellini remembered it years later) confirms Michelangelo's study of Masaccio and also tells us something about the young Michelangelo's personality:

This Buonarroti and I used to go along together when we were boys to study in Masaccio's chapel in the church of the Carmine. Buonarroti had the habit of making fun of anyone else who was drawing there, and one day he provoked me so much that I lost my temper more than usual, and, clenching my fist, gave him such a punch on the nose that I felt the bone and cartilage crush like a biscuit. So that fellow will carry my signature till he dies.

Our first report of a sculpture by Michelangelo seems to date back to 1590. Condivi relates that among the other antiquities that Michelangelo studied in the Medici garden he

studied one day the head of a faun, in appearance very old, with a long beard and a laughing face, although the mouth could hardly be seen because of the injuries of time . . . he determined to copy it in marble. Lorenzo il Magnifico was having some marble worked and dressed in that place to ornament the noble library that he and his ancestors had gathered together . . . Michelangelo begged a piece from the masons and borrowed a chisel from them: with so much diligence and intelligence did he copy that faun that in a few days it was carried to perfection, his imagination supplying all that was missing in the antique, such as the lips, open, as in a man who is laughing, so that the hollow of the mouth was seen with all the teeth. At this moment passed Il Magnifico to see how works progressed; he found the child, who was busy polishing the head. He spoke to him at once, noticing in the first place the beauty of the work, and having regard to the lad's youth he marvelled exceedingly, and although he praised the workmanship he nonetheless joked with him as with a child, saying: 'Oh! you have made this faun very old, and yet have left him all his teeth: do you not know that old men of that age always lack some of them?' It seemed a thousand years to Michelangelo

before Lorenzo went away and he remained alone to correct his error. He cut away a tooth from the upper jaw, drilling a hole in the gums as though it had come out by the roots. He awaited the return of Il Magnifico upon another day with great longing. At last he came. Seeing the willingness and single-mindedness of the child he laughed very much, but afterwards appreciating the beauty of the thing and the boy's youth, as father of all talent he thought to bestow his favor upon such a genius and take him into his house . . .

The head is long lost; a seventeenth-century Florentine artist, illustrating scenes from the life of a Lorenzo who had by then become legendary, shows the patron with a marble bust of a faun [4] – but whether he knew the original or simply invented one we do not know.

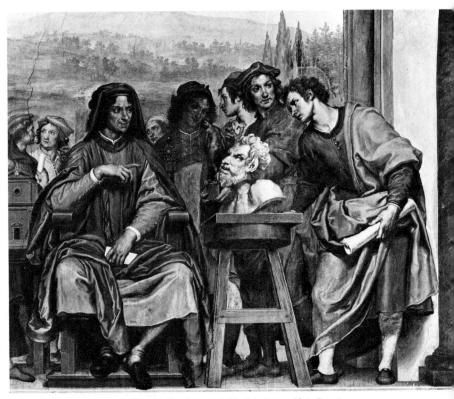

4. Ottavio Vannini, Lorenzo il Magnifico Surrounded by his Artists (detail). 1635

The lost faun is Michelangelo's first recorded work of sculpture, but it may not have been the first example of his rivalry with the past. We read that as a boy he had forged a drawing, smoking the paper to make it look old.

From this time, aged fifteen, Michelangelo was part of the Medici household along with Bertoldo, who died in 1491, the poet and humanist Angelo Poliziano, and various Medici children. Among them were Giovanni, the future Leo X, one year younger than Michelangelo but already a cardinal; Giuliano, whom Michelangelo immortalized in the Medici tombs [125]; and Giulio, later Clement VII, the illegitimate son of Lorenzo's murdered brother Giuliano. Lorenzo himself was a dilettante who had erected a monument to Giotto and submitted his own design in a competition for the facade of the Cathedral. In his time the Medici palace was a showplace of contemporary arts and crafts; and his collection of ancient coins, cameos, and medals was famous all over Italy. Lorenzo was also a bittersweet lyric poet who tended to repeat Ficino's Neoplatonic ideas. We should not think, however, that Michelangelo breathed in pure Neoplatonic air in Lorenzo's house, for the tutor of the Medici children, Angelo Poliziano (1454-94), although close to Ficino, was in his own thought more Aristotelian than Platonic, and more interested in poetry and philology than in philosophy.

The Battle Relief

Poliziano, as Condivi tells us.

recognizing the lofty spirit of Michelangelo, loved him exceedingly, and little as he needed it, spurred him on in his studies, always explaining things to him and giving him subjects. One day, amongst others, he suggested 'The Rape of Deianira' and 'The Battle of the Centaurs,' telling him in detail the whole of the story . . .

Condivi tells us that Michelangelo then carved a relief, which was finished just before Lorenzo il Magnifico died. Since Lorenzo died on 8 April 1492, this precocious relief, the first serious work known to the early writers, would date shortly before that time [5]. Perhaps Michelangelo remembered leaving the work behind when he left the Medici palace, as he did immediately afterwards. If so, it might explain something that makes this relief so typical of the master: it was in fact left unfinished. More important, it has an antique subject and, as well, an antique model. Bertoldo had made a small bronze relief in imitation of a ruined Roman battle sarcophagus; in Michelangelo's time the bronze was above the mantel next to the grand *salone* of the Medici palace [6]. Michelangelo's marble is far more blocky, crowded, and powerful. It apparently shows a mythical battle between Greeks

and centaurs, a story that had been carved on the Parthenon metopes and was later retold by Ovid and more recently by Boccaccio. The conflict began with the attempted rape of the Lapith princess Hippodameia

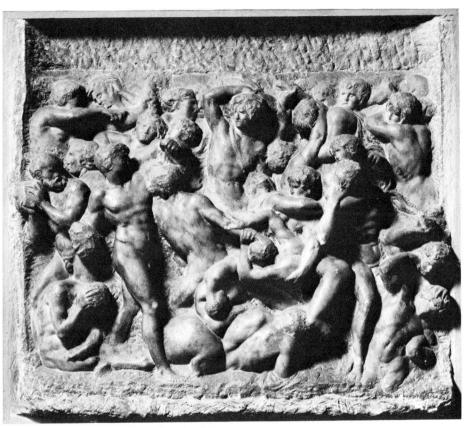

5. Michelangelo, Battle relief. 1491-2

6. Bertoldo di Giovanni, Battle relief. c. 1475?

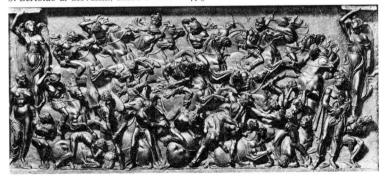

(not Deianira) by a centaur. Ovid and Boccaccio tell the story as Poliziano must have later, episode by episode. Michelangelo presents one confused primitive mass of fighting bodies. Half of these people ought to be centaurs, but Michelangelo has disguised them by showing their upper torsos and hiding the horses' bodies; his representation of Hippodameia, at the center right, is also disguised by showing her from the back; thus all but the most careful observers take this for a battle of nude men. That theme had already been made popular by Antonio Pollaiuolo; it was one that Michelangelo found preeminently to his taste because of the opportunity it offered for the depiction of muscular male torsos in violent action and torsion. The old axiom of Protagoras, 'Man is the measure of all things,' quoted in the earlier Quattrocento by Alberti and Filarete, finds its artistic echo in Michelangelo's works. Kenneth Clark has observed that here

we seem to be looking into the boiling cauldron of his mind, and fancy that we can find there, foaming and vanishing, the principal motives of his later work . . .

We know how this small nucleus of energy will expand, and how each pose will reappear, polished by art and weathered by experience, to create a new heroic style of painting. The young Michelangelo could not know that he had released a world of shapes which were to travel with him all his life and prove, after his death, a Pandora's box of formal disturbance.

Michelangelo's *Battle* is carved in relief from marble – from the beginning, he was a carver. The great theoretician of the early Renaissance, Leon Battista Alberti, wrote treatises on all three of the visual arts; the earliest, significantly, was on sculpture, *De Statua*, and shows the influence of Donatello. Alberti clearly differentiated between the technique of modeling, which is used by sculptors who then cast their works in bronze, and the process of marble carving. The latter is the technique Michelangelo used and advocated all his life (see p. 56).

In *The Battle of the Centaurs*, space has been all but eliminated; or, rather, no space is created by the youthful artist. If the strip at the top was reserved in order to indicate a background, in the end he left it roughed-out so that the nude figures could act out their drama unencumbered. Unlike Bertoldo's relief, Michelangelo's mass of figures, vigorously clumped and intertwined, cannot be esthetically detached from a rear plane. This crowded style can be seen in an earlier manifestation on Nicola Pisano's Siena pulpit of 1260 [7], a relief that can almost be termed proto-Renaissance in its reliance on antique models. Lying behind Michelangelo's conception is the long antique history of sculptured male nudes. Both the matter and the manner of his relief are consciously antique.

7. Nicola Pisano, The Damned, 1260

It is hard to resist the temptation to interpret the story depicted as a dualistic allegory, or Psychomachia, of man's higher and lower natures - the struggle of mind against base instinct. The young Michelangelo, here and elsewhere, could interpret such Platonic-Christian concepts only through the expressive manipulation of the idealized male body. Ernst Gombrich pointed out that the Neoplatonic approach to ancient myth succeeded 'in opening up to secular art emotional spheres which had hitherto been the preserve of religious worship.' Something of this new, personal quality is already found in Michelangelo's earliest works. Condivi recalled that the aged artist, seeing this early relief once again, bemoaned the years he had lost on other pursuits - clearly the Battle reveals a basic quality of his artistic esthetic. For almost fifty years Michelangelo's art continued to express psychic as well as overt conflict, a strong sense of frustration. Throughout this time his means of expression was, essentially, the male nude.

The Madonna of the Steps

In these early years Michelangelo carved another relief of a very different kind, the little Madonna of the Steps [9]. Here we see his earliest known draped figures, chiseled in a daring low-relief technique that is indebted to a virtuoso style perfected by Donatello (c. 1386–1466), rilievo schiacciato (literally, squashed relief). The Madonna, too, is reminiscent of powerful types created by Donatello [8]. It was perhaps inevitable that the young Michelangelo, under Bertoldo's tutelage, should turn back to the greatest Quattrocento sculptor for inspiration. The Virgin in Michelangelo's relief sits in almost perfect profile on a cube of stone. Even she is not wholly finished, and the background is sketchy. A number of awkward features, such as her right foot, indicate that this is an early, experimental sculpture, probably begun even earlier than the Battle relief. In contrast to the latter, an illusion of space is created by the steps and by the small, inchoate background figures. The narrow frame Michelangelo carved all around dramatizes the shallowness of the carving.

8. Donatello, Pazzi Madonna. c. 1430?

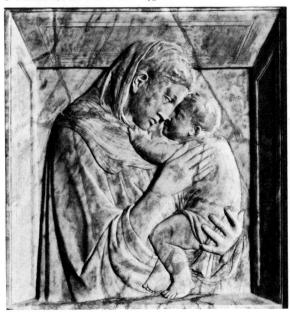

9. Michelangelo, The Madonna of the Steps. c. 1491

This relief was unknown to Condivi and to Vasari in 1550; it has caused a lot of trouble since, with dates proposed that range from c. 1490 to 1510 and later, with an occasional suggestion that it is a mid-sixteenth-century pastiche. Different though it is from the Battle relief, the Madonna too is replete with hints of things to come [cf. 133]. The sibylline mother, lips parted and staring into the distance, seems to foresee the tragic future. The Christ child, daringly shown from behind, is like an infant Hercules, his powerful arm propped behind him. Michelangelo has revived an older iconographic motif, the Virgo lactans, but instead of suckling, the child has fallen asleep, reminding us of his death and his mother's lamentation over his body, the Pietà. St Bernardine of Siena (1380–1444) believed that the Virgin Mary possessed all the knowledge of the prophets, and perhaps this idea, which was well known, is reflected here in the aspect of Mary as Seer.

Michelangelo's first religious sculpture may also reflect another idea that was widely diffused: in 1477 a book was published entitled Libro . . . della . . . scala del Paradiso (Book of the Stairway to Heaven), which was so popular that a third edition was printed in Florence (no center of publishing in those days) in 1491. The ideas in this book go back to a medieval text attributed to St Augustine in which Mary was likened to a stairway by which God came down to earth as Jesus, and by which we mortals in turn may ascend to heaven. Similar conceits were also familiar to Poliziano's circle. His friend Domenico Benivieni wrote a book published in 1495 entitled Scala della vita spirituale sopra il nome di Maria in which the five letters of Mary's name were associated with five steps.

Still other mystical ideas may be found in the relief – the enigmatic children in the background may be angels; the balustrade could allude to the wood of the Cross; the cloth the children handle may even be Christ's future winding sheet. The cube on which the Virgin sits might symbolize a kind of Pythagorean or Hermetic perfection; it is also stone, which recalls an image often found in earlier writings – the Virgin seated *super petram*. The foundation-stone of Christianity is of course Christ, whom she holds in her arm and to her breast. Like the Church itself, Mary supports Christ while being founded on him. This little relief, then, may be much more than a traditional Madonna. It alludes persistently to Christ's Passion, and seems to indicate that Salvation through Christ can be achieved by devotion to his mother.

Michelangelo's two early reliefs, in their very different styles and different sources of inspiration, seem to confirm that he had no single teacher in sculpture. The freedom he enjoyed studying among the antiquities of the Medici garden left him at liberty to experiment, to suit his ideas to the different styles and techniques, ancient and modern,

that he found around him. Michelangelo's own later claim to being an autodidact is perhaps essentially just. Like a few other artists – notably Leonardo before him – Michelangelo's art ultimately expresses only himself, perhaps stimulated by the same humanist world of the Medici circle, where Poliziano could say 'it is myself that I express, or so I think.' And like very few other artists, Michelangelo always gives the sense of a demonic thrusting-ahead into unknown territory, a quality already apparent in his earliest works. As John Pope-Hennessy put it,

More than any other artist, Michelangelo worked at the limits of the possible. Each of his sculptures from the very first dealt with an artistic problem, and it seems that his interest in them waned once they were formulated to a point at which the solution was no longer in doubt. Michelangelo's concern lay with the problem, not with the completed work of art.

Although over-simple, this is an admirable statement of the esthetic of the early Michelangelo so long as he was on his own. When working for others he could not be so cavalier.

The Crucifix

After Lorenzo de' Medici died, Michelangelo went back to his father's house. He determined at this time to master human anatomy by dissecting corpses, which he did at the Hospital of Santo Spirito. 'Nothing could have given him more pleasure,' Condivi writes, and in return for this favor he carved for the Prior of Santo Spirito a wooden crucifix. That work, long believed lost, may have survived in the form of a crucifix recently discovered in a corridor of Santo Spirito [10]. The slight figure, of painted poplar, originally hung over the altar of the church. It is surprisingly un-Michelangelesque - the vigorous nudes of the Battle relief and the powerful anatomy of the Christ in the early Madonna of the Steps find no echo here. The Crucifix hardly seems to be the product of an artist who had been devoting himself to the study of anatomy - the slender body is softly modeled with little attention to anatomical detail. If this is indeed Michelangelo's lost Crucifix it must be earlier than the old writers led us to imagine. It is in fact fairly conventional and could be by a number of sculptors of the period. The sweet expression of the face of the dead Christ is also found in contemporary works by Benedetto da Maiano (1442-97). who has been proposed as Michelangelo's first teacher of sculpture. It is, however, difficult to imagine just when this study would have

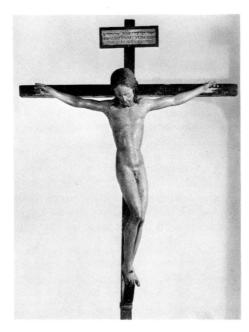

10. Michelangelo (?), Crucifix. c. 1492?

taken place, and the stylistic relationship between them is not very persuasive.

The fact that Michelangelo was allowed by a churchman to dissect corpses points up the new spirit of the age. Some years earlier, Pollaiuolo and Verrocchio had both begun this unpleasant but useful research, whose results can be studied in Pollaiuolo's paintings [cf. 46] and in Leonardo da Vinci's notebooks. For Michelangelo, anatomy was destiny, and he based his increasingly expressive designs solidly on this study which, as Condivi says, 'he followed as long as fortune allowed him.'

Hercules

In 1491 Michelangelo's older brother Lionardo had become a Dominican friar, making Michelangelo in effect the eldest son, with new responsibilities; his letters increasingly reveal the seriousness with which he took this burden and the importance he gave his family's status and welfare. It is just conceivably with these thoughts in mind that, late in 1493, he bought a large block of marble, about eight feet high, to carve for his own pleasure. The resulting work, a giant *Hercules*, was bought by the influential Strozzi family and later found

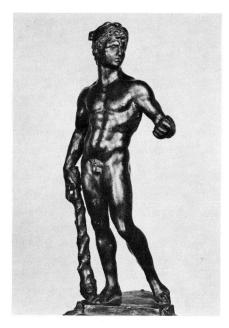

11. Anonymous, *Hercules. c.* 1505?

its way to Versailles – but is now lost. A bronze statuette, formerly attributed to Bertoldo but more probably of the early sixteenth century, may reflect Michelangelo's statue [11]. It shows a powerful body in classical *contrapposto* (see p. 56), related to some on the *Battle* relief, club in his right hand and the apples of the Hesperides in his left. Both this and Michelangelo's lost giant seem to have depended upon an antique marble formerly in the Medici collection.

Before he was twenty years old Michelangelo dared to carve an over-life-size figure of an antique hero in direct competition with the ancients. It was surely unusual for a sculptor, especially one so young, to buy and work a large block of marble on his own. The lack of patronage may have driven him to it, for Piero de' Medici, Lorenzo's successor, despite his friendship, commissioned only one work from Michelangelo. Condivi tells us that while he was working on the *Hercules*

there was a great snowstorm in Florence, and Piero . . . wished childishly to have a statue of snow made in the middle of the court-yard [an unusually heavy snowfall was recorded in January 1494], so he remembered Michelangelo, and had him found and made him make the statue. He desired him to live in his house as he had done in his father's time, and gave him the same room and kept him continually at his table as before . . .

Some scholars have actually conjectured how this snowman might have looked.

Michelangelo's first eighteen years were spent in a time of peace during the forty years after the Peace of Lodi, of 1454, Italy was almost free of war, a period that later seemed like a golden age. But Piero de' Medici's rule was unpopular, the times increasingly unsettled. In 1493 itinerant blood-and-thunder preachers attracted as many as 10,000 Florentines at a time to hear their sermons; riots broke out in June; and in the following year everything went to pieces. When King Charles VIII of France invaded Italy (the first of three French invasions in twenty years), Piero vacillated, first calling on Naples for help, then on Venice, finally sending his Neapolitan allies away. At this time the Dominican Prior of San Marco, Fra Girolamo Savonarola (1452-98), rose to prominence with sermons that foretold the punishment of Florence by the scourge of God. Rumors of Charles VIII's arrival in Genoa had reached a frightened Florence on 21 September, and on that day Savonarola preached to thousands of people in the Cathedral that a new flood was coming to punish the wicked. This sermon so terrified the audience that all Florence shook with cries and moaning. (Condivi tells us in 1553 that Michelangelo still remembered the words of Savonarola and could recall the sound of his voice.) Then, on 24 September, Michelangelo's friend Poliziano died. Because of Piero's unpopularity and increasing insecurity - but also, possibly, because of Savonarola's frightening predictions of the end of Florence - Michelangelo left town before mid-October 1494. This has been called his first 'flight', but when we realize the circumstances we can only think that he was prudent to leave.

Bologna 1494–5

He went first to Venice. Albrecht Dürer (1471–1528), the first truly Renaissance man of the North, was also there at the time; but no record survives of a meeting between these two future giants. By late October 1494 Michelangelo was in Bologna, where luck took him to the house of Gianfrancesco Aldrovandi, a learned gentleman who had lived in Florence, a connoisseur of Florentine culture and literature, and himself an author. Michelangelo stayed in his house for over a year. Aldrovandi, Condivi tells us, 'honored him highly, delighting in his genius, and every evening he made him read something from Dante or from Petrarch, or now and then from Boccaccio,

until he fell asleep.' Vasari adds that Aldrovandi loved him because of his Tuscan accent. In later years Michelangelo had a formidable reputation as an expert on Dante, 'which he knew in great part by heart.'

Aldrovandi also found Michelangelo some work, for the sculptural decoration of the tomb of St Dominic had been left incomplete at the death of Niccolò dell'Arca in 1492. Michelangelo carved three statuettes: an angel holding a candelabrum, and two local saints [13]. Although these figures are but two feet high, they have a monumentality and equipoise rarely found in the Quattrocento - certainly not in Niccolò's charmingly decorative figures [12]. Michelangelo's St Proculus has a genuine anatomical foundation; his St Petronius Holding a Model of Bologna, which reflects a statue by the great Sienese pioneer Jacopo della Quercia, is impressive for the power of its contrapposto pose, expressed through voluminous drapery. The Angel makes more decisive contrast with Niccolò's fragile, childlike work,

12. Niccolò dell'Arca. Angel Bearing Candelabrum. 1470-73

13. Michelangelo, Angel Bearing Candelabrum, 1495

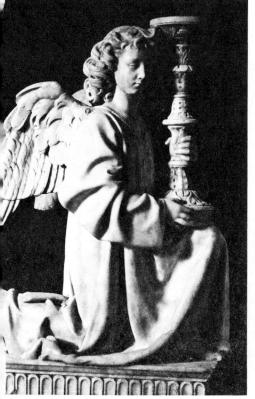

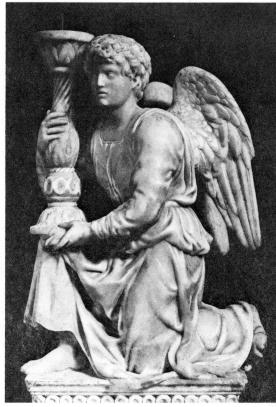

although Michelangelo did have to imitate it by giving his figure wings, the only winged angel in his entire $\alpha uvre$. There is a veiled, lambent softness to Michelangelo's technique here that makes the marble look as creamy as wax. Despite an elaborate play of drapery, his little figure is one of massive calm. Even in the design of the two candlesticks, which were surely meant to be a pair, we find a contrast between the elegantly decorated Quattrocento style of Niccolò and the monumentality of the incipient High Renaissance.

The Sleeping Cupid

Michelangelo seems not to have found these little statues very challenging and, leaving a fourth still to be carved, he returned to a newly pacified Florence in the winter of 1495-6. The city he found was under the virtual dictatorship of Savonarola, who had 'a vision of the city as the New Jerusalem, chosen by God as the headquarters for the regeneration of Christian society.' The charismatic Savonarola had made his peace with the French, established a general amnesty, and set up a potentially democratic government on the model of Venice. A Great Council was formed and a huge hall for the Council was begun - the hall that, eight years later, Leonardo and Michelangelo were commissioned to decorate. From this time on we sense the growth of Michelangelo's latent republican sympathies. In Florence, Michelangelo knew Botticelli's patron, a minor Medici, Lorenzo di Pierfrancesco (1463-1503), who was sympathetic to the new government. For Lorenzo Michelangelo carved a little St John the Baptist that is lost. And for his own amusement, Condivi tells us, he made a marble Cupid between six and seven years of age, lying asleep; this figure, which is now lost,

was seen by Lorenzo di Pierfrancesco . . . and he judged that it was most beautiful and said of it: 'If you can manage to make it look as if it had been buried under the earth I will forward it to Rome, it will be taken for an antique, and you will sell it much better.'

The *Cupid* is only the most obvious and famous example of Michelangelo's rivalry with antiquity. This running competition had a rationale, for ancient art was revered as the greatest model for modern artists to follow. That prejudice was brought home to Michelangelo after the *Cupid* was sold as an antique by an unscrupulous merchant to the wealthy Cardinal Riario. Riario paid 200 ducats, but Michelangelo got only 30 from the dealer. Hearing of this double

deception, Michelangelo, 'partly indignant at being cheated, and partly to see Rome,' left Florence and arrived in the Eternal City for the first time on 25 June 1496. The story, told by Condivi, is perhaps only partly true. All Florence was gripped with a new sense of impending doom, and he was probably eager to leave. Rain and famine added to the tension and fear of the populace. Shortly after Michelangelo left, plague broke out.

2 The First Roman Sojourn 1496–1501

The Rome Michelangelo found was sadly reduced from her antique splendor; her churches and palaces were huddled in the lowlands near the Tiber, where fresh water still flowed fitfully through the one remaining ancient aqueduct. Huge open spaces within the Aurelian wall, in part cultivated, often hid roaming outlaws. Michelangelo would have seen many new buildings - Old St Peter's had a new choir under construction, and Cardinal Raffaele Riario, the purchaser of the Cupid, was finishing a great new palace that we know today as the Cancelleria. But above all Michelangelo would have been enthralled by the opportunity to study antique sculpture at first hand. A kind of sculpture museum had been established by Sixtus IV on the Capitol; Cardinal Riario had a rare collection of antiquities in his palace - with, as Michelangelo himself said, 'many beautiful things'. Riario's cousin, Cardinal Giuliano della Rovere (later Pope Julius II). cherished another collection that included the famous Apollo Belvedere, which had been found on his own land. There were also many smaller collections [cf. 15], sculptured sarcophagi all over town, and antique monuments like the Horse-tamers and the equestrian Marcus Aurelius [194].

Rome was governed by the notorious Borgia pope, Alexander VI (1492–1503), but, although Michelangelo was familiar with one or

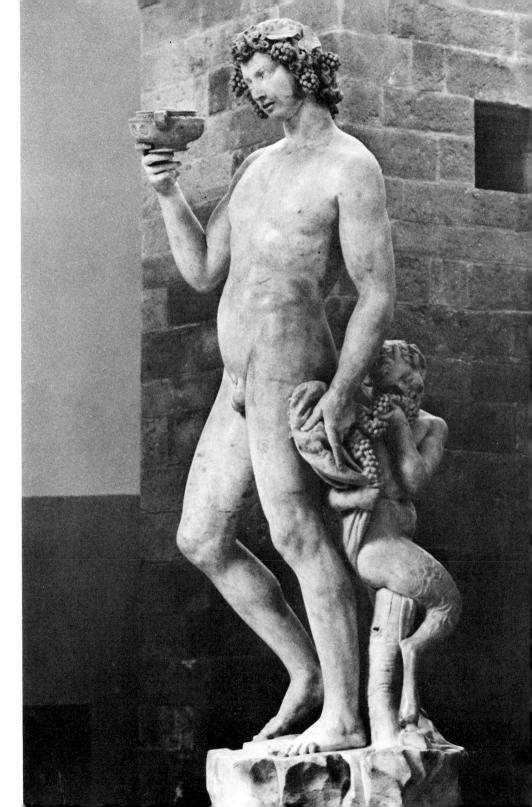

two cardinals, he seems to have had no direct contact with the papal court. Nevertheless, Cardinal Riario himself embodied all those worldly qualities of the Curia that Savonarola, now virtual ruler of Florence, was so actively denouncing, and the contrast between Florence and Rome must have been disquieting.

The Bacchus

From the time of his earliest works Michelangelo had been fascinated with antique sculpture and felt impelled to compete with it. Hence the interest of the *Cupid*, which really did fool the experts. In his first letter from Rome, on 2 July 1496, Michelangelo wrote to Lorenzo di Pierfrancesco de' Medici that Cardinal Riario, after showing him his collection of ancient statues.

asked me whether I had courage enough to attempt some work of art of my own. I replied that I could not do anything as fine, but that he should see what I could do. We have bought a piece of marble for a life-sized figure and on Monday I shall begin work.

Before he had been in Rome a week, Michelangelo already seems to have had a commission. Condivi specifically says that the Cardinal 'understood little and was no judge of sculpture, as is shown clearly enough by the fact that all the time Michelangelo remained with him, which was about a year, he did not give him a single commission.' Indeed, when the *Cupid* was revealed as modern, the Cardinal insisted on getting his money back; a writer of the time noted that since it was modern it was not worth as much – just as Lorenzo di Pierfrancesco had said. Despite what now seems critical blindness, Riario encouraged young artists to copy in his collection, as Lorenzo il Magnifico had done. Condivi goes on to say that

Messer Iacopo Galli, a Roman gentleman of good understanding, made Michelangelo carve a marble *Bacchus*, ten palms in height, in his house; this work in form and bearing in every part corresponds to the description of the ancient writers – his aspect, merry; the eyes, squinting and lascivious, like those of people excessively given to the love of wine. He holds a cup in his right hand, like one about to drink, and looks at it lovingly, taking pleasure in the liquor of which he was the inventor; for this reason he is crowned with a garland of vine leaves. On his left arm he has a tiger's skin, the animal dedicated to him, as one that delights in grapes; and the skin was represented rather than the animal, as Michelangelo desired to signify that he who allows his senses to be overcome by the appetite for that fruit,

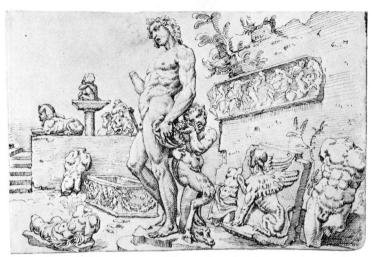

15. Maerten van Heemskerck, view of the sculpture garden of Jacopo Galli, Rome. 1532–5

16. Michelangelo, Bacchus (detail)

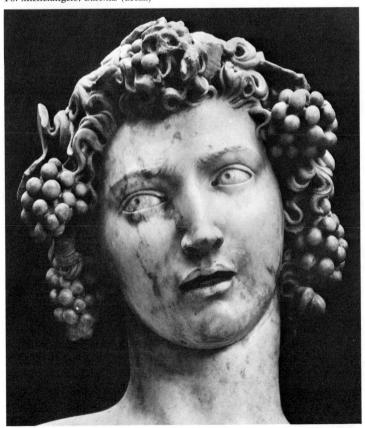

[1496-8] · 39

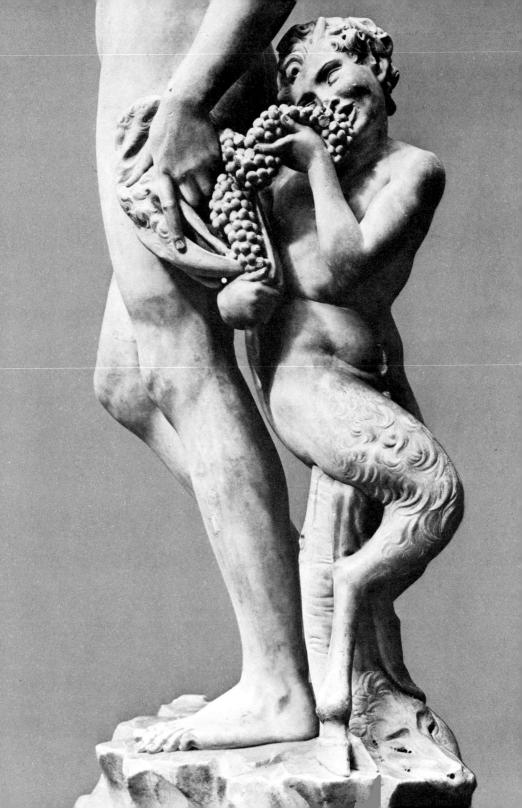

and the liquor pressed from it, ultimately loses his life. In his left hand he holds a bunch of grapes, which a merry and alert little satyr at his feet furtively enjoys.

Perhaps this, Michelangelo's first masterpiece [14], was carved from Riario's block. Galli was a friend and close neighbor of Riario's, and a date 1496–8 is essentially right. The *Bacchus* formed part of Galli's collection and can be seen there, looking like one of the antiquities, its right hand broken off, in a drawing of the early 1530s [15]. Perhaps because of its free-standing site in the garden Michelangelo carved a figure that is unusual in his work; from a frontal position the pointed base and raised cup deflect the viewer to the right: the chief view is shown in illustration 14 – but the composition begs to be seen from several points of view around 180 degrees, from front to back. This slow movement is encouraged by the fascinating torsion of the coy little satyr, which also furnishes the support needed by a standing marble statue [17]. Michelangelo's figure is standing in one of the traditional art-poses of antiquity, but seems to sway back tipsily as he eyes his large cup, mouth open.

Vasari, writing about what we would call the transition from Quattrocento to High Renaissance art, emphasizes the beneficial influence of antiquity, citing the newly-discovered 'appeal and vigor of living flesh' and the free attitudes, 'exquisitely graceful and full of movement.' This new spontaneity, 'a grace that simply cannot be measured', and the 'roundness and fullness derived from good judgement and design' are perhaps seen here for the first time in modern sculpture. In addition the statue is novel in its depiction of the god of wine, naked and enraptured with his own sacred fluid. Michelangelo combined familiar ancient proportions with a suspiciously naturalistic rather than ideal nude body. Although several figures of Bacchus survive from antiquity, none is so evocative of the god's mysterious, even androgynous antique character: as Condivi says, it is in the spirit of the ancient writers. Nevertheless, grapes, vine leaves, a wine cup, a skin, and a little satyr can all be found accompanying one or another of the ancient representations.

The *Bacchus* is at first disconcerting. We imagine the sculptors of antiquity producing noble, heroic works; when we think of sculpture by Michelangelo, the *David* or *Moses* perhaps spring first to mind [25, 107]. Here we have instead a soft, slightly tipsy young god, mouth open and eyes rolling [16], his head wreathed in ivy and grapes, as pagan and natural as Michelangelo could make him. Since the statue was in the open for over half a century its polished surface is weathered.

Jacopo Galli, a banker, was the intimate of a Humanistic circle that included not only Cardinal Riario but also such men as the writer

Jacopo Sadoleto, whose dialogue *Phaedrus* was set in Galli's suburban villa. We can therefore suspect that Michelangelo was given learned iconographical information to incorporate into his statue. The teacher of Bacchus was Silenus, who was reputed to be the father of the Satyrs. The flayed skin (probably not a tiger, but perhaps the legendary *leopardus*), full of grapes, with its head between the hooves of the little satyr, must symbolize life in death. The ancient cults of Dionysus–Bacchus were associated with wine and revelry but also with darker things: grisly orgies, ritual sacrifice, the eating of raw flesh. Some of this veiled frenzy seems to have been incorporated in the attributes of the *Bacchus*, and a sense of mystery filtered down even to the naïve Condivi. In later years Michelangelo returned to the image of a flayed skin as symbol of his own plight, both in poetry and in the eerie figure of St Bartholomew in *The Last Judgement* [163].

In a letter of 1 July 1497 Michelangelo wrote his father:

Do not be astonished that I have not come back, because I have not yet been able to work out my affairs with the Cardinal, and don't want to leave if I haven't been satisfied and reimbursed for my labor first; with these great personages one has to go slow, since they can't be pushed...

If this means that the *Bacchus* was finished, it must soon have been acquired by Galli, since Riario was obviously not attracted by modern antiquities. A further letter of 19 August reports that

I undertook to do a figure for Piero de' Medici and bought marble, and then never began it, because he hasn't done as he promised me. So I'm working on my own and doing a figure for my own pleasure. I bought a piece of marble for five ducats, but it wasn't a good piece and the money was thrown away; then I bought another piece for another five ducats, and this I'm working for my own pleasure. So you must realize that I, too, have expenses and troubles . . .

Michelangelo's complaints are made at least partly in response to his father's; the older man was threatened with a lawsuit following his brother's death. But perhaps we can also detect a genuine unhappiness, which Michelangelo could not analyze, and to which he referred in later years: in 1509 he wrote that

for twelve years now I have gone about all over Italy, leading a miserable life; I have borne every kind of humiliation, suffered every kind of hardship, worn myself to the bone . . . solely to help my family

The choice of 1497 as the year his troubles began is repeated in a letter to his father of 1512:

I live meanly . . . with the greatest toil and a thousand worries. It has now been about fifteen years since I have had a happy hour; I have done everything to help you, and you have never recognized it or believed it. God pardon us all.

We have only the *Bacchus* to show for the block Michelangelo was carving for Riario, for the block he bought and worked for himself, and for the commission from Piero de' Medici. There are records of a standing *Cupid* (perhaps an *Apollo*) with arrows and quiver, also done for his friend Jacopo Galli. This statue, described as life-size, with a vase at its foot, has disappeared without a trace.

The Pietà for St Peter's

> Michelangelo's letter to his father of 1 July 1497 suggests that he would be returning to Florence, but a new Roman commission soon appeared to delay him. On 18 November 1497 a French cardinal, Jean Villiers de Fezenzac, wrote to Lucca for help in quarrying a marble block. The marble was for Michelangelo, and by the end of the year he was evidently in Carrara, returning early in March of 1498. The marble he quarried was for the famous Pietà [18]. The block arrived in Rome the following summer, when a contract was finally signed on 27 August, according to which Michelangelo was to finish the statue in one year for the price of 450 ducats. Jacopo Galli, who must have procured the commission, acted as guarantor, writing that the Pietà would be 'the most beautiful work of marble in Rome, one that no living artist could better' - a seemingly rash prediction, vet one that was to be wholly fulfilled. At that time Galli was paid 150 ducats which, according to the contract, were to be given to Michelangelo before he began work. Nevertheless, in order to quarry the marble Michelangelo must already have designed the group with considerable precision, and indeed it is described quite accurately in the Cardinal's letter of November 1497. The Cardinal died on 6 August 1499 when the sculpture, meant for his tomb chapel in St Peter's, was probably still unfinished.

> Michelangelo's *Pietà* is one of those famous works, like the *Mona Lisa* or the *Venus de Milo*, that it is almost impossible to see afresh. In 1500, however, it was a novelty in Italian art and at first must have looked strange to the Romans who flocked to see it. The subject represents one of the 'Seven Sorrows of the Virgin', which were increasingly the subject of devotion in the fifteenth century. The original

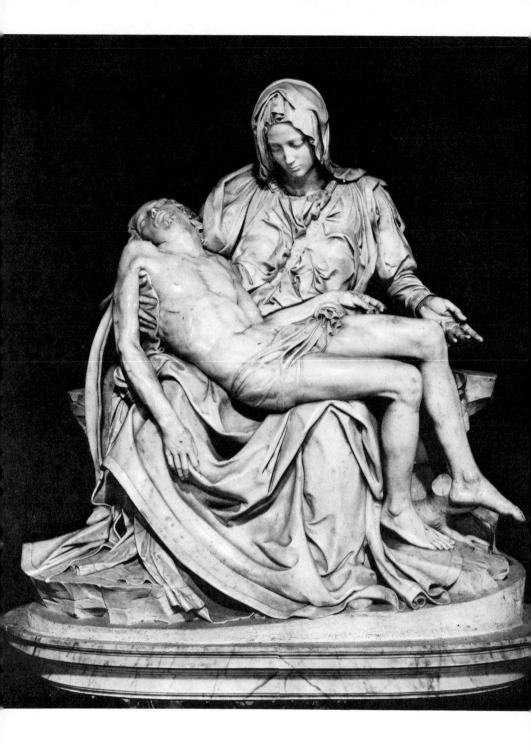

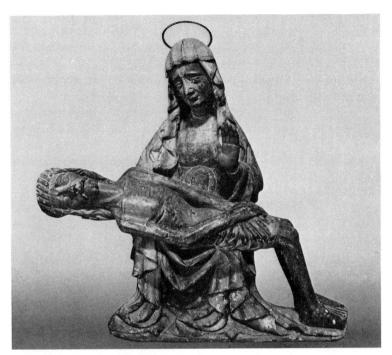

19. German, fifteenth century, Pietà

image of Mary cradling the body of the dead Christ is not Italian but Northern, a German invention that had spread to France in the fourteenth century. The *Pietà*, then, was doubtless the choice of the French cardinal, for whom it would have been a familiar theme. By 1497 a number of sculptured Northern *Pietà*s had reached Italy [19], and a few Italian paintings of the subject existed. The idea had been known to St Bernardine of Siena, who in one of his sermons described the Virgin holding the body of her dead son, thinking back to the days in Bethlehem when he was a baby in her arms, dreaming that he has merely fallen asleep. This tradition, which is intimated in the *Madonna of the Steps* [9], may explain Mary's unusual youthfulness, which could also have been suggested by a passage in Dante's *Paradiso*:

Vergine Madre, figlia del tuo Figlio . . .

(Virgin Mother, daughter of your Son . . .)

That this was a common interpretation of the statue is proved by a poem on the *Pietà* printed in Vasari's *Life*.

Mary is seated on the rock of Golgotha that had supported Christ on the Cross – possibly another example of Mary *super petram* (see p. 28), and another sign of the continuity of thought that we find in most of Michelangelo's work. But there are other overtones here, for the group is not merely a *Lamentation* but a symbol of the central mystery of Christianity – God made truly human, now dead, whose body is the *Corpus Domini* of Christian communion. He is held by his mother who is also, symbolically, the Church (see p. 114).

Every Northern Pietà posed a knotty esthetic problem, the awkward contrast between the ungainly male body and the smaller woman holding it [19]. Michelangelo solved this difficulty (if it can be said to be soluble) by creating a giant pyramid of marble with drapery cascading over the Virgin's enormous lap. The handsome Christ follows her contours, his head falling back into the line of her drapery. It is hard to deny that Michelangelo simply carved the most beautiful young woman and the most handsome man he could imagine, whatever other meaning the statue may have. He never again so reveled in his sheer technical virtuosity, which shapes and polishes every fold and plane with joyous precision. His unprecedented mastery of the craft led to a conflict of interest between incised line and sculptural mass that he could not immediately resolve. Despite its beauty, the parts surpass the whole [20]. In his first large religious sculpture, much more than in his previous works, we sense the debt to his Early Renaissance forebears - Verrocchio and Jacopo della Quercia - and of course this is still, chronologically, a work of the Quattrocento. Highly finished and polished, it shows a Quattrocento love of detail; linear drapery folds pile up in ornamental abundance.

The group is now displayed at a height that could not have been originally desired; from the correct point of view, with the figures no higher than eye level, the group composes beautifully, with the Virgin's compassionate gesture to the right and above Christ's knee. The lovely Florentine face of the Virgin is without legible expression yet is full of finely-incised detail. Although the group was severely criticized in later years for lack of religious feeling, the *Pietà* became one of the images closest to Michelangelo's own spiritual aspirations. Late in life he drew and carved several new versions, including one destined for his own tomb [170, 184]. We can at least ask whether this particular theme so moved him because of his own missing mother, even though such a question might appear foreign to so exalted a work of art.

Michelangelo's later, unfinished works of sculpture may seem more profound to us, but in Vasari's time the *Pietà* was considered perfect:

It would be impossible for any craftsman or sculptor no matter how brilliant ever to surpass the grace or design of this work or try

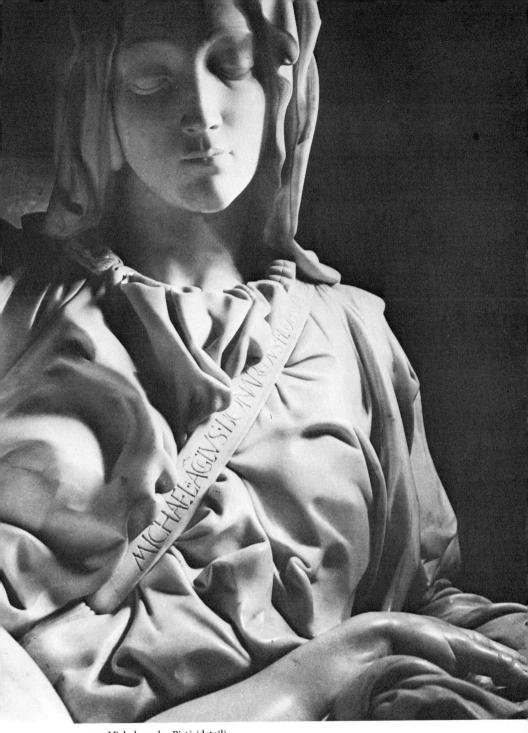

20. Michelangelo, Pietà (detail)

to cut and polish the marble with the skill that Michelangelo displayed. For the Pietà was a revelation of all the potentialities and force of the art of sculpture. Among the many beautiful features (including the inspired draperies) this is notably demonstrated by the body of Christ itself. It would be impossible to find a body showing greater mastery of art and possessing more beautiful members, or a nude with more detail in the muscles, veins, and nerves stretched over their framework of bones, or a more deathly corpse. The lovely expression of the head, the harmony in the joints and attachments of the arms, legs, and trunk, and the fine tracery of pulses and veins are all so wonderful that it staggers belief that the hand of an artist could have executed this inspired and admirable work so perfectly and in so short a time. It is certainly a miracle that a formless block of stone could ever have been reduced to a perfection that nature is scarcely able to create in the flesh. Michelangelo put into this work so much love and effort that (something he never did again) he left his name written across the sash over our Lady's breast. [cf. 20]

Mary's age, nevertheless, aroused repeated criticisms, as we learn from Condivi:

Some there be who complain that the Mother is too young compared to the Son. One day I was talking to Michelangelo of this objection; 'Do you not know,' he said, 'that chaste women retain their fresh looks much longer than those who are not chaste? How much more, therefore, a virgin in whom not even the least unchaste desire that might work change in her body ever arose? And I tell you, moreover, that such freshness and flower of youth besides being maintained in her by natural causes, it may possibly be that it was ordained by the divine power to prove to the world the virginity and perpetual purity of the Mother . . . Do not wonder then that I have, for all these reasons, made the most Holy Virgin, Mother of God, a great deal younger in comparison with her Son than she is usually represented . . . [cf. the line from Dante on p. 45]

Just how ironic these words were in Michelangelo's mouth cannot now be proved; he was notoriously cryptic. The sophisticated Vasari wrote in 1550 that 'his manner of speech was very veiled and ambiguous, his utterances having in a sense two meanings.'

A Painting

We do not know when the *Pietà* was finished – perhaps not until sometime in 1500. Early in that year we learn from Michelangelo's father that the sculptor was penniless, lacking food, and ill. On 2 September 1500, however, Michelangelo deposited 230 gold ducats in Galli's

bank, which might have been the final payment for the *Pietà*. But at just that time the Brothers of Sant'Agostino in Rome gave him a commission for a painted panel. A commission for a painting is surprising, but Michelangelo had never ceased drawing, and surely had done some painting in Ghirlandaio's shop. Raffaele Riario was the Cardinal-protector of the Augustinian Order, and both Riario and Galli were on close terms with its General, Fra Mariano da Genazzano. The commission, then, was the direct result of Michelangelo's earlier connections. Just possibly the picture he began for these Brothers, who

21. Michelangelo and assistant, Entombment. c. 1500?

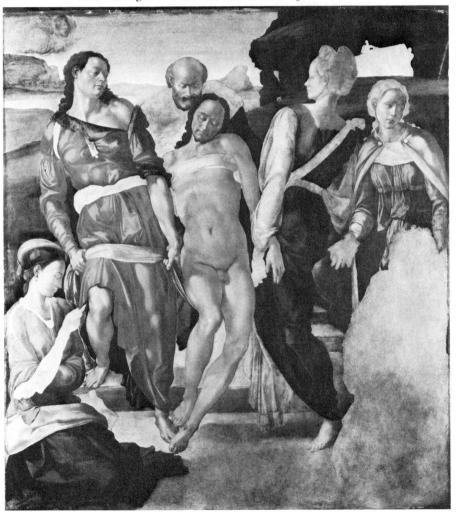

were described by a learned contemporary as 'both pious and elegant, is the unfinished *Entombment* now in London [21], which appears to have been painted by two different artists. For reasons of costume and hairstyle the panel has usually been dated somewhat later, but since it is the only picture of unknown origin that can reasonably be ascribed to Michelangelo's hand, it should be given serious attention. The body and head of Christ are clearly related to that of the Pietà and could easily have been produced by him at this time. The Joseph of Arimathea or Nicodemus behind looks suspiciously like the figure of Joseph in the Doni Madonna, which was presumably painted in 1503 [33], but the comparison is inconclusive. The bulky St John at the left is worthy of the master and conceivable at this time, but it may reflect the Laocoön, which was discovered only in 1506 (see p. 89). The excessive planarity of the central group might well be a sculptor's solution to an unfamiliar problem. However, since someone else was paid to finish the panel when Michelangelo left for Florence, the resulting picture ought not to be unfinished. Other problems remain; the mannered poses of the figures to the right and in the left foreground could also argue for a later date.

We do not know precisely why Michelangelo returned to Florence in May of 1501. The most obvious reason is disclosed in a letter written on 22 May, discussing a contract for statuettes to be carved for the Piccolomini altar in the Cathedral of Siena. The patron, Cardinal Francesco Piccolomini, contracted with Michelangelo the following month for fifteen statuettes, about four feet tall, to be finished in three years. The contract stipulated that 'before he begins to make these figures . . . he is obliged to draw them on a sheet of paper so that their clothes and gestures can be seen . . . so that additions and subtractions can be made if necessary.' This record of working procedure is the single most interesting thing about the commission. The guarantor, and no doubt the instigator of the commission, was again Jacopo Galli. Michelangelo's return to Florence was perhaps made via Siena to see and measure the altar. Eventually Michelangelo carved only four statuettes, which were delivered in 1504; they did not engage his interest and he let the commission lapse.

3
The
High Renaissance
in
Florence
1501–5

When Michelangelo returned to Florence in the spring of 1501 after an absence of almost five years, he found the city considerably changed. Savonarola, after some four years of turbulent rule, had been condemned by the Church for heresy and burned at the stake in the Piazza on 23 May 1498. Slowly a stable government emerged; on 4 August 1501 the constitution was radically changed to allow a lifetime Gonfaloniere, like the Venetian Doge, and on 1 November 1502 Pietro Soderini, a great supporter of Michelangelo's, was elected as the first Gonfaloniere for life. Michelangelo, upon arriving in May of 1501, got a unique civic commission that established him once and for all as the premier Florentine artist – the giant *David*.

David

The history of the *David* [25] is long and complex. The block from which it was carved – some eighteen feet high – had been acquired in 1464 as part of an old program to furnish giant statues of Prophets for the adornment of the tribune buttresses of the Cathedral. The idea went back to the previous century, and Donatello had set to work on one such *Prophet* in 1410. This, the first Renaissance colossus, was described in 1412 as *homo magnus et albus*, the white giant. The Prophet program was revived in the 1460s when Donatello was

again back in Florence; and it may have been Donatello who was behind the new commission of a terracotta colossus that was given to the sculptor Agostino di Duccio. His statue, described as uno gughante overo Erchole - a giant, or Hercules - was finished in 1464, at which time a second giant was commissioned, to be carved this time out of the marble block that ultimately became the David. The influence of the patriarchal Donatello can only be inferred, but immediately after his death in 1466 the contract with Agostino was terminated without recrimination or notice of any difficulty. In 1474 the task was taken up again by Antonio Rossellino, evidently reluctantly and without result. The block remained lying in the yard of the Cathedral workshop until, on 2 July 1501, a document records that the Overseers of the Office of Works (Operai) determined to find a master capable of finishing it. Perhaps rumors of this impending commission provided the true reason for Michelangelo's return to Florence, as Vasari thought. Such diverse artists as Andrea Sansovino and Leonardo da Vinci were apparently also being considered. Michelangelo was clearly a more appropriate choice since he had already carved the large Hercules, then still in Florence. It is a sign of the newly ambitious times that this old block suddenly became so attractive.

On 16 August 1501 Michelangelo was entrusted with the commission, a task that joined the medieval Cathedral program with the new republican government and that fused the aspirations of Donatello, the greatest sculptor of the Quattrocento, with those of his unique successor of the High Renaissance. Before Michelangelo got the official commission the figure was already called a David: 'a certain figure of marble called David badly blocked out and carved...' (homo ex marmore vocato Davit male abbozatum et sculptum). On 9 September, with a few blows of the hammer, Michelangelo knocked off a 'certain knot' (quoddam nodum) that had been on the chest of the future figure. He started working in earnest on the 13th. Vasari says that

He began work on the statue in the Office of Works of Santa Maria del Fiore, erecting a partition of planks and trestles around the marble; and working on it continuously he brought it to perfect completion, without letting anyone see it.

The following year Michelangelo got a commission for another *David*: the French general of Charles VIII, Pierre de Rohan, had occupied the Medici palace in 1494 and admired Donatello's *David*, which was then in the courtyard [22]. In 1501 he asked for a bronze copy, and on 12 August 1502 Michelangelo contracted to furnish a statue. We have a record of Michelangelo's early idea for this figure on a sheet that can probably be dated 1502 [23]. The bronze statue is

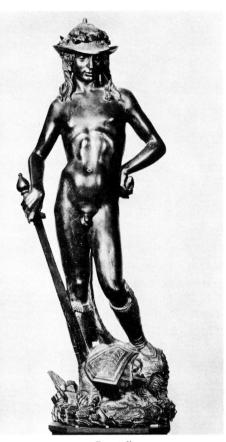

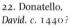

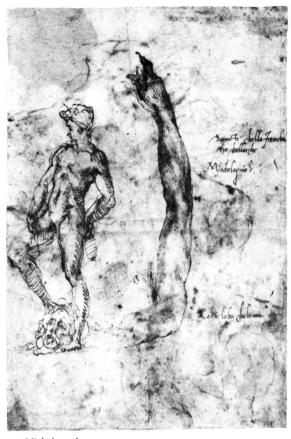

23. Michelangelo, drawing for marble and bronze *Davids*. 1502

lost, and its commission must have proved an impediment to Michelangelo's other work; as it was finally completed, years later, the bronze may have looked more like Donatello's *David*: a bronze statuette now in Paris may well be a casting from Michelangelo's own small wax model [24].

The drawing [23] also has on it a study for the powerful right arm of the marble *David* and, most fascinating of all, a few rhythmic lines:

Davicte cholla fromba e io chollarcho

- Michelagniolo.

(David with the sling and I with the bow – Michelangelo.)

24. After Michelangelo, bronze *David*

25 (opposite). Michelangelo, David. 1501-4

These words link the writer and the biblical hero, but the meaning of *io coll'arco* (as we would spell it now) has been in doubt. Recently, however, Charles Seymour ingeniously proposed that Michelangelo was thinking of his own 'weapon,' the running drill, which was operated by means of a bow. 'David conquered with his sling, I with my drill,' the lines seem to say. This kind of free-association, poetic if not properly poetry, may lead on to the next fragment, the first line from a mournful sonnet by Petrarch:

Rocte lalta cholonna el ver[de lauro . . .]

(Broken the high column and the green laurel felled . . .)

Petrarch was mourning the deaths of his patron, a member of the Colonna family, and of Laura; Michelangelo echoed the tone of this sonnet in the earliest of his poems that has come down to us, which is to be dated at about the same time. But on this sheet of drawings the association may again be with David as well as with himself: the biblical hero was considered a personification of courage, a kind of twin to Hercules, and an emblem of Fortitude, which is one of the Cardinal Virtues (see also p. 57). The virtue Fortitudo was already symbolized by a column in the Quattrocento; later it was sometimes shown as a broken column. Thus, possibly, Michelangelo associated the brave David not only with his own daring but also with the column symbolizing Fortitude.

The marble *David* is first of all the figure that Michelangelo could carve from a very tall, rather shallow block [25]. There is simply no point in trying to imagine what condition the block was in before

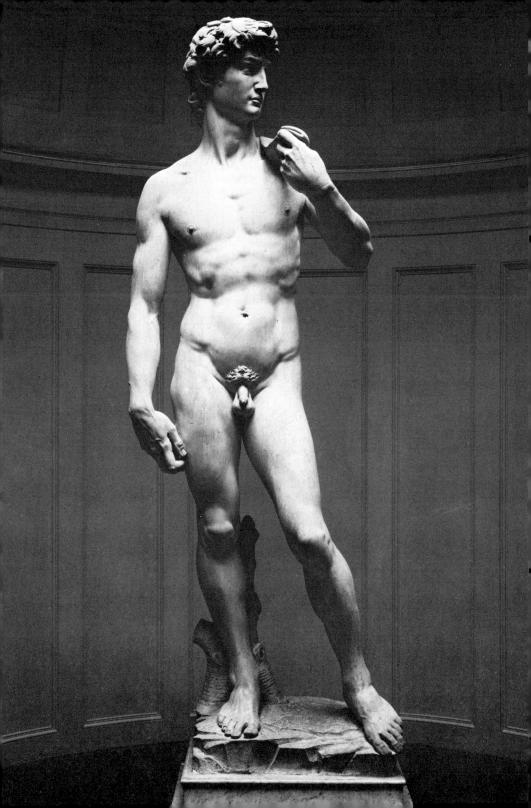

he started to carve – all that can be known now is that some kind of figure had been begun, and whatever it was allowed him to create the *David*. Vasari says that 'Michelangelo measured and calculated whether he could carve a satisfactory figure from the block'; he goes on to say that Michelangelo made a wax model; we can be sure that he drew the figure on the face of the block and then carved back from the face to create a typically frontal figure – not only because of the shallowness of the slab but also because that was his usual method of carving, as Vasari makes clear (see p. 94). Benvenuto Cellini, describing the technique of marble sculpture, wrote:

The best method ever was used by the great Michelangelo; after having drawn the principal view on the block, one begins to remove the marble from this side as if one were working a relief and in this way, step by step, one brings to light the whole figure.

The figure Michelangelo carved stands in a pose hallowed by Greco-Roman statuary - neither walking nor still, it is a version of the contrapposto pose that had become standard for standing male statues in the later fifth century B.C. By contrapposto is meant the asymmetrical arrangement of limbs, with the weight borne chiefly by one leg, which gives a sense of the normal action of gravity and the possibility of movement. The result looks natural, a unified pose rather than an accumulation of observed details. It is, however, an artifact, a simulation of nature. The torso of the David represents Michelangelo's version of a Hellenistic athlete - powerful and occasionally knotty, full of observed detail translated into pattern, yet fluid, with a dynamic movement through the muscles that unites the parts of the figure. This is the first wholly successful union of antique inspiration with the new Florentine celebration of man; and from the time of its unveiling it was understood as the beginning of a new epoch in art. As Kenneth Clark observed,

Michelangelo, like the Greeks, was passionately stirred by male beauty, and with his serious, Platonic cast of mind he was bound to identify his emotions with ideas. This passage of violent sensuous attachment into the realm of non-attachment, where nothing of the first compulsion is lost but much gained of purposeful harmony, makes his nudes unique. They are both poignant and compelling.

David has strongly contrasting sides – his right is closed, with a long, bowed outline from shoulder to hand that continues down the leg. His left side – the symbolically ambiguous *sinister* – is open, with the arm bent to hold the hidden sling. The two most arresting features of the statue are the powerfully outsized right hand and the large, proudly defiant head. The hand probably illustrates the appellation

manu fortis that was commonly applied to David in the Middle Ages: strong of hand. In fact, Michelangelo's *David*, in its size and strength, is related to figures of Hercules as Fortitude, such as Nicola Pisano's powerful figure in Pisa, which is an example of the late-medieval

26. Nicola Pisano, Fortitude (Hercules). Finished 1259

revival of antique figural types in central Italy [26]. By contrast, *David's* torso looks like a genuine antiquity. But the turn of the head, the thick, strained neck, furrowed brow, and leonine hair all seem to indicate apprehensive defiance. This head breaks the antique spell of the abstract torso by investing the figure with the human thought and consciousness so prized in Humanist Florence. Even Vasari,

writing under the restored dictatorial Medici, states that the statue was a symbol of liberty. It may be even more: an emblem of republicanism containing specific anti-Medicean ideas.

As the David was being completed, a meeting was held on 25 January 1504 to discuss where it should be placed. In part, the gathering may have been a device used by the new government to break the figure from its bonds with the old Cathedral program. Although no one thought any more of hoisting it up onto a buttress, a group of early opinions expressed at the meeting favored a position on the steps before the Cathedral. Others suggested the Palazzo della Signoria either inside the court or outside. Most seemed to want it within the central arcade of the Loggia dei Lanzi, next to the Palazzo Vecchio. where it would have been beautifully framed - and, possibly, desensitized as a hostile, anti-Medici symbol. It should be remembered that the symbolic Guelph-republican lion, the Marzocco, stood together with Donatello's Judith outside the palace, like apotropaic symbols to ward off enemies. Although the Judith had been a private Medici commission, the subject, tyrannicide, was clear enough, and with the expulsion of the Medici the statue was set up with a warning inscription outside the Palazzo della Signoria. Nevertheless, as the first witness said, the Judith 'is not fitting for the Republic . . . it was erected under an evil star, for from that day to this things have gone from bad to worse: for then we lost Pisa . . .' (Pisa will continue to play a part in our story.) All of this suggests that the David had a fairly clear meaning, which was, in a sense, being discussed during the meeting. Various hints in the contemporary records show that the statue was considered potent in its references to republican, anti-Medicean, civic spirit. If, as Vasari and now Saul Levine suggest, it was finally erected where the artist and the Signoria wanted it, we must think about the meaning of the statue and its site together. Levine argues that, placed as it was before the seat of republican liberty, the gaze of the David, facing South, was a warning to hostile Rome and, most particularly in 1504, to the Medici, who were gathering forces for their eventual reconquest of the city in 1512. Hostile citizens pelted the David with stones as it was being moved on the night of 14 May 1504, but whether their animosity was aroused by its pagan nudity or by its political implications we will never know.

Michelangelo's *David* was transported to the piazza in May 1504 and erected on the site of the *Judith* on 8 June. A base was constructed and on 8 September the entire work was unveiled. The copy now in front of the palace [27] gives an idea of how the statue should look, in front of a wall in open space. With the hindsight afforded by the later marble giants on either side, the *David* is lithe and Ouattrocen-

27. Palazzo della Signoria, Florence: view showing a copy of Michelangelo's David in the original position, and in center Bandinelli's Hercules and Cacus

tesque; but it is also free and natural, unbound by the straitjacket of an antique *cuirasse esthétique*, as are the statues by Ammannati and Bandinelli. Inside the Accademia, where it has been since 1873, the statue looks gargantuan and its silhouette is blurred. Nevertheless, we can still feel the force of Vasari's appreciation, which sees in the *David* a modern victory over antiquity:

without any doubt this figure has put in the shade every other statue, ancient or modern, Greek or Roman . . . such were the satisfying proportions and beauty of the finished work . . . To be sure, anyone who has seen Michelangelo's *David* has no need to see anything else by any other sculptor, living or dead.

One outstanding novelty of the David, apart from the startling transformation of a boy hero into a nude giant, is the moment

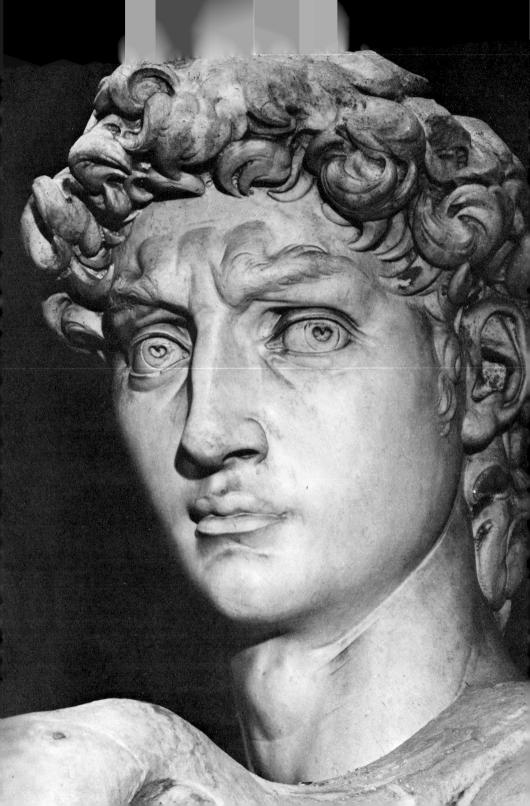

Michelangelo chose to depict – a psychologically charged pause of apprehension before doing battle with Goliath. Previous sculptors had shown the placid young boy after his victory – notably Donatello in his famous bronze [22]. Michelangelo reconstructed an ambiguous, unfulfilled, emotionally tense moment in the hero's career that seems to correspond to his own mental state.

The head of *David*, with its famous, precise, over-emphatic features, was meant to be seen, at the closest, from some yards' distance. Modern photographs reveal what only the sculptor can have seen as he worked the marble [28]. If we give weight to the lines on the drawing [23], it is Michelangelo's private view of a heroically idealized projection of himself – not of his own features, but of his troubled ambition.

The speed and assurance of Michelangelo's technique seemed to open a new era in the production of marble sculpture, just as his imagination and insight had created a newly mature style. The several Roman works, produced in a few years, and the David, already described as 'half-finished' in February of 1502, gave a promise of unprecedented productivity that is reflected by new contracts and demands on Michelangelo. In August of 1502 the contract for the bronze David added a new and unfamiliar task to the marble David and the burdensome Piccolomini commission. With the encouragement of Pietro Soderini, the Operai of the Cathedral commissioned Michelangelo in April 1503 to carve twelve Apostles, one a year for twelve years. During this time he was also working on three round Madonna compositions, one of them painted [33]; and in December 1503 he was given a first payment for the mysterious Bruges Madonna [39], which was finished by 1505. As if this were not enough, late in 1503 the almost legendary Leonardo da Vinci had begun working on a sixty-foot mural of a battle between Florence and Milan, and in the following year Michelangelo was asked to paint an equally large composition. Then in March of 1505, Pope Julius II ordered him to Rome to create a tomb of unprecedented size and magnificence. By the time that episode ended, with the cancellation of the contract the following year, Michelangelo's vouth was at an end. his dreams shattered.

Four Madonnas 1503-5

The great artistic event of 1500 in Florence was the return of Leonardo da Vinci (1452–1519) after an absence of some eighteen years. He brought with him studies for a commission he had received in Milan, which survive in the form of a beautiful cartoon [29]. Here, as in all of Leonardo's works, we find an interest in grouping for

29. Leonardo da Vinci, cartoon for a Madonna with St John and St Anne. c. 1500?

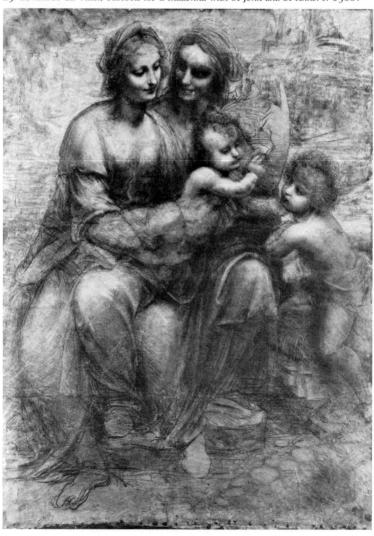

unity, not only on the plane of the design but also in its imaginary depth – an interwined physical, psychological, and spatial unity that had been, when he began his career, the decisive new force in Florentine art and the first sign of what we now label the High Renaissance. In the early years of the 1500s this style, matured and sophisticated, became the school for every Florentine artist, most notably Raphael, and for Michelangelo as well. In April of 1501 Leonardo exhibited another version of this cartoon and it created a sensation. Vasari says that

30. Michelangelo, drawing of a Madonna with St Anne. c. 1501-2?

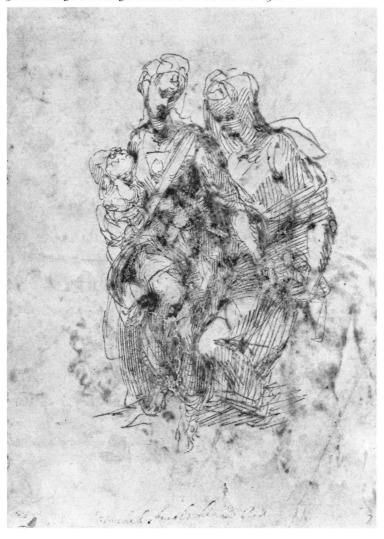

for two days it attracted to the room where it was exhibited a crowd of men and women . . . who flocked there, as if they were attending a great festival, to gaze in amazement at the marvels he had created.

When Michelangelo arrived fresh from his Roman triumphs the following month, instead of being greeted like a conquering hero, he may have found himself overwhelmed by the fame, accomplishment, and charm of the tall, handsome older artist.

It is with Leonardo's mature art in mind that we should turn to the Madonnas of the succeeding years. Michelangelo must have been working on several of them more or less simultaneously and the dates will probably never be wholly secure. A drawing at Oxford [30] shows an attempt by Michelangelo at a Leonardesque group; on the verso are a series of heads, including a bearded one that may be a

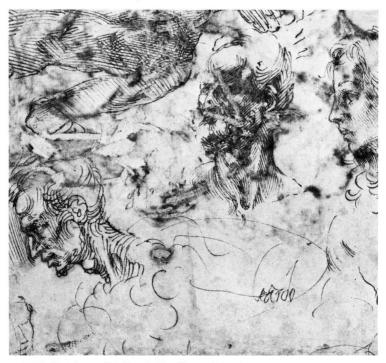

31. Michelangelo, study of heads (detail). c. 1501-2?

sketch of Leonardo himself, with the inscription 'le[on]ardo' below [31]. The Madonna group is clearly hatched, like a study for a sculpture; it is wholly unlike Leonardo's misty *sfumato*, which unites figures and their surroundings. The Anne in the drawing is in her pose reminiscent of the Madonna in St Peter's [18]. Mary is also quite similar to the

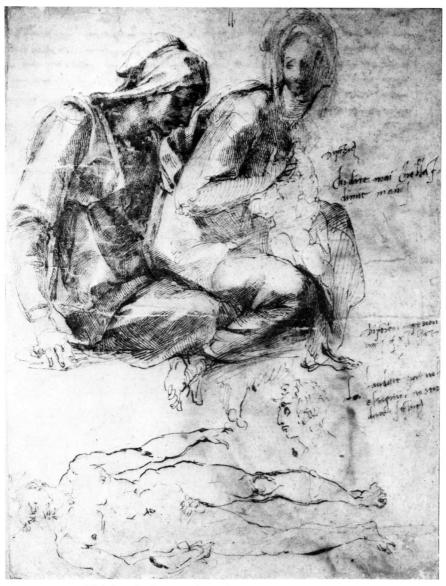

32. Michelangelo, drawing of a Madonna and St Anne and other subjects. c. 1505?

figure at the right of Christ in the *Entombment* [21]. These similarities hint at a fairly early date, 1501–2, for the drawing, which was followed or accompanied by other studies, such as the group in Paris, still inspired by Leonardo, which may be as late as 1505 [32] (see pp. 196–9 and illustration 135).

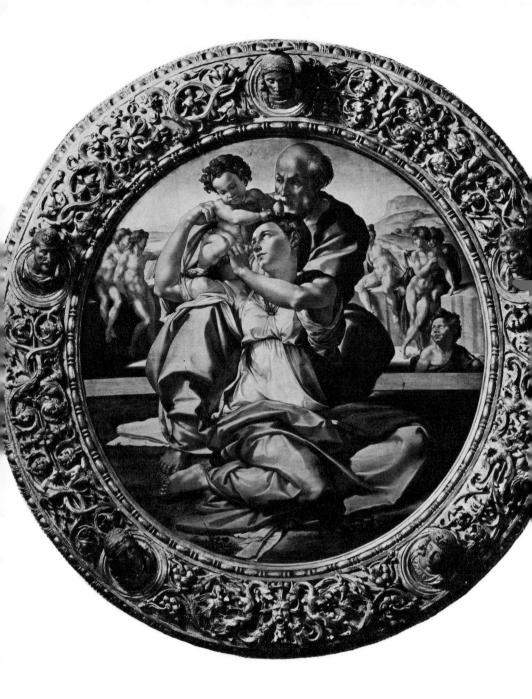

33. Michelangelo, Doni Madonna. 1503-4

Michelangelo may have begun the athletic *Doni Madonna* in 1503 [33]. It is painted in oil, with the hard, emphatic shot-colors that we associate with later Quattrocento masters like Ghirlandaio and Signorelli. Thus it is somewhat old-fashioned, especially if we remember that Leonardo's miraculous *Mona Lisa* was underway in the same year. The frame of the *Doni Madonna* has on it the arms of the Strozzi family: Angelo Doni, the patron, married Maddalena Strozzi late in 1503 or early in 1504. A Mary of heroic proportions, seated on the ground, twists to adore and receive the Christ child, who is evidently supported by Joseph behind her – a highly artificial grouping that must have been inspired by Leonardo's experiments. There is a beautiful chalk study from life, of astounding maturity, for the head of the Virgin [34]. Red chalk drawings were an innovation of Leonardo's; Michelangelo's drawing in that novel medium seems so advanced that it has occasionally been dated

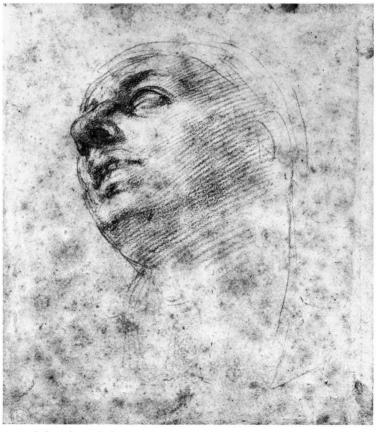

34. Michelangelo, study for the Doni Madonna

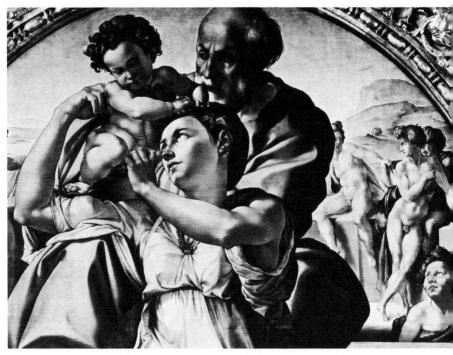

35. Michelangelo, Doni Madonna (detail)

several years later. The figures in the painting are preternaturally clear and sculpturesque, standing out boldly against the airless distance and separated from one another by firm modeling in light and dark. The head and shoulder of the Virgin is outlined by light striking Joseph's chest [35]. This kind of glyptic clarity stands or falls on the muscular composition and the draughtsmanship of the powerful forms and outlines, which are without Leonardo's enveloping atmosphere. It was a challenge to the older man but not wholly successful.

The round (tondo) format of the Doni Madonna was traditional for domestic decorations. Here Michelangelo takes up a theme that had been investigated by Botticelli, Luca Signorelli, and others. One of Signorelli's pictures [36] had belonged to Lorenzo de' Medici and was in his palace when Michelangelo lived there. Condivi and Vasari tell us that Michelangelo

was a man of tenacious and profound memory, so that on seeing the works of others only once, he remembered them perfectly and could avail himself of them in such a manner that scarcely anyone has ever noticed it.

36. Luca Signorelli, Virgin and Child

This fact becomes clearer the more one studies the artist. In the *Doni Madonna* there are clear echoes of Signorelli, especially in the background full of nude youths. Michelangelo loved the nude male above all other artistic subjects and Vasari discusses the figures as mere displays of his technical virtuosity. But there must be iconographical reasons (or at least excuses) for the presence of such nudity in a representation of the Holy Family. Signorelli's *tondo* provides the clue: we are observing the era of Grace, personified by Christ, against the foil of pagan life – the era *ante legem*. The intermediate period of the Old Testament (the era *sub lege*) is telescoped into Mary and Joseph (who is symbolically situated behind the Madonna) and the little Baptist who gazes up at the group. Christ's forerunner is partially barred from the Christian foreground by a low wall. In the background a body of water suggests, perhaps, the efficacy of baptism.

The *Doni Madonna* should therefore be read as an icon of Christian salvation. In Signorelli's picture the head of John the Baptist appears above, between two grisaille figures of Prophets. The fulfillment of Old Testament prophecy, the New Order superseding the old, is clearly implied in both pictures. The *Doni Madonna* is elaborately

finished and framed with a carved cornice that includes the sculptured heads of Christ, two Prophets, and two Sibyls, which again refer to the fulfillment of prophecy and the three ages of mankind.

Michelangelo, according to one source, was paid seventy ducats for this unusual work: Vasari tells an elaborate anecdote:

When it was ready [Michelangelo] sent it under wrappings to Angelo's house with a note asking for payment of seventy ducats. Now Angelo, who was careful with his money, was disconcerted at being asked to spend so much on a picture, even though he knew that, in fact, it was worth even more. So he gave the messenger forty ducats and told him that that was enough. Whereupon Michelangelo returned the money with a message to say that Angelo should send back either a hundred ducats or the picture itself. Then Angelo, who liked the painting, said: 'Well, I'll give him seventy.'

However, Michelangelo was still far from satisfied. Indeed, because of Angelo's breach of faith he demanded double what he had asked first of all, and this meant that to get the picture Angelo had to pay a hundred and forty ducats.

The *Doni Madonna*, whatever its success or failings, represents an important aspect of Michelangelo's art: its uniqueness, its supreme individuality. No other artist could or would have painted it. The sense of having an individual style, as opposed to that of one's master, or of one's contemporaries, or of antiquity, flowered at just this time. The Italian word for style is *maniera*, and the idea of having one's own *maniera* became so powerful that Cinquecento art ultimately became in certain places *manieroso* – mannered. We also speak of mannerism, not here as a period, but as the tendency to create an idiosyncratic, personal style.

Perhaps at about the same time or earlier, Michelangelo began working an unusually large, round, marble composition that is now in London [37]. On the evidence of drawings, it was underway by early 1504. In it he followed different principles from those of the Doni painting – as indeed the medium dictated. Michelangelo followed the inner contours of the rough circle with the figures – John the Baptist at the left, the Madonna in profile at the right. This uniquely relaxed and gracious *tondo* was the property of the connoisseur Taddeo Taddei, who was a great patron of Raphael's. Raphael (1483–1520) came to Florence in the autumn of 1504 and stayed until late in 1508; his early *Madonna of the Meadow*, a Leonardesque exercise, was done for Taddei. Taddei had Raphael 'constantly about the house and at his table,' and it was no doubt there that Raphael saw and drew the unusual motif of the Christ child straddling the Madonna's thigh, which

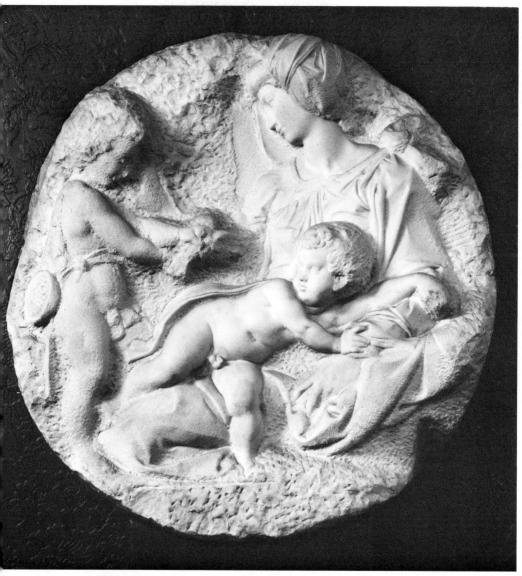

37. Michelangelo, Taddei tondo. c. 1504

is found in Michelangelo's relief. St John has presumably awakened and possibly frightened Jesus by holding out a bird, probably a gold-finch, which was common in paintings of this subject: it emphasized Christ's humanity by showing him as a playful child, and finches were common pets in Florence. But the goldfinch was also a symbol for

Christ's passion and death. Here, as in the *Madonna of the Steps*, the Virgin, in pensive profile, does not participate in the action but seems to meditate on the future [cf. 9].

Perhaps the greatest interest of the unfinished *Taddei tondo* is technical, since it shows Michelangelo's chiseling at various stages of finish. Michelangelo perfected the use of the *gradina*, the toothed (or claw) chisel. Vasari wrote that 'with this sculptors go all over the figure, gently chiseling it . . . and treating it in such a manner that the notches or teeth of the tool give the stone a wonderful grace.' The figure of Christ has been chiseled in the round down to its penultimate skin, as has most of the Madonna. It is fascinating to see the web of grooves that Michelangelo's tool created as he followed the forms in his mind, rounding out the stone into softly-modeled relief. On the more

38. Michelangelo, Pitti tondo. c. 1503-5

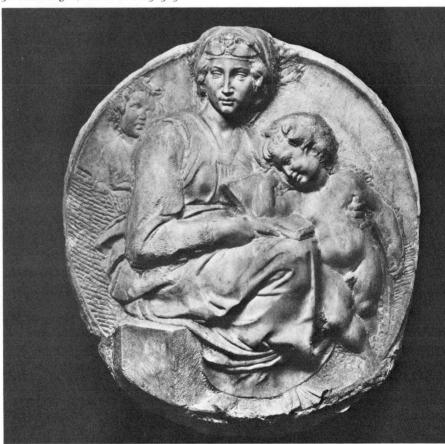

finished surfaces the chisel marks recall Michelangelo's drawing technique of firmly hatched pen-lines, and indeed his drawing and his carving were two versions of the same creative process [cf. 31]. In the head of the little St John, in his body, and in the background we see varying stages of preparation ranging from almost untouched to finished. As in his drawings, Michelangelo would work up one part of the composition almost to completion, leaving the rest to the imagination – or, in the case of sculpture, for future completion. We can only suppose that in solving the problem he was working on here, he tired of the actual task of carving and allowed Taddei to purchase the unfinished *tondo* – had it been commissioned, Michelangelo would have been under pressure to finish. Or perhaps, when called to Rome early in 1505, he gave up the work unfinished, since he could not expect to return soon to complete it.

The same remarks apply to the second marble *tondo*, which seems to show a more mature style [38]. It was done for a Bartolommeo Pitti and exhibits a compact group, seen obliquely, again in different stages of completion. The Madonna's face, for example, is essentially finished but not polished. Both of these sculptured Madonnas are seated on rocks, following the familiar iconography. Whereas Michelangelo beautifully accommodated the Taddei composition to the plane of the *tondo* and to the roundness of the marble form, the Pitti Madonna fights it – her firmly modeled head overlaps the curve of the border, her rock seat projects out into our space. All of this implies a freestanding statue, which exists in the form of the mysterious *Bruges Madonna* [39].

We know nothing of the commission other than its probable connection with Jacopo Galli and, possibly, with the Piccolomini commission of June 1501. By 1503 Michelangelo was involved in more interesting affairs, but the election of Piccolomini as Pius III in September of that year must have sent him scuttling back to work on the statuettes, and may also have seen the birth of the Madonna - we simply do not know. As luck would have it, Pius reigned for less than a month; and on 14 December 1503 the Flemish cloth merchant Alexandre Mouscron paid fifty ducats to Michelangelo, who got a second payment in October 1504. Neither Condivi nor Vasari had any idea what the Bruges Madonna looked like (they described it as a bronze tondo); since Michelangelo repeatedly wrote about the Madonna from Rome in 1505-6, asking to have it taken inside so as not to be seen, scholars have speculated that he first conceived the Madonna for the Siena altar and then allowed himself, after the death of Pius III. to be persuaded to send it to Mouscron. In any event, a date 1503-5 is correct.

Michelangelo began with an idea for a Madonna lactans, as shown in several drawings [135]. As carved, however, the Madonna is iconographically similar to the Pitti tondo: Mary sits pensively with her right hand on a closed book, the Christ child between her knees. Gripping her thigh with his left hand, Christ holds her left in the other. He seems about to step down from the security of her lap, as if learning to walk - and symbolically start down the path that must end with his Passion. It is this future that Mary seems to understand intuitively in all of Michelangelo's early Madonnas, and to accept without tears in the Pietà. The Bruges group is beautifully finished, almost as highly polished as the Pietà, but reveals Michelangelo's declining interest in ornate folds of drapery. The Bruges Madonna is more compact. simple, and emphatic than the Pietà. The total enclosure of Christ's silhouette within that of his mother, carrying on from the early example in the Madonna of the Steps [9], is characteristic of Michelangelo's increasingly monumental style. The new sobriety and restraint of the Bruges Madonna, in comparison with the Roman Pietà, typifies the developing gravity of the High Renaissance.

The Battle Cartoon

One of Michelangelo's most famous compositions, the cartoon for *The Battle of Cascina* (pronounced Cáscina), does not exist and is known only from various studies and copies, of which the most reliable is shown in illustration 43. The commission was in competition with Leonardo, who began working on his battle-piece late in 1503. Michelangelo probably both feared and relished the opportunity to compete with the magus-like older artist, not least because of a growing antipathy between them that was expressed clearly in Leonardo's satirical contrast of the sculptor with the painter in his manuscript *Treatise on Painting*:

the sculptor in creating his work does so by the strength of his arm by which he consumes the marble, or other obdurate material in which his subject is enclosed: and this is done by most mechanical exercise, often accompanied by great sweat which mixes with the marble dust and forms a kind of mud daubed all over his face. The marble dust flours him all over so that he looks like a baker; his back is covered with a snowstorm of chips, and his house is made filthy by the flakes and dust of stone. The exact reverse is true of the painter . . . [who] sits before his work, perfectly at his ease and well dressed, and moves a very light brush dipped in delicate color; and he adorns

himself with whatever clothes he pleases. His house is clean and filled with charming pictures; and often he is accompanied by music or by the reading of various and beautiful works which, since they are not mixed with the sound of the hammer or other noises, are heard with the greatest pleasure.

There was also a profound difference in the natures of these two supreme geniuses of Italian art. As Kenneth Clark wrote in his fascinating book on Leonardo,

We see that the antipathy, the *sdegno grandissimo* as Vasari calls it, which existed between the two men was something far more profound than professional jealousy; sprang, in fact, from their deepest beliefs. In no accepted sense can Leonardo be called a Christian. He was not even a religious-minded man . . Michelangelo, on the other hand, was a profoundly religious man, to whom the reform of the Roman Church came to be a matter of passionate concern. His mind was dominated by ideas – good and evil, suffering, purification, unity with God, peace of mind – which to Leonardo seemed meaningless abstractions, but to Michelangelo were ultimate truths. No wonder that these ideas, embodied in a man of Michelangelo's moral, intellectual, and artistic power, gave Leonardo a feeling of uneasiness thinly coated with contempt. Yet Leonardo held one belief, implicit in his writings, and occasionally expressed with a real nobility: the belief in experience.

This beautiful characterization, although it imputes to the younger Michelangelo some of the features of his old age, sets the scene for what should have been an epic confrontation.

The two mural commissions were intimately bound up with current political events. The French had freed Pisa from Florentine domination in 1494 and from that time on the Florentines were vitally concerned with reconquering the coastal city, which finally succumbed to a siege led by Niccolò Machiavelli in 1509. The new republican government therefore wanted to decorate its huge new Council Hall – the Sala del Gran Concilio – with scenes of victories. Leonardo was commissioned to paint the battle of Anghiari (which had taken place in 1440) and conceived a magnificent hurly-burly of horsemen. More than any living artist, Leonardo was master of the anatomy of the horse, and a furious equestrian battle was perfectly suited to his interest in the fusion of disparate forms into a unity of motion and atmosphere. Leonardo's conception proved so potent that, although never executed, it continued to inspire romantically-inclined artists from Rubens to Delacroix [40].

Michelangelo's *David*, begun in September of 1501, had perhaps been a semi-political commission of the newly-appointed government;

40. Peter Paul Rubens, free copy of the central section of Leonardo's Battle of Anghiari

in any event the Signoria took it away from the Cathedral when it came time to set it up in 1504, and it was widely interpreted afterward as a dangerous republican symbol. The decoration of the Sala del Gran Concilio was overtly propagandistic - the hall had been built specifically for large meetings of the members of the Savonarolan democracy. (Although later changed, the enormous room can perhaps be reconstructed as in illustration 41; the dotted lines show the intended murals by the rival artists - but all of this is very controversial.) With the election of Pietro Soderini as Gonfaloniere in 1502 the stage was set for the completion of the hall - not only with Leonardo's fresco, which was to be some 60 feet long and 24 feet high, but also with an altarpiece showing 'all the patron saints of the city of Florence, and those saints on whose days the city has had victories', and, as well, a statue of the Savior by Andrea Sansovino. (One member of the David committee of January 1504 had actually suggested that David be set up in the center of the Council Hall.) The date of Michelangelo's commission for his share of the painted decoration is unknown; presumably the idea arose at the time of the David's completion in 1504. On 31 October 1504 a payment was made for the paper for Michelangelo's cartoon; on 31 December a payment is recorded for putting together the pieces of the cartoon 'that Michelangelo is making.' Obviously he was hard at work on the huge drawing which, characteristically, 'he refused to let anyone see.'

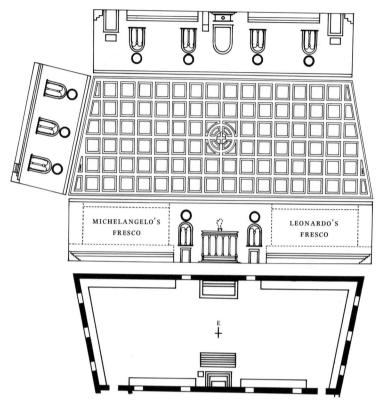

41. Wilde's reconstruction of the Great Hall of the Palazzo della Signoria, Florence, at the time of the frescoes planned by Michelangelo and Leonardo

The subject of Michelangelo's painting was the victory over Pisa at Cascina on 29 July 1364, which ended some five years of open warfare between the rival cities. As Johannes Wilde put it, the frescoes were

not merely meant to glorify the state; at this moment they had become an urgently required instrument of propaganda. The victory of Cascina over the Pisans was regarded by the Guelphs as the triumph of the party, and the day of the battle was celebrated as an annual festival. The battle of Anghiari against an army of Milanese mercenaries was also a memory which had associations with the fight against Pisa, for Neri Capponi, the commissioner who distinguished himself at Anghiari, was the son of the first conquerer of Pisa; his grandson, Piero Capponi, was the first commissioner in the new war against Pisa and lost his life on the battlefield in 1496, mourned by the whole population of Florence. In representing these wars, the frescoes would have been a glorification of civilian preparedness, and this idea was

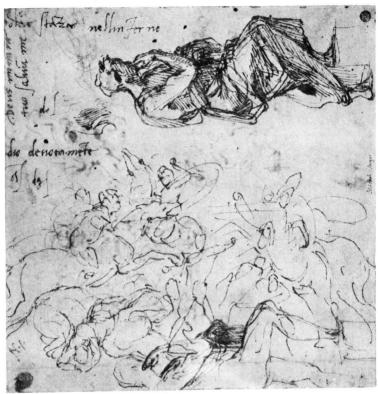

42. Michelangelo, drawing of a battle scene (after Leonardo?), and of an Apostle. 1504-5

a step on the way towards Machiavelli's law constituting the militia, a law which was perhaps the most notable political event in the short life of the democratic republic.

Michelangelo's section of the wall was evidently to be the same size as Leonardo's, and like Leonardo he probably planned subordinate scenes towards the ends of the vast space as well as the central scene that has come down to us in copies. We know very little about what Michelangelo planned for these peripheral areas, but a drawing of a furious equestrian battle, perhaps reflecting Leonardo's composition, gives an idea [42]. Since Michelangelo's cartoon was destroyed – according to reports, by the over-eager artists who copied it (see p. 162), and since the painting itself was never done, we depend basically on a copy of the central scene done by a member of the Sangallo family [43]. The event Michelangelo chose to make the center-piece of his painting does not depict a battle at all, but a peculiar

incident that took place the day before the battle. The Florentine army was encamped by the Arno in sweltering heat, and the men stripped to bathe in the river while their leader lay ill. The hero of the episode, Manno Donati, realized that the army was ill-prepared and undefended; he raised a false cry of alarm, shouting that the Pisans

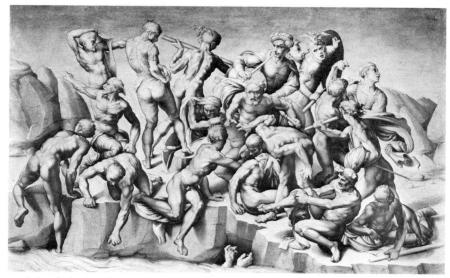

43. Aristotile da Sangallo, copy of the central section of Michelangelo's cartoon for *The Battle of Cascina*. 1542?

were attacking, thus revealing the weakness of the Florentine position. As a result the Florentines pulled themselves together, posted a guard, and won the following day with an attack on the Pisan flank. Michelangelo combined the episodes of two days in order to be able to show the alerted Florentines emerging from the water and hastily donning their clothes. This choice enabled him to draw more than a dozen over-life-size nudes in positions of extreme foreshortening, torsion, and exertion – his favorite theme.

In the exact center of the copy we probably see the leader, Galeotto Malatesta, unwinding a bandage from his head. Immediately to the right is the charging figure of the bearded Manno Donati, alarming the bathers. As in the related *Battle of the Centaurs* [5], there is nothing like an adequate space for the various actions depicted, even though here Michelangelo has provided a background of sorts. His completed picture would surely have been less than the sum of its parts. But in order to grasp the quality of Michelangelo's lost cartoon we have to turn to his individual studies, perhaps the greatest of the kind ever

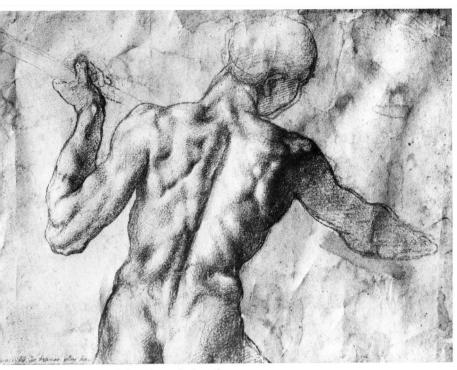

44. Michelangelo, study for a figure for *The Battle of Cascina. c.* 1504

made. Illustration 44 shows the upper torso of the pikeman in the center rear, done in black chalk heightened with white. Typically, Michelangelo concentrates on what interested him at the moment, leaving head and right arm as sketches and highly finishing the muscular back and left arm. In later years teachers of drawing would point to such 'academies' as models. Perhaps the most famous of these studies is illustration 45, a pen and wash drawing so finished that its authenticity was once needlessly doubted. It is only by such drawings that the quality of Michelangelo's lost cartoon should be judged.

These finished studies suggest that the primitive power of the early *Battle* relief may have been lost at the expense of elegance and virtuosity. The meaning of the episode was buried in Michelangelo's overriding desire to show the beautiful nude in movement. Benvenuto Cellini, however, thought that in the *Battle* cartoon Michelangelo

showed all their actions and gestures so wonderfully that no ancient or modern artist has ever reached such a high standard. Leonardo's as well... was wonderfully beautiful... and while they remained intact

45. Michelangelo, study for a figure for The Battle of Cascina. c. 1504

they served as school for all the world. Although the divine Michelangelo later on painted the great chapel of Pope Julius he never reached half of the same perfection; his genius never again showed the power of those first studies.

Cellini surely exaggerated, perhaps because of a natural tendency to extoll what is lost. Certainly *The Battle of Cascina* would have been a painting of extraordinary fascination; but it must have verged on a formalism or mannerism, with an exaggeration of poses and an unnatural juxtaposition of mirror-like forms that smack more of a *tour de force* than of a great and moving work of art. Nevertheless, the studies Michelangelo made for the *Cascina* cartoon were the school from which he evolved the repertory of forms that he used – it must be said more successfully – on the Sistine ceiling.

Michelangelo's potential achievement was to create a composition that would enable succeeding artists to use the human body in every possible position, with a freedom that had heretofore been lacking. Leonardo had developed a glorious fluidity in his compositions that Michelangelo never rivaled; Michelangelo, however, revolutionized the anatomical interests of the later Quattrocento by assimilating them into a lofty rhetorical style. This is already apparent in the Christ of the *Pietà* [18]. We have mentioned a tendency to create mirror-images in the *Battle* drawing, but comparison with the disarmingly naïve figures of the Pollaiuolos' *Martyrdom of St Sebastian*, of c. 1475, illuminates Michelangelo's achievement [46]. And here, as in the *Doni Madonna*,

46. Antonio and Piero del Pollaiuolo,
The Martyrdom of St Sebastian.
c. 1475?

Michelangelo elevated art – at least as his contemporaries and followers supposed – above the narrative discursiveness, the bourgeois horror vacui of his first teacher. The Battle of Cascina is an example of the style that we call High Renaissance and is vitally different from the Quattrocento style practiced by Ghirlandaio [1], which seems to follow a prescription found in Leon Battista Alberti's Treatise on Painting:

That which first gives pleasure in the narrative comes from copiousness and variety . . . in which in their places are mixed old, young, maidens, women, youths, young boys, fowls, small dogs, birds, horses, sheep, buildings, landscapes . . .

At the same time the cartoon represented a special kind of High Renaissance art, even for Michelangelo: the conquest of extreme difficulty in the pursuit of grace and ideal beauty. This new goal, obviously one that assumes an art-for-art's-sake point of view, was the incubator of Mannerism (see p. 204), and is paralleled in contemporary literature. The danger of the tendencies found in the cartoon was pointed out by Leonardo himself:

O anatomical painter, beware, lest in the attempt to make your nudes display all their emotions by a too strong indication of bones, sinews, and muscles, you become a wooden painter.

Kenneth Clark wrote of this passage that 'Leonardo has understood that the true purpose of Michelangelo's anatomical display is the expression of emotion, but has seen in it the seeds of mannerism.'

4 The Julius Tomb and Lesser Tragedies 1505–8

The first block for the group of twelve Apostles that Michelangelo contracted to carve in 1503 arrived in Florence when he was in the midst of his *Cascina* cartoon. Although he may have begun working on it [51], he cannot have done much, since the contract was annulled in December of 1505 because the Apostle 'was not carved, nor will be'. The interference did not come from the *Cascina* painting, for which Michelangelo received an advance in February of 1505 – it too had to be postponed. For at some time in March of 1505 Pope Julius II della Rovere (1503–13) commanded Michelangelo to come to Rome, an event that permanently changed his career – for the worse.

Giuliano della Rovere had been made cardinal in 1471 by his uncle, Pope Sixtus IV (1471–84). Della Rovere, 'hated by many and feared by all,' had been elected, thanks to a deal with Cesare Borgia, late in 1503. In his almost ten-year rule he re-established the power and unity of the sprawling Papal States and made Rome the center of humanistic learning. In addition, he attracted all the best artists of Italy to decorate the buildings that were already there, and began building a new Christian Rome on an antique scale. He had been, while still cardinal, a notable patron of art within the limits of his income (we have mentioned that he owned the *Apollo Belvedere*). As Pope he stepped up both the quality and the scale of his patronage, discarding lesser artists for greater and small plans for large. It was this

megalomania that first attracted Michelangelo to him, and soon afterward it doomed Michelangelo's project for his tomb. Julius II operated as a patron on a scale and on a level of quality that make him equal to the artists we associate with him: Bramante, Raphael, Michelangelo. If, as many believe, this was the greatest assembly of talent ever to work for one man at the same time, we must hail Julius as the most perspicacious as well as the most fortunate patron the world has ever known.

Michelangelo was apparently recommended to the Pope by Giuliano da Sangallo (1443-1516), a close friend of Michelangelo's and a distinguished architect who had worked for Della Rovere when he was a cardinal. But it is even possible that Julius had been following Michelangelo's career for some time, since he had been archbishop when Michelangelo came to Bologna in 1494. Perhaps the Pope did not at first know just how to take advantage of Michelangelo's genius - Condivi, erroneously, reports that, 'coming then to Rome, many months passed before Julius II resolved in what way to employ him. Ultimately it came into his head to get him to make his monument.' Michelangelo tells us that he made many drawings for the tomb, one of which was chosen by the Pope. When Michelangelo left Rome for Carrara in April of 1505 to quarry marble for the tomb, the decisions about its form and character had been made and the individual statues were in some sense designed. The tomb was to be huge, about 23×36 feet $(7.2 \times 10.8 \text{ meters})$, and high, with three levels and some forty figures. The contract does not survive, but we know that Michelangelo was to have been paid 10,000 ducats for a labor that was to be finished in five years.

Since, however, Michelangelo carved almost nothing of this design, and since later versions of the tomb differ from it, we have to rely on surviving drawings and elements from later projects that were taken over with minor changes – and on the writers. Condivi tells us that

this tomb was to have had four faces, two of eighteen *braccia*, that served for the flanks, and two of twelve for the heads, so that it was to be a square and a half in plan. All around about the outside were niches for statues, and between niche and niche, terminal figures; to these were bound other statues, like prisoners, upon certain square plinths, rising from the ground and projecting from the monument. They represented the liberal arts, and likewise Painting, Sculpture, and Architecture, each with her symbol so that they could easily be recognized; denoting by this that, like Pope Julius, all the virtues were the prisoners of Death, because they would never find such favor and nourishment as he gave them. Above these ran the cornice that tied all the work together. On this level were four great statues; one of these, the *Moses*, may be seen in San Pietro in Vincoli [107]... So the work

mounted upward until it ended in a plane. Upon it were two angels who supported a bier; one appeared to be smiling as though he rejoiced that the soul of the Pope had been received amongst the blessed spirits, the other wept, as if sad that the world had been deprived of such a man. The entrance to the sepulchre was by one of the ends... in the middle was a marble sarcophagus, where the body of the Pope was to be buried... Briefly, more than forty statues went to the whole work, not counting the subjects in relief to be cast in bronze, all appropriate in their stories and showing the acts of this great pontiff.

We probably see the front end of this gigantic project in a later drawing that shows the prisoners alternating with niche figures and, on the platform above, seated figures [47]. Just how the tomb was to be ter-

47. Drawing after Michelangelo's project of 1513 for the tomb of Julius II

minated we do not know. Condivi mentions no image of the Pope, but an arca – a sarcophagus or coffin – held by two figures. In later versions the Pope was to be shown held up on a bier [102], and this could have been the case in 1505. From what we know of Michelangelo's habits

of planning we can be sure that whatever he thought about the tomb in 1505 was subject to change.

The great free-standing tomb was clearly planned in imitation of antique sepulchral monuments, as they were known (or misunderstood) from the available evidence. The three-tiered design probably derives from coins or other representations of sepulchres, and perhaps of the imperial *rogus*, or ceremonial immolation, as Alfred Frazer has suggested. The lower story probably derived its articulation from more specific ancient sources, such as a superb sarcophagus in the Vatican that shows niche figures alternating with genii crowned by Victories, and in the center the 'door of death' that would also have been in

48. Roman sarcophagus

49. Antonio del Pollaiuolo, tomb of Sixtus IV. 1484-93

Michelangelo's façade [48]. But the idea of a free-standing papal tomb with allegorical representations around its base has its ultimate origin closer to home. Julius II was a dynast, the successor to Sixtus IV, and in many ways strove to continue his uncle's projects. The unusual tomb of Sixtus IV had been finished by Antonio Pollaiuolo just before Michelangelo's first visit to Rome [49]. Like Michelangelo's project, the tomb of Sixtus IV is free-standing and surrounded with allegories of the arts. Both artist and patron must have started with this as a model to surpass.

Michelangelo set off for Carrara late in April of 1505 with the greatest sculptural commission of modern times in his pocket. Condivi tells us that 'Michelangelo stayed in these mountains more than eight months with two workmen and his horse, and without any other provision except his food.' His ambitions were so great, his spirits so high, that

One day while he was there he saw a crag that overlooked the sea, which made him wish to carve a colossus that would be a landmark for sailors from a long way off, incited thereto principally by the suitable shape of the rock from which it could have been conveniently carved, and by emulation of the ancients . . . And of a surety he would have done it if he had had time enough . . . afterwards he regretted it very much.

Michelangelo ordered a vast quantity of marble to be shipped, returning to Rome in December, where he eagerly awaited delivery. Reality, all too soon, dampened his enthusiasm. Late in January of 1506 he wrote his father from Rome:

all would be well if my marbles were to come, but as far as this goes I seem to be most unfortunate, for since I arrived here there have not been two days of fine weather. A barge, which had the greatest luck not to come to grief owing to the bad weather, managed to put in with some of them a few days ago; and then, when I had unloaded them, the river suddenly overflowed its banks and submerged them, so that I haven't been able to begin anything; however, I'm making promises to the Pope and keeping him in a state of agreeable expectation so that he may not be angry with me, in the hope that the weather may clear up so that I can soon begin work – God willing.

While waiting, he was witness the same month to one of the great events of his day, the recovery of the famous marble statue of Laocoön and his sons killed by snakes [50]. The group had been described by Pliny the Elder as

a work to be preferred to all that the arts of painting and sculpture have produced. Out of one block of stone the consummate artists, Agesandros, Polydoros, and Athenodoros of Rhodes made, after careful

50. Ages andros, Polydoros, and Athenodoros of Rhodes, ${\it Laoco\"on}.$ Hellenistic-Roman period

planning, Laocoön, his sons, and the snakes marvellously entwined about them.

On Wednesday, 14 January 1506, a Roman digging in his vineyard on the Esquiline hill opened a long-closed niche and discovered the group. The Pope, hearing of it, sent Giuliano da Sangallo, and, as Giuliano's nine-year-old son later recounted: Michelangelo was our constant guest, and my father wanted him to come . . . We then set off, I too. Directly my father saw the statue he exclaimed 'this is the $Laoco\"{o}n$ mentioned by Pliny'; the opening had to be enlarged to get the statue out.

The *Laocoön* was soon set up in Julius's new statue-court in the Vatican Belvedere. The group, with its powerful twisting figures, became one of Michelangelo's favorite models or, perhaps better, rivals. Many of his later works seem to depend in one way or another on his knowledge of it. The importance of the *Laocoön* for Michelangelo is not merely the expressive movement of the struggling bodies, which is so similar to Michelangelo's own private visions, but the sense of a spiritual struggle bound up with the purely physical – Laocoön is the victim of divine wrath and radiates a tragic sense that is paralleled in Michelangelo's own life and art.

The tomb of Julius II was to be so grandiose that it needed an exalted site. The unfinished Quattrocento choir of St Peter's, begun under Nicholas V, seemed at first the most likely spot, according to Condivi, and Julius consequently set about planning its completion. He was thus led, typically, to an even grander plan – to tear down the venerable Constantinian basilica and build a new church. Donato Bramante (1444–1514) was soon entrusted with the commission; with the greatest building of modern times underway – and to pay for – Julius lost interest in the tomb. The end of the first act of what Condivi called the Tragedy of the Tomb is told by Michelangelo himself in a letter written to Giuliano da Sangallo from Florence in May 1506:

Giuliano: I have learned from one of yours how the Pope took my departure badly . . . and that I should come back and not be doubtful about anything.

As for my departure, it is true that on Holy Saturday I heard the Pope, speaking at table with a jeweler and the Master of Ceremonies, say that he didn't want to spend a penny more on large or small stones, which amazed me a good deal. Still, before I left I asked him for part of what I needed for going on with the work. His Holiness answered me that I should come back Monday; and I came back there Monday and Tuesday and Wednesday and Thursday, as he saw. Finally, on Friday morning I was sent out, that is, chased away, and the fellow who sent me out of there said that he knew me but those were his orders. So, since I had heard those words on Saturday, and then seeing the result, I got extremely desperate. But this was not the entire cause of my departure; there was also another thing, which I don't want to write; suffice it that it made me think that if I stayed in Rome my tomb would be built before the Pope's. And this was the cause of my sudden departure.

Michelangelo fled to Florence on 17 April; on the following day the foundation stone was laid for New St Peter's. When we realize that this immense building was almost constantly under construction and completion for the following 120 years – it was consecrated only in 1626 – we begin to see what Michelangelo was up against: a monument to Julius's ambitions that totally dwarfed the tomb. In fact, however, Michelangelo himself made decisive changes in the design of the great church some forty years later; and so, ironically, the church that doomed the first project for the tomb of Julius II ultimately became one of Michelangelo's greatest achievements (pp. 298ff.).

The *Lives* by Condivi and Vasari clearly reflect Michelangelo's paranoid hostility to Bramante. Michelangelo imagined that there were all kinds of schemes against him instigated by Bramante, by his 'nephew' Raphael, and by the courtiers around them. From what we know, however, these suspicions were largely unfounded (see p. 144). It was more properly Michelangelo's friend Giuliano da Sangallo who had lost his position to Bramante; Michelangelo took on Giuliano's hatred as his own.

St Matthew

Michelangelo stayed in Florence over seven months. The *Bruges Madonna* was presumably entirely finished, since he had asked his father in January 1506 to crate it, and payments for crating were made in April and June. Nevertheless, it was shipped only in October, and Michelangelo may still have done some final polishing in 1506. He may also have finished the *Cascina* cartoon at this time – the evidence is contradictory. A letter of July 1508 asks his brother to help a young Spanish painter see 'the cartoon I began,' which seems to imply that it was still unfinished. But a letter of December 1523, reviewing his work on the Julius tomb, records that before he left Florence in 1505

the cartoon was already done, as is known to all Florence \dots And of the twelve Apostles that I still had to do for the Cathedral one was roughly cut, as is still to be seen \dots

The date of this letter makes the precision of the statements suspect, however, and it seems quite likely that during the summer of 1506 he worked again on the *St Matthew*, the only one of the Apostles Michelangelo ever began [51]. He had had little time to carve it between the arrival of the block in December 1504 and his departure for Rome the following March. Moreover, the *Matthew* seems to reflect Michelangelo's thoughts about figures for the Julius tomb – particularly the

fettered 'Prisoners' – and may also betray his knowledge of the Laocoön. Although the contract for the Apostles had been cancelled, the block lay waiting to be carved, and a letter from Pietro Soderini dated November 1506 implies that the Apostle contract had been revived. Michelangelo was greatly disturbed after his rejection by the Pope; his emotional state may have found expression in the incomplete statue.

A drawing, probably done late in 1504, seems to show an Apostle in profile, with one foot on a pedestal, his right hand raised to touch the head [42]. The *Matthew* as carved is radically changed from this drawing, but there is still a raised foot and protruding knee. The creative

51. Michelangelo, St Matthew. 1504-8

process that transformed the static drawing into this imposing movement cannot be documented, but we have to presume some elapsed time and experience, such as he had had in Rome. The figure's right shoulder and arm are swung forward in a contrary direction to the raised leg; against this powerful motion the head is seen in almost pure profile – a triple twist that exceeds in power of torsion any of his previous works. Although only blocked out, and still essentially a relief, the *Matthew* announces a newly dynamic style that develops sporadically in Michelangelo's succeeding works.

Carved back fairly uniformly from one face of the block, the *Matthew* is a perfect illustration of Michelangelo's technique as it was described by Cellini (see p. 56). Vasari, explaining this method, compares the gradual emergence of the figure from the marble block to a model sunk under water that is slowly pulled up, revealing the topmost parts first and then, part by part, the rest. This way of thinking about the figure in the block, and the technique itself, tends to produce statues that even when free-standing have one main view. Michelangelo, no matter how contorted a pose he created, normally had in mind a dominant aspect and produced it by carving back in the manner we see in the *Matthew*. Such a statue, when completed, would be interesting from various positions; but the frontal view is always the most important.

The *Matthew* is unfinished and yet in it we seem to perceive, more than in Michelangelo's previous, finished works, his restless imagination and fierce passions working themselves out in the chiseled stone. No post-antique work of sculpture is so seized with visible emotion, which is expressed with the awesome power that contemporaries called *terribilità*. Matthew seems to be in the grip of some supernatural force of inspiration – surely an autobiographical moment in Michelangelo's art. Even John Pope-Hennessy, who avowedly sees in Michelangelo's unfinished statues no more than the finished works of art they seem to imply, finds that here

the statue was no longer something external to himself, but a projection of his total personality. Where his emotional condition came into play was in the speed and recklessness with which the work was carved. Precisely because its promise is so rich and its psychological horizons are so wide, it is in some respects more moving than the uncompleted later works. It is as though, after his rebuff in Rome, he had attacked the inert block in an effort to affirm to himself, not to the world, that he was indeed the supreme, the transcendent genius he supposed.

Michelangelo's precipitous flight after his rejection by the Pope proved that the artist was as *terribile* as the patron. Julius, recognizing that he

had met his match, promised Michelangelo immunity from punishment if he would return. In May Michelangelo answered through Giuliano da Sangallo that he would be glad to carry on – but in Florence, where he could work cheaper and better. He was so upset by the treatment he had received and by his consequent flight that he actually seems to have considered working for the Sultan of Turkey. Perhaps hearing of this, the Pope issued a Brief on 8 July summoning Michelangelo to Rome, but to no avail – Michelangelo feared the Pope's wrath. Condivi reports that when a second and then a third Brief arrived, Pietro Soderini called Michelangelo in and said:

You have braved the Pope as the King of France would not have done... We do not wish to go to war with him on your account and risk the State, so prepare yourself to return.

But at this point the Pope himself took to the battlefield to restore the lost provinces of the Papal States. In September Michelangelo tried to meet him at Viterbo, missed him, and hurried back to Florence. Julius conquered Bologna on 11 November 1506 and summoned Michelangelo there in order 'to have some works done by him.' Michelangelo arrived in Bologna at the end of November 'with a rope around his neck' to ask for pardon.

Bologna Again 1506–8

To help Michelangelo's cause, Pietro Soderini had him deliver a revealing and sensitive letter to Soderini's brother, who was travelling with the Pope's retinue. It states:

The bearer will be Michelangelo the sculptor, whom we send to please and satisfy His Holiness. We certify that he is an excellent young man, and in his own art without peer in Italy, perhaps even in the universe. It would be impossible to recommend him more highly. His nature is such that he requires to be drawn out by kindness and encouragement; but if love is shown him and he is well treated, he will accomplish things that will make the whole world wonder.

Condivi relates:

So he arrived at Bologna one morning, and going to San Petronio to hear mass, behold, the grooms of the Pope, who recognized him and conducted him to His Holiness, who was at table in the Palazzo de' Sedici. When he saw Michelangelo in his presence, Julius, with an angry look, said to him, 'You ought to have come to us, and you have

waited for us to come to you.' Meaning to say, that His Holiness had come to Bologna, a place much nearer to Florence than Rome . . . Michelangelo with a loud voice and on his knees craved pardon, pleading that he had not erred maliciously but through indignation. for he could not bear to be hunted away as he had been. The Pope kept his head lowered and replied nothing, to all appearances much troubled, when a certain monsignore, sent . . . to excuse and intercede for Michelangelo, broke in, saying: 'Your Holiness, do not remember his faults, for he has erred through ignorance; these painters in things outside their art are all like this.' The Pope indignantly replied: 'You abuse him, whilst we say nothing; you are the ignorant one, and he is not the culprit; take yourself off . . .' But as he didn't go, he was, as Michelangelo used to tell, hustled out of the room with blows . . . Thus the Pope, having spent his fury on the bishop, called Michelangelo closer to him, and pardoned him, ordering him not to leave Bologna . . .

The commission Michelangelo got was an unwelcome one, an overlife-size memorial statue of the Pope, to be cast in bronze. 'Non era mia arte,' as Michelangelo said, and not only was bronze sculpture 'not his work' but portraiture never interested him. In the end, after more than a year's travail, the huge statue was finally cast and finished – only to be destroyed by the irate Bolognese less than four years later. We know little of the statue, save what Condivi tells us: before the Pope left Bologna Michelangelo made a clay model,

but he was doubtful as to what the statue should hold in the left hand; the right was raised as if giving a benediction. He asked the Pope, who had come to see the statue, if it pleased him that he should be made holding a book. 'What! a book?' he replied, 'a sword! As for me, I am no scholar.' And jesting about the right hand, which was in vigorous action, he said, smiling the while, to Michelangelo, 'Does this statue of yours give a blessing or a curse?' Michelangelo replied to him: 'It threatens this people, Holy Father, lest they be foolish.'

A number of letters from Bologna reveal Michelangelo's misery as he continued his compulsive work on the statue. Bologna was at first so crowded that he had to share a bed with three others in a miserable room. Later, a deadly plague broke out, and in August he reported that

since I have been here it has only rained once and has been hotter than I ever believed it could be anywhere on earth. Wine here is dear . . . but as bad as can be, and everything else likewise, which makes for a miserable existence and I long to be quit of it.

After one unsuccessful effort the statue was finally cast; Michelangelo wrote that he had been

in the greatest discomfort here, with the hardest kind of toil, and I'm busy with nothing but working day and night, and I have endured and am enduring such labor that if I had another such again I don't think my life would be long enough, because it has been a very large piece, and if it had been in someone else's hands something would have gone wrong with it. . . . Suffice it that I've brought it just about to completion . . .

Michelangelo told Condivi that he had often worked so hard that he slept in his clothes; when he related such stories he may have had Bologna in mind.

The statue was finally finished on 15 February 1508 and raised up to its niche on the façade of San Petronio on the 21st. Early in March Michelangelo returned to Florence with great relief, finally 'free of Rome.'

Florence 1508

As if to signal his definitive return, on 9 March 1508 Michelangelo purchased houses on the via Ghibellina, near Santa Croce – houses that were rebuilt in the following century as the Casa Buonarroti, a shrine to the great artist. Perhaps Michelangelo took up the *Matthew* block again at this time – but as luck would have it he was called once more to Rome that very spring. He must have been particularly disappointed at the Pope's new demands, since Pietro Soderini had ordered a huge block of marble, some twenty feet high, for Michelangelo to carve into a *Hercules* for the Piazza as a counterpart to the *David*. Michelangelo was probably eager to show what he could do with a block cut to his own desires. In the end it was the subject of intrigues and finally was given to Michelangelo's rival and enemy Baccio Bandinelli (1493–1560), who produced a lumpy *Hercules and Cacus* between 1525 and 1534 [27] (see p. 207).

Between the completion of the *David* in 1504 and his return to Rome in 1508 Michelangelo had embarked on four major commissions: the *Cascina* battle painting, the twelve Apostles for the Cathedral, the tomb of Julius II, and the memorial statue in Bologna. Only the last was completed, and it soon perished. After some fifteen years of youthful precocity Michelangelo now entered a frustrating period that proved, in a sense, endless. The tomb project was to plague him for another thirty-five years, and almost all his other sculptural projects remained unfinished.

II The Sistine Chapel and its Aftermath

5 The Sistine Ceiling 1508–12

In March of 1508 Michelangelo settled in Florence as if he planned to stay indefinitely. The Pope's Brief calling him to Rome must have been unexpected, and when it came Michelangelo may have hoped simply to go back to work on the tomb. Condivi tells us that Michelangelo, learning that the Pope's plan was to have him paint the Sistine Chapel, and

realizing that painting a vault was a difficult thing, made every effort to get out of it . . . pleading that this was not his art, and that he would not succeed, and he went on refusing to such an extent that the Pope almost lost his temper. But then, perceiving the Pope's obstinacy, he embarked on that work which is to be seen today in the papal palace . . .

A letter of May 1506 shows that the Pope even then wanted Michelangelo to paint the Chapel – whether as a lure or as a substitute for the tomb is hard to say. In the letter, Bramante is reported to have said that he knew Michelangelo well, and that Michelangelo had told him 'over and over that he didn't want to paint the Chapel'; Bramante went on to say that he doubted Michelangelo's ability to paint foreshortened figures. This letter reveals that the idea of completing the Chapel begun by Sixtus IV had been broached while Michelangelo was

previously in Rome. On 10 May 1508 Michelangelo contracted to paint the ceiling for 3,000 ducats, 'and began work that very day.'

In 1473 Sixtus IV began building the ceremonial chapel next to the Vatican, which only recently had become the permanent papal residence. One of the functions of the chapel was to house the cardinals during the conclave in which the new pope was elected; and both the shape and the location of the building – of which Sixtus was described as 'author' - relate to the solemnity and historic significance of the papacy. It is, first of all, built according to the proportions of Solomon's temple as described in the Book of Kings: the length is twice its height and three times its width, and all the surfaces that Solomon had covered in cedar and gold were to be painted. Sixtus assembled a distinguished but heterogeneous group of painters, including Perugino, Signorelli, and Botticelli, to girdle the chapel with painted scenes [160]. Episodes from the life of Christ on the north side oppose scenes from the life of Moses on the south. The clear meaning of these oppositions, according to traditional Christian interpretation, was to show in parallel episodes the authority and dignity of the Mosaic law (tempus legis) and to insist upon the legitimate succession of Christ's unwritten law (the era of grace - tempus gratiae). The connections are made explicit by inscriptions over the scenes that refer to Moses and the written law and inscriptions over the New Testament scenes that speak of the new era and the evangelical law of Christ. The emphasis on just succession and legality was important in a chapel of the papacy, so recently schismatic, which claimed descent from Peter and insisted on the foundation of the Church by Christ himself. To confirm this succession the visitor found displayed prominently near the entrance a ceremonial scene of Christ giving the keys to St Peter. The sequence of Old Testament and New Testament scenes was arranged to emphasize the *primatus papae*, the authority of the pope in his triple role as priest, teacher, and ruler. Between the windows above are painted images of pre-Constantinian sainted popes [57]. The chapel was dedicated in 1483 to Mary Assunta; a fresco of the Assumption by Perugino was above the altar. To left and right on the altar wall were The Finding of Moses and The Birth of Christ, beginning the two cycles. Above them, on the level of the popes, was the beginning of the papal series (Linus and Cletus?) and, in the center, possibly an image of Christ flanked by Peter and Paul [52]. This wall of the chapel was eventually painted over by Michelangelo himself [161].

Julius II wanted to decorate the ceiling with a modern ornament. Michelangelo was first commissioned to paint the twelve Apostles on the twelve pendentive-like areas that carried the curved vault

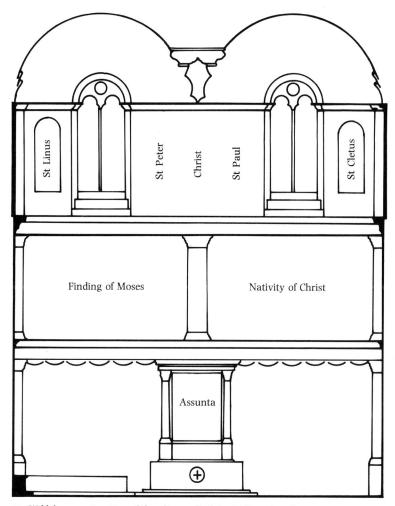

52. Wilde's reconstruction of the altar wall of the Sistine Chapel before Michelangelo's *Last Judgement*

down to the wall between the windows [cf. 53, 55]. The Apostles, followers of Christ, would have been appropriate precursors of the popes, but this addition already creates a chronological confusion that was perhaps inevitable and that Michelangelo's ceiling ultimately compounded. Sixtus's chapel had episodes from the lives of Christ and Moses on one level and the early popes above. Only a series of later personages or events could have carried on this scheme with total logic – and no such scenes seemed worthy of the site.

Two sketches by Michelangelo show that he first planned to paint a ceiling decoration of a type that had come into vogue after the chapel had been decorated by Sixtus. Michelangelo's first project, based on the drawing in illustration 53, would have looked something like illustration 54, with Apostles on decorative thrones in the pendentives amidst an ornamental decoration of geometric forms. In

53. Michelangelo, sketch for the decoration of the Sistine ceiling. 1508

54. Sandström's reconstruction of the scene implied in illustration 53

Michelangelo's second drawing [55] the fictive architecture has become more tectonic and grand, with winged figures – angels or genii – holding oval frames. These decorative schemes are versions of

55. Michelangelo, sketch for the decoration of the Sistine ceiling. 1508

ceilings that had been discovered rather recently in the *grotte*, which were actually the underground vaults of Nero's Golden House. Some of these decorative forms were consequently called *grotteschi* – our word 'grotesque'. A modern version of an ancient vault was painted by Bernardo Pinturicchio at about this time, with figures on thrones comparable to Michelangelo's early projects [56]. The ceiling of the

56. Bernardo Pinturicchio, vault over the high altar of Santa Maria del Popolo, Rome. c. 1508

Stanza della Segnatura, where Raphael established his reputation in 1509–11, was given a similar decoration.

A later letter tells us that Michelangelo decided that his painting in this style would have been a 'poor thing', and so the Pope released him from the original project and allowed him to develop his own scheme. Michelangelo's statement that the Pope 'let him do what he wanted' must not be taken as excluding an iconographic program drawn up with the help of a theologian, however, for Michelangelo himself may not have been capable of working out the program he painted in all its allusive subtlety. The change of plan shows that Michelangelo had the bit between his teeth, and the grandeur of his new scheme was unprecedented.

The simplest description of Michelangelo's final organization of the ceiling [57] is provided by Condivi, who says that

starting from the brackets, which support the horns of the lunettes, up to about a third of the arch of the vault, a flat wall is simulated; rising to the top of it there are pilasters and bases of imitation marble projecting outwards from a plane that looks like a parapet, with ledges below and with other small pillars about the same plane against which the Prophets and the Sibyls are seated [cf. 58] . . . On the said bases are imitation sculptures of little nude children in various poses, which, like terms, support a cornice that surrounds the whole work, leaving the middle of the vault from head to foot like an open sky. This opening is divided into nine segments . . .

Michelangelo invented an alternation of architectonic thrones and sculpturesque figures that translates the forms of the Julius tomb into paint. The scale of this conception and the power of the individual figures are particularly notable in comparison with the populous, busy, decorative Quattrocento frescoes on the walls below.

In place of the twelve Apostles who followed Christ, Michelangelo painted the Hebrew Prophets and pagan Sibyls who foresaw the coming of a Messiah. Here, for the first time in the Chapel, Greco-Roman culture is joined to the Hebrew world. These Prophets and Sibyls inhabit the curved lower part of the vault, sitting on thrones. By this method Michelangelo created an imaginary architecture: the bands across the vault are united by the cornice above with its projecting segments, as Condivi described. The Prophets and Sibyls are clearly to be understood as sitting in front of the Ancestors of Christ, painted in the spandrels and lunettes [58: cf. 63]. These are pictorial versions of the mere list of names that begins the Gospel of Matthew, the generations linking Christ with the tribe of David, as was necessary according to Old Testament prophecy. Thus the Hebrew and pagan

seers who foretold the coming of the Messiah alternate with representations of Christ's own ancestors. This part of the vault is closely connected with the scenes below that show Christ's life and work on earth as the counterpart and fulfillment of the prophetic example of Moses.

In the double corner spandrels (usually called pendentives) are scenes of Old Testament salvation: near the entrance, David killing Goliath, and Judith and Holofernes - both tyrannicides, both decapitations [78, 79]. At the other end are The Death of Haman, and Moses and the Serpent of Brass [65, 66]. Below the painted architectural cornice. then, we see figures and scenes of Hebrew Prophets and heroes together with the family tree of the Savior. Michelangelo painted a series of simulated levels of reality in this band: flesh-colored Prophets and Sibyls sit on stone-colored thrones decorated with pairs of putto-atlantes painted to look like statuary [60]. Each prophetic figure is accompanied by two smaller, flesh-colored children, perhaps their inspirational genii. In the triangles between the thrones are shadowy bronze-colored figures. Above the thrones, flesh-colored nudes hold bronze medallions. All of this framework (with its figures) on the level of the thrones is supposedly projecting into the space of the room, as reconstructed in illustration 58, where we see that the illusion of the lunettes creates a space behind the wall that emphasizes the outward projection of the thrones. But the multiplication of imaginary levels of space, and the various levels of aliveness of the figures, is not pressed very hard this is not by any means a trompe-l'æil decoration meant to deceive (even though above Zechariah and Jonah we seem to look up through the framework to blue sky). Rather, Michelangelo hit upon this device to separate the different levels of illusion and meaning and to break up the potentially boring stretch of the central vault.

On the vault itself, between the stone-colored bands, are nine scenes from Genesis. The scenes are oriented so that they can be read from the correct point of view from the entrance to the Chapel, although the series begins over the altar. Perhaps in order to accommodate laymen who would be barred from the sanctuary, the figures in the scenes over the altar-half of the Chapel are large and clear. Reading in chronological sequence from the altar wall are, first, three scenes of the creation of matter by God [59]; then three scenes of the creation of man and his subsequent temptation and fall; and, finally, three scenes from the story of Noah. The obvious and basic subject of the ceiling is the creation and fall of man and the emergence of a new chosen man, Noah. These scenes of the early world before the Mosaic law, ante legem, form the background to the cycles below of events sub lege and sub gratia. This iconography was probably dictated by the

58. Michelangelo's illusionistic architecture on the Sistine ceiling drawn as if actually three-dimensional (after Sandström)

 $59\ (right).$ Scheme of Michelangelo's decorations on the Sistine ceiling

twelve prophecies sung by the chapel choir on Holy Saturday before Easter, which began with the first chapter of Genesis up to the Flood. Thus, as Ernst Steinmann wrote, 'the mysteries and revelations that the ear heard from the altar and the chancel were reinforced by visual images in the frescoes.'

In the time Michelangelo had at his disposal it is inconceivable that every figure of the ceiling was fully planned from a doctrinal and theological point of view, but he must have had theological advice, and there was plenty available at the Vatican. Some of the Prophets and Sibyls seem to be specifically chosen for their places on the vault. Some of the scenes of Genesis are obviously related typologically to Christian events, others are less obviously relevant. But the program, as Edgar Wind pointed out,

rests on a relatively simple theological thought. According to a doctrine of concordance that goes back to the early Fathers, the beginning of the Old and New Testaments – the first book of Moses and the first chapter of Matthew – were prophetically connected by the word *generation*: what Moses had called 'the generation of Heaven and Earth' reappeared in Matthew as 'the generation of Jesus Christ.'

There are also clear symptoms of stylistic evolution and change as Michelangelo progressed with the work over a period of some four years; we can imagine that to some degree the meaning of the figures may also have changed and expanded. Since the cartoons for the altar end of the ceiling were not prepared until I5IO-II, there may also have been some adjustment of the program during the course of painting. The scenes over the altar area of the Chapel, which Michelangelo painted last, are more powerful, majestic, and awesome than the early scenes and figures near the entrance; they are all iconographically rich, with interpenetrating levels of meaning.

Michelangelo's decoration of the Sistine ceiling is the most grandiose pictorial ensemble in all of Western art, and for that reason it has to be approached from different points of view. Before trying to see it as any kind of unity (which is hard) we need to see how its component parts work, alone and in consort. Michelangelo approached the decoration of the ceiling on the rebound from the tomb project; a portion of the ceiling is occupied with large, sculpturesque figures that translate into paint ideas evolved for the tomb.

Entering the Chapel we discover above us the prophet Zechariah [60; cf. 57], who prophesied 'Here is a man named the Branch; he will shoot up from the ground where he is and will build the temple of the Lord' (6.12). Christ was the topmost branch of the family tree of

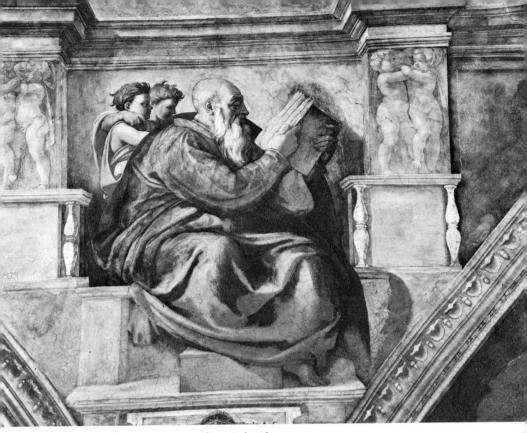

60. Michelangelo, Sistine ceiling: Zechariah

Jesse, which is represented by the Ancestors in the lunettes and spandrels. But even more obviously connected with this prophecy were the popes who built and decorated the chapel; they were of the Della Rovere family; *rovere* in Italian means 'oak', and the ceiling is replete with heraldic acorns referring to the patrons. The choice of Zechariah as the introductory prophet to the Chapel seems adequately explained by these connections. In addition, he seemingly predicted Christ's symbolic entry into Jerusalem:

Rejoice, rejoice, daughter of Zion, shout aloud, daughter of Jerusalem; for see, your king is coming to you, his cause won, his victory gained, humble and mounted on an ass . . . He shall speak peaceably to every nation, and his rule shall extend from sea to sea from the River to the ends of the earth.

(9.9-10)

The pope, Christ's vicar, ceremonially enters the Chapel by the door directly under Zechariah after distributing palms to the people on Palm Sunday, commemorating Christ's entry into Jerusalem. Since Palm Sunday was specially observed with services in the Chapel, the prophecy of triumphal entry seems particularly fitting.

At the other end of the Chapel we see the dynamic and disquieting figure of the prophet Jonah, emerged from the belly of the fish [61]. The three days Jonah spent in the fish symbolize Christ's burial just as Jonah's emergence from the fish typifies the Resurrection, a parallel specifically drawn by Jesus:

some of the doctors of the law and the Pharisees said 'Master, we should like you to show us a sign.' He answered: 'It is a wicked, godless generation that asks for a sign; and the only sign that will be given it is the sign of the prophet Jonah. Jonah was in the sea-monster's belly for three days and three nights, and in the same way the Son of Man will be three days and three nights in the bowels of the earth.' (Matthew 12.38–40)

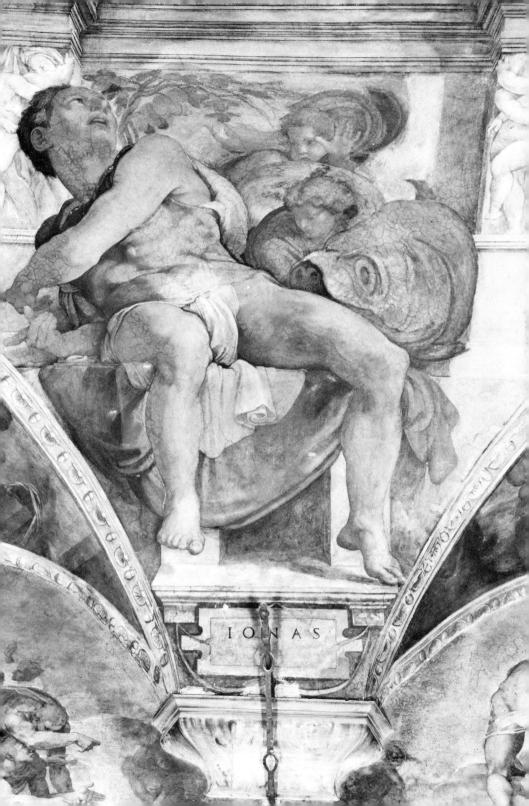

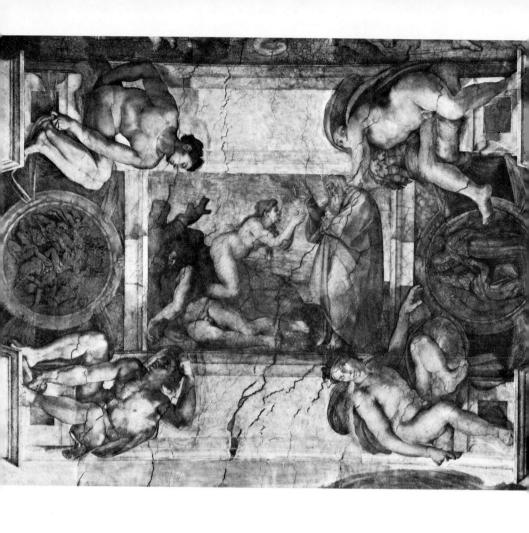

Over the entrance to the Chapel the pope's temporal and spiritual power is announced by calling attention to Christ's symbolic entry into Jerusalem and to the pope's role as Christ's earthly vicar. Over the altar the basis for this authority is symbolized by Jonah's reference to the central mystery of Christianity: Christ's death as a man and his resurrection as God. These explanations account for the selection of two minor Prophets for places of honor at the ends of the Chapel.

Some of the other Prophets and Sibyls may have been placed arbitrarily, but so much was written in the theological literature about each of the Genesis scenes, and so much can be read into the words of the Prophets and into the interpretations of those words by Christians, that it is possible to link almost any figure in a meaningful way with the figures and scenes around it. Isaiah, for example, could be quoted to support any of the possible Prophet-positions – he prophesied the fruition of the tree of Jesse, the virgin birth of the Savior, and so on. There is, however, another axis of importance, in the center of the Chapel, where there seems to be an especially meaningful juxtaposition. The Chapel was and still is divided by a choir screen that separates the lay (eastern) half from the sanctuary. The screen has now been moved; it was originally in the middle, under the boundary separating the scene of The Creation of Eve from The Temptation. The Creation of Eve is crucial for the whole decoration [62; 160]. According to the common interpretation of theologians, Mary was the new Eve who redeemed the sin of her predecessor; and Eve-Mary was also Ecclesia: the Church. The Creation of Eve invokes automatically in any mind acquainted with Church thought both Mary and the Church. Since the Creation of Eve was taken to typify the foundation of the Church, it was placed just past the barrier that separates outsiders from Churchmen - symbolically, the barrier between true Christians and heretics, infidels, and others outside the salvation of the Church.

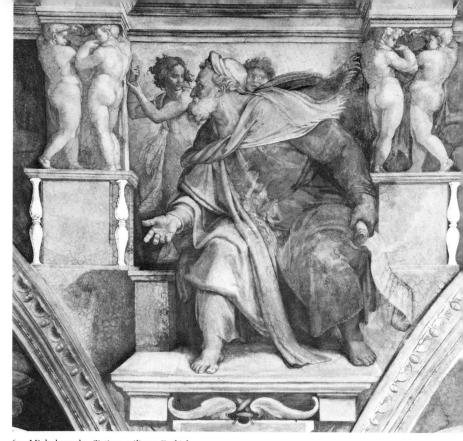

63. Michelangelo, Sistine ceiling: Ezekiel

The Creation of Eve is flanked by the Cumaean Sibyl and by the Prophet Ezekiel [63, 64]. Ezekiel, one of the major Prophets, wrote:

He again brought me round to the outer gate of the sanctuary facing eastwards, and it was shut. The Lord said to me, 'This gate shall be kept shut; it must not be opened. No man may enter by it, for the Lord the God of Israel has entered by it. It shall be kept shut \dots ' (44.1-3)

This passage was interpreted as a prophecy of the virgin birth; but it also clearly refers in our context to the gate in the choir screen below. Moreover, Ezekiel says: 'I the Lord . . . have dried up the green tree, and have made the dry tree to flourish' (17.24). The sleeping Adam in the fresco leans against the dead tree from which Christ's cross will come. All of these parallels stem from St Augustine, who wrote: 'Adam is Christ and Eve the Church.'

The Cumaean Sibyl [64], in Vergil's Fourth *Eclogue*, made a similar but seemingly clearer prediction:

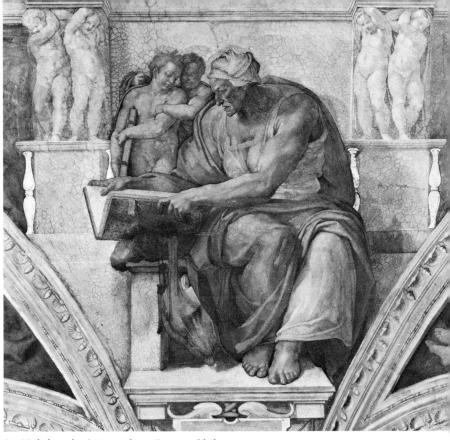

64. Michelangelo, Sistine ceiling: Cumaean Sibyl

We have reached the last Era in Sibylline song. Time has conceived and the great Sequence of the Ages starts afresh. Justice, the Virgin, comes back to dwell with us, and the rule of Saturn is restored. The Firstborn of the new Age is already on his way from high heaven down to earth.

With him, the Iron Race shall end and Golden Man inherit all the world. Smile on the Baby's birth, Immaculate Lucina; your own Apollo is enthroned at last.

This passage was supposed by Christians to refer to Jesus, and so both Prophet and Sibyl foresaw his virgin birth, connecting Mary with Eve in the central scene. This connection furnishes a clue to the reading of all the Genesis scenes – they represent what is shown but at the same time they may also be interpreted on a second level of meaning. The parallel between the Old and New Testaments found on the walls below continues on the ceiling, but telescoped into a single cycle. The Prophets and Sibyls may, however, also relate to the scenes of Christ's life on the lower wall.

65. Michelangelo, Sistine ceiling: The Death of Haman

Starting over the altar we find on the left double spandrel the death of Haman shown, not as in the Bible by hanging, but by crucifixion [65]. In the other scene, Moses and the Serpent of Brass [66] was commonly taken as the antetype of Christ's Crucifixion: we read in the Gospel of John:

No one ever went up into heaven except the one who came down from heaven, the Son of Man whose home is in heaven. This Son of Man must be lifted up as the serpent was lifted up by Moses in the wilderness, so that everyone who has faith in him may in him possess eternal life . . . It was not to judge the world that God sent his Son into the world, but that through him the world might be saved. (3.13-17)

Between them, Jonah [61] symbolizes both Christ's burial and Resurrection. So the Crucifixion, Entombment, and Resurrection are clearly typified on the ceiling over the altar. The first three episodes from Genesis, God Separating Light from Darkness, Creating the Sun and Moon, and Separating the Waters [89–91], are creation scenes that may also

66. Michelangelo, Sistine ceiling: Moses and the Serpent of Brass

invoke the coming of Jesus – we recall that both the finding of Moses and the birth of Christ were represented on the altar wall below [52].

And so we may read the scenes, now fairly confidently, now less surely. But there is no doubt of the direct relationship of the Creation scenes to the pope's half of the chapel or of the mediating nature of the central triad, in which God creates Man and Woman and is in turn defied by them. The Creation of Adam – an antetype of the birth of Christ – lies over the sanctuary [86]. The Creation of Eve–Ecclesia also lies, as we have seen, just over the barrier toward the altar. The Temptation and Expulsion from Paradise are over the lay section, where we continue to read of man's punishment (The Flood [81]) and the ultimate survival of a single pious man chosen by God. The final scene on the ceiling, over the entrance, is The Drunkenness of Noah, which symbolically differentiates between the saved and the damned [80]. No one who stands within the entrance to the great Chapel can miss the general significance of the central series of images, which leads from God in all the force of his creation, to man's temptation

and fall, and finally ends above with one sinning, almost bestial, drunken man – whom yet God loved.

In the two double spandrels flanking the entrance [78, 79], the punishment of those outside the Church (Holofernes, Goliath) is brutally shown at the hands of Judith (who was also taken as an antetype for Mary) and David (a precursor of Christ). So themes of pagan prophecy, Old Testament, New Testament, and Church history are intertwined, and what looks complex as a decoration is still more complex as theology – even if we reject the more arcane interpretations that are constantly being thought up and elaborated. Ultimately, it is the power and richness and variety of Michelangelo's art that make the ceiling a central monument of Western culture.

Michelangelo began painting in the winter of 1508-9, not the earliest scenes of creation over the sanctuary, but the Noah episodes over the entrance. At first he had trouble with mold and had to paint some of the ceiling over. The medium he used was true fresco watercolor painted into newly applied, damp plaster, a technique he must have learned from Ghirlandaio but had never before practiced independently. He transferred his design to the wet plaster by holding it up and following the lines with a stylus, making grooves that can still be seen. He was at first conscientious in following these lines, but later became much freer, sometimes improvising around the drawing on the ceiling. He also had his usual trouble with assistants. The Flood [81] is painted by several hands, with Michelangelo's part in the center. He then dismissed the assistants (among them his old friend Granacci) and painted the rest almost wholly by himself, although he surely had help with the preparation of the plaster and other such menial tasks. On 27 January 1509 he wrote to his father:

I do not ask anything [of the Pope] because my work does not seem to me to go ahead in a way to merit it. This is due to the difficulty of the work and also because it is not my profession. In consequence, I lose my time fruitlessly. May God help me.

In June he wrote again:

I am attending to work as much as I can . . . I don't have a penny. So I cannot be robbed . . . I am unhappy and not in too good health staying here, and with a great deal of work, no instructions, and no money. But I have good hopes God will help me.

It was at this time, too, that he complained of having led a miserable life for the past twelve years (see pp. 42-3). Evidently he was working hard and was often depressed. In October he wrote his brother Buonarroto:

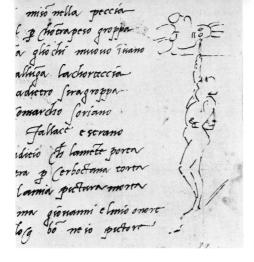

67. Michelangelo, detail of poem satirizing his painting with a caricature of himself

I live here in great toil and great weariness of body, and have no friends of any kind and don't want any, and haven't the time to eat what I need \dots

In July 1510 he writes in somewhat better spirits: 'Here I'm working as usual and will have finished my painting by the end of next week, that is to say, the part I began . . . I'm not very well.'

We have Michelangelo's own caricature of himself painting [67], together with a satirical sonnet written to a close friend, Giovanni da Pistoia. The poem, written in 1510, reads in part:

I've got myself a goiter from this strain . . .

My beard toward Heaven, I feel the back of my brain
Upon my neck, I grow the breast of a Harpy;
My brush, above my face continually,
Makes it a splendid floor by dripping down . . .

And I am bending like a Syrian bow . . .

John, come to the rescue
Of my dead painting now, and of my honor;
I'm not in a good place, and I'm no painter.

This first part of the ceiling was evidently completed in July or August of 1510. It comprised the vault from *Zechariah* to the top of *The Creation of Adam*, and may well have included the spandrels up to that point but probably not the lunettes. In this part of the ceiling we already have three great double strips of throne-architecture crossing the vault, peopled with scenes and figures. Freedberg likened these long bays to a 'concord of brasses, sounding in massive chords across the ceiling.' Two more throne-strips and two more large scenes between were to complete the main vault of the ceiling [cf. 57]. Condivi tells us that:

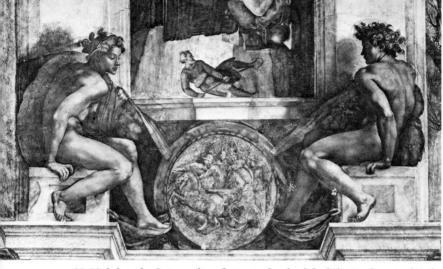

68. Michelangelo, Sistine ceiling: first pair of nudes, left of The Drunkenness of Noah

While he was painting, Pope Julius went to see the work many times, ascending the scaffolding by a ladder, Michelangelo giving him his hand to assist him onto the highest platform. And, like one who was of a vehement nature, and impatient of delay, when but one half of the work was done, the part from the door to the middle of the vault, he insisted upon having it uncovered, although it was still incomplete and had not received the finishing touches.

There are notable stylistic differences between the first half and the second – which was continued only after a lapse of some six months. The novel scaffolding, which was of Michelangelo's design, had to be moved. By that time the Pope was in Bologna and, needing money, Michelangelo had to make two trips, one in September 1510 and another in December. Then, in February 1511, he set to work again for another twenty-one months, finishing the ceiling in October 1512. Condivi writes:

It is true that I have heard him say that the work is not finished as he would have wished, as he was prevented by the hurry of the Pope, who demanded of him one day when he would finish the Chapel. Michelangelo said: 'When I can.' The Pope, angered, added: 'Do you want me to have you thrown down off this scaffolding?' Michelangelo, hearing this, said to himself: 'No, you shall not have me thrown down,' and as soon as the Pope had gone away he had the scaffolding taken down and uncovered his work upon All Saints' Day. It was seen with great satisfaction by the Pope (who came that very day to visit the Chapel), and all Rome crowded to admire it. It lacked the retouching a secco of ultramarine and gold in certain places, which would have made it appear more rich.

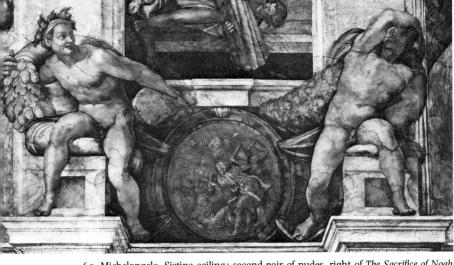

69. Michelangelo, Sistine ceiling: second pair of nudes, right of The Sacrifice of Noah

The stylistic changes we have mentioned document the break in work in 1510. In order to understand their character we must examine some typical figures. The nudes - ignudi in Italian - form one of the clearest case-histories as well as showing a characteristic side of Michelangelo's art. They are his most personal and revealing contribution to the ceiling, having no necessary function - their ostensible purpose, holding the ten bronze-colored medallions, hardly calls for such a powerful corps of workers. It has been proposed that they are angels, and once our surprise at the idea of nude, wingless male angels is overcome, we remember that such angels are clearly shown in Michelangelo's Last Judgement of the 1530s on the altar wall of the same Chapel [164]. Even on the ceiling itself there seem to be, in other contexts, angelic figures of similar types [88]. But the ignudi do not behave like angels and are more interesting as expressions of Michelangelo's unique artistic daemon than as iconographic symbols. It becomes clear in examining the earliest nudes, near Zechariah, that Michelangelo thought of them as sculptured pairs above the thrones [68]. (One of the nudes of the first two pairs has almost disappeared because of damage.) The preserved pair sit as almost exact mirrorimages with contrasting faces, one moving toward us into the light, the other shadowed. They twist their upper bodies in an athletic manner, almost seeming to swing their legs. Both nudes are carefully accommodated to the picture plane, like relief sculptures. The imperfect pair opposite must have been rather similar, but with their bodies turned toward us. Here we still seem to be in the world of the Battle cartoon.

The nudes around The Sacrifice of Noah show the same characteristics (although Michelangelo has now given them cushions to sit on, clearly an afterthought). One pair moves in profile, the other works in and out of the surface plane [69]. But Michelangelo's thought has already evolved and the almost heraldic symmetry is subtly broken more clearly in the pair illustrated, over Isaiah, where the similarity of torso and legs gives way to an athletically playful contrast of gesture, with the right-hand nude assuming one of those evocatively complex poses that we associate with Michelangelo's middle period. Some of these attitudes must have evolved from his ideas for the fettered captives of the Julius tomb; there too, as we shall see, the original iconographic impetus became almost meaningless as the artist's vision developed, on a level of purely stylistic dynamism, to achieve an exalted emotional goal [cf. 103, 105]. The two series tomb prisoners and Sistine nudes - are alike in their muscular activity and in a veiled sense of ultimate captivity within a rigid architectonic scheme. All of the ignudi are in a sense ideal restorations of the famous Belvedere Torso [70], which of the surviving antique statues was per-

haps the most evocative for Michelangelo's muscular art. Michelangelo was enamored of this great fragment, and was quoted as saying 'this is the work of a man who knew more than nature.'

With the nudes around the center panel, *The Creation of Eve*, we find Michelangelo breaking away further from the mirror conception, or at least stretching it [62]; and here too we start sensing a frenetic activity, even alarm (seen clearest in those at the right, over the *Cumaean Sibyl*), together with its opposite, a kind of dreamy lethargy. These states correspond to aspects of Michelangelo's personality – demonic, obsessive energy, contrasted with a strange passivity, a sense of being in the hands of God. The following nudes, over *Daniel* and the *Persian Sibyl*, were painted after the break of 1510–11 [cf. 89]; they are larger, seemingly closer to us, and have a more complex (if still roughly heraldic) relationship. Again there is a contrast between repose and alarm, which is now violent and accompanied by extravagant and unlikely movement [71]. Finally, around the first creation scene, we see a distillation of these tendencies into powerful, idealized figures that show, as Freedberg has said, that 'Michelangelo

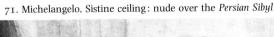

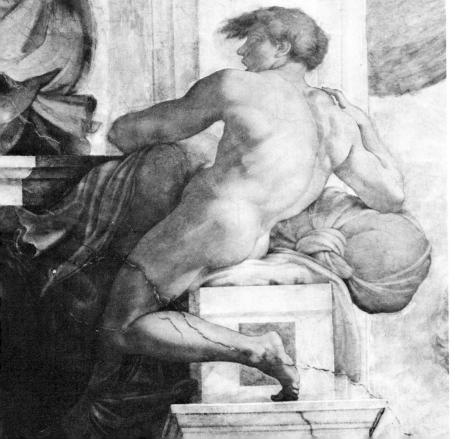

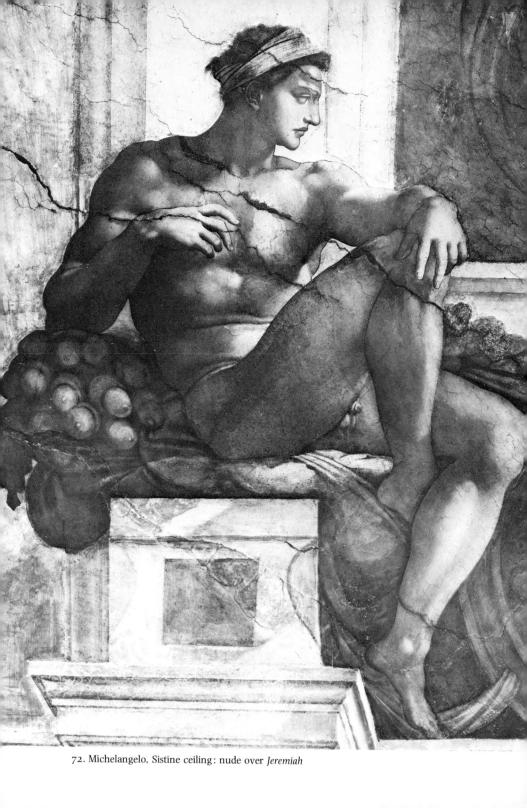

finally has won his long private war with the Laocoön, and surpassed the envied model of the Torso Belvedere' [72-4]. This progression of twenty nudes done in fresco enabled Michelangelo to evolve an essentially sculptural style in a time so short that he could have carved very few actual figures. And so, despite the trials of the ceiling, we can be pleased with the unwelcome commission - as we sense, finally, he was too. If we compare the left nude in illustration 68 with that of illustration 72, we see how the same essential type and inspiration has grown, become more powerful, complex, and remote from reality. The later nudes are less realistic, less anatomically possible, closer to a kind of abstract musical dream-language of art [74]. The physical ideal that Michelangelo used as the vehicle for artistic expression ultimately gave way in his old age to a spiritual one. Here we see his art evolving in its full physicality, but with an increasingly imaginative and spiritual content. The later ignudi seem to illustrate some of his later poems:

> l'anima, della carne ancor vestita, con esso è già più volte ascesa a Dio. (*Rime*, 83)

(Your soul already, still clothed in its flesh, Repeatedly has risen with it to God.)

In a sense these *ignudi* are fettered like the later *Slaves* of the Julius tomb [103–6], caught in some invisible web of carnal and spiritual frustration against which they pose and rebel. Michelangelo used this image often and effectively, but it never became a cliché. It expresses a basic quality of his own experience, pathos:

l'amor mi prende, e la beltà mi lega . . . (Rime, 41)

(Love seizes me, and beauty keeps me bound . . .)

and such images constantly recur in both his art and his poetry.

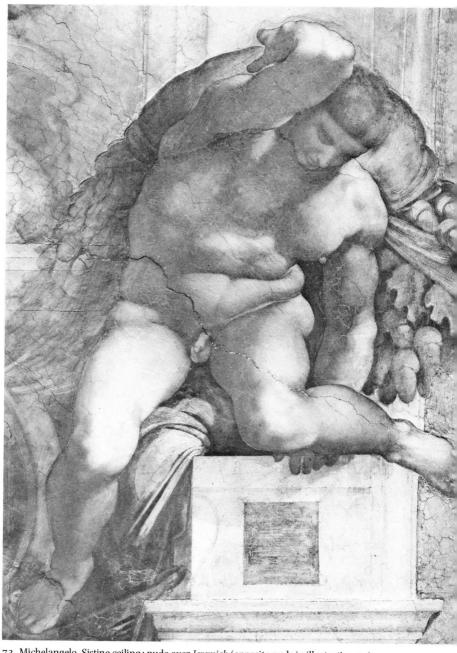

73. Michelangelo, Sistine ceiling: nude over \textit{Jeremiah}\xspace (opposite nude in illustration 72)

74 (opposite). Michelangelo, Sistine ceiling: nude over the Libyan Sibyl

A comparable evolution can be seen in the Prophets and Sibyls: after the figures accompanying *The Creation of Eve* we find an increase in size and activity. The early *Delphic Sibyl* sits compactly in her throne with scroll unfurled at our left, her head and eyes turned away from the movement of her arm [75]. Such a figure can stand for Michelangelo's artistic style of the first decade – the *Doni* Virgin is comparable, and the *Pitti* Madonna a true model [33, 38]. Turning to a late Sibyl, the *Libyan* [76], we find that the throne has become too

75. Michelangelo, Sistine ceiling: *Delphic Sibyl*

76. Michelangelo, Sistine ceiling: *Libyan Sibyl*

small, and the huge figure – now posed rather than seated – is in front of it. The decorative gilt balusters of the earlier thrones are gone, and the platform for her feet has been lowered to accommodate her increased size. The *Libica* was studied in a beautiful chalk drawing that shows the model, here as elsewhere in his work, to have been male [77]. The elaborately elegant pose, like those found in the nudes above, indicates a momentary crisis in Michelangelo's style. The *Libica* is not a believable figure – the artifice of pose and elegance of

conception far outweigh the references to the possible and the real. Such a figure may be called proto-Mannerist in the sense that the meaning of the action is artistically rather than humanly or iconographically generated: she is not so much a Sibyl as a Style. This must have been one of the last parts of the ceiling to have been planned and executed: a spirited drawing for the accompanying Genius is partly covered with little sketches for *Prisoners* for the Julius tomb, on which Michelangelo resumed work in late 1512 or early 1513 [101].

77. Michelangelo, drawing for the *Libyan Sibyl. c.* 1511

Nowhere is the contrast between early and late so persuasive as in the comparison of the Prophets at the ends [60, 61]. Zechariah sits in profile, though his legs extend out from the throne. Like the other early figures, he is comfortably enclosed within the massive architectural frame. His peaceable accompanying genii seem to read over his shoulder. These comments, with minor variations, can also stand for the next two pairs of prophetic figures [cf. 75]. Those accompanying The Creation of Eve, however, seem to take on greater intensity of motion (Ezekiel) or greater power and size (Cumaea) [63, 64]. These are the last of the prophetic figures to have gilt balusters on their thrones, and even this detail is telling. Finally, the incredible Jonah at the end of the vault violates the picture plane with a powerful thrust of leg and knee, while heaving backward and sideways, creating a huge space in front of the throne that did not exist in the early scenes. Consequently, there is now an extensive bench before the throne on which the Prophet sprawls, as the fish and one Genius also pour out of the space of the former seat. Here we see the clearest evidence of Michelangelo's impatience with his conception of 1508: by 1511-12 he simply could not use the framework and continue to evolve his figure style with its increasing charge of psychic and formal content. (The tomb project of 1505 would have been similarly outgrown perhaps we need not even regret its loss.) The Jonah is like a tilted cross in its spatial implication - feet out towards us, body and head

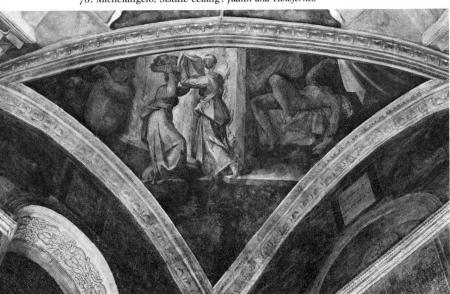

78. Michelangelo, Sistine ceiling: Judith and Holofernes

back, he looks up at God and points down, all on an oblique axis that tends to destroy the careful tectonic framework of the ceiling.

Something of the same evolution is found in the double spandrels of the corners, though here even the early two are spatially complex [78, 79]. David, doing his grisly work on top of Goliath, forms an upside-down T that is just the opposite of the triangle he is in. The figures are consequently small, and contained within the frame. The Judith scene is divided into left and right by the projecting corner of Holofernes' house - thus the fictive space moves contrary to the concave spandrel. Here the broad upper area carries the message -Holofernes and his severed head are both near the upper margin of the area. In the later corners we immediately sense a compounded complication together with a larger scale. Like Jonah, the crucified Haman works forward and back on diagonal, but now the space is complex and irrational [65]. In the Serpent of Brass the solids and voids do violence to the shape and space - an emotional piling, a twisted climbing, sinking, and foreshortening that becomes oppressive [66]. In these late works of the ceiling we find Michelangelo emerging from the essentially classic formulations of the first years of the century and experimenting with different formal possibilities. Both elegance for its own sake [76] and complex spatial irrationality [65] are qualities that we associate with Mannerism, a leading stylistic current of the succeeding years and one that Michelangelo was in-

79. Michelangelo, Sistine ceiling: David and Goliath

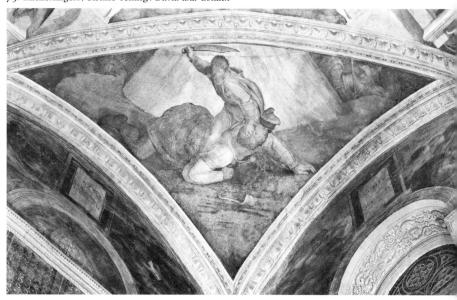

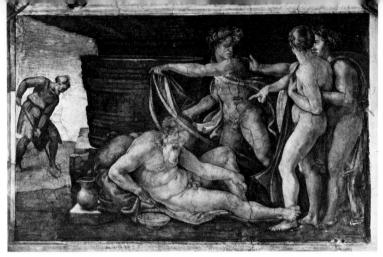

80. Michelangelo, Sistine ceiling: The Drunkenness of Noah

strumental in creating. On the other hand, the powerful spatial and emotional presence of such figures as the *Daniel* and the *Jonah* [61] seem to foreshadow the seventeenth century: Rubens and Bernini.

The evolution we have traced in the single figures is repeated in the main scenes. The early ones – in the order of Michelangelo's execution – are relatively busy, and even imperfectly legible from the floor below [81]. The later scenes – notably the creation panels and especially the great *Separation of Light from Darkness* [91] – are clear and dynamic at the same time, with the figure of God becoming even larger than the long dimension of the picture space.

Of the earliest three scenes Michelangelo painted, only The Drunkenness of Noah [80] shows an awareness of the clarity and simplicity needed for observation from the floor, which is over sixty-five feet below. The Flood, on which he supposedly first began, is perhaps connected compositionally with ideas evolved for The Battle of Cascina, his only major pictorial composition before this time [81, 43]. The surface diagonal of the foreground, with its refugees, becomes spatial as we read back to the frenzied figures on the boat and, behind, on the ark. We see brother attacking brother in order to survive, and elsewhere we see examples of what Michelangelo thought of primitive life and instincts - an interest that was common in Florence around 1500 [82]. Mothers and children, fathers and sons, husbands and wives are shown in extremis, saving and clutching, fighting and pushing. Yet one woman calmly saves her belongings amid the rout. Noah, the chosen man, is seated up in his ark in the far distance: what we witness is the effect of God's wrath. The drama of this scene may owe something to Savonarola's famous sermon of 1494, predicting a terrible flood.

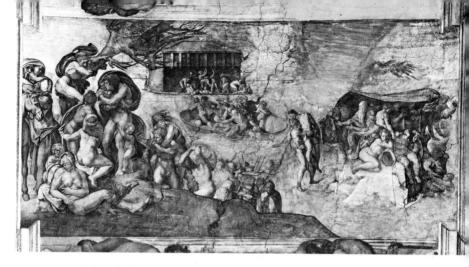

 $8\,\mathrm{I}$ and $8\,\mathrm{2}.$ Michelangelo, Sistine ceiling: The Flood (and detail)

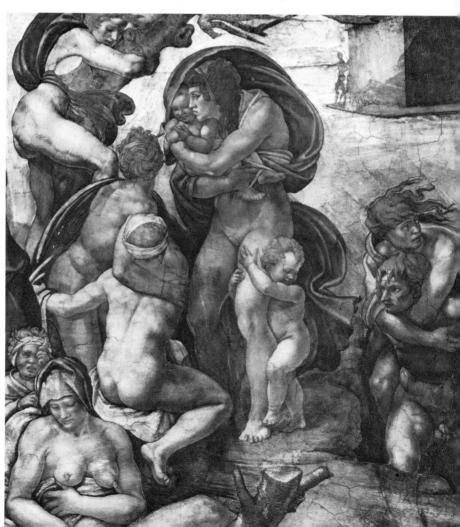

83. Michelangelo, Sistine ceiling: The Temptation and Expulsion from Paradise

Michelangelo must soon have realized that these compositions were more appropriate to traditional wall painting. The central triad is clearly legible and increasingly moving. The Temptation is a tour de force divided in half by the tree [83]. At the left, Adam and Eve, compactly posed, succumb to sin. At the right they are expelled from their desert Paradise by an angel brandishing a sword. The parallelisms of arms and gestures at left and right are made poignant by the contrast between enclosed human comfort at the left and desolate isolation at the right. In these scenes Michelangelo could draw upon his memory of the great portal sculptures in Bologna by Jacopo della Quercia (c. 1374–1438). He knew them well since he had installed the bronze statue of the Pope above in 1508 (see p. 97). The connection with Ouercia is particularly clear in *The Creation of Eve* [84, 85]. With a horizontal field, Michelangelo could expand the scene, which seems to take place on a deserted shore. Eve emerges like an animal, solely through the force of God's will. Like Quercia, Michelangelo was impatient with extraneous details. Paradise is reduced to the one necessary tree, and Noah's vineyard is a wasteland.

84. Michelangelo, Sistine ceiling: *The Creation of Eve*

85. Jacopo della Quercia, The Creation of Eve. 1430–34

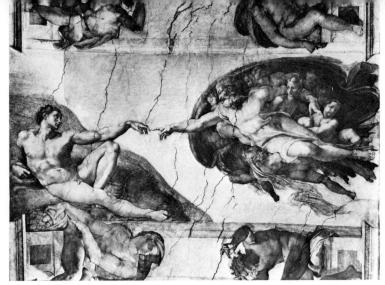

86. Michelangelo, Sistine ceiling: The Creation of Adam

The famous *Creation of Adam* [86] is less dependent on Quercia and more obviously based on the antique. Adam, made in God's image, is like an awakening river god, the long, undulating left outline contrasting with the projections and concavities of the right [cf. 25]. A powerfully modeled study for the *Adam* shows Michelangelo's first, muscular conception, which he modified on the ceiling for increased clarity and ornamental contour [87]. God, having made Adam 'after

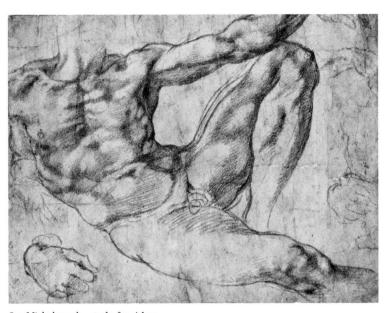

87. Michelangelo, study for Adam

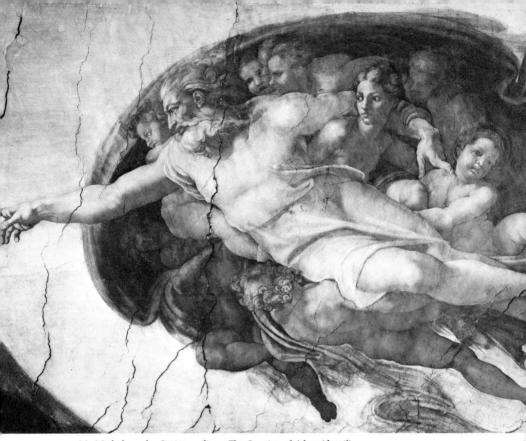

88. Michelangelo, Sistine ceiling: The Creation of Adam (detail)

the manner of sculptors,' reaches out and with a piercing gaze invests the beautiful clay with a thinking brain and troubled soul. Here, made explicit, is the source of the division between body and spirit we detect in the David [25]. God is evidently supported by wingless angels, and probably embraces unborn souls – no doubt including Eve, and probably also Jesus [88]. The symbolic heavenly cloak surrounding the energetic figure of God contrasts with the exposed, naked languor of Adam. The contrast between the two halves of the composition becomes electric at the juncture of the two extended fingers, which also reinforce the sense of twin forms. The Creation of Adam is perhaps Michelangelo's most famous image, and rightly, for it seems to express his own galvanic creative power, which encompassed both God and man. But this is only one side of Michelangelo, who also had a strangely passive, dream-like side, best seen in the Night of the Medici Chapel [123]. In fact both – active and passive – are beautifully present in the single image of The Creation of Adam.

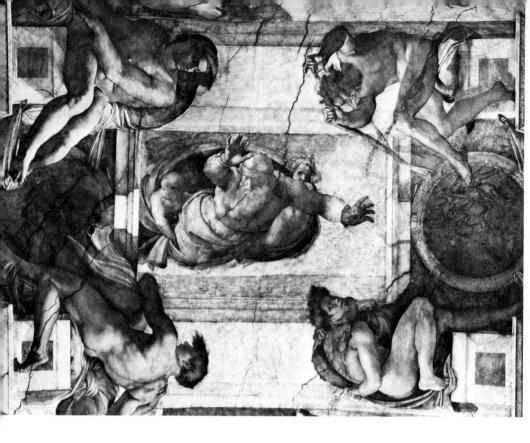

89–91. Michelangelo, Sistine ceiling:
89. The Separation of Land from Water
90 (opposite above). The Creation of the Sun and Moon
91 (opposite below). The Separation of Light from Darkness

An even larger God comes toward us in *The Separation of Land from Water*, hovering over the infinite stretch of sea [89]. In *The Creation of the Sun and Moon* he seems to fly toward us at the right, away at the left, a dynamic, orbiting motion [90]. The stages of creation have been confused or telescoped – at the bottom left of the scene we see a verdant island. Perhaps several creation scenes are implied here, since Michelangelo had to compress six days of creation into five panels. Finally, *The Separation of Light from Darkness* invokes all the creative physical force of the deity into one foreshortened, whirling figure of awesome generative power [91].

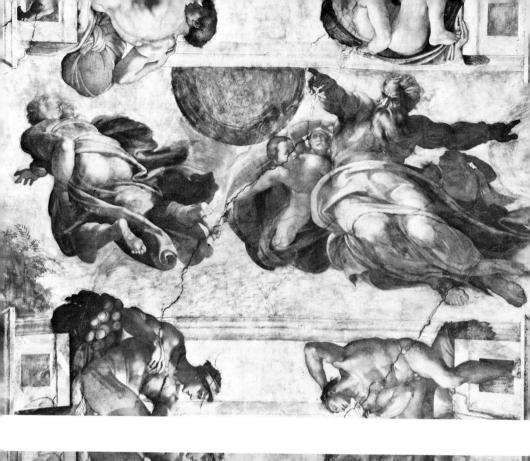

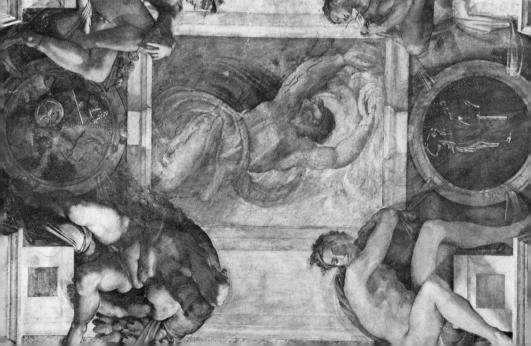

When we compare details of the ceiling we find a tentative, linear conception in the early part that expands toward the middle and later scenes into a broader, more emphatic and pictorially decisive conception. Probably the interruption of 1510 and the first opportunity to inspect what he had done from the floor, free of scaffolding, helped Michelangelo to develop a more eloquent technique and more forceful modeling, which was coupled with the grander conceptions of the later figures and episodes. This contrast can be seen between *The Creation of Eve* and that of *Adam*, where the head of God becomes newly virile, the features clearer and larger, and the hair alive with excited movement [92, 93].

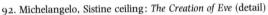

94. Michelangelo, Sistine ceiling: Jesse

The spandrels, and particularly the lunettes (which are the hardest to see) are painted in a more negative style. Michelangelo's noncommittal approach was perhaps appropriate for these shadowy ancestors of Christ. Nevertheless, the series has its own fascination and secret beauties. The spandrels contain family groups, the early ones imaginative variants of standard High Renaissance compositions for the Holy Family or the Flight into Egypt. The later ones are strange, even catatonic or solipsistic, witness *Jesse* [94]. The lunettes are even odder [cf. 65-6, 78-9, 95]; in one case (Eliud) the main personage looks away so that we see only the back of her head. As in the double spandrels next to Zechariah, Michelangelo sometimes seems to compose the figures in deliberate opposition to the awkward space, as if to emphasize it. The righthand figure in the Alia lunette is so tired as to have collapsed, giving a sense of isolated depression that is characteristic of the whole series. I detect no stylistic break in the lunettes, which must have been painted last; Michelangelo himself may imply this in a letter of December 1523 in which he says that his last work was for 'the ends and sides around the aforesaid chapel'.

The coloration of the Sistine ceiling has suffered from age, dirt, and restoration. Nevertheless, it is still a subtle harmony of contrasting warm and cool fresco tones: green shot with gold; rose; blue; and

95. Michelangelo, Sistine ceiling: details of two lunettes

gold. The mixture of flesh- and stone-colored figures, nude and draped, gives it a variegated continuity that is endlessly fascinating. Never before had such a grandiose project been carried out with so complex a program, with such thorough planning, and with so monumental and life-like a cast of figures and scenes, adjusted to perspective variations, and differentiated according to levels of reality. The Sistine ceiling, as was immediately realized upon its unveiling, is one of man's greatest achievements. Never again was such a project to be conceived. But the frescoes remained an ideal and an inspiration; at the dawn of the Baroque era Annibale Carracci used them as the model for his lighthearted Galleria Farnese.

Michelangelo and Sebastiano

In later years Michelangelo blamed the interruption of his first tomb project on Raphael, who had not even arrived in Rome in 1506. By 1512, however, Raphael had amazed the world with the concerted harmony of his frescoes in the Stanza della Segnatura, where we can probably also see the first sign of the influence of Michelangelo's ceil-

ing. In *The School of Athens* there reposes a heroic figure on the steps, often identified as Heraclitus [96]. The figure has a grandeur and scale that were unusual in Raphael's earlier, more mellifluous work. Moreover, the figure is quite probably a thinly disguised portrait of Michelangelo himself. The figure is absent from Raphael's cartoon and must have been a last-minute addition. This interpolation into the

96. Raphael, The School of Athens (detail). c. 1511

fresco of a new style seems to be a straightforward homage to the master, and Raphael clearly benefited from Michelangelo's example, as he had from others. Far more than Michelangelo, Raphael was a great assimilator and synthesizer. Michelangelo resented him, denigrated his great gifts, and years later made the absurd claim that everything Raphael knew he got from him. Michelangelo made Raphael and his host of friends and followers in Rome his lifelong enemies. No doubt Pope Julius II and others encouraged a rivalry between the two great but different artists, but it scarred Michelangelo for life and impaired his perception of reality.

Once the Sistine ceiling was finished the rivalry continued on a different basis. Michelangelo painted no more during Raphael's lifetime, but he had a kind of deputy in the form of an admiring Venetian, Sebastiano Luciani, now known as Sebastiano del Piombo (c. 1485–1547). A gifted pupil of Giorgione's, Sebastiano came to Rome early in 1511. He had no future there either as an expatriate Venetian on

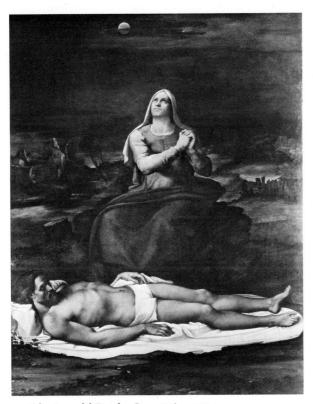

97. Sebastiano del Piombo, Lamentation. 1514

his own or as a member of Raphael's Roman entourage. A natural collaborator, he fell completely under the influence of Michelangelo's powerful anatomical style, which he attempted to unite with his own Venetian manner. As Michelangelo's brush, so to speak, he had before him infinite possibilities. The first and in many ways the most striking product of their collaboration is the Lamentation of 1514, which is based on a lost drawing by Michelangelo of c. 1512 [97]. The painting translates Michelangelo's style so as to reveal the statuesque figures in a poignant nocturnal desolation that is wholly Sebastiano's. How pictorial and un-Michelangelesque the result is in mood may be seen by comparing the painting with the sculptured $Piet\grave{a}$ on which it was also, in a sense, based [18].

The collaboration worked, and the odd team prepared to challenge Raphael's primacy. The competition came to a head early in 1517 when Sebastiano and Raphael were given rival commissions by Cardinal Giulio de' Medici (later Pope Clement VII). Sebastiano's pic-

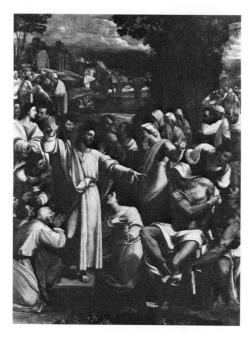

98. Sebastiano del Piombo, *The Resurrection of Lazarus*. 1517–19

ture is the populous *Resurrection of Lazarus*, now in London [98], in which perhaps only a few figures (such as Lazarus) were actually developed from Michelangelo's drawings. This picture shows a novel combination of strange colors set within a generally darkened palette that became fashionable at about this time, perhaps through the indirect influence of Leonardo (who was then in Rome, but not painting) and of ancient writers on painting. Raphael's picture, *The Transfiguration*, was painted later and was probably left incomplete at the artist's untimely death in 1520. There the rivalry ended, although it continued to be a sore point with Michelangelo for years. He also tried to get Sebastiano inserted into Vatican commissions that had been destined for Raphael – to no avail. The mock-humble letter that Michelangelo wrote, too late, to an old acquaintance, the worldly Cardinal Bibbiena, is a particularly amusing example of his irony:

Monsignore: I beg your most reverend lordship, not as a friend or servant, since I do not deserve to be either the one or the other, but as a base, poor, crazy man, that you permit Bastiano the Venetian painter to have some part of the work in the Palace, since Raphael is dead; and if your reverend lordship feels you would be throwing away your favors on somebody like me, I think one can on rare occasions find some enjoyment even in doing a service to madmen, just as one does with onions as a change of diet when one is bored with capons.

You make use of worthwhile men daily; may your lordship please to try me in this, and the favor would be very great; and the aforesaid Bastiano is a very good man, and even if it would be thrown away on me, it wouldn't be on Bastiano, for I am sure he would do your lordship honor.

The letter failed (it was naturally the talk of the papal court), but the collaboration went on. In 1516 Michelangelo had furnished Sebastiano with small drawings that he used to develop the figures in his great fresco of *The Flagellation of Christ*, which was painted several years later [99]. Although translated into Sebastiano's more lyrical idiom, in the fresco we see Michelangelo's anatomy and movement in a classic composition that influenced artists for at least a century. Michelangelo supplied Sebastiano with a drawing or two as late as the 1530s [171]. A highly finished anatomical drawing, clearly done for instructional purposes, may be connected with the *Flagellation* and shows Michelangelo's interest in a canon of proportions [100]. Perhaps he was influenced by Pliny's description of the canon of Polykleitos. Condivi tells us that Michelangelo hoped to publish a treatise on proportion, and some of his ideas are evidently repeated in Vincenzo Danti's incomplete *Treatise* of 1567.

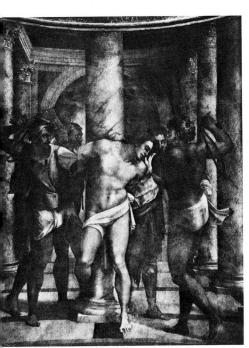

99. Sebastiano del Piombo, The Flagellation of Christ. c. 1520

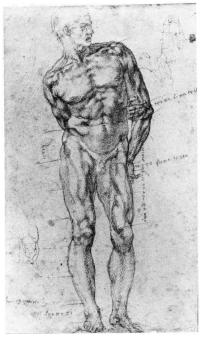

100. Michelangelo, anatomical drawing. c. 1516?

6
The Julius Tomb
Again,
and Other Failures
1512–20

The Tomb Project of 1513

Pope Julius must have been pleased with the Sistine ceiling, but two letters of the period immediately following its completion in the fall of 1512 imply that Michelangelo was not immediately employed on the old tomb project. A letter of 5 November 1512 does say that he is working, but we don't know on what. The drawing for the *Libyan Sibyl* with sketches for the tomb [101] implies, however, that the tomb was again on his mind and perhaps in some sense again underway. A letter, presumably of October 1512, makes sarcastic inquiry about the whereabouts of marbles ordered for the Julius tomb, and the November letter goes on to ask his father

whether there is some lad in Florence, the son of poor but honest people, who is used to roughing it and would be prepared to come here to serve me . . . and in his spare time would be able to learn . . . let me know because here only rascals are to be found and I have great need of someone.

In February he wrote about 'this nasty mess of this boy' and complains of the cost of the mule ride he had had from Florence – and so it went. But our picture of this characteristic episode is incomplete without Michelangelo's postscript:

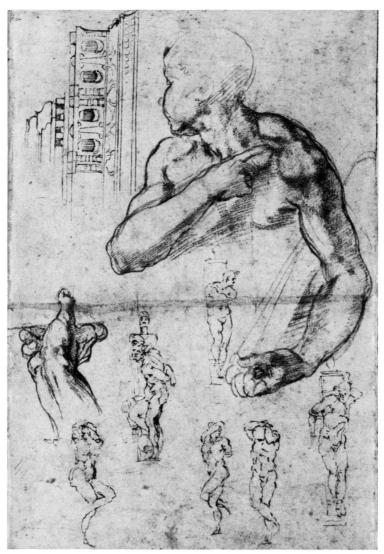

101. Michelangelo, drawing for the *Genius* of the *Libyan Sibyl* and of *Slaves* for the Julius tomb. 1511-12

If you should speak to the boy's father, tell him about it nicely, that he is a good boy, but too soft and not fit for my service, and he should send for him.

When the great Pope died on 30 February 1513 he left 10,000 ducats to continue the tomb. The new Pope, Leo X (1513-21), was

102. Copy after Michelangelo, frontal view of the project of 1513 for the tomb of Julius II

Michelangelo's old acquaintance Giovanni de' Medici, second son of Lorenzo il Magnifico. But he seems to have had no immediate use for the problematic sculptor; Leo was particularly sympathetic to the more accessible art and personality of Raphael. An altogether different man from his predecessor, Leo's most famous remark was 'Since God has given us the papacy, let us enjoy it.' He ate, drank, and hunted; the Church, in precarious condition, began to fall asunder.

On 6 May 1513 a new contract for the tomb was drawn up with the heirs of Julius II: it was to contain some forty statues. Michelangelo was to finish the new project in seven years and to receive 13,000 ducats in addition to what had already been paid. He started up in a fury of work that lasted into 1516 with little interruption. In July he wrote his brother Buonarroto 'I'm being pressed in such a way that I haven't time to eat. God willing, I can bear up.' His workshop was in an impressive house on a street known as the Macel' de' Corvi, near the Trajan Column; this house became his permanent Roman home. It was finally destroyed late in the last century to make way for the Victor Emmanuel monument.

Michelangelo set to work on a new tomb, no longer freestanding like the project of 1505, but with its lower part on three sides quite similar to the first design. The rear face was to abut against a wall, and above this end rose a high cappelletta – a tabernacle that was to frame a statue or relief of the Madonna [102]. Since only three figures for this tomb were carved we need not bother with the archeological details of the project that are so dear to Michelangelo scholars. The contract of 1513 marks the beginning of the transformation of Michelangelo's triumphant free-standing tomb of 1505, with all its antique connotations, into a wall tomb like the more modest ones of the Renaissance. In addition, the new design was far more explicitly Christian and Marian in iconographic content. Michelangelo, in later letters, said that the tomb of 1513 was bigger than the earlier design; he was probably referring to the addition of the high tabernacle. In fact, the measurements in the contract show that the entire scheme was reduced in size as well as number of figures since the facade abutting the wall lost its lower decoration.

Michelangelo began with the two so-called *Slaves* [103–6], which found their way to France before 1550 and are now in the Louvre. They have evolved from the 'Liberal Arts' that were to be shown fettered in the first project, and owe much to the nudes of the Sistine ceiling [68–74]. There was a good antique tradition for representations of slaves, but no one today sees these figures as simple captives. Nor, however, do they satisfy as normal representations of the Arts, although the inchoate ape holding what may have been intended as a

mirror, at the rear of one figure, seems to imply the old saving, ars simia naturae – art apes nature [104]. Perhaps this statue, the more highly finished of the two, was the first begun; it could even have been a block left over from the first contract. Michelangelo often began a new project with plans for abundant iconographical symbols and gradually abandoned them in favor of figures with more general significance. As in all of Michelangelo's statuary from this time on, a personal vision transforms the prosaic program. We cannot be sure now whether this apparently sleeping figure was to represent art (painting) awakened by Julius, or - more likely - sleeping after his death, as Condivi has it (see p. 86). Detached from its intended context as it is, we see a figure that would be more comfortable lying down. in an elegant contrapposto pose - perhaps his most hedonistic and voluptuous homage to the male body, whose form he loved above all else. Symbolic fetters seem to encircle the neck, the upper chest, and left wrist. But Michelangelo's interest was obviously in the dreamily sensual pose, derived from the younger son of the Laocoon [50], and in the stylized beauty of the face. He finished very few male heads in his career: the specificity of even potential portraiture seems to have interfered with his vision of ideal beauty. This inspired figure carries on the highly charged style and ecstatic vision found in the later nudes of the Sistine ceiling [72–4]. Unlike the David, where muscles remain details within the whole, there is now a fluid movement throughout the body, a concerted harmony that still reveals loving touches of surface detail. Despite its easy torsion, the statue was obviously meant to be seen from the front and would have decorated one of the inner pilasters of the tomb [cf. 102].

The other *Slave* [105], also begun in 1513, is rebelling against his bonds. Such a conception was foreign to antique slave iconography but was nonetheless antique - witness the Laocoon [50]. There was, moreover, an old Christian tradition of the fettered hero - St Sebastian, and representations of that saint may have been part of Michelangelo's inspiration for these figures. Certainly the Rebellious Slave was used as a source for many painted Sebastians of later years. Once again the statue seems to be a development from certain nudes of the Sistine ceiling [cf. 69, 74]. Michelangelo needed a figure offering striking views around 180 degrees. Some of the twisting *Slaves* in the Oxford drawing [101] seem to be for such corner figures, which are far more active and powerful than anything he had planned or carved in 1505. For this we can again thank the experience of the Sistine ceiling. Seen from the front, the Rebellious Slave turns his torso and shoulders to our left while deflecting his knee and head in the other direction. The torsion encourages us to move to the right, where we find an expressive pro-

103 and 104. Michelangelo, Dying Slave. c. 1514

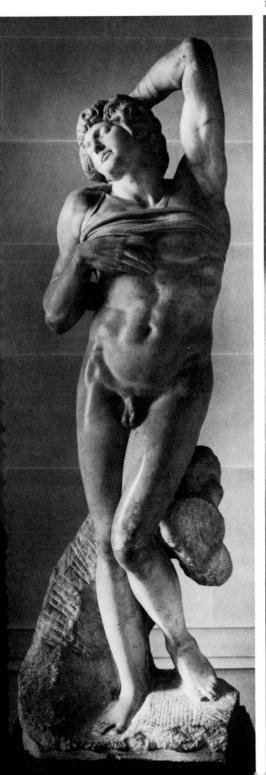

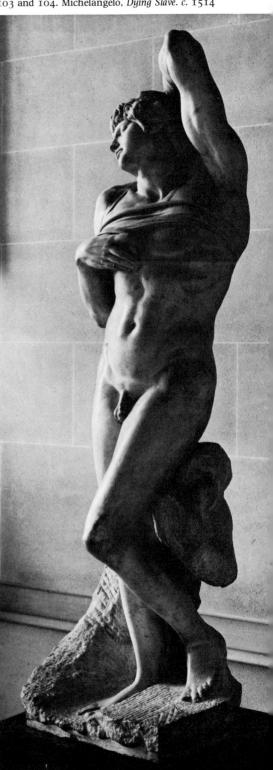

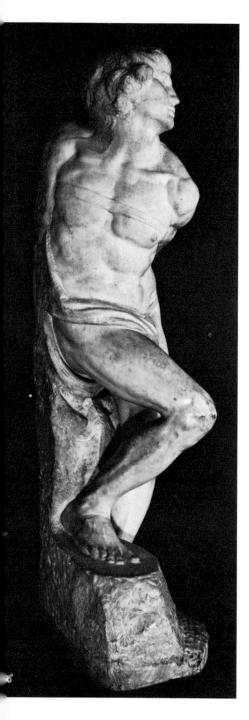

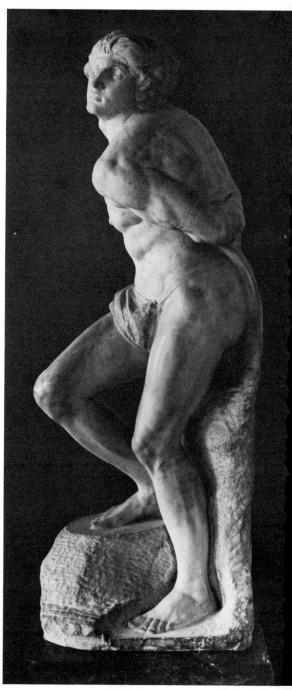

105 and 106. Michelangelo, Rebellious Slave. c. 1514

file [106]. Assuming that Michelangelo started with the figures for the narrow, projecting end of the tomb, whose architectural decoration was being carved at this time, we can probably best imagine the 'Dying Slave' on a central pilaster and the Rebellious Slave at the right corner [102] – but Michelangelo was so successful in achieving views around the angle that no agreement has been possible and it is quite conceivable that it was planned for the left corner, or for the figure around either corner. The Rebellious Slave developed a crack across the face and shoulder at some time, presumably during its creation, which probably forced Michelangelo to give it up.

Like many paired figures in Michelangelo's work, the Louvre Slaves seem to represent two opposing principles, one active, one passive (we can hardly say contemplative). The bonds, and especially the struggle of the Rebellious Slave, have invited various Neoplatonic interpretations: man fighting off the shackles of the body, spirit vs. flesh. These ideas were certainly current and are probably so old and basic that we cannot exclude their unconscious influence. Pietro Bembo's Gli asolani of 1506 presented a modern formulation of Platonic love that was immediately popular and influential, and the same Bembo (later a cardinal, almost a pope) is made to extoll Platonic love in the closing pages of Castiglione's Courtier. But there are no grounds for a Neoplatonic interpretation of the tomb of 1513 as a whole. Higher is usually better, iconographically, and these Slaves are on the lower tier of the tomb. But if, as it seems, they were to alternate with figures representing Virtues [cf. 102], upwardly rising Platonism can hardly be argued as the programmatic basis for the monument. The Rebellious Slave, if it is intended to personify one of the Liberal Arts (there is a lump that could represent the beginning of a second ape), could be a symbol of sculpture awakened from its imprisonment by Julius II or unhappily fettered by his death.

We have seen in our discussion of the Sistine *ignudi* that these bound figures are a leitmotiv with autobiographical associations:

Cosi l'atti suo perde chi si lega, e salvo sé nessun ma' si disciolse. (*Rime*, 70)

(He cannot act who by himself is bound, And of himself no one is freely loosed.)

He also wrote, in the same sestina, which is full of binding images:

Così fuor di mie rete altri mi lega.

(Thus outside of my bonds others bind me.)

Similar iconographic confusion has surrounded the famous Moses [107], the only other figure begun in this period (probably c. 1515). Numerous explanations of the seeming mystery of the great work have been proposed. It has been discussed on the one hand as a purely symbolic image of the Old Testament leader, and on the other as a dramatic moment in the life of the Prophet. Actually, like the other figures for the monument, its meaning was symbolic, and it is Michelangelo's expressive genius that has made Moses so impressive, so evocative of inner spiritual life, so charged with potential thought and action. Moses was to be another corner figure - above, on the right of the platform, presumably over the Rebellious Slave. Moses therefore looks to his left in order to function around the space outside. To interpret the figure, as has been done, as about to reproach the Israelites for worshiping the Golden Calf, would destroy the meaning of the tomb as a whole. In the project of 1505 Moses was to have been coupled with St Paul at the end of the platform (cf. pp. 86-7). The project of 1513, as represented in illustration 102, does not show St Paul but anonymous figures together with minor architectural elements that may have been dropped in Michelangelo's mind as he worked on. Thus the

108. Donatello, St John the Evangelist. c. 1410

Neoplatonic interpretation favored by Panofsky, that Michelangelo somehow summoned up a passage by Giovanni Pico della Mirandola in which it is stated that 'With this vision Moses and Paul and many others among the elect saw the face of God and this vision is the vision that our theologians call intellectual or intuitive cognition,' becomes irrelevant to the tomb of 1513. The origins of the pairing in 1505 were probably banal, and by 1513 another set of figures took their place. Perhaps the *Moses* was actually blocked out before the Pope died, and so survived the first project.

Condivi writes of

that most marvelous Moses, leader and captain of the Hebrews, who is seated in an attitude of thought and wisdom, holding under his right arm the tables of the law, and supporting his chin with his hand, like one tired and full of cares. Between the fingers of that hand escape long waves of his beard – a very beautiful thing to see. And his face is full of life and thought, and capable of inspiring love and terror, which, perhaps, was the truth. It has, according to the usual descriptions, the two horns on his head a little way from the top of the forehead. He is robed and shod in the manner of the antique, with his arms bare. A work most marvelous and full of art, and much more so because all the form is apparent beneath the beautiful garments with which it is covered. The dress does not hide the shape and beauty of the body, as, in a word, may be seen in all Michelangelo's clothed figures, whether in painting or sculpture. The statue is more than twice life-size.

Michelangelo consciously kept the traditional horns found in medieval representations. They derive – as was by then known – from a mistranslation of the Hebrew word for 'rays of light,' which is how the ancient texts describe his head: surrounded with a halo. Perhaps Michelangelo knew that in the antique world a horned head often symbolized divinity, honor, and power, and kept the horns for that reason [109]. Moses derives from a long tradition of seated sculptured figures, most obviously from Donatello's seated Apostle in Florence [108]. But Michelangelo's own Prophets on the Sistine ceiling are the clearest antecedents - indeed, without his startling evocation of these painted figures between 1509 and 1512 it is hard to imagine that he could have come to so complex and dynamic a vision of *Moses* at this time [63]. He invested the stone with a psychic force equal to the physical might of the great statue – as was long ago observed, Moses is a kind of amalgam of the personality of Julius with Michelangelo's own, a quality his contemporaries called terribilità: frightening power or sublimity. We have seen the early growth of this sense of psychic force in the face of the David [28].

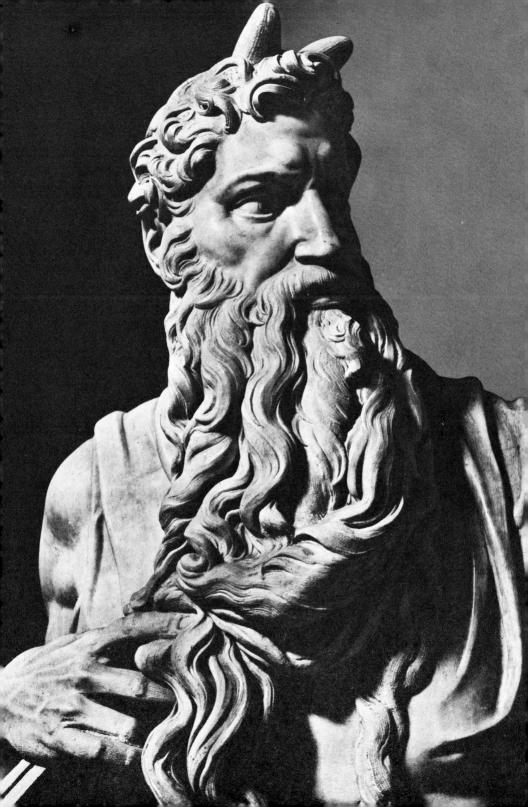

As we see the imposing figure today, at eye level on the sadly reduced tomb [174], we get a theatrical and distorted impression very different from seeing the statue from below, foreshortened and more distant. The Moses is now most effective from the front, with a clear opening of interest to our right since he turns his head, juts out his left arm, and tucks back his left leg. Michelangelo conceived the figure, however, for a position many feet above our heads that would have changed its entire proportion - the long face would have been foreshortened, the torso telescoped, the feet and left hand partially hidden. In order to produce this optically corrected view Michelangelo, as he himself said on another occasion, held 'the compass in his eyes and not in his hands.' Preliminary blocking-out may even have been done with the statue lying on its back, which would have given the possibility of seeing the forms from the desired worm's-eye view. The contract of 1513 specifies that the figures on the platform were to be larger than those below, and the figures in the 'Cappelletta' above larger still [102]. Michelangelo understood the problems of perspective diminution, and apparent distortions in the figure of Moses chiefly derive from his desire to accommodate the statue to the position of the viewer below. But none of Michelangelo's works is 'correct' in proportion; all express his idea of perfection, or struggle, or longing through an anatomy that is based on study but created by art.

The exalted, potentially active stance of the seated Moses seems to quiver with vital force; the powerful head looks as the great leader might have appeared after forty days and nights with Jehovah. 'With this,' Vasari said.

no other modern work will ever bear comparison (nor, indeed, do the statues of the ancient world) . . . Michelangelo expressed in the marble the divinity that God first infused in Moses' most holy form . . . every part of the work is finished so expertly that today more than ever Moses can truly be called the friend of God . . . And well may the Jews continue to go there (as they do every Sabbath, both men and women, like flocks of starlings) to visit and adore the statue, since they will be adoring something that is divine rather than human.

In June of 1515 Michelangelo wrote to his father that he had to make a great effort to finish the tomb as soon as possible because he anticipated having to work for the Pope. This could refer to the colossal *Hercules* for the Piazza in Florence (see pp. 207–8), or may simply be a general statement without a focused commission in mind. In August he wrote:

since I returned from Florence [in April] I have done no work at all; I have devoted my attention solely to making the models and to pre-

paring the work, in such a way that I can make one great effort with a host of workmen to finish the work in two or three years. And this I have undertaken to do and have incurred heavy expenses . . .

In September he complained of having no marble to work, and in November he writes 'I have another two years' work to do before I'm square with these people, as I've had so much money.' This does not mean that he foresaw the end of the tomb in two years. In September 1516 he wrote from Carrara that

I hope, if it remains fine, to have all my marbles ready within two months. Then I shall decide whether to work them here or in Pisa, or I shall go to Rome \dots

But nothing came of all this preparation.

Work on the *Moses* must have ended late in 1515 or in 1516. Francesco Maria della Rovere had become *persona non grata* to the Pope for political reasons, and was replaced by Lorenzo de' Medici as Duke of Urbino. The tomb, despite the interest of two Della Rovere cardinals, fell under a cloud. Michelangelo, for his part, was hopelessly behind schedule, and we may also suspect that he had outgrown the conception, which in the lower zone was still essentially that of 1505. The Pope, moreover, finally decided to put the great artist to work for himself – but in Florence.

The Façade of San Lorenzo

Michelangelo's old friend Pietro Soderini had been forced to resign as Gonfaloniere of Florence in the summer of 1512 when the republican government fell victim to irresistible Medici pressure. In September 1512 Giuliano de' Medici, younger brother of the future Leo X, took over Florence. With the Medici back in power Michelangelo had found it necessary to write his father in October 1512 denying that he had made anti-Medicean statements:

I have never said a single thing against them except in the way that every man did generally, as over the affair of Prato, which the stones would have talked of too, if they had known how to talk.

With the accession of Leo X the following year, Medici rule in Florence was further strengthened; in an atmosphere of Medicean dynastic

power the Pope made a triumphant return to Florence in December 1515. The lavish temporary decorations that were erected all over the city may have been in part based on Michelangelo's *Cascina* cartoon, which was perhaps cut up and distributed to the artists for this purpose. If so, it would explain its mysterious disappearance at about this time.

Leo X was determined to beautify his native city with a great monument symbolizing the family's patronage and power. He first had the idea of completing the Medici church of San Lorenzo with a magnificent façade. San Lorenzo is one of the great monuments of the Quattrocento. Begun by Filippo Brunelleschi for Cosimo de' Medici in 1421, it was the first attempt by the father of Renaissance architecture at a basilican church design [110]. Michelangelo's old friend Giuliano da Sangallo (d. October 1516) made several façade projects, and many other artists including Raphael were eager to get the commission, which was the greatest of its kind. Michelangelo was originally drawn

110. San Lorenzo, Florence, showing the unfinished façade. At right, the Medici Chapel by Michelangelo (lower dome)

into the project because of its lavish sculptural decoration. In the course of negotiations in 1516 he began to have the idea of designing the entire façade and getting the whole commission for himself.

Michelangelo's façade project was officially accepted only in 1518. but from July 1516 he was in Carrara, beginning a Tuscan sojourn that lasted some eighteen years. At first he was looking for marble for the Julius tomb, for which he had a new contract allowing him nine years to finish a project only half as large as the one of 1513. and with half as many figures. This contract of 1516 [cf. p. 169] reflects the reduced power of the Della Rovere family, and we may speculate that Michelangelo used the papal project for San Lorenzo as a lever to reduce the unwelcome load of the burdensome tomb commission. By November 1516 Michelangelo had the facade commission for himself, and before the year was out he returned to cut marble for the church rather than for the tomb. In February of 1517 we hear of marble for ten statues for the façade; in April he bought a house in Florence in which to work the marbles; and in June, foundations for the facade were underway. Leo X saw and greatly admired the final wooden model in December 1517 [111].

Michelangelo estimated that the façade would take six years and cost 35,000 ducats. He chafed at the money he was spending and worried about his losses on bad marble for the façade, which had been quarried without a contract; he urged the Pope to provide one. The fine sculptor Jacopo Sansovino (1486–1570), who at the very least wanted some of the sculpture for himself (the Pope had promised him that), and who had his own architectural model as well, was brushed aside. Sansovino's angry letter of late June 1517, accusing Michelangelo of dishonesty, egoism, malice, and slander, cannot be dismissed merely as the jealous outpourings of a defeated rival. Michelangelo chose to forget his unsavory behavior in later years: Vasari and Condivi tell us that the Pope pressed Michelangelo into service against his will. Condivi wrote that Michelanglo

was interrupted, much to his disgust, for it came into the head of Pope Leo... to ornament the façade of San Lorenzo, in Florence, with sculpture... Michelangelo made all the resistance he could, saying that he was bound [to the Della Rovere commission]... the Pope... sent for both [Della Rovere cardinals] and made them release Michelangelo... In this fashion, weeping, Michelangelo left the tomb and betook himself to Florence.

This passage is one of the best examples of the Michelangelo myth in process of creation: the great artist, virtuous and pious, diverted from honest goals by fickle and venal patrons. The facts are clearly different.

In retrospect, the San Lorenzo commission was a bad patch in the artist's life – particularly since he lost some three years quarrying marble for nothing. He could not tolerate collaboration in sculpture and had an unreasonable fear of competition. After his failures to finish even a large fraction of the tomb of Julius II he should have been happy to accept help in this, a comparable commission. But like all great men he also had self-knowledge of a different kind: he trusted himself to make a better façade than another could produce. And he knew himself to be the supreme sculptor. He even boasted that this façade would be 'the mirror of architecture and sculpture of all Italy.'

The architectural design Michelangelo produced for the façade of San Lorenzo was novel; earlier Renaissance façades had been more or less unsuccessful compromises between classical rules of architectural composition and the idiosyncratic, unclassical profile of the Christian basilica with its high central nave and lower, sloping roofs above the aisles [110]. Michelangelo finally cut this Gordian knot by designing a palace-like façade all one height [111]. The design has a careful balance of horizontal and vertical; the projecting central section with its pediment is countered by projecting bays at the ends. The wooden

111. Michelangelo, wooden model for the façade of San Lorenzo. 1519

model makes it clear that the façade was not simply a relief but truly three-dimensional, with a full bay's depth at the ends that made it a kind of narthex-façade. The design is in many respects related to the current project for the Julius tomb (see below); as in so much of Michelangelo's work, ideas developed for one commission bore fruit in the next.

Michelangelo's contract of 19 January 1518 allowed him eight years to complete the façade, but almost immediately trouble began. The Medici had insisted that Michelangelo quarry marble from Florentine territory rather than from Carrara, which caused intolerable delays – a new road had to be built through the mountains, and infinite difficulties ate up months of Michelangelo's life.

We get an idea of his troubles in 1516–20 if we remember that he was also constantly harried by renewed demands from the Della Rovere, who were perhaps spurred on by the furious Jacopo Sansovino. Michelangelo had to quarry an immense amount of marble for San Lorenzo in unfamiliar territory with poor, perhaps hostile workmen; and in addition he was under obligation to produce a new statue of *The Risen Christ* (see below). In a letter of April 1518 from the quarries of Pietrasanta he wrote:

These stonecutters I brought from down there [Florence] don't understand the first thing about quarries or marbles either. They have already cost me more than a hundred and thirty ducats and they have not yet quarried me a slab of marble that is any good, and they go about faking that they have found great things . . . I have taken on the bringing of the dead to life in wanting to tame these mountains and bring skill into this countryside . . . it eats me up to stay here in suspense . . . The boats I hired in Pisa never arrived. I think I have been hoodwinked, and that is how everything goes with me . . . Today it is a sin to do good . . .

He also had trouble with the house he wanted to build in order to work the marbles, which occasioned another cry of pain, this one sent to Cardinal Giulio de' Medici in Rome in July 1518:

They [the Cathedral Chapter] have made me pay sixty ducats more for [the land] than it is worth, showing that they know they are doing wrong, but they say they cannot deviate from what is stated in the Bull on selling that they have from the Pope. Now if the Pope makes Bulls to license stealing, I beg your most reverend lordship to have still another made for me, because I have more need than they . . .

Unlike the Sistine ceiling, all the unwelcome trouble was for nothing – the grandiose project lapsed early in 1520 with the annulment of

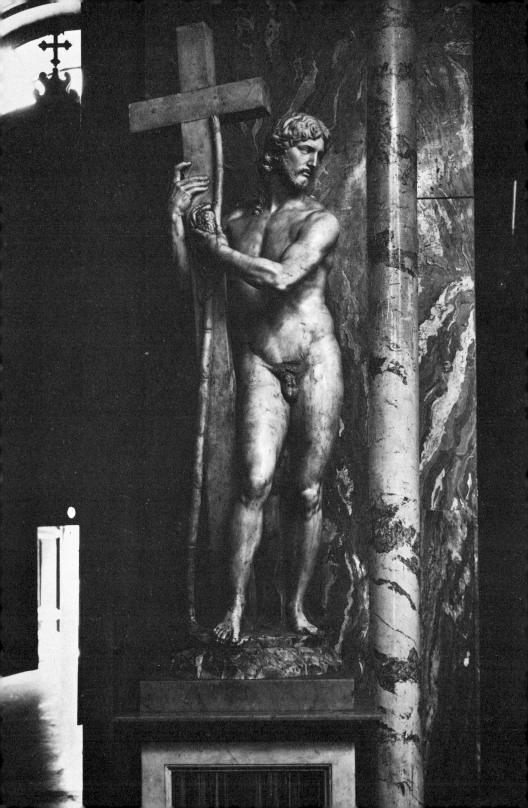

the contract, and we simply do not know why. Michelangelo was furious, writing in March of 1520 about his expenses:

I am not charging to [Pope Leo X's] account over and above the space of three years I have lost over this; I am not charging to his account the fact that I have been ruined over the said work for San Lorenzo; I am not charging to his account the enormous insult of having been brought here to execute the said work and then of having it taken away from me; and I still do not know why . . .

The Risen Christ

A letter of December 1518 mentions more troubles and the commission for *The Risen Christ*:

I'm dying of vexation through my inability to do what I want to do, owing to my ill-luck . . . a loaded boat at Pisa . . . has never appeared because it hasn't rained and the Arno is completely dried up. Another four boats are commissioned for the marbles in Pisa, which will all come loaded when it rains . . . On this account I am more disgruntled than any man on earth. I am also being pressed by Messer Metello Vari about his figure, which is likewise there in Pisa and will be in one of the first boats . . . I'm dying of anguish and seem to have become an impostor against my will.

I have an excellent workshop in preparation here, where I shall be able to erect twenty figures at a time. I cannot roof it because there is no wood here in Florence, nor likely to be any until it rains, and I don't believe it will ever rain again from now on, unless to do me some mischief.

The story of Metello Vari's figure is this: on 14 July 1514 Michelangelo had succumbed to the pressures of three Roman gentlemen to carve a nude figure of *The Risen Christ* for the Dominican church of Santa Maria sopra Minerva. When Michelangelo left Rome for Florence in 1516 he abandoned the statue, whose face was disfigured by a black vein that had appeared in the marble. The statue now in the Minerva was carved in Florence under difficult circumstances in 1519–20 and sent to Rome, almost finished, in 1521 [112]. Michelangelo's assistant Pietro Urbano saw the statue through customs, where he had difficulties 'because they wanted Christ to pay duty to enter Rome.' The statue, not easily visible in the dark Gothic church, was at first to stand in a tabernacle. Nevertheless, it is effective as a free-standing figure, with a twisting *contrapposto* pose that seems more suitable to a pagan statue. Indeed, the nature of this

Christ is ambiguous and the reasons for its total nudity are obscure. He holds instruments of his Passion, including an undersized, symbolic cross. Some of the unsuccess of the statue probably derives from its status as a copy of another work – artists rarely do so well a second time, and Michelangelo in particular was by then already more interested in concepts than in final execution.

A sketch of great interest [113] is probably for the first version, since it deals with problems of form and surface that would have been worked out before the second statue was begun, if the later work is in fact a replica of the first. The drawing exhibits Michelangelo's

113. Michelangelo, drawing for The Risen Christ

characteristic hatched technique, so similar to the mesh of chisel marks that covers his unpolished statues [cf. 136, 139]. It is an extreme example of his habit of working up a portion of the anatomy

characteristically the torso, which he found so moving a topographyand leaving the rest blank.

The coarseness of the incompetent Urbano's finishing touches reduces the impact of this unusual work. The face is bland, the hair unconvincing, the attributes finicky. Nevertheless, it is a gracefully commanding figure; Michelangelo used its general outlines in the beautiful Apollo of 1530 [153], and the rhythmic continuity of the twisting pose inspired artists for centuries. The antique motif of the arm crossing the body with the head turning the other way is already found in the Doni and Bruges Madonnas [33, 39]. Unlike these works, the Christ is constructed according to a spiralling esthetic that becomes more characteristic of his works of the 1520s, most particularly the Victory [138]. Just as in the Dying Slave [103], we see here Michelangelo's unabashed love, even hunger, for the beauty of the nude figure, which from the rear could be in every sense a pagan work. It is ultimately this conflict between pagan nude and the Man of Sorrows of Christian iconography that has placed Michelangelo's Christ in a special limbo, separate from all his other works.

By this time Michelangelo was so famous that patrons vied with each other for any kind of work from his hand. Thus in January 1519 Michelangelo learned that Francis I in Paris 'has no greater wish than to have some work, even small, of yours.' As John Shearman pointed out, 'This is the birth of the idea of a work of art made in the first instance to hold its place in a gallery.' Such requests, leaving subject, size, and medium up to the artist, become a characteristic aspect of Mannerist thought – the style of the master was wanted for display, no matter what the subject. It is a logical result of the cult of the Antique.

The Four Florentine Slaves

On 23 October 1518 one of the Della Rovere cardinals wrote asking Michelangelo about the great papal tomb. Michelangelo had been ill, but marble was ordered for two figures, one of which was desired by spring. Early in 1519 Michelangelo promised four tomb sculptures for early summer. These are evidently the famous *Prigioni – Prisoners* [115–18]. We do not know just when Michelangelo did the preliminary carving that we see on these blocks, but their conception belongs to this time. They were to be part of the new wall-tomb contract of 1516 (see p. 163), which Wilde reconstructed tentatively as

114. Wilde's sketch of the tomb project of 1516

shown in illustration II4. It was much reduced from the project of I5I3 [cf. I02], with only twenty-two figures instead of forty. The four *Slaves* are larger than those specified in the contract, which may indicate that Michelangelo went on enlarging the scale of the figures even as the total size of the tomb was reduced – just as he enlarged the later figures of the Sistine ceiling. It is unlikely that much was done on the statues in these hectic years of quarrying, but in I520 and again in I52I-3 he had time to work on the tomb, and it is probably to this period that they should be assigned. Cardinal Giulio de' Medici, the future Clement VII, saw the statues before leaving

115. Michelangelo, Young Slave. 1520-23?

Florence late in 1523 and still claimed years later to remember their attitudes.

We may well agree with John Pope-Hennessy that 'the contrast with the Louvre Slaves is so great that at first sight it might appear that Fafner and Fasolt supplanted Mars and Apollo on the front of the tomb' [cf. 103-6]. The new figures are a foot taller, far heavier, and so unfinished as to give only a rough idea of what the sculptor might have produced. Indeed, one or two of them may not actually show much of Michelangelo's carving – some of the work is rough, unformed chiseling done by an assistant. The most finished, the

Young Slave [115], was perhaps the first begun and shows affinities with the earlier Dying Slave [103]. Like the others it is carved out of a deeper block, characteristic of Michelangelo's practice in the 1520s. He was becoming more concerned with internal modeling than in his earlier works, and less dependent on silhouette. Two of the Florentine Slaves were in part carved back from the narrow face of the block, allowing the exploration of movement in depth that he had begun with the Rebellious Slave [105]. The Florentine Slaves are also much more architectural than the earlier figures. They seem to have been conceived as carriers of real weight rather than as ornamental symbols posed in front of an architectural background. The word prigione

116. Michelangelo, Atlas. 1520-23?

could mean, in the Cinquecento, a caryatid or atlas, and this explains the popular name. That aspect is particularly clear in the *Atlas* [116], obviously a corner figure, which is poignant in its burial in the block but also revealing of Michelangelo's great anatomical skill and power in the more highly worked parts of the torso. Michelangelo worked this block in from the corner – again showing his desire for a frontal view, since the statue was to be on a corner of the tomb. By this method he could achieve a figure that, when finished, would be effective around a wide arc. The *Awakening Slave* [117] is still immersed in the block and seems to be a perfect illustration of Vasari's description of Michelangelo's technique (see p. 94). Again, this is a corner figure

117. Michelangelo, Awakening Slave. 1520-23?

worked from one angle of the block, which becomes therefore the chief view. The *Bearded Slave*, quite fully worked [118], shows less of Michelangelo's personal intervention than most of the others and may indicate a later phase when all but the finishing work was done by assistants.

The Florentine *Slaves*, truly imprisoned in their blocks of stone, have led romantics to see in them much more than is actually there. Indeed, one of the secrets of later artists like Rembrandt is to show something, but to hint at much more, leaving the imagination of the viewer to supply a spiritual content, to identify with the person or scene in a way he could not do in surgically lit and defined surroundings. Like Leonardo, Michelangelo always seems to have been more

118. Michelangelo, Bearded Slave. 1520-23?

attracted by a new challenge or idea than by actually finishing what he had begun – even the *Madonna of the Steps*, his earliest surviving work, is unfinished [9]. Perhaps too he eventually did fall in love with the mere process of revealing, of gradually uncovering his figures, and he may slowly have begun to feel the attraction of the potential and unrealized – of Becoming as opposed to Being (cf. pp. 260–61). But in 1520, when he was beginning to work these *Prisoners*, he would not have dreamed that the half-begun blocks were in any sense finished. They do afford an unparalleled opportunity to distinguish the crude blocking and shaping of an assistant from the miraculous web of chisel marks that define and shape the areas Michelangelo himself worked up. And they offer us, however spuriously, an idea of what it was like to be a great sculptor, slowly revealing the forms that he had already imagined inhabiting the rude stone.

A passage in a letter of July 1523 – when he was presumably working on the tomb – may explain why so little was done: 'I have an obligation but I'm old and unwell, so that if I work one day I have to rest four . . .' But Michelangelo was always over-dramatizing his disabilities, and the man known to Benvenuto Cellini in these Florentine years was neither old nor feeble. According to Cellini, Michelangelo fell in love with the singing of one Luigi Pulci, who later became a poet and Latin scholar:

When this Luigi had been a boy in Florence it used to be the custom on summer evenings to gather together in the streets; and on those occasions, he used to sing, improvising all the time, among the very best voices. His singing was so lovely that Michelangelo Buonarroti, that superb sculptor and painter, used to rush along for the pleasure of hearing him whenever he knew where he was performing. A goldsmith . . . and I myself used to accompany him.

Michelangelo himself explained this aspect of his personality, which has been too often misunderstood or neglected:

I am a man more inclined than anyone who ever lived to care for people. Whenever I see anyone possessed of some gift which shows him to be more apt in the performance or expression of anything than others, I become, perforce, enamored of him and am constrained to abandon myself to him in such a way that I am no longer my own, but wholly his.

Although these words were put into Michelangelo's mouth by Donato Giannotti many years later, they seem to express with precision the ultra-sensitive temper of his mind, which consequently needed the protection of an increasingly hard-shelled exterior.

119. Filippo Brunelleschi, Old Sacristy of San Lorenzo, Florence: interior.1421 ff.

III Medicean Florence with a Republican Interlude 1519–34

7 The Medici Tombs and the Victory

Michelangelo's greatest sculptural ensemble is not the tomb of Julius II, which limped to its miserable completion in the 1540s, but the decoration of the so-called New Sacristy of San Lorenzo, more properly the Medici funerary chapel. Brunelleschi had built a sacristy off the left transept of the church whose elegance of proportion and clarity of form make it an Early Renaissance jewel [119]. In May of 1519 the idea was broached to build Medici tombs in a new pendant to this sacristy on the other side, and in November of that year demolition began on the site. The architecture was at first to follow Brunelleschi's example, but Michelangelo was himself becoming involved with architectural design and, as it was finished, the Chapel – and even more the Library that was commissioned soon after – is a characteristic example of a new kind of architectural vision that we can only call Michelangelesque. The architecture will be discussed in Chapter 8.

Construction of the new Chapel was underway before the tombs inside were planned. Michelangelo's first design was submitted to

Cardinal Giulio de' Medici in November 1520. It was for a free-standing tomb for four members of the family: Lorenzo il Magnifico and his brother Giuliano (murdered in 1478), who were referred to as the Magnifici; and two recently dead Medici dukes (Capitani), who, leaving no legitimate male issue, ended the dreams of a Medici dynasty. They were Giuliano, Duke of Nemours by marriage, who had died in 1516, aged thirty-eight, and Lorenzo, Duke of Urbino, who died aged twenty-eight in 1519. Lorenzo left only the month-old Catherine. future Queen of France. As plans progressed, the centralized tomb design quickly got so large as to be cumbersome in the small space and was abandoned in favor of wall tombs. Edgar Wind suggested that Cardinal Giulio planned from the first to be buried in the Chapel, and that the first wall designs were for two double tombs and one single tomb for the Cardinal, but this is not clear from the evidence [121, 122]. When he became Pope in 1523, in any event, Giulio de' Medici could no longer be included in the scheme, which was then modified as two opposing single tombs for the Capitani on the side walls, and one double tomb for the Magnifici opposite the altar [120, 143]. We know that something approaching the final design was achieved by April of 1521, since Michelangelo was in Carrara to supervise quarrying the marble for the statues. The membering of the pietra serena order on the ground floor of the interior was already begun late in 1520. This preliminary work progressed apace until December 1521, when Leo X died.

Although quarrying continued in 1522-3, the Chapel was delayed during the reign of the severe Dutch Pope Hadrian VI, a Counter-Reformatory figure avant la lettre. (When he was shown the Laocoön and other antiquities in the Vatican Belvedere as wonderful and excellent things, he said 'Those are the idols of the ancients.') During this interval we have supposed Michelangelo to have been working on the Julius tomb project of 1516: not only the four *Prisoners* [115–18] (p. 169), but also perhaps doing preliminary work on the Victory [138] (p. 202). Hadrian died, just possibly by poison, on 19 September 1523 - and none too soon for the Romans. In November, Cardinal Giulio de' Medici, illegitimate son of the murdered Giuliano, was elected, to everyone's great relief, as Pope Clement VII. Michelangelo was now under heavy pressure not only to continue the Chapel but also to work on the tomb. The Della Rovere even threatened to sue the artist, and the new Pope tried to secure Michelangelo's total services by putting him on salary. Michelangelo was so harried and worried by the tomb obligation that he drew this salary only sporadically in these years: he had a great sense of honor and personal honesty. It is often hard to distinguish between Michelangelo's justifiable pride

and sense of duty, and his undoubtedly neurotic reactions to many situations. Indeed, he constantly refers to his strange mental states. In a letter of January 1524 he wrote:

no one has ever had dealings with me. I mean workmen, for whom I have not wholeheartedly done my best. Yet because they say they find me in some way strange and obsessed, which harms no one but myself, they presume to speak ill of me and abuse me; which is the reward of all honest men.

His continual depression is clear from a letter to Sebastiano in Rome of May 1525:

Last night our friend Captain Cuio and certain other gentlemen, in their courtesy, wished me to go with them to dinner, from which I had the greatest pleasure, because I came out of my melancholy a bit, or rather out of my madness, and I not only enjoyed the dinner, which was very pleasant, but also, and much more than that, the discussions that took place . . .

120. Michelangelo, Medici Chapel, San Lorenzo, Florence: interior showing the altar and tomb of Giuliano de' Medici. 1519–33

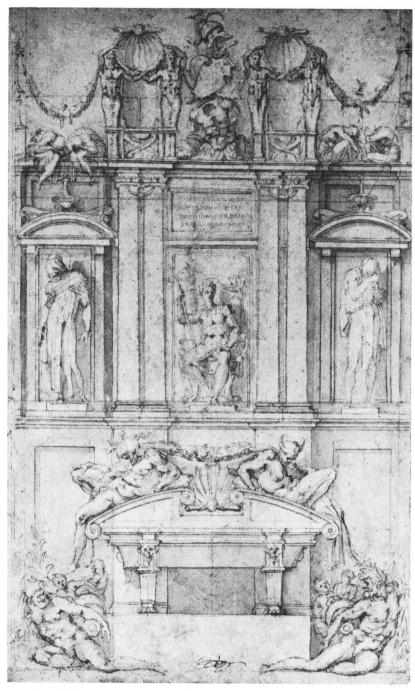

121. After Michelangelo, drawing for a Medici tomb

A letter of April 1523 mentions that Michelangelo offered to make full-sized models of the tombs and 'put in them all the figures of clav and wool shearings, in size and finish exactly as they would have to be. This was eventually done because Michelangelo counted on the help of many assistants, who would need the guidance of models. They were executed in mid-1524, since with the election of Clement VII work had started up again - the lantern of the dome was finished by January 1524 [cf. 110]. But all the marble had not arrived since Michelangelo increased the size of the figures and ordered new marble for them in 1523. Such changes were, as we have seen, typical of the evolution of his designs, which tend to begin as complex groupings of smaller figures and then evolve into simpler combinations of larger, more expansive, less specific forms. By 24 October 1525, however, four figures for the Chapel were well begun. In the spring of 1526 one of the Capitani and all four of the sarcophagus figures were on the way. 'and in two weeks I shall have the other Captain begun.' Since the double tomb was never built, and only the Madonna was carved by the master, we thus have notice of most of the figures by 1524-6; but work limped on for years owing to wartime interruptions.

The tombs are marble wall decorations of three bays over a basement, before which stand the sarcophagi [120]. The marble contrasts with the gray pietra serena of the architectural membering, which is essentially a copy of Brunelleschi's great example [119]. A drawing [121] shows that the upper parts of the tombs were to have been developed as thrones, which were part of an elaborate iconographic scheme including relief sculptures in the lunettes above [120], all of which was gradually abandoned. In 1526 Michelangelo announced that he was himself going to carve only what we now see plus the four Rivers; in the 1530s he gave up the rest as, gradually, a combination of external circumstances and his own impatience led him to lose interest in the Chapel. Nevertheless, we do have the essential elements of what Michelangelo hoped to carve. He left a large number of drawings, some of them with cryptic, semi-poetic jottings, which help us to follow the progress both of the design itself and of the changing concepts underlying it. One of the early drawings, probably 1520–21, shows the double tomb, presumably of the Magnifici, with a Madonna in the center. The inscription says 'Fame holds the epitaphs,' and we see such a sketchy figure in the drawing [122]. An explicit iconography of Fame with inscriptions was dropped, but the idea seems to have been basic to the entire concept. These tombs were always meant as honorific monuments, although for us they preserve the fame of Michelangelo more effectively than that of the Medici.

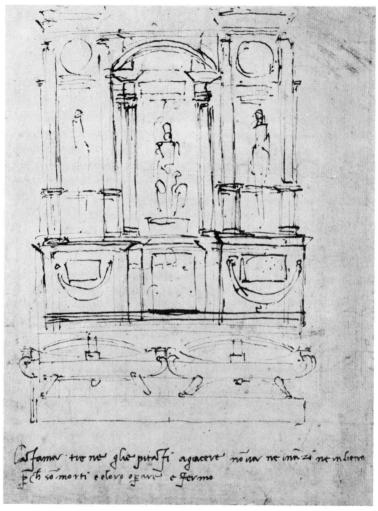

122. Michelangelo, sketch for a double tomb. 1520-21

The two single tombs that were built are almost identical [cf. 143]. In the central niches we see seated figures of consummate grace and elegance – Giuliano and Lorenzo – without any identification whatsoever [125, 126]. Michelangelo imagined them not as dead men, or Christian, but alive and clad in antique armor. This is only the most obvious novelty in these staggeringly original and iconoclastic tombs. Below, at our eye level, strange sarcophagi with curved lids defined by volutes support pairs of figures, male and female. These unusual tombs with their figures may be explained by a later 'quotation' from Michel-

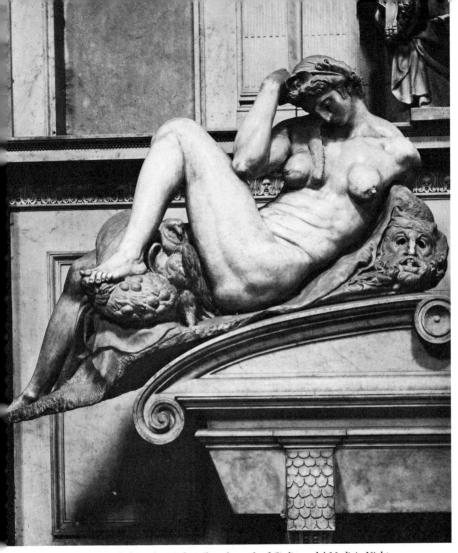

123. Michelangelo, Medici Chapel, tomb of Giuliano de' Medici: Night

angelo. In the later 1540s his friend Donato Giannotti (1492–1573) wrote a curious *Dialogue*, in which Michelangelo is the chief speaker. The subject is 'How many days Dante spent in Hell,' and in its course Giannotti makes Michelangelo quote Dante on the subject of time: once he quotes the prose *Convivio*, which had been printed in Florence in 1490. Toward the end of the *Convivio*, as Creighton Gilbert has pointed out, 'Dante describes life as being an arc that rises and then falls and has four segments, the four ages of man, the four seasons, the four times of day.' Although drawings prove that Michelangelo had other

ideas for the sarcophagi before he settled on the novel lids, some such memory may have played a part in his choice.

The sarcophagus figures are similar to spandrel figures in ancient sculpture, and are closely related to several in the Sistine Chapel [80, 86]. But they may also be distant reflections of Etruscan funerary urns with figures above, which Michelangelo would have known. Only one of these figures has iconographic adjuncts, a beautifully reclining woman who has evidently borne children, surrounded by symbols of night: a crescent moon, an owl, a mask, and perhaps a bunch of poppies [123]. We learn from Condivi that still another symbol was planned for one of these figures: a mouse,

because this little animal gnaws and consumes, just as Time devours all things. [Michelangelo] left a piece of marble on the work for it, which he did not carve . . .

The general significance of the *Night*, and of the *Times of Day* as a group, seems to be clarified by this uncarved mouse, which makes us think of Bernini and Baroque imagery. As Gilbert has argued, 'it is a version of the truth stated in Petrarch's *Triumphs*, that death yields to the triumph of fame but then fame yields to the triumph of time.' Certainly man's mortal life soon succumbs to the gnawing of time, and this is the simplest explanation of the statues and of the mouse.

The program is further elucidated by another jotting on a drawing of c. 1524 [124]. Above, Michelangelo wrote:

Heaven and Earth

and in fact an exultant Heaven and a mourning Earth were planned as flanking figures in the middle register of Giuliano's tomb [cf. 121]. The inscription goes on to say:

Day and Night speak, and say: We with our swift course have brought the Duke Giuliano to death . . .

Since two *Rivers* were planned to lie below each sarcophagus, it seems clear that the earth and the dismal passage of time on it were to be represented around the mortal remains of the *Capitani*; above, their statues were to be flanked by mourning figures of cosmic significance. (Vasari thought that the meaning of the subsidiary figures was 'that earth [terra] alone did not suffice to give them an honorable burial worthy of their greatness but that they should be accompanied by all the parts of the world.') The note on the drawing continues:

It is only just that the Duke takes revenge as he does for this, and the revenge is this, that, as we [Day and Night] have killed him, he, dead, has taken the light from us; and with his closed eyes has locked

124. Michelangelo, drawing of molding with inscription relating to the tomb of Giuliano de' Medici. c.~1524

ours shut, which no longer shine on earth. What then would he have done with us while alive?

The last line is not easy to interpret, but it seems to mean that if the Duke could blind *Day* and *Night* after death, in life he could have done much more. All the figures have blind eyes – that is, are without carved pupils. In Michelangelo's finished works like the Dukes and the *Dawn* [125, 126, 131], the lack of carved pupils is unique; the inscription may explain this oddity. But the two Dukes do turn their heads as if to look – according to older theories, toward the *Madonna*

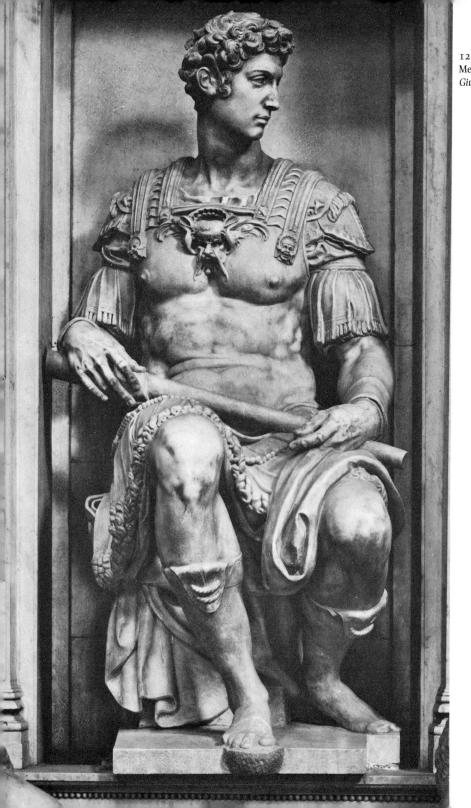

125. Michelang Medici Chapel: Giuliano de' Med

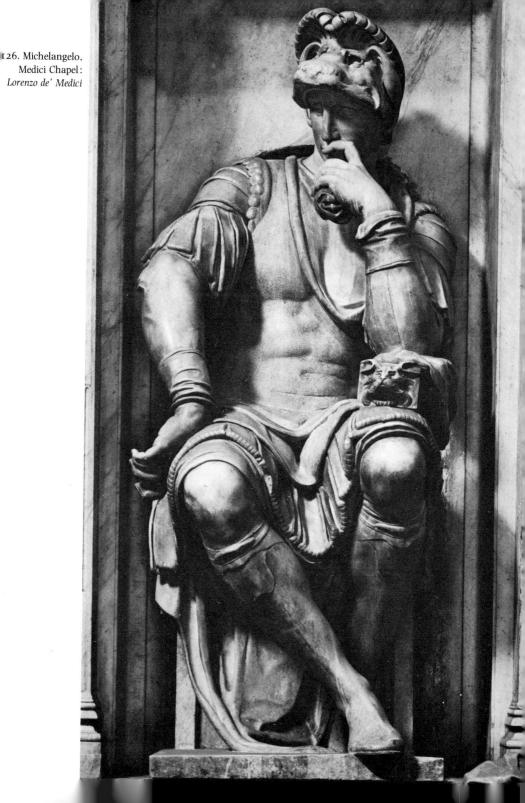

of the unfinished double tomb opposite the altar. If that were true, Michelangelo would surely have given them eyes to see her. Rather, as Gilbert pointed out, they seem to look toward the original entrance to the Chapel, as if hearing our approach, and 'look' at the intruders in their mortuary chapel with the sightless eyes of the dead. Again we seem to be in the world of Bernini.

Many writers have supposed that Michelangelo did not gladly participate in the task of honoring these two mediocre members of the increasingly degenerate Medici family. But we forget the general adulation that was then due to a ruler, and perhaps too we forget the gratitude that Michelangelo still bore toward Lorenzo il Magnifico. Michelangelo later replied to a questioner, who commented that the Captains were not good portraits: 'No one will know how they looked in a thousand years.' But this, far from denigrating them, refers to their idealization, which gave them 'a greatness, a proportion, a decorum, that he felt would bring them more praise.' In their own time, moreover, the two Capitani were quite special: Giuliano is one of the figures in Baldassare Castiglione's Courtier, where he is commended for his liberality. Machiavelli's Prince was dedicated to Lorenzo in the hope that he would use it to unify Italy. This sounds ridiculous in retrospect, but with a Medici on the papal throne, and two young Medici generals ruling in central Italy, all Florence hoped for an end of foreign domination in the peninsula and many looked forward to a new unity under the Florentine aegis. This is the atmosphere in which The Prince was written in 1513, and it is with this in mind that, after their premature deaths, we should understand the Pope's desire to commemorate his dashed hopes for a Medici dynasty. Hearing of the death of Lorenzo in 1519, Leo X said: 'Henceforward we belong no more to the house of Medici. but to the house of God.'

The two *Capitani* are contrasted types. Giuliano [125] is represented in fanciful, skin-tight antique armor with a general's baton, holding coins in his left hand, perhaps referring to the liberality Castiglione praised. His head is erect, looking sharply to his left on a long neck. The pose owes something to the *Moses* [107]. (The characterization would seem more appropriate for Lorenzo, and there is even the faint possibility that they got confused, but according to Vasari Michelangelo set the two *Capitani* in their niches before leaving for Rome in 1534, and we surely have them right.) Lorenzo, opposite, seems sunk in thought, his left elbow on a moneybox carved with a grotesque head [126]. The pose is lax and strange, the left foot partially supporting the right, the right hand held palm outward, the left holding a pouch as it supports the head. In the slanting light that falls from above, Lorenzo's face is shadowed by a fantastic zoomorphic head-

127. Michelangelo, Ideal Head

dress. Perhaps the whole pose was influenced by the fact that he died insane. A similar idealized male head with fantastic headdress is found on a sheet at Oxford [127]. Such helmets were known in Etruscan art. Lorenzo's head, like the rest of him, is less highly finished than Giuliano's.

These two figures, in their contrasts of pose and demeanor, have tempted writers to interpret them as the active and contemplative life. Some such idea is implicit, since Michelangelo wanted to differentiate them strongly. Pairs of this kind run through Michelangelo's work like a leitmotiv, ending with a true Active and Contemplative pair on the Julius tomb [175]. As with so many of Michelangelo's

figures, the expressiveness of the conception, the breathtakingly evocative carving, the finish of the details, lead us to make verbal or intellectual interpretations that are often unwarranted.

Below Giuliano are the famous Night and Day - perhaps appropriately positive times to correspond with Giuliano's alert pose: the passive Lorenzo has Dusk and Dawn. Night and Day are not carved to fit the sarcophagus lids as their opposites are; for this reason they are clearly a pair and were surely blocked out first [123, 128]. Night and Day may have flat bottoms because they were originally quarried to surmount two separate sarcophagi of the abandoned double tomb. But Eugenio Battisti has shown that the design of the lids of the Giuliano tomb itself was changed in mid-1524; the marble for Night and Day was evidently blocked out before this time. (As carved, however, they reflect their present positions.) Night wears a diadem of moon and star, her head resting on her right hand in a pose of supreme

128. Michelangelo, Medici Chapel, tomb of Giuliano de' Medici: Day

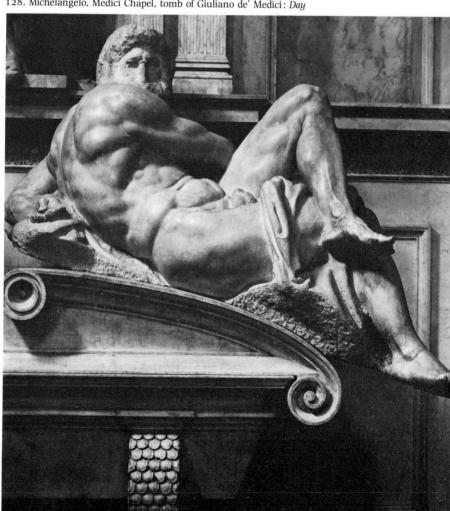

elegance. The unpolished contours of the face [129] already show the triangular tendency of the *Victory* [138], of which this is the more finished and particularized female version. Michelangelo was obsessed by tactile form, and this timeless image is perhaps the most hauntingly evocative figure in Western art. Such a statue, beautiful in pose and head, also offers us more than a hint of Michelangelo's lack of sensual feeling for the female body (see p. 231). Her breasts, used and spent, become unwanted appendages, attached in an unanatomical fashion, and betraying Michelangelo's lack of interest in or even familiarity with the female nude. Nevertheless, the statue seems to betray unconscious associations that many men have had in relating women to night, darkness, and death. James Joyce expresses the same ideas early in *Ulysses*:

. . . underdarkneath the night: mouth south: tomb womb.

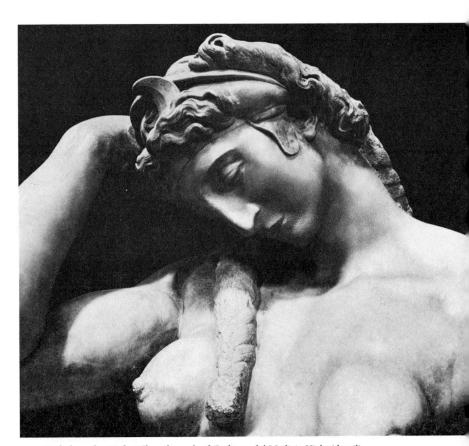

129. Michelangelo, Medici Chapel, tomb of Giuliano de' Medici: Night (detail)

Michelangelo's *Night* is a kind of petrified association hinting at sexual fears and inadequacies. The owl is so situated that one might think of it as newborn, and the generative pose is confirmed by the statue's antique source, a copulating *Leda* (cf. illustration 150 and p. 223). The poppies and mask represent Sleep and Death, which were considered the children of Night. Vasari says that

in her may be seen not only the stillness of one who is sleeping but also the grief and melancholy of one who has lost something great and noble . . . In this statue Michelangelo expressed the very essence of sleep. And in its honor various erudite people wrote many . . . verses and rhymes . . . of which the following . . . is an example:

The Night that you see in such loveliness, Sleeping, was carved by an angel In this rock, and since she sleeps, has life; Wake her, if you disbelieve, and she will speak to you.

To this, speaking in the person of Night, Michelangelo replied:

I prize my sleep, and more my being stone, As long as hurt and shamefulness endure. I call it lucky not to see or hear; So do not waken me, keep your voice down!

Michelangelo's poem, written in Rome c. 1545, may refer to the Duchy under Cosimo I de' Medici and seems to substitute a new political meaning for the originally temporal significance of the *Times of Day* (see p. 263).

The figure of Day is another version of the Torso Belvedere [128: cf. 70], and, like all of the figures, has relatives on the Sistine ceiling. The pose is extraordinary: left arm underneath, right crossing to reveal the muscular back, legs crossed in the opposite way, and above all this the unusually expressive head, only blocked out. At this point Michelangelo seems to have given up subsidiary iconographic symbols and simply carved a marvelously powerful figure, but one bound up in himself, like some of the later Sistine ignudi, or like a *Prisoner* of the Julius tomb [103, 105]. The prison is not only the pose but the state of petrification – as Michelangelo's own note reveals. The Capitani are effigies, dead men honored by memorial statues. The Times of Day are rather, as Pope-Hennessy expressed it, 'living figures turned to stone.' But this still does not quite express the full force of the paradox, for we feel strongly that Michelangelo deliberately kept the head of Day in its inchoate state - vastly unlike a petrified man because he found it more expressive. In a later poem, Michelangelo shows that the mere process of carving had a fascination for him

(p. 260). And he could even point to a passage in Pliny that states that the last works of artists and the pictures left unfinished at their death are valued more than any of their finished paintings – the reason being 'that in these we see traces of the design and the original conception of the artists, and sorrow for the hand that perished at its work.' Michelangelo must have known this passage, and it confirmed his growing reluctance to finish his sculptures, particularly the faces, which seemed somehow reduced when polished, shallower than the unfinished forms. Perhaps for this reason he seems also to have recarved the face of *Night*, leaving chisel marks [129]. These sculptural and spiritual considerations make us distrust too literal an interpretation of the program – although the image of Day failing to materialize because of the death of the Duke is a possible contemporary idea.

The figures below *Lorenzo* [130, 131] represent *Dusk* and *Dawn* (*Evening* and *Morning*). By contrast to their opposing companions they are basically mirror-images, and recline securely, tilted toward us, their lower curvatures accommodated to the lids. *Dusk*, relatively finished apart from the head, is represented as a brooding man of middle age, less evocative by far than *Day*, and not least because of its higher finish in the face. *Dawn* is a beautiful, potentially sensual maiden, rousing herself from a deeply troubled sleep. The women, including their faces, are highly finished, the men less so. Michelangelo may have found it easier to finish female faces because they had for him less emotional charge (see p. 231).

How this ensemble would have looked in the symphonic surroundings desired in illustration 121, we can hardly imagine. One of the characteristics of Michelangelo's development as an artist is a constant simplification of means, a reduction in ornament and detail, together with increased importance given to single figures or architectural members. We need not regret the drastic simplification of program, since the subsidiary elements would not have been carved by Michelangelo. Nor was he a Bernini, who could drive or cajole lesser artists into producing figures more or less equal to his own. The two statues of Cosmas and Damian produced for the tomb of the Magnifici are witnesses to that, as are the figures in the upper register of the Julius tomb [174]. But the architectural carving is supremely beautiful, astounding in its economy. Both tombs are decorated above with urns, that of Lorenzo with dolphins [143]. Most extraordinary, the pseudo-antique reliefs at the end of the sarcophagi make their dryly elegant statement on a perfect plane. The relief of masks running below the lower cornice of the tombs is no mechanical yardage of

130. Michelangelo, Medici Chapel, tomb of Lorenzo de' Medici: Dusk

131. Michelangelo, Medici Chapel, tomb of Lorenzo de' Medici: Dawn

132. Michelangelo, Medici Chapel: frieze of masks

carving but a miraculous series of inventive and surprising variations on the theme [132]. We know that this was at least in part carved by Francesco da Sangallo to Michelangelo's design; he failed in some way to please the master and found Michelangelo's sour looks and avoidance – a characteristic response – unbearable. In many of the architectural details we seem to discover an exuberance in the presumably earlier Lorenzo tomb that changes into grander and simplified forms in that of Giuliano.

The Medici Madonna

In addition to the tombs of the *Capitani*, Michelangelo began to carve a *Madonna* for the double tomb of the *Magnifici* [133]. In April of 1521 he had already ordered the block for the *Madonna* 'according to the drawing.' The conception of 1521 was, however, radically altered in succeeding years. This extraordinary work completes the series of Michelangelo's sculptural Madonnas, which began with the tiny *Madonna of the Steps* [9]. The Medici figure is not precisely a *Madonna lactans*, but the Christ child twists around – and how athletically! – to engage his mother. He thus presents his back to us (and to the priest behind the altar), a daring but not unprecedented composition [cf. 9]. The early drawings for the double tomb in which the *Madonna* was to

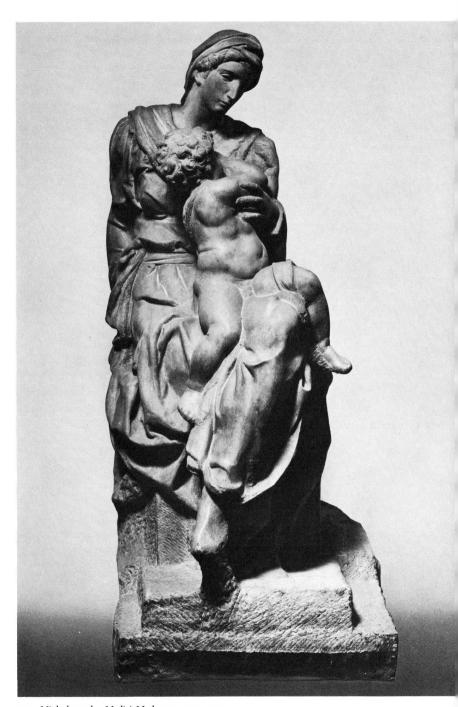

133. Michelangelo, Medici Madonna. 1521–34

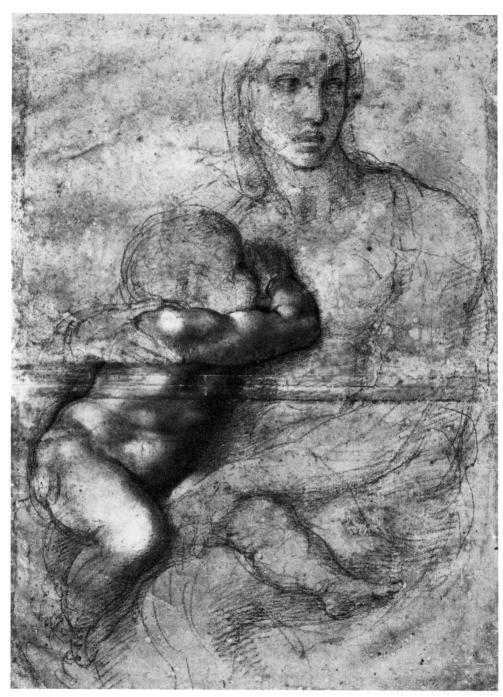

134. Michelangelo, cartoon of a Madonna

sit show a composition similar to the *Bruges Madonna* [39, 122]. A number of drawings of the 1520s show Michelangelo's renewed fascination with the theme, with ever more active children. One, an enormous cartoon, shows a nursing child, highly finished, with a sketchy, perhaps apprehensive Madonna [134]. The straddling child of the *Medici Madonna* recalls the *Taddei tondo* [37] and again reveals the continuity of motif that we find running through Michelangelo's works. He

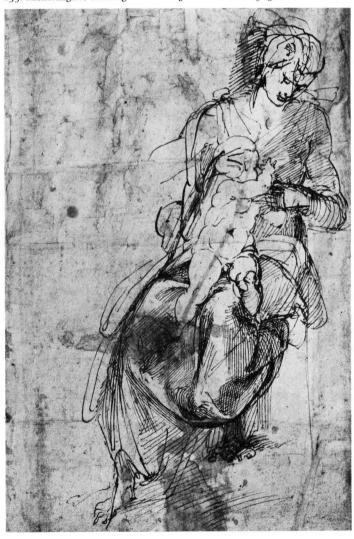

spent his life on variations of a limited number of themes. The impossible twist of the Christ – his left arm is far to the right of the other – is a development from the active figures he had already carved and painted [9, 76, 105]. An earlier drawing, in Vienna, possibly a study for the *Bruges Madonna* [135], already shows in his sketchy style of that period the twisting form of the child and the slanted head of the *Medici Madonna*. The sculpture emphasizes the contrasts between the gyrating child at the center of the composition and the calmer countermovement of his mother.

The Madonna, tall and elegant, supports the child on crossed legs, an antique – but, in this context, daring – motif. The brooding beauty of the Madonna again recalls the sense of foreknowledge that we have

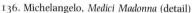

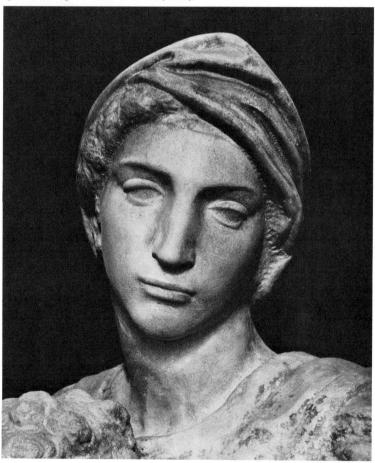

found in the earlier Madonna compositions. Unlike them, Michelangelo has now left behind the girlish Florentine types of his youth and participates in a newly elegant stylishness that is called, as a stylistic current of this time, Mannerism (cf. p. 204). Mary's head is a handsome, rather masculine expansion of the feminine ideal found in *Night* and *Dawn* [129, 131]. Her face offers an unusually fascinating example of the penultimate layer of stone with its network of chisel marks [136]. The effect is like a face covered and blunted by very fine scar-tissue, a veil lying over the beautiful features. Vasari, recognizing what we do, wrote in 1550:

Although this statue remained unfinished, having been roughed out and left showing the marks of the chisel, in the imperfect block one can recognize the perfection of the completed work.

This is a statement of great historical importance, since it is the first printed record of the beginning of a positive attitude toward Michelangelo's unfinished statuary – one that became more or less standard by the nineteenth century. The next step, which also came in the Cinquecento, was to value the unfinished statues even more than the finished, because they showed the great artist's idea in the process of finding objective form. This attitude is corollary to another one expressed by Vasari, that artists' rough sketches often have more interest than their finished works, because they show the mind of the creator at work. And Ernst Kris pointed out that a late-sixteenth-century Florentine guidebook already expresses the opinion that Michelangelo's unfinished *Prisoners*

are even more admirable than his finished statues because they are nearer to the state of conception. It is not difficult to formulate this esthetic attitude in psychological terms. The work of art is – for the first time in European history – considered as a projection of an inner image. It is not its proximity to reality that proves its value but its nearness to the artist's psychic life . . . Here is the beginning of the development which culminates in the attempts of expressionism and surrealism to make art a mirror of the artist's conscious or unconscious.

The *Madonna* was to be the focal point in the tomb of the *Magnifici* opposite the priest, who, unusually, stands behind the altar of the Chapel. In 1532 the Pope issued a Bull charging two priests to make almost continual intercession for the Medici, living and dead, and to read at least four masses every morning for the *Capitani*. The Chapel was dedicated to the Resurrection, and we must not forget the basic religious meaning of the commemorative art works it contains. Early in the 1530s Michelangelo made a number of drawings of the Resurrection.

rected Christ, conceivably for a projected altarpiece or fresco in the Chapel [158].

Very little can have been done in the Chapel during the troubled years 1527–30 (see Chapter 9). Whereas one tomb was all but assembled in 1526, the other (of Giuliano?) was put together only in 1531–3. A great deal was done in 1531 – letters from Sebastiano comment on Michelangelo's progress and the Pope's pleasure. A letter written by a friend of Michelangelo's in September 1531 records the following:

I had not seen Michelangelo . . . for some months, as I had stayed at home through fear of the plague. During the last three weeks he has twice come in the evening to visit me at home for a little relaxation . . . After much discussion of art, I had still not seen the two female figures, but I did so the other day. They are indeed marvelous. I know that you saw the first, the figure of Night, with the moon on its head and the owl; the second surpasses it in beauty in every respect, and is a marvelous thing. At present he has been finishing one of the old men . . .

The double tomb of the *Magnifici* was begun only in August 1533, and its architecture was left totally unfinished when Michelangelo left Florence for good in September 1534. The *Madonna* was found in Michelangelo's house years later. The other statues were left strewn about the floor of the Chapel; the tombs were assembled by Michelangelo's followers, and the public admitted, only in 1545. As in other commissions, Michelangelo evidently tired of the process of finishing and reducing a once grandiose project to something less than he had originally conceived.

The Statue of Victory

During his last Florentine sojourn Michelangelo also produced another statue for the Julius tomb, the *Victory* [138]. In order to understand this figure we must recall that from the beginning the bound *Slaves* on plinths were to alternate with other figures, perhaps Virtues, in the niches between [47]. We have reason to believe that this scheme prevailed until the contract of 1516; Michelangelo had probably made a model or drawing of a Virtue that was later used by Bartolommeo Ammannati (1511–92) as the basis for a marble group of *Victory*, carved about 1540 [137]. Ammannati's group shows a draped female in a rather stilted pose, standing on a crouching figure. Although gauche in comparison to what Michelangelo might have carved, it

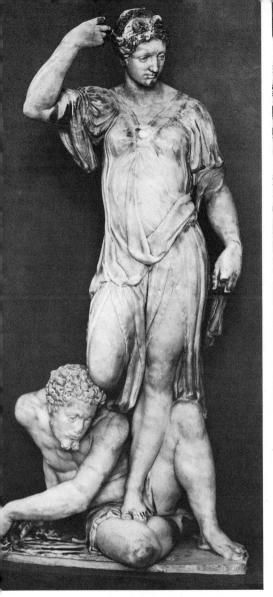

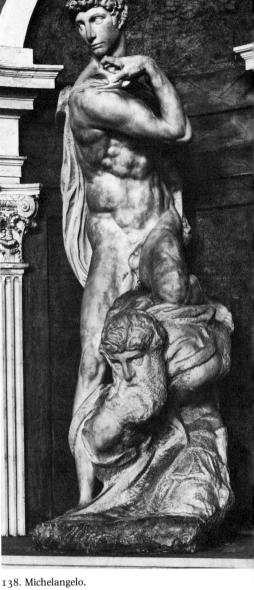

137. Bartolommeo Ammannati, *Victory. c.* 1540

138. Michelangelo, *Victory*. 1527–30?

probably gives an idea of Michelangelo's early conception for these groups as well as documenting the mid-century use of Michelangelo's ideas by other artists for self-contained, often elegant monuments.

In the meantime, however, Michelangelo evolved a somewhat different iconography, and at some point – perhaps chiefly in 1527–30 – came close to finishing his own, male version of the theme [138].

Once again the statue must be understood as a niche figure, and one of a pair. It is a composition of spiraling, almost contorted verticality. The beautiful, languidly sensual youth rests his left leg on the back of the miserable victim. Whether the latter represents vice, deceit, or heresy we do not know; but the rough features are not unlike Michelangelo's own and we may have here one of those increasingly ironic self-references that people his later work. Like the *Slaves*, the block has been worked back from the narrow side, with greater interest in torsion and depth than ever before. The powerful twist of *Victory*'s body to our right is countered by an even greater thrust of the head and shoulder to our left, neutralizing the spiraling tendencies of the group into a tense, somewhat uncomfortable dynamic balance, devoid of peace or repose. Late in the century, G. P. Lomazzo wrote that

Michelangelo once gave this advice to his pupil Marco da Siena, that one should always make the figure pyramidal, serpentine, and multiplied by one, two, or three.

The lithe, powerful torso with its rippling musculature contrasts with the beautifully impassive face [139]. There we see perhaps the best example of Michelangelo's final carving, left unpolished. His toothed chisel leaves a miraculous web of grooves and ridges, defining and shaping the highly idealized form. We can be forgiven for seeing in the group some private meaning, such as Michelangelo enchained by love or beauty:

L'amor mi prende, e la beltà mi lega.

But the temptation to be more specific – to identify the youth with the handsome Tommaso de' Cavalieri, Michelangelo's beloved friend of the 1530s, must be rejected. *Victory* surely dates from before their first meeting, which took place late in 1532.

Victory is Michelangelo's clearest statement in statuary of an ideal that became basic for artists whom we call Mannerists – the beautiful serpentine figure, existing for its own sake, exercising its limbs from purely esthetic motives, pyramidally composed with flame-like proportions. Shearman has cleverly called Mannerism 'the stylish style,' and we have found germs of it at least as early as The Battle of Cascina [43], where the forms were shown in extremes of torsion, extension, and contraction – not so as to unfold a dramatic event or to further our understanding of the scene but for their own sake (see Leonardo's comments, p. 84). This stylistic tendency cropped up again in some of the later figures of the Sistine ceiling – the nude above and to the right of the Libyan Sibyl is even a kind of prototype for the Victory [74]. The Victory solidifies and, for Michelangelo, ends this particular

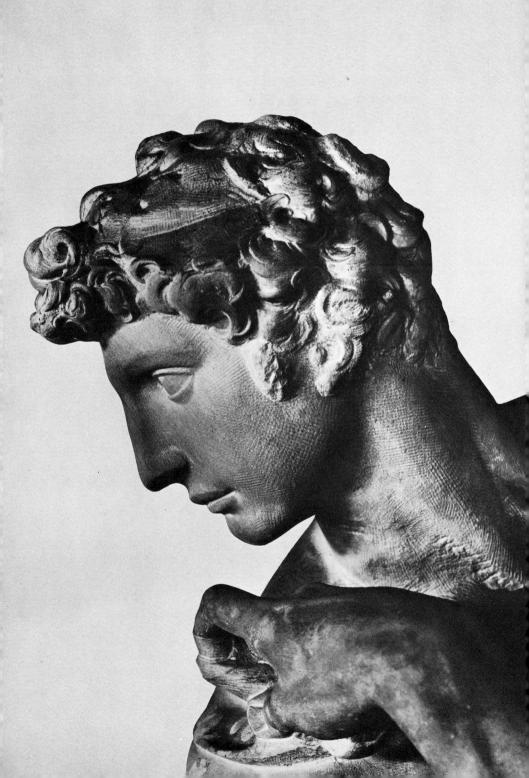

development. But we now see the group alone in the Palazzo Vecchio, instead of as part of a populous monument honoring Pope Julius, and its very isolation – typically, the work of a later generation – is part of its Mannerism.

We are not sure what the figure was like that was to have been paired with the *Victory* on the lower façade of the tomb. The most reasonable assumption is that it is reflected in Vincenzo Danti's *Honor Triumphant over Falsehood*, of c. 1562 [140]. Danti (1530–76), in his brief career, moved from an avid Michelangelism to a slicker *maniera* style as-

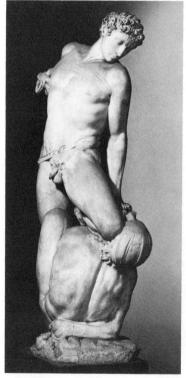

141. Giovanni Bologna, Florence Victorious over Pisa. 1565–70

sociated with the preciously decorated Studiolo of Francesco I de' Medici in the Palazzo Vecchio [cf. 154]. The *Victory* was eventually set up in the newly refurbished and enlarged Salone dei Cinquecento in the Palazzo Vecchio, not as part of any reference to a pope but as a symbol of the new Duke Cosimo I de' Medici. It then became some-

thing that it was never meant to be, a political symbol, and one honoring a despot whom Michelangelo refused to serve. The great Giovanni Bologna (1529–1608) was commissioned to supply a pendant representing *Florence Victorious over Pisa* [141]. In this typical figure of the later Cinquecento we see the ultimate reduction of Michelangelo's highly-charged emotionality into a beautiful exercise in geometric esthetics.

The other possible pendant to the *Victory* that may have been planned for the tomb project of 1516 is represented by a clay model [142].

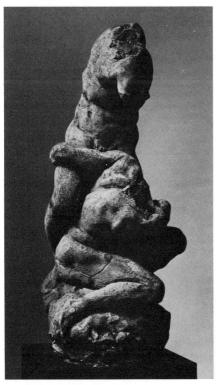

142. Michelangelo, clay model, probably for *Hercules and Cacus. c.* 1528

It is, however, more probably one of Michelangelo's projects for a companion piece to the *David*. I have mentioned that in 1508, just as Michelangelo was called to Rome to paint the Sistine Chapel, Pietro Soderini had ordered an immense block of marble for Michelangelo's use, 'in order to have the two statues, *David* and *Hercules*, symbols of

the palace' – that is, of just, republican government (p. 97). Perhaps because of intrigue, or possibly in order to set up a rivalry to spur Michelangelo on to further heights, but probably merely to keep Michelangelo working on the Medici Chapel – Clement VII, in 1525, gave the long-delayed commission to Baccio Bandinelli (1493–1560). Bandinelli had been given a different commission for the same subject by Leo X in 1515; the result was a failure and Bandinelli became a symbol of pro-Medicean favoritism, despised by the Florentines. The commission of 1525 was opposed by the Signoria of Florence, who preferred Michelangelo; thus the statue became a political issue. The Medici. knowing Michelangelo's republican inclinations and fully aware of the popular significance of the David, may have chosen Bandinelli because he would produce a monument of Medicean force to counteract the David – as indeed, ultimately, he did [27]. (The block itself had a notable career: at one point it fell off the barge into the Arno, as if as one wit put it - after being destined for the genius of Michelangelo it learned that it was to be mauled by Baccio, and in despair cast itself into the river.) After the Medici were driven out early in 1527, Michelangelo got the commission back in August 1528. He then decided to make the half-begun group into a Samson and a Philistine, but the approaching war between Florence and a new, surprise coalition of Papal and Imperial forces stopped the work. which was finished by Bandinelli between 1530 and 1534, with the Medici permanently back in power.

Michelangelo's clay model shows an intertwining spiral of bodies that makes more sense as a project for a free-standing piazza group than as the companion to the *Victory*. The difference is important, for whereas the *Victory* is elegant and *serpentinata*, it is potentially effective around an arc of no more than about 135 degrees; the clay model, however, is a splendid example of a spiraling work that needs – indeed, demands – to be seen from all around. We move back and forth in front of the *Victory* in order to understand its complex pose and see its different aspects, but it is still essentially a frontal niche figure. The *Hercules* model is a prototype for the brilliantly gyrating late-Mannerist groups of Giovanni Bologna.

8 Michelangelo's Medicean Architecture

We have seen that Michelangelo began the Medici Chapel on the model of Brunelleschi's sacristy [119, 120]. But almost immediately he made a major change: instead of supporting the dome on pendentives that reach down to the ground floor, he inserted a mezzanine, and then continued the pendentive architecture and dome, which was now much higher, with antique coffering instead of Brunelleschi's Byzantinizing umbrella form. Moreover, the window frames on the inside of the Chapel do not entirely correspond with the openings outside [110], all of which leads us to believe that in the very short period of construction (1520–21, 1523–4) Michelangelo made rapid changes in the design, which typically grew and developed as work progressed. We see in illustration 124 with what relish he studied moldings, carving them out, as it were, with his powerful line.

The most important change from Brunelleschi was the development of what may be called a third element: marble architectural membering set within the thin, blue-gray pietra serena moldings [120]. Michelangelo probably developed this marble architecture along with the marble tombs once the wall tombs had been decided on (as opposed to the free-standing tomb in the center that was first desired by the Pope). Michelangelo must have wanted a continuity of marble

architecture on the ground floor in order to give a setting for the tombs – to acclimatize them, so to speak, within the Brunelleschian environment. An interest in continuity is the most notable feature of his later, Roman architecture; here we see it only embryonically.

Of this marble architecture the tombs themselves are the earliest in design and the most elaborate [143]. Each tomb seems wedged into the framework – cut off by it, for we would expect the paired pilasters of the center to have some echo at the sides. Now this squeezing was Michelangelo's own doing, for he modified the Brunelleschian architecture by inserting a pier-like molding within the arch of the framework found in the Old Sacristy [cf. 119]. The marble pilasters themselves support fantastic capitals, in part inherited from the capriciousness of Florentine Quattrocento design, in part novel examples of Michelangelo's expressive carving. This expression, we learn here for the first time, was not to be suppressed by the traditional, mechanical demands of architecture: Michelangelo always refused to be satisfied with a routine traditional form, and specifically approved of the grotesque and chimerical in architectural design. The flanking niches [143] are odd in that they are hardly more than rectangular holes carrying volutes and heavy, decorated gables. The membering gets heavier as we go up, in contrast to expectation and to the laws of gravity that have normally governed architecture. But balancing this architectural strangeness is the pyramid of figures and the sarcophagi themselves which, though novel, bring us back to earth. The beauty of the chaste architectural carving, the precision of the moldings with their keen edges, the sharpness of relief, of solid against void, is unparalleled in earlier Renaissance design.

The strangeness of the tombs is complemented by the other work in marble. Between the corner pilasters of the Chapel Michelangelo built eight doors (only four of which opened) with modest marble frames [144]. The tops of the doors, however, support huge niches, which have, as symbolic supports, volutes on the door frames; door and niche are thus perversely joined. These niches, unlike the doors, have a sort of pilaster order - but not a canonical one since the 'capital' is now part of the gable molding. The pilasters support segmental gables that are penetrated by another kind of frame, separate both from the pilasters and from the niche, which opens up into an uncomfortable rectangle within the curved lines of the gable. The niche itself - a classical form meant to hold sculpture - has at the top an antique decoration of swag and boss, but the area below is shallow and blank. Perhaps the strangest quality of these niches is their proportional size within the pietra serena framework - they actually wedge against and, visually, overlap the Brunelleschian order, just as they dwarf and threaten to crush the doors below. Vasari calls the marble architecture of the Chapel

extremely novel, and in [it] he departed a great deal from the kind of architecture regulated by proportion, order, and rule that other artists did according to common usage and following Vitruvius and the works of antiquity, but from which Michelangelo wanted to break away.

Vasari comments that

The license he allowed himself has served as a great encouragement to others to follow his example; and subsequently we have seen the creation of new kinds of fantastic ornamentation containing more of the grotesque than of rule or reason.

Far from denigrating this development, Vasari goes on to say that

all artists are under a great and permanent obligation to Michelangelo, seeing that he broke the bonds and chains that had previously confined them to the creation of traditional forms.

This keen critical appraisal comes from one who was hardly a Michelangelesque architect. Whatever terms we use, it is obvious that Vasari saw in Michelangelo's architecture a license to break the rules that men of the Quattrocento had worked so hard to discover and exhibit in their works.

The Biblioteca Laurenziana

If the Medici Chapel seems strange in the context of Renaissance classicism, what can we say of the Biblioteca Laurenziana? In time it precisely follows the design of the Chapel, for although the idea for both buildings went back to 1519, nothing was done on the library until 1524. Michelangelo paid a visit to Rome in December 1523, immediately after the election of Cardinal Giulio de' Medici as Clement VII. Michelangelo, like everyone, was overjoyed at what seemed an auspicious choice:

You will have heard that Medici is made Pope, which I think will rejoice everyone. I expect, for this reason, that as far as art is concerned many things will be executed here.

After paying his respects he was asked, on 2 January 1524, to send a drawing showing dimensions of separate Greek and Latin libraries, with provisions for a well-lighted vestibule. Michelangelo wrote to his agent in Rome:

I learn . . . that His Holiness . . . wishes the design for the Library to be by my hand. I have no information about it nor do I know where he wants to build it . . . I will do what I can, although it's not my profession.

The site chosen, on the upper story of the cloister of San Lorenzo, was a traditional one. Although the Medici collection of manuscripts, greatly enriched by Lorenzo il Magnifico, had hitherto been in the Ralazzo Medici, the newly ecclesiastical Medici saw the need for installing the manuscripts in a more public but no less Medicean place. Michelangelo rejected a site on the church piazza because it would impede the view of the church - a façade was still hoped for. Michelangelo's closest model was the library at San Marco, a long, threeaisled room placed on the upper story of the cloister so as to admit light and assure some freedom from damp. In their correspondence we discover a constant demand for practical utility on the part of Pope Clement and a driving concern for artistic expression on the part of Michelangelo. In March 1524 the site was determined and necessary strengthening and vaulting of the rooms below the site begun. Later that year work on the substructures began, and during 1525 the library progressed rapidly. As Ackerman has pointed out. Michelangelo 'worked moment by moment; he still was designing the upper story while the lower was under construction.' Later in 1526 economies were instituted – the Pope wanted the Chapel to be done at the expense of the Library if necessary; and then, with the disastrous Sack of Rome and the flight of Clement in 1527, work stopped dead. A little more was done in 1533-4 before Clement died. It was then left without the stairway when Michelangelo moved to Rome; the floor and ceiling were built in their present form in 1549-50, and the stair. perhaps newly designed, was built only in 1558-9 - all with Michelangelo in Rome.

As built, the reading room is a very long hall with special desks that are part of the design [145]. The elaborate terracotta floor echoes the pseudo-antique design of the wooden ceiling. The walls continue the rhythm of the desks in a series of vertical divisions made by a pietra serena order that carries an unbroken molding around the room. Within these divisions, box-like elements frame two unequal tiers of windows. This busy relief design helps to mitigate the railroad-car shape and also lightens the load of walls and stone by using, essentially, a rib system with curtain walls in between. One of the striking aspects of the architecture is the virtual disappearance of the wall, which becomes a set of white strips or frames, forming a regular but intricate pattern against the dark stone. Low-relief surface patterning was traditional in Florence, and Michelangelo's version be-

145. Michelangelo, Biblioteca Laurenziana: reading room

came, in vernacular form, a typical mural decoration in the later Cinquecento. The use of a two-color architecture is also traditionally Florentine; it had been revived by Brunelleschi [119], and here receives another revision that still looks new.

The vestibule, or *ricetto*, leading to the Library is the most unusual part of the design [146, 148]. Its most startling, even unbelievable, feature is a projecting stairway that takes up most of the floor space. In contrast to it, the *ricetto* was made high, even shaft-like (it was raised in the course of construction to let in more light), as the receptacle for Michelangelo's bizarre steps. It forms an airy contrast to the long, monotonous reading room beyond. The articulation

of the walls is so contrary to Renaissance practice that Jacob Burckhardt called it an 'incomprehensible joke of the great master.' In Greek architecture, columns were free-standing, supporting the entablatures of temples. The Romans, who invented a much more versatile building style based on hydraulic concrete, kept the Greek orders as a kind of ornamental cloak for their concrete shells, applying pilasters or engaged columns onto walls that needed no support. The architects of the Renaissance inherited this purely ornamental use of the orders and imitated it by applying them to perfectly sound walls – just as Michelangelo had in the Medici Chapel and in the reading room of the Library [120, 145]. In the vestibule, however, Michelangelo set the stone columns into the wall, in pairs. The use of a paired order

146. Michelangelo, Biblioteca Laurenziana: vestibule

was a notable feature of Bramante's architecture; its recession into the wall, although unusual, was familiar from antique examples around Rome and had even been revived by Leonardo. Although we can look for structural reasons behind this iconoclastic betrayal of the column as either support or surface decoration, ultimately the choice was dictated by esthetic considerations. Michelangelo chose to alternate roughly equal wall and column units on one story, decorating the plane surfaces with fanciful tabernacles and linear decorative moldings. As if to stress the impotence of the columns, the frieze above them jogs back toward the wall, contrary to the norm. Visually, the design appears unstructural. Below the columns are hefty but purely ornamental brackets, separated from the columns they seem to support. Strangest of all, the columns and brackets join at the corners, where, as Ackerman put it, they not so much meet as mate. Individual elements like the doors can be followed in a sequence of drawings that show Michelangelo's change from heavier but already unclassic combinations of forms to the perverse linear elegance of the executed frames. In the Laurenziana we find Michelangelo making imaginative variations on the traditional elements of architecture.

The stair caused Michelangelo the most trouble, since he wanted it to play an active part in the room. After trying out a design with flights on each of the side walls, meeting in the center, he then brought them out into the open [147]. This drawing probably dates from around April 1525, when the Pope expressed preference for a single stair; the verso of the drawing shows unified, but still tripartite designs. After the troubles of the later 1520s the stairs were left unbuilt. Years later (in September 1555), when finally asked for the design, Michelangelo wrote to Vasari:

Messer Giorgio, dear friend: As regards the staircase for the Library, of which I have heard so much, believe me, if I were able to remember what I proposed to do with it no entreaties would have been necessary.

I recall a certain staircase, as it were in a dream, but I do not think it is exactly what I thought of then, because it is a clumsy affair, as I recall it. However, I will here describe it.

Thus, if you take a number of oval boxes, each a palmo in depth, but not of the same length and breadth; first place the largest upon the paved floor as far distant from the door in the wall as you require, according to whether the staircase is to be shallow or steep; upon this place another, which should be as much smaller in each direction as will leave enough level room on the first one below as the foot needs to ascend, diminishing and narrowing them one after the other continuously as they ascend toward the door, and the size to which the last step is reduced should equal the width of the door opening. The aforesaid section of the oval staircase should have, as it were, two wings, one on each side and one on the other, the steps of which should correspond to the others, but should be straight, not oval; these being for the servants and the middle for the master . . . I'm writing nonsense,

147. Michelangelo, drawings for the stairs of the vestibule

but I know very well that you and Messer Bartolommeo [Ammannati] will make something of it . . .

Only in January 1559 did Michelangelo send a model and instructions to Ammannati, who then built the stairs in stone. Michelangelo had said he thought it would be better built of fine walnut, 'more in keeping with the desks, the ceiling, and the door.'

Stairways had been, during most of the world's history, simply a means of getting up and down. Michelangelo promoted the utilitarian stair into a major architectural element, strange, fascinating, and

perilous, which reduces the vestibule to a case for its enclosure. Although there are three flights (the outer ones unprotected by rails, and in their very design frightening), they all lead to the same single door and are from a practical point of view ridiculous. The several landings, the convex shape of the central steps with their ornamental scallops at the edges – all conspire to hinder rather than help the cause of scholarship to which the library beyond is dedicated.

148. Michelangelo, Biblioteca Laurenziana: stairs

Michelangelo, almost single-handed, invented the use of the interior stair as a major, sculptural feature of architectural design. Oddly enough, however, it was the Pope who may have given him the idea, as reported in the letter of April 1525; Clement, it says, 'would prefer . . . one [stair] that takes up the whole *ricetto* . . .' (una che tenessi et pigliassi tutto il ricetto). The stair has no immediate followers, but the grand Late Baroque stairways by Balthasar Neumann at Bruchsal and Würzburg ultimately owe their existence to Michelangelo's strange fancy at the Laurenziana.

9 Years of Turmoil 1527–34

The Medici Chapel and the Biblioteca Laurenziana were interrupted by a political crisis. Pope Clement VII had fallen out with the new Emperor, Charles V, in the mid-1520s, whereupon Charles instigated a Roman uprising against the Pope in September 1526. Imperial troops, unrestrained by any merciful leader, rampaged through Italy the following year, and on 6 May 1527 entered Rome. The defenders of the city were cut to pieces; orphans and invalids were thrown into the Tiber. No method of torture was left untried by the ingenious Spanish soldiers, but the favorite was simply to tie up the victim and let him starve. The German landsknechts, many of them new Lutherans, amused themselves with even less refined activities. Every church was plundered, tombs ransacked, altars desecrated, palaces burnt. Churches were turned into stables, as was Clement's unfinished suburban palace, the Villa Madama. It was reported that 'some soldiers clothed an ass in bishop's vestments, led him into a church, and tried to force a priest to . . . offer him the Sacred Host. The priest, on refusing, was cut in pieces.' Nuns were raped and sold into prostitution. Even the Emperor's own agent was so ill-treated that he died in the street from hunger and exhaustion. 'All the Romans are prisoners,' a Venetian wrote, 'and if a man does not pay his ransom he is killed.' Clement VII and some of his retinue escaped to the relative safety of the Castel Sant'Angelo (Cellini gives a memorably boastful description of the fighting). After peace was declared, Clement escaped to Orvieto,

a broken man, dragging with him the remnants of a seriously damaged authority.

Since the Pope was powerless, in April 1527 the citizens of Florence rose up against their Medici rulers. Vasari relates that in the mêlée *David*'s arm was broken off, and that he and a friend 'went to the piazza and picked up the pieces fearlessly in the midst of the guard' (at this time he was barely sixteen). On 21 May a new republican regime was declared with Machiavelli as Gonfaloniere. In these years Michelangelo turned away from the Medici commissions to more purely Florentine projects, but he may also have gone back to the tomb (e.g. the *Victory*). This is the period of Michelangelo's project for the colossal piazza statue (see pp. 207–8). The Pope, exiled in Orvieto and Viterbo for most of 1528, tried to keep Michelangelo in his service, writing that he would continue to pay for the works at San Lorenzo, although he was bankrupt and his court had been reduced to a pitiful handful of hangers-on. Michelangelo, for his part, had to turn to still another project: the defense of Florence.

War has been described as the leading art of the Renaissance, and artists often served as military engineers. In a famous letter of 1482

149. Michelangelo, fortification design

to the Duke of Milan, the young Leonardo da Vinci had related his qualifications as an (untested) military planner, adding almost as an afterthought that he could paint. So Michelangelo, when the time came, was called on to design fortifications for Florence. The occasion was prompted by an alliance between Pope and Emperor that threatened, and eventually crushed, the republican government: Clement VII wanted above all to get Florence back for the Medici. Late in 1528 Michelangelo was engaged in improving Florentine defenses. In January 1529 he was appointed to a committee assigned to complete the fortifications begun by the Medici in 1526. In April he was Governor-General of the fortifications, working on the earthwork defenses of the hill of San Miniato. Warfare was changing rapidly; a number of drawings, exciting just as abstract patterns, survive to show the kinds of masonry bastions he wanted to design [149]. Michelangelo's imaginative, often zoomorphic drawings show artillery fire coming out belligerently at every angle. But his complex, isolated corner bastions were probably too exposed to have been wholly successful. In other respects his designs seem to anticipate Vauban.

Michelangelo's earthworks around the hill of San Miniato have not survived. Condivi tells us that

If the enemy took this hill nothing could prevent them from becoming master of the city . . . [Michelangelo's] foresight was . . . very dangerous to the enemy: [the hill] being, as I have said, of high elevation, it menaced the hosts of their antagonists, especially from the bell-tower of the church, where two pieces of artillery were placed, which continually did great damage to the camp without the walls. Michelangelo, notwithstanding that he had made provision beforehand for whatever might occur, posted himself upon the hill. After about six months the soldiers began to grumble amongst themselves of I know not what treachery; Michelangelo partly knowing about this himself, and partly by the warnings of certain captains, his friends, betook himself to the Signoria and discovered to them what he had heard and seen, showing them in what danger the city stood, saying that there was yet time to provide against the danger, if they would. But instead of thanking him they abused him, and reproached him with being a timid man and too suspicious. He who replied to him thus had better have lent him his ears, for the Medici entered into Florence and his head was cut off . . . When Michelangelo saw how little his word was considered, and how the ruin of the city was certain, by the authority he had he caused a gate to be opened, and went out with two of his people, and betook himself to Venice . . . The departure of Michelangelo caused a great stir in Florence, and he fell into deep disgrace with the governors. All the same, he was recalled with many prayers, with appeals to his patriotism . . . Persuaded by all this . . . but chiefly by his love for his

country, after he had received a safe conduct \ldots he returned, not without danger to his life.

The escape to Venice took place on 21 September 1529; he was asked to stay in Ferrara on the way, and even negotiated with France. In Venice he made a design, now lost, for the Rialto bridge. By 20 November he was back home.

Leda

In January 1530 Michelangelo was working on a painting of Leda and the Swan, which he had promised Duke Alfonso I d'Este while staying in Ferrara [cf. 150]. D'Este had known Michelangelo since 1512, when the Duke had made an enraptured visit to the Sistine scaffolding. He had begged for a painting then, and now Michelangelo finally responded. But its completion was interrupted by the fall of Florence. Late in February 1530, Clement VII ceremonially crowned Charles V in Bologna with the iron and golden crowns of Empire. Thereafter the Pope concentrated on subduing Florence. which fought for its life with grim tenacity. But the city was ravaged by famine and plague; in July the Florentine general Malatesta Baglioni finally betrayed the republicans. The Medici, again masters of Florence, declared a general amnesty, but it was not honored. An order was issued to seek out Michelangelo and kill him. He, fortunately, was hidden away in the house of a friend. In November, letters from Clement urged that Michelangelo be treated in a friendly way; and before the year was out he was back at work in the Medici Chapel.

The *Leda* was completed at this time, but the Duke never got it. The story, told by Condivi and Vasari, illustrates Michelangelo's pride and sense of station above that of an artisan:

Michelangelo was visited by a gentleman from the court of Duke Alfonso of Ferrara, who having heard that he had made for him an outstanding work was anxious not to lose such a gem. When the man arrived in Florence he sought Michelangelo out and presented his letters of introduction. Michelangelo made him welcome and showed him the picture of Leda embracing the swan, with Castor and Pollux coming forth from the egg, which he had painted very rapidly in tempera. The Duke's go-between, mindful of what he knew about Michelangelo's great reputation and being unable to perceive the excellence and artistry of the picture, said to him: 'Oh, but this is just a trifle.'

Michelangelo asked him what his own profession might be, knowing that no one can be a better judge than a man with experience of

what he is criticizing. With a sneer, the courtier replied: 'I'm a dealer.' He said this believing that Michelangelo had failed to recognize him for what he was, and laughing at the idea of such a question as well as showing his scorn for the trading instincts of the Florentines. Michelangelo, who had understood what he was getting at perfectly well, retorted:

'Well, you've just made a poor deal for your master. Now get out of my sight.'

This story, undoubtedly told by Michelangelo himself, reveals at once his neurotic sensitivity and his keen sense of morality. If he deprived the Duke of the *Leda*, in turn Michelangelo would not profit from it. And so in 1531 he gave it to his long-time assistant Antonio Mini, to provide his two sisters with dowries, and to give Mini some money for a trip to France. Michelangelo's painting is lost: but the cartoon for it, also lost, was the basis for several paintings [150]. We

150. Rosso Fiorentino (?) after Michelangelo, Leda. Early 1530s

are immediately struck by the similarity to the pose of *Night* [123], but the *Night* was itself derived from an antique *Leda*; and so with his painting Michelangelo came back to the original subject. Edgar Wind has pointed out that, according to Plutarch, Leda 'is generally associated with Leto and explained as the Night, the mother of luminary gods.' Michelangelo separated this fusion of funereal and myth, but used a relief of *Leda* as his source for both figures. Leda, like *Night*,

151. Michelangelo, drawing for the head of Leda

seems asleep, as if dreaming her rape. This may save the sensuality of the subject from becoming overwhelming. A beautifully finished drawing – evidently of a man – must be a study for Leda's head [151]. Renaissance artists customarily used male models; Michelangelo's practice is not significant for his sexual orientation.

We have mentioned the sexual implications of *Night* (p. 191). As if to confirm them, Michelangelo himself wrote in another context

Man can be planted only in the shade. Therefore the nights are holier than the days.

For Michelangelo, Night and Leda may have been mythologically related. For other artists, however, these two different subjects, employing essentially the same form, became an inspiration to use similar images with different meanings. Artists more and more began to make learned quotations of older works in new contexts. The lesson they learned – perhaps wrongly – was, as Freedberg has said, that 'meaning now need not internally determine form but is attached to it by illustrative adjuncts – form is essential; its content may be incidental.' That Michelangelo himself participated in, even led, this general tendency is illustrated again by the fact that his *Tityus* [156], reversed and stood upright, could become a *Resurrected Christ*.

Venus and Cupid

In 1532–3 Michelangelo produced a related cartoon of *Venus and Cupid*, which was to be painted by Pontormo (1494–1556) [152]. It represents, instead of the act of love, the process of falling in love, and

152. Jacopo Pontormo after Michelangelo, Venus and Cupid

again embodies a self-quotation. The picture was to hang below portraits of Dante, Petrarch, and Boccaccio – Florentine writers of love. Although the rather ungainly Venus was clearly based on a male model, the subject – Venus kissed by her son Cupid – opens up an era of courtly sexual metaphor best known in Bronzino's painting of *Venus, Cupid, Folly, and Time*; there is also a version of Michelangelo's cartoon by Bronzino, who was Pontormo's pupil. The cartoon's influence is manifest in many other paintings of the mid-Cinquecento, when it became a Florentine answer to the sensual Venetian nudes of Giorgione and Titian.

During the years 1531-4 Michelangelo was harried by competing commissions – Medici and Della Rovere – and by trips to Rome that became more frequent. In April of 1531 the Pope complained to Sebastiano 'I have never done him any injury,' but Sebastiano reported that Michelangelo was still angry, and he was never fully reconciled with the Medici. Nevertheless he was just then hard at work on the Medici tombs, to the Pope's great delight (see p. 202). In November 1531, out of concern for Michelangelo's health, the Pope drew up a Brief ordering him under penalty of excommunication to work only on the Julius tomb and on papal projects.

The Apollo

One rather mysterious product of these years is a beautiful little Apollo [153]. It was carved, Vasari tells us, for Baccio Valori, one of the hated Medici agents who governed Florence in 1530. Michelangelo could have begun the figure earlier and then decided that it would be prudent to give it to Valori – we do not know. Vasari, in 1550, wrote that

He began a small marble figure of Apollo taking an arrow from his quiver for Baccio Valori, so that the latter would use his credit as a mediator in making his peace with the Pope and the Medici family, who had been much wronged by him.

(Vasari of course writes as the vassal of Duke Cosimo I.) A letter from Valori, probably of 1531, refers to the figure as incomplete; with Valori's departure as Governor of Romagna it was no longer a politically useful present and ended in the Medici collections.

The *Apollo* has been mentioned in our discussion of the *Risen Christ* [II2]; the comparison is all in favor of the former, a lithe and handsome *contrapposto* figure that is, unusually, finished to a similar degree all around (save the rear), but unpolished. Fully effective

from the front, the figure should be imagined as free-standing, since it composes beautifully from several points of view. In this sense it is related to the *Christ* and also to the piazza statue project [142]. To get an idea of Michelangelo's influence and at the same time be persuaded of his lack of true Mannerism we need only look at Giovanni

153. Michelangelo, *Apollo. c.* 1530

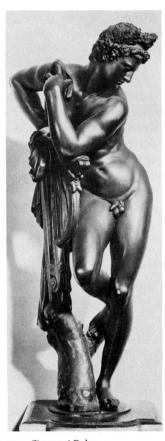

154. Giovanni Bologna, *Apollo. c.* 1578

Bologna's self-conscious bronze *Apollo* from the Studiolo [154]. This brilliant *tour de force* looks almost like a caricature of Michelangelo's tender boy, whose limbs fall naturally, as if moving in a beautiful dream.

Michelangelo's father, who had become increasingly querulous, died early in 1531, aged ninety-two. In July of that year a new Medici, Alessandro (1511–37), an illegitimate son of the Pope, took up residence

in Florence; he was formally declared Duke the following April. This strange dark man, half mad and perhaps half-breed, hated Michelangelo. From this time on Michelangelo tended to avoid Florence. The increasingly irrational Alessandro was finally murdered by another Medici in a widely applauded act of tyrannicide (see pp. 263–5).

Tommaso de' Cavalieri

Late in 1532, during one of his Roman visits, Michelangelo met the young Tommaso de' Cavalieri, and fell, in some sense, violently in love with the handsome nobleman. Certainly he loved Cavalieri's beauty, which must have seemed an incarnation of the ideal the artist had been seeking all his life. Michelangelo, who was then fifty-seven, had a strong element of Neoplatonism in his formation, and naturally equated beauty with the Good. This assumption is already evident in the *David* [25]. His letters to Cavalieri, involved and self-conscious, reveal his infatuation:

I started to write to your lordship, very inconsiderately, and in my presumption I was the first to make a move, as if I had to do it as owing an answer to one from you; and later I realized my error all the more, when I read and savored yours, through your courtesy; and you seem to me so far from being only just born, as you write me in it, that you have been in the world a thousand other times, and I label myself as not born or else born dead, and I would have said, to the distress of earth and Heaven, were it not that in yours I had seen and believed that your lordship willingly accepted some of my works, which made me no less greatly marvel than delight. And if it is really true that you feel within as you write me outwardly, as to your judging my works, if it should happen that one of them as I wish should please you, I shall much sooner call it lucky than good . . . [I January 1533]

In a draft of this letter he calls Cavalieri 'light of our century, paragon of all the world.' In July of that year Michelangelo wrote again:

My dear lord: If I had not believed that I had made you sure of the very great, rather, the immeasurable, love I bear you, I would not have thought it strange or wondered at the great suspicion you show in yours that you had of my not writing you, that I might forget you . . . but perhaps you do it to tempt me or to rekindle a new and greater fire, if a greater can be; but be it as it will, I know well that I can forget your name in the same hour when I forget the food I live on; rather, I can sooner forget the food I live on, which only nourishes my

body unhappily, than your name, which nourishes body and soul, filling both with such sweetness that I can feel neither pain nor fear of death as long as memory preserves it to me. Think, if the eye too had its part as well, in what state I would be.

In July 1533 he wrote his friend Bartolomeo Angiolini in Rome:

if I long day and night, as it were, without any intermission to be in Rome, it is merely in order to return to life, which is impossible without the soul. And since the heart is in truth the abode of the soul, and my heart being for the first time in the hands of him to whom you have confided my soul, the natural impulse was for it to return to its own abode . . .

This is, of course, rhetoric, but rhetoric based on real emotion. Michelangelo seems all his life to have been in love with the idea of love, which he apostrophized:

In me la morte, in te la vita mia (*Rime*, 37) (In you is my life, in me my death.)

He wrote love poems to Cavalieri, reminiscent of some of Shakespeare's sonnets, that revel in platonic imagery:

Veggio nel tuo bel viso, signor mio, quel che narrar mal puossi in questa vita: l'anima, della carne ancor vestita, con esso è già più volte ascesa a Dio.

E se 'l vulgo malvagio, isciocco e rio, di quel che sente, altrui segna e addita, non è l'intensa voglia men gradita, l'amor, la fede e l'onesto desio.

A quel pietoso fonte, onde siàn tutti, s'assembra ogni beltà che qua si vede più c'altra cosa alle persone accorte;

né altro saggio abbiàn né altri frutti del cielo in terra; e chi v'ama con fede trascende a Dio e fa dolce la morte. (*Rime*, 83)

(I see within your beautiful face, my lord, What in this life we hardly can attest: Your soul already, still clothed in its flesh, Repeatedly has risen with it to God. The evil, foolish and invidious mob May point, and charge to others its own taste, And yet no less my faith, my honest wish, My love and my keen longing leave me glad. All beauty that we see here must be likened

To the merciful Fountain whence we all derive, More than anything else, by men with insight. We have no other fruit, no other token Of Heaven on earth; one true to you in love May rise above to God, and make death sweet.)

Michelangelo insisted, obviously contrary to rumor, that his love was chaste, a 'foco onesto.' In a poem of 1532 he writes

Therefore, alas, how will the chaste wish That burns my inward heart ever be heard By those who always see themselves in others?

And in another sonnet to Cavalieri, of the same year, he wrote:

If a chaste love, if an excelling kindness, If sharing by two lovers of one fortune, Hard lot for one the other one's concern, Two hearts led by one spirit and one wish, And if two bodies have one soul, grown deathless . . . Neither loving himself, but each one each . . .

The protests may well have been just: we have no evidence that Michelangelo had a sexual life of any kind.

I burn, I consume myself, I cry

- this is his characteristic response to strong emotion:

Nearby you set me on fire, and parting, murder.

Later, when he was enamored of Vittoria Colonna, it was her poetry, her mind, and her religion that he loved. With Cavalieri the attraction was violently physical – even if chaste.

Resto prigion d'un Cavalier armato (Rime, 98)

as he put it in one punning line: 'I am held prisoner by an armed Cavalier.' Michelangelo's great love for Cavalieri is difficult to grasp in modern terms because of the Neoplatonic imagery he habitually used in his poems. But I cannot agree with the usually astute Creighton Gilbert that because some of Michelangelo's earlier poems make sensual reference to female breasts, he was therefore heterosexual. Those poems give every indication of being typical exercises in courtly petrarchan formulas, without much personal meaning for the artist. And only these early, in a sense practice, poems show any real interest in females as sexual objects. But what he could disguise in words his art betrays at every step – it is the most personal and autobiographical of the entire Renaissance, and shows his physical passion for the male body to an overwhelming degree. And there are no sensual, desired

female figures in his entire œuvre. He shaped the buttocks of David and Christ alike with sensuous joy, and his everyday preoccupation with the male nude is not paralleled by another artist. Nevertheless, we have no 'courtroom' evidence. People knew that Michelangelo was attracted to young men and took it for granted that he bedded them down – perhaps wrongly. In a letter of September 1533, in which he refuses to take on a new apprentice, Michelangelo writes that the boy's protector had said

that if I [Michelangelo] were but to see him I should pursue him not only into the house, but into bed. I assure you that I'll deny myself that consolation, which I have no wish to filch from him . . .

This shows both that Michelangelo was believed to be a pederast and that he, for his part, was capable of being open about it – since, presumably, he was not. In another letter to a young boy who had left his service, Michelangelo is very tender, but is clearly denying sexual intimacy:

Febo: Although you feel the greatest hate for me, I don't know why; I don't really think it's due to the love I feel for you, but rather to other people's words, which you shouldn't believe, since you have tested me; however, I can't resist writing you this. I leave tomorrow . . . and I shall not come back here again, and I am letting you know that as long as I live I shall always be at your service with faith and love, more than any other friend you have in the world.

I pray God he will open your eyes in another way, so you will realize that he who wishes your good more than his own health knows how to love, and not to hate as an enemy.

A few years later, perhaps in 1535, Michelangelo wrote several poems on Febo's death. Still later the blackmailer Pietro Aretino alluded to Michelangelo's supposed homosexual preferences, but he is a prejudiced witness. To contradict such malicious gossip, Condivi wrote that Michelangelo

has also loved the beauty of the human body, as one who best understands it: and in such wise that certain carnal-minded men, who are not able to comprehend the love of beauty unless it be lewd and shameful, have taken occasion to think and speak evil of him . . . I have often heard Michelangelo reason and discourse of Love, and learned afterwards from those who were present that he did not speak otherwise of Love than is to be found written in the works of Plato. For myself I do not know what Plato says of Love, but I know well that I, who have known Michelangelo so long and so intimately, have never heard issue from his mouth any but the most chaste of words, which had the power to extinguish in youth every ill-regulated and unbridled desire

that might arise. By this we may know that no evil thoughts were born in him. He loved not only beauty, but universally every beautiful thing . . .

None of this is at all conclusive. Michelangelo was at once a passionate lover of male beauty and a self-critical, obsessive ascetic. Perhaps he sublimated his sexual drives far more than most men. Possibly he was impotent. But when his infatuations did crop up they were overwhelmingly homosexual in form. Beneath the fashionable Neoplatonic language of his love poems to Cavalieri we must now read what Michelangelo himself did not want to reveal: a burning, frustrated sexual desire transmuted into lofty sentiment. Once, however, it seems to break through completely: in a sonnet of 1533 he expresses his wish to have

My so much desired, my so sweet lord, In my unworthy ready arms for always.

The Cavalieri Drawings

The bulk of the drawings by Michelangelo that we have discussed hitherto were working drawings - sketches, anatomical details, lifestudies. Michelangelo was always drawing, believed in drawing as the only road to successful mastery. A letter of 1518 to his assistant Pietro Urbano says 'Work hard and don't on any account neglect your drawing.' A drawing of 1524 bears the lines: 'Draw, Antonio, draw. Antonio, draw and don't waste time' - addressed to the young assistant Antonio Mini, to whom he later gave the Leda. Nevertheless. Michelangelo's highly finished drawings of the 1530s represent a new departure. From this time on he produced a number of drawings that are conscious works of art, done in a novel and painstaking stippled technique [156, 157]. Unlike his earlier drawings, these are placed on the page as self-framed, independent works of art - a very different esthetic from his jumbled workshop drawings of earlier times [cf. 23, 32]. Perhaps these highly finished drawings were done in lieu of the paintings and sculptures he knew he could not finish.

Early in 1532 Michelangelo probably drew his only surviving portrait, which represents a young friend, Andrea Quaratesi [155]. Quaratesi, the eighteen-year-old son of a distinguished Florentine family, greatly admired Michelangelo. Although Vasari claimed that Michelangelo refused on principle to make portraits, Vasari himself records one, life-size, of Tommaso de' Cavalieri. And for Cavalieri

155. Michelangelo, drawing of Andrea Quaratesi. 1532

156a. Michelangelo, drawing of Tityus. 1532

Michelangelo also made several highly-finished drawings of pagan subjects. Vasari explains them as models from which Cavalieri might learn to draw, and there are copies that could be his. The earliest of Michelangelo's drawings for Cavalieri, done late in 1532 and referred to in the letter of January 1533 quoted above, are a *Tityus* and a *Ganymede* [156, 157]. Even the subjects must allude to the relationship between the two men and are open to different levels of interpretation. Ganymede was a beautiful boy who was snatched up by Zeus to be his cupbearer and, presumably, lover. Tityus, the son of Earth, was punished in Hades for assaulting Leto: his liver, thought to be the seat of the passions, was continuously eaten by two vultures, and continuously renewed. In the Renaissance Tityus was a symbol of the hopeless suffering of one who loves in vain.

The *Ganymede*, known only from copies, shows a beautiful, muscular youth almost enveloped by a large, predatory bird. The *Tityus* shows a nude in a related pose, but reclining and chained as a single, rather ornamental bird (evidently the same one) attacks from above. Both clearly show the victimization of helpless man by an otherworldly power – Love. But this love was not always interpreted as physical, although the antique stories would lead us to believe it so. If we interpret the drawings in the light of Michelangelo's verses to Cavalieri, we may decide with Erwin Panofsky that

156b. Michelangelo, Tityus (detail)

The Ganymede, ascending to Heaven on the wings of an eagle, symbolizes the ecstasy of Platonic love, powerful to the point of annihilation, but freeing the soul from its physical bondage and carrying it to a sphere of Olympian bliss. Tityus, tortured in Hades by a vulture, symbolizes the agonies of sensual passion, enslaving the soul and debasing it even beneath its normal terrestrial state. Taken together, the two drawings might be called the Michelangelesque version of the theme 'Amor Sacro e Profano.' In both compositions the traditional allegorical interpretation of a mythological subject was accepted, but it was invested with the deeper meaning of a personal confession, so that both forms of love were conceived as the two aspects of an essentially tragic experience.

Michelangelo's love for Cavalieri was so intense that in 1533 he stayed in Rome for the entire first half of the year. Back in Florence in July, he expressed his misery with the commission he had to execute, writing to a friend

although I may seem to jest with you, please realize that I am also serious in saying that I have aged twenty years and lost twenty

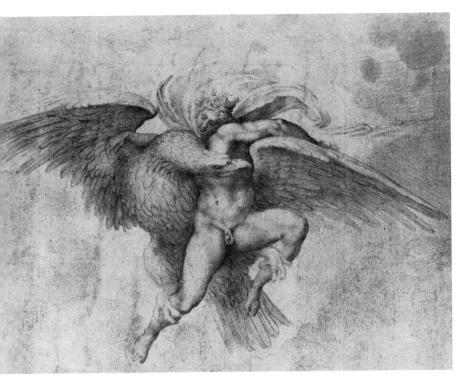

157. Copy after drawing by Michelangelo, Ganymede

pounds since I've been here, and I don't know when the Pope is leaving Rome [for the wedding of Catherine in France], what he wants with me, nor where he wishes me to be.

His last letter from Florence, of September 1534, says 'I shall not come back here again' (see p. 232).

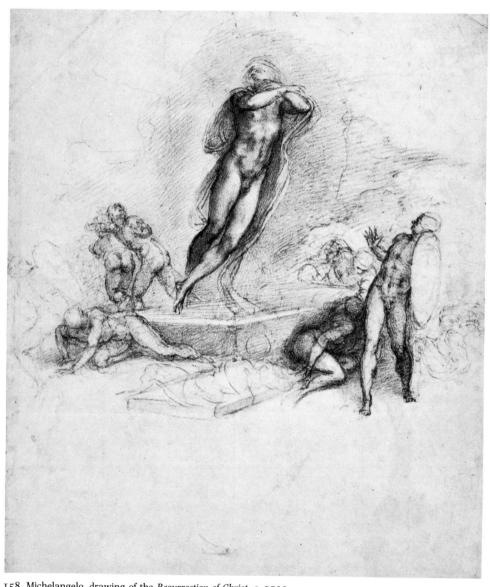

158. Michelangelo, drawing of the Resurrection of Christ. c. 1533

IV Rome 1534–64

10
The Last Judgement,
a Pious Lady,
and Tyrannicide
1534–47

Late in 1533 Pope Clement VII conceived the idea of a new decoration for the altar wall of the Sistine Chapel. Perhaps, as one report of February 1534 has it, the subject was to be the Resurrection of Christ ('che sopra l'altare si farà la resurrectione'). It goes on to say that a modello ('tavolato') was made by Michelangelo before he left Florence in 1534. Although this has been interpreted as the first idea for The Last Judgement, twelve surviving drawings of the Resurrection [cf. 158] make one wonder whether a smaller painting of that subject was not originally planned for the wall (but see p. 201). It would have made perfect sense under the Prophet Jonah (see pp. 110, 116), and in fact [159] has on its verso a sketch of the Resurrected Christ, confirming the coincidence of the ideas. Nevertheless, there was already a Resurrection next to the entrance to the Chapel, and to make this scheme sensible we would have to imagine two new wall decorations - a Fall of the Rebel Angels on the entrance wall and a Resurrection on the altar wall, which is what Vasari claimed was first planned. Condivi, however, wrote that Clement VII

as one who had a good wit . . . thought of one thing after another until finally he resolved to have the Day of the Last Judgement painted on the grounds that the grandeur of the chosen subject must allow the man scope to display his powers.

There may have been other reasons for choosing the Last Judgement – the defection of King Henry VIII in 1533 and rebellion against papal authority elsewhere, notably by Luther, may have suggested the subject as a grim warning to those who sought salvation outside the Church. Condivi also tells us that Michelangelo

tried as best he could to avoid this new commission. But when he realized that it was impossible, he delayed the matter as long as he could by claiming that he was busy with the cartoon – which was partially true – although he was secretly working on the statues for the tomb.

Only days after Michelangelo returned to Rome late in September of 1534, the Pope suddenly died, aged fifty-six. Michelangelo rejoiced at being finally free of the Medici and their commissions, because he hoped desperately to finish the tomb, for which a new contract had been ratified in 1532. But once again he was at the mercy of a determined, though friendly pope.

Alessandro Farnese, elected on 13 October 1534 as Paul III, was even more eager than his predecessors to have a work by Michelangelo; indeed, he said he had been waiting for the opportunity for thirty years and would not be denied; he even threatened to tear up the tomb contract. Paul III in his own person illustrates the transformation from Renaissance to Counter-Reformation. He had sired four children as a younger cardinal, but his reign (1534-49) marks the true beginning of internal reform of the Church. We may recall two symbolic events among many: the confirmation of the militant Jesuit Order by the Pope in 1540, and the convocation of the Council of Trent in 1545. Paul was a true lover of art; during his reign Michelangelo not only painted in two great papal chapels but also became the Architect of St Peter's and designed the great piazza on the Capitol (see pp. 291ff.). In order to persuade Michelangelo to work for him, the Pope and eight of his cardinals went to visit the sculptor in his house on the Macel' de' Corvi. While examining the various statues and cartoons, one of them exclaimed of the Moses: 'This figure alone would suffice to honor the tomb of Julius' - and the Pope himself arranged with the Della Rovere duke to be satisfied with what he eventually got [174].

According to Vasari, the first plan for the completion of the Chapel with a Last Judgement, as it may have been discussed with Clement VII in 1533–4, was in fact to pair it with a fresco of The Fall of the Rebel Angels on the entrance wall, replacing the Quattrocento fresco of that subject to the left of the door. Under Paul III The Last Judgement became the sole commission. Michelangelo set to work and by September

1535 was preparing the cartoons. At this time he was given the unprecedented title of Chief Architect, Sculptor, and Painter to the Vatican palace – Paul wanted his exclusive service. The early designs for the fresco evidently included Perugino's altarpiece of the *Assumption*, as shown by one of the few composition drawings that survives [159]. Christ, in the center above, is seated on a cloud. He raises his right arm above the figure of the interceding Mary to raise the blessed, and holds out a sharply foreshortened *sinister* to damn those on our

right below. Christ is already surrounded with nebulous figures of the blessed; we make out the rise of a few bodies at the left and see an increasing number flying up or being helped up to heaven. To the lower right are sketchy scenes of punishment and condemnation, so that the final, dynamic rhythm of the rise of the blessed on our left, at Christ's beckoning, and the fall of the damned on our right [161] is clearly shown.

In the picture as finally painted, the altarpiece was dismissed and Michelangelo's earlier lunettes above were also defaced in order to make one homogeneous composition covering the entire wall [160]. The windows were closed, the old Quattrocento paintings removed; Vasari tells us that the wall was rebuilt of specially baked bricks with the upper part projecting out about a foot beyond the lower, to prevent any dust or dirt from settling on the painting. Michelangelo probably painted the fresco from large cartoons, such as he had drawn for *The Battle of Cascina* and for the ceiling. Scaffolding was put up in March–April 1535. At that point he decided not to paint in oil, for which the wall had been prepared with plaster under the direction of Sebastiano del Piombo; Michelangelo graciously said that oil painting was good only for women and for lazy people like Sebastiano. He then ordered the plaster removed, and that was evidently completed by January 1536. Why these operations took so long is unclear.

Michelangelo was aging, and it took him a long time to paint the huge fresco. The scaffolding was moved down to the lowest level only in December 1540. Early in the following spring Michelangelo had an accident, but late in March 1541 he was able to write his friend Luigi del Riccio:

I've recovered and hope to live another few years, since Heaven has placed my health in the hands of Messer Baccio and in the Trebbiano [wine sent by Del Riccio].

The whole fresco was unveiled on All-Hallows Eve 1541, exactly twenty-nine years after the ceiling. Condivi says of *The Last Judgement* [161] that

In this work Michelangelo expressed all that the human figure is capable of in the art of painting, not leaving out any pose or action whatsoever . . . In the central part, in the air near to the earth, are seven angels, described by St John in the Apocalypse, with trumpets to their lips, calling the dead to judgement from the four corners of the earth. With them are two others having an open book in their hands, in which everyone reads and recognizes his past life, having almost to judge himself. At the sound of these trumpets all graves open and the human race issues from the earth, all with varied and marvellous gestures; while in some, according to the prophecy of Ezekiel, the

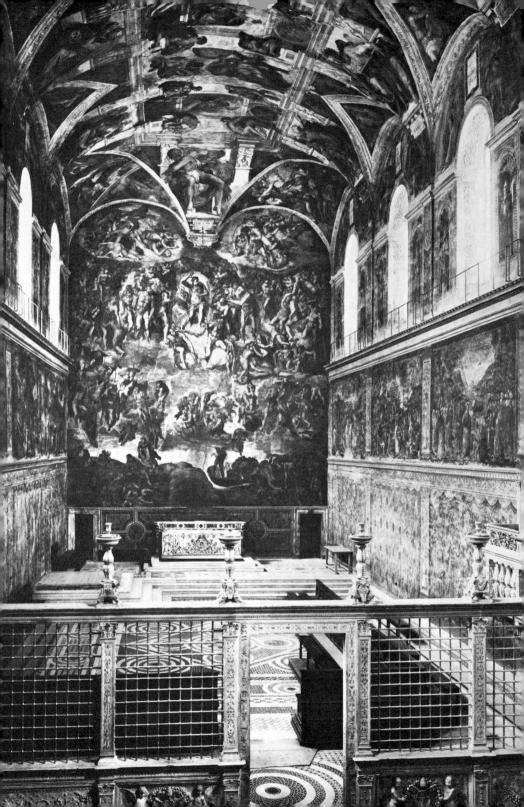

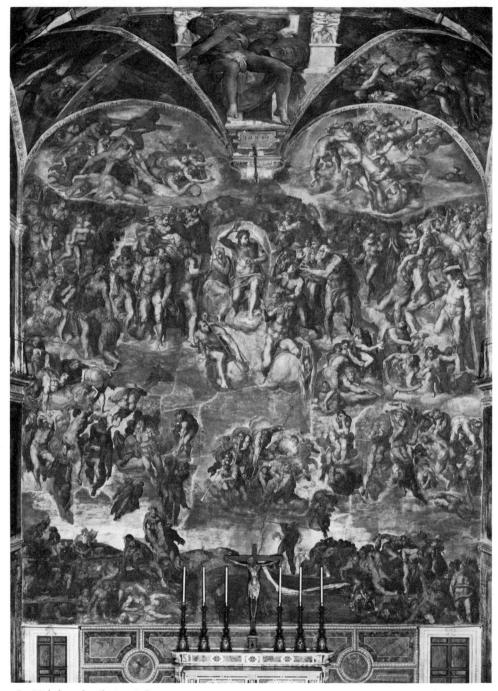

161. Michelangelo, The Last Judgement. 1534–41

bones only have come together [see p. 250], in some they are half clothed with flesh, and in others entirely covered; some naked, some clothed in the shrouds and grave-clothes in which they were wrapped when buried, and of which they seek to divest themselves. Among these are some who are not yet fully awakened, and looking up to heaven in doubt as to whether Divine justice shall call them. It is a delightful thing to see them with labor and pains issue forth from the earth, and, with arms out-stretched to heaven, take flight . . . Above the angels of the trumpets is the Son of God in majesty, in the form of a man, with arm and strong right hand uplifted. He wrathfully curses the wicked, and drives them from before His face into eternal fire. With His left hand stretched out to those on the right, He seems to draw the good gently to Himself. At His sentence are seen the angels between heaven and earth as executors of the Divine commands. On His right they rush to aid the elect . . . and on His left to dash back to earth the damned, who in their audacity attempt to scale the heavens. Evil spirits drag down these wicked ones into the abyss . . . every sinner by the member through which he sinned. Beneath them is seen Charon with his boat, just as Dante described him in the Inferno on muddy Acheron, raising his oar to strike some laggard soul . . . Afterwards they receive their sentence from Minos, to be dragged by demons to the bottomless pit, where are marvelous contortions, grievous and desperate as the place demands. In the middle of the composition, on the clouds of heaven, the Blessed already arisen form a crown and circle around the Son of God. Apart . . . all the saints of God, each one showing to the tremendous Judge the symbol of the martvrdom by which he glorified God: St Andrew the cross, St Bartholomew his skin, St Lawrence the gridiron, St Sebastian the arrows, San Biagio the combs of iron, St Catherine the wheel . . . Above these on the right and left, on the upper part of the wall, are groups of angels . . . raising in heaven the Cross . . ., the Sponge, the Crown of Thorns, the Nails, and the Column of Flagellation . . .

Michelangelo balanced the rising figures at the left and the falling ones at the right by creating at the same time large horizontal bands that can be read across, from the bottom level of resurrection and damnation, to the level of the trumpeting angels, to the level of Christ, and finally the divided crown of lunettes. These horizontal bands help unite the gigantic new decoration with the two strips of mincing Quattrocento paintings on the adjacent wall [160]. The horizontal banding reflects an old tradition of hieratic, static scenes. Unlike earlier representations, however [cf. 7], the entire composition moves, and we can distinguish a flat, central oval of figures with Christ at the top and the trumpeters below, all in the air, with a rising movement at the left and a falling at the right, a cosmic simile, with Christ like the sun surrounded by clouds of figures.

The figures in *The Last Judgement* increase in size as they rise, more than compensating for the normal perspective diminution. But even above, the figures follow a semi-medieval hierarchy of sizes that has little to do with space. Indeed, the picture is peculiarly spaceless; each group is seen from its own point of view. The upper areas develop backward in space as if there were a ground line moving up and back behind Christ. The fresco is unframed and seems therefore to be merely the center of an indefinite continuum that ends arbitrarily at the edges by the older frames of the chapel. The size of the figures and the unity of the entire design put *The Last Judgement* in another category from the ceiling - the stylistic distance between Michelangelo's later decoration and his earlier one on the ceiling seems almost as great as the contrast of the ceiling with the busy Quattrocento scenes below [160]. Unlike the ceiling, The Last Judgement is like a gigantic relief, full of massive sculptural forms. In 1549 Michelangelo, responding to a discourse by Benedetto Varchi, wrote

In my opinion painting is to be considered the better the more it approaches relief, and relief is to be considered the worse the more it approaches painting . . . [see p. 278]

The central figure of Christ, nude and beardless, is like an antique hero-god [162]. It is developed from the figure of Helios (Sol) in one of the Cavalieri drawings, and has always been recognized as more Hellenic than Christian in inspiration. In 1529 an inscription was put up in the Audience Hall of the Palazzo Vecchio in Florence by the insurgent republican government:

SOL IVSTITIAE CHRISTVS DEVS NOSTER REGNAT IN AETERNVM

The equation of Christ with the sun of Justice was commonplace and may have influenced Michelangelo's conception. Christ is nevertheless also the Man of Sorrows, with emphatic stigmata. His position, whether seated or rising, is ambiguous, as are his gestures – his right hand apparently has beckoned the dead to rise, his left seemingly points to the wound in his side while condemning the damned at his left. Despite this vigorous activity his face is impassive. This is not the traditional representation of the enthroned Christ as Judge. In this period Michelangelo turned directly to the Bible for inspiration, and he is here probably illustrating the passage in Matthew in which Christ speaks:

'As soon as the distress of those days has passed, the sun will be darkened, the moon will not give her light, the stars will fall from the

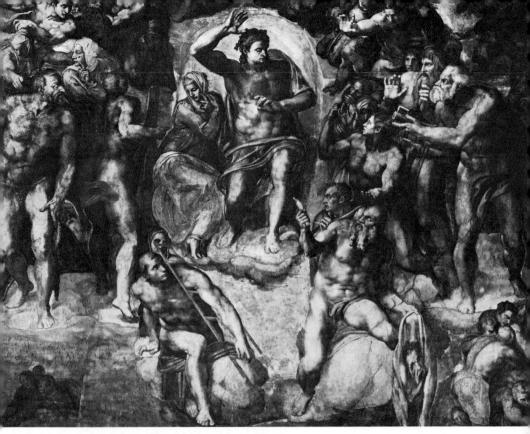

162. Michelangelo, The Last Judgement (detail)

sky, the celestial powers will be shaken. Then will appear in heaven the sign that heralds the Son of Man. All the peoples of the world will make lamentation, and they will see the Son of Man coming on the clouds of heaven with great power and glory. With a trumpet blast he will send out his angels, and they will gather his chosen from the four winds . . .' (Matthew 24.29-31)

Mary cowers decoratively beneath his raised hand – her days of intercession are over, the final judgement is made, the book written. Michelangelo had to distribute the elect to symbolize various kinds of Blessed, and there is still controversy about some of them. To the right of Christ as we view the fresco is Peter, fundamental in a papal chapel as the first of the line of popes. Directly behind him to our left, we seem to recognize a traditional representation of John the Baptist, who normally appears on Christ's left together with Mary on his right to form the so-called *deisis*. Corresponding to Peter is a powerful man on the left, presumably not John (as Condivi says), who was never

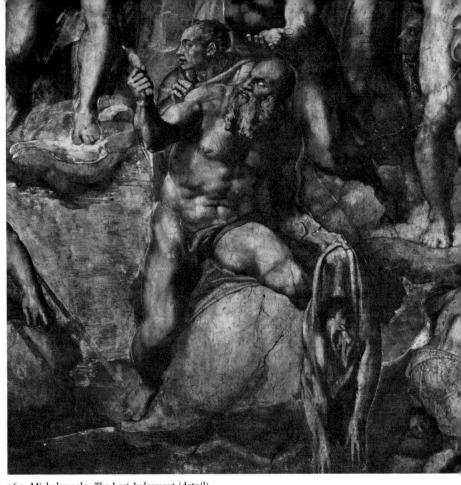

163. Michelangelo, The Last Judgement (detail)

represented looking so robust, but Adam, as Vasari called him. It is possible that the figure holding on to Adam is Eve, but its sex is unclear (though the headdress suggests a woman). Jesus was the new Adam and Mary the new Eve. Christ's forerunner was John, his earthly successor Peter, upon whom the Church was founded. These figures, then, sum up the creation of man, the coming of the Savior, and the institution of Christianity. Immediately behind Peter and John are the Apostles, then Prophets and Confessors. Some of the Blessed greet each other with rapturous physicality. Behind Adam are Patriarchs, Sibyls, and Virgins. None of these powerful figures participates in the act of judgement; all are powerless to change the ineluctable force of last events.

Below are ranged a series of saints: Lawrence and Bartholomew are directly below Christ, larger than the others because their feast

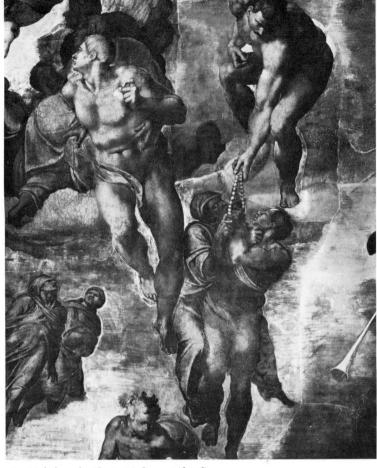

164. Michelangelo, The Last Judgement (detail)

days are associated with the construction of the Chapel. Bartholomew was flayed; he looks up quizzically at Christ, but holds a flayed skin bearing the distorted, disconsolate face of Michelangelo himself [163], another of his ironic images that is paralleled in his poetry. The other saints are a representative selection of martyrs, important in a chapel in which the festival of All Saints was particularly observed (both the ceiling and *The Last Judgement* were ceremonially unveiled for this feast). The other saints to the right of Bartholomew serve as a curtain below heaven; underneath them all is lost, whereas at the left the Saved can rise upward, helping each other and being helped by wingless angels. One negroid couple is being raised by a rosary [164], indicating the power of prayer and faith, a concept Michelangelo was much occupied with at the time (see p. 255), and which he called in one poem 'la catena della fede.'

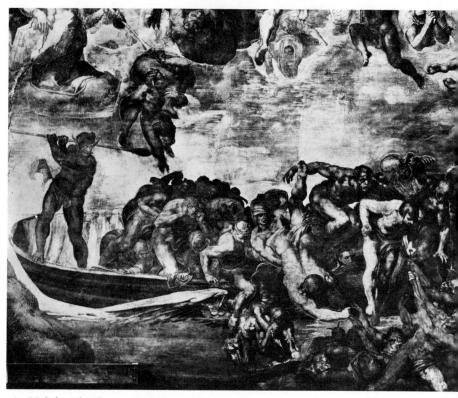

165. Michelangelo, The Last Judgement (detail)

Perhaps the lowest zone of this great *Dies Irae*, although badly discolored, is the most memorable: at the left we see the bodily resurrection, sometimes of skeletons not yet fleshed out [167], as Ezekiel wrote:

The Lord . . . set me down in the midst of the valley which was full of bones . . . and lo, they were very dry. And he said unto me 'Son of man, can these bones live?' And I answered 'O Lord God, thou knowest.' Again he said unto me 'Prophesy upon these bones . . . Thus saith the Lord God unto these bones: "Behold I will cause breath to enter into you, and ye shall live . . ."' and as I prophesied, there was a noise, and behold a shaking, and the bones came together, bone to his bone . . . and the breath came into them, and they lived . . . (37. I fl.)

On the right of the fresco Charon whips the Damned with his paddle, and above, figures who seem originally to have risen are attacked and dragged down [165, 166]. It seems possible that some details of the fall of the Damned were inspired by ideas originally formed for the

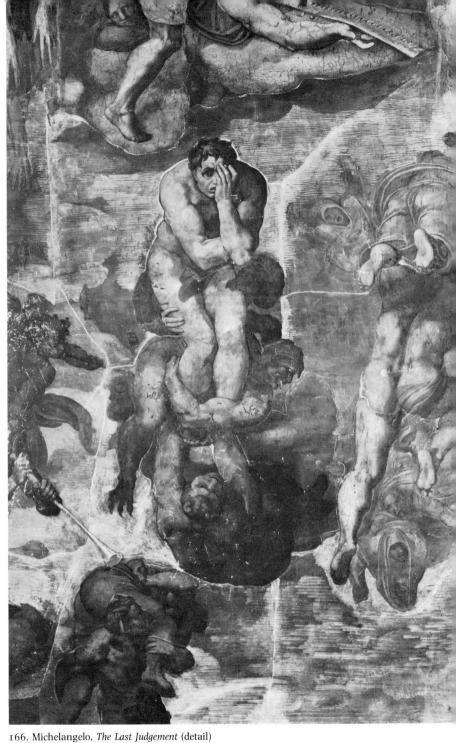

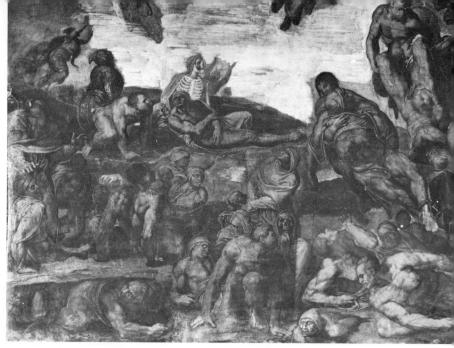

167. Michelangelo, The Last Judgement (detail)

projected Fall of the Rebel Angels. In any event, in these scenes of punishment and damnation, no less than in the scenes of resurrection, Michelangelo was notably influenced by Luca Signorelli's famous series of frescoes in Oryieto depicting the end of the world [168]. In comparison with Michelangelo's nudes, Signorelli's look like inflated plastic dummies; but the images of skeletons clothing themselves with flesh and of the torments of the damned are surely indebted to Signorelli, as Vasari states.

The effect of the fresco was overwhelming from the first: Paul III, upon its unveiling, reportedly fell to his knees, crying 'Lord, charge me not with my sins when thou shalt come on the Day of Judgement.' Nevertheless, Michelangelo's nudes in the fresco were the subject of prudish criticism and soon after his death many figures were given loincloths; the St Catherine, originally nude, was wholly repainted. The style of these nudes is novel and noticeably thickwaisted; Michelangelo seems to have fallen under the spell of certain Hellenistic models for figures such as Christ, Peter, and Adam, whose waists equal or exceed their other dimensions, a development that begins with the Florentine tomb statues [162]. There are also daring foreshortenings, and poses, especially in the upper left portion, of Mannerist complexity. The figures of *The Last Judgement* are more abstract and objectified than those of the ceiling, which seem to incarnate all

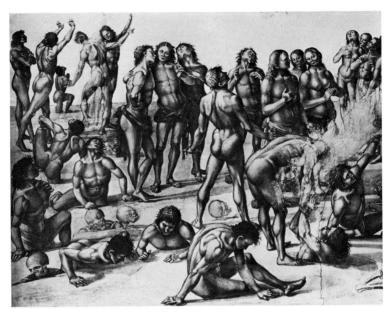

168. Luca Signorelli, The Last Judgement (detail). 1500-1504

of the youthful Michelangelo's hopes and fears. In this sense there is a Mannerism in *The Last Judgement*, a return to a kind of formalism that began with the *Doni tondo* and the *Cascina* cartoon [33, 43]. For strict reformers like Pope Paul IV (1555–9) the entire painting was a stew of vulgar nudes, and he was hardly dissuaded from effacing the whole thing. But for those who were more interested in art than morals, the fresco was a revelation. Vasari wrote:

When *The Last Judgement* was revealed it was seen that Michelangelo had not only excelled the masters who had worked there previously but had also striven to excel even the vaulting that he had made so famous; for *The Last Judgement* was finer by far, and in it Michelangelo outstripped himself. He imagined to himself all the terror of those days . . . And the paintings he did were imbued with such force that he justified the words of Dante: 'Dead are the dead, the living truly live . . .' We are shown the misery of the damned and the joy of the blessed.

. . . this extraordinary man chose always to refuse to paint anything save the human body in its most beautifully proportioned and perfect forms and in the greatest variety of attitudes, and thereby to express the wide range of the soul's emotions and joys. He was content to prove himself in the field in which he was superior to all his fellow craftsmen, painting his nudes in the grand manner and displaying his great understanding of the problems of design. Thus he

has demonstrated how painting can achieve facility in its chief province: namely, the reproduction of the human form. And concentrating on this subject he left to one side the charm of coloring and the caprices and novel fantasies of certain minute and delicate refinements . . .

Vasari's remarks about coloration are true for *The Last Judgement* but not for the ceiling: whereas the earlier work displays a lovely harmony of pastel and darker fresco shades, *The Last Judgement*, at least as we now see it, is a bituminous, bluish darkness unrelieved by coloristic passages. But Vasari is correct in calling attention to the nude figures as the real point of the display:

The Last Judgement must be recognized as the great exemplar of the grand manner of painting, directly inspired by God and enabling mankind to see the fateful results when an artist of sublime intellect infused with divine grace and knowledge appears on earth. Behind this work, bound in chains, follow all those who believe they have mastered the art of painting; the strokes with which Michelangelo outlined his figures make every intelligent and sensitive artist wonder and tremble, no matter how strong a draughtsman he may be. When other artists study the fruits of Michelangelo's labors, they are thrown into confusion by the mere thought of what manner of things all other pictures, past or future, would look like if placed side by side with this masterpiece.

Together with expressive form there is expression itself, and, as Vasari said.

in it may be seen marvelously portrayed all the emotions that mankind can experience . . . Michelangelo's figures reveal thoughts and emotions that only he has known how to express.

According to Freedberg, 'This is the image in which Michelangelo's own *terribilità* conjoins absolutely with the meaning and the stature of the theme, and it is his most awesome creation.'

Vittoria Colonna

Michelangelo's *Last Judgement* is redolent with the pessimism and fear that followed the Sack of Rome, and probably reflects increasing awareness of the precarious state of the Church. It is also a very personal credo, for Michelangelo had a clear and simple faith in God. This religious faith, evident throughout his life but less clear in his earlier art, deepened and strengthened in the 1530s. Probably beginning in 1536, his religious inclinations were stimulated by an impas-

sioned friendship with the widowed Marchioness of Pescara, Vittoria Colonna (1490–1547), granddaughter of Federigo da Montefeltro, and one of the outstanding women of the Renaissance. Often abandoned by her soldier husband, she became the friend of men like Castiglione and Ariosto; upon her husband's death in 1525 she often retired from society 'to be able to serve God more tranquilly', and wrote mournful poetry. Her elevated spirit and calm wisdom particularly commended her to everyone she met. A cardinal wrote 'not only does she surpass all other women, but, as well, she seems to show the most serious and famous men the light that is a guide to the harbor of salvation.' Kenneth Clark thought that, for Michelangelo, Vittoria Colonna

symbolized a release from the tyranny of the senses. His long struggle with physical passion was almost over, and as with many other great sensualists, its place had been taken by an obsession with death.

He wrote poems to her of impassioned fervor and piety – and did not find it necessary to insist on the chastity of his love. Tolnay pointed out that Michelangelo elevated her while she was still alive to the spiritual transfiguration of Dante's Beatrice or Petrarch's Laura. She. in true Renaissance fashion. returned his admiration with more poems, and called him unique - a typical Renaissance concept. The main period of their friendship, apart from their presumed first meetings in 1536, was the time of her residence in Rome from October 1538 to March 1541, and from 1544 to 1547. Through her, Michelangelo was introduced to strict, reforming elements of the Church, and to ideas that were sometimes very close to Protestantism. The leader of this group, the Spaniard Juan de Valdés, had been in Rome from 1531 to 1534. Influenced by Erasmus, he believed in justification through faith alone (sola fide). This had also been a Savonarolan precept, and appealed to Michelangelo, who called faith 'the gift of gifts.' Michelangelo was not particularly interested in theology, but his poems show that he felt 'weighed down by years and filled with sin.'

A young Portuguese painter, Francisco de Hollanda, recorded dialogues in fictional form between Michelangelo and Vittoria Colonna. They often met on Sundays at the cloister of San Silvestro on the Quirinal (later the central church of the austere Theatine Order), where there was a splendid panorama overlooking all of Rome. These conversations were reportedly preceded by commentaries by a friar on Paul's Epistles, which were the earliest source of the idea of justification by faith alone. Some of these ideas may have influenced *The Last Judgement*: the finality and fatefulness of salvation and damnation are expressed there, dramatized in the attitude of the Virgin [162].

At this time Michelangelo worked on several iconic themes, including a *Pietà* for Vittoria Colonna [170], which was engraved in 1546. He also made a moving drawing of the crucified Christ, according to Condivi, 'per amor di Lei' [169], and perhaps also painted the same scene. Before it was finished he sent it to her, and she replied that 'I saw the *Crucifix*, which certainly has crucified in my memory every other picture I ever saw . . .' (Just as in Michelangelo's poetry,

169. Michelangelo, drawing of Crucifix for Vittoria Colonna. c. 1539

170. Michelangelo, drawing of Pietà for Vittoria Colonna. By 1546

we see in this phrase the clever, proto-Metaphysical nature of their language.) The *Crucifix* is one of the last of Michelangelo's highly-finished drawings, dating from around 1539. In that year a Confraternity was founded in Rome dedicated to the *Corpus Domini* – the body of Christ – which had become an object of increased devotion during Michelangelo's lifetime. The figure of Christ is shown alive, his face turned toward God. The moment Michelangelo chose was not often represented:

From midday a darkness fell over the whole land, which lasted until three in the afternoon; and about three Jesus cried aloud 'Eli, Eli, lema sabachthani?', which means 'My God, my God, why has thou forsaken me?' (Matthew 27.45 ff.)

Its depiction could be interpreted in various ways, some of them worrisome to the orthodox. (It is notable that this potentially heretical image is not found in his later drawings of the subject [186].) The body has much of his earlier, purely physical idealism, despite the new content that can be presumed. An undated letter (probably of 1539) says:

Lady: Before I took the things your ladyship has repeatedly desired to give me, I wished to make something for you with my hand, so as to receive them as little unworthily as I could; then, having realized and seen that the grace of God is not to be bought and it is a great sin to keep you in suspense, I avow my fault and willingly accept the aforesaid things; and when I have them I shall feel I am in Heaven, not because I have them in my house, but because I am in theirs . . .

The reference to something made 'with my hand' must be to the *Crucifix*, which was the subject of particular devotion to the group who believed solely or chiefly in salvation through faith. These ideas, very close to Lutheranism, culminated in 1542 with a book, written by theologians close to the papal court, entitled *Del beneficio di Gesù Cristo crocifisso* . . . It sold some 60,000 copies and advocated an Augustinian theory of justification that was later declared heretical. It was in this climate of religious thought that Vittoria Colonna and Michelangelo met and talked, and in which the *Crucifix* was drawn.

The *Pietà* for Vittoria was also of a novel type, and seems to have been done to her prescription [170]. Two angels support Christ before his mother and the cross. This is another highly-finished drawing, although it is trimmed and badly damaged, of the type he perfected for Cavalieri. The unusual cross is inscribed with a line from Dante:

NON VI SI PENSA QUANTO SANGUE COSTA
(Little do you think what His blood has cost)

Condivi explains that

The Cross is like that which was carried in procession by the Bianchi at the time of the plague of 1348, and afterwards placed in the church of Santa Croce, at Florence.

Christ, not Mary, is now central, a combination of the 'Man of Sorrows' [cf. 112] and the *Pietà*. This conception grew slowly, from the St Peter's *Pietà* to Sebastiano's *Pietà* of 1514 [18, 97], and then changed in a later *Pietà*, also by Sebastiano, for which Michelangelo drew a torso [171].

171. Michelangelo, drawing of torso for Sebastiano's $Piet\hat{a}$ now in Ubeda, Spain. c. 1534

In addition to works of art, Michelangelo also wrote a number of exalted poems to or for Vittoria Colonna, including several that use artistic metaphors:

Sketch upon me, without, As I do on bright page or on a rock, Which having nothing in it takes what I like.

This idea was then developed:

Non ha l'ottimo artista alcun concetto c'un marmo solo in sé non circonscriva col suo superchio, e solo a quello arriva la man che ubbidisce all'intelletto.

Il mal ch'io fuggo, e 'l ben ch'io mi prometto, in te, donna leggiadra, altera e diva, tal si nasconde; e perch'io più non viva, contraria ho l'arte al disïato effetto.

Amor dunque non ha, né tua beltate o durezza o fortuna o gran disdegno, del mio mal colpa, o mio destino o sorte; se dentro del tuo cor morte e pietate porti in un tempo, e che 'l mio basso ingegno non sappia, ardendo, trarne altro che morte.(Rime, 151)

(The best of artists never has a concept A single marble block does not contain Inside its husk, but to it may attain Only if hand follows the intellect.

The good I pledge myself, bad I reject, Hide, O my lady, beautiful, proud, divine, Just thus in you, but now my life must end, Since my skill works against the wished effect. It is not love, then, fortune, or your beauty, Or your hardness and scorn, in all my ill That are to blame, neither my luck nor fate, If at the same time both death and pity Are present in your heart, and my low skill, Burning, can grasp nothing but death from it.

This poem became famous when it was given learned commentary in a lecture by Benedetto Varchi, an eminent man of letters, published in 1550 (see pp. 278–80). Varchi was a leader of the distinguished new Accademia Fiorentina, of which Michelangelo was elected a member. Since the Academy was devoted to literature and the Tuscan tongue, this was a more unusual honor than it might seem. A madrigal by Michelangelo, of about the same time, uses similar images:

Sì come per levar, donna, si pone in pietra alpestra e dura una viva figura, che là più cresce u' più la pietra scema; tal alcun'opre buone, per l'alma che pur trema, cela il superchio della propria carne co' l'inculta sua cruda e dura scorza. Tu pur dalle mie streme parti puo' sol levarne, ch'in me non è di me voler né forza. (Rime, 152)

(Just as we put, O lady, by subtraction, Into the rough, hard stone A living figure, grown
Largest wherever rock has grown most small, Just so, sometimes, good actions
For the still trembling soul
Are hidden by its own body's surplus,
And the husk that is raw and hard and coarse,
Which you alone can pull
From off my outer surface;
In me there is for me no will or force.)

In another famous madrigal he compares Vittoria to a man or a god speaking inside a woman – a revealing image, however it may be interpreted:

Un uomo in una donna, anzi uno dio per la sua bocca parla, ond'io per ascoltarla son fatto tal, che ma' più sarò mio. I' credo ben, po' ch'io a me da lei fu' tolto, fuor di me stesso aver di me pietate; sì sopra 'l van desio mi sprona il suo bel volto, ch'i' veggio morte in ogni altra beltate. O donna che passate per acqua e foco l'alme a' lieti giorni, deh, fate c'a me stesso più non torni. (Rime, 235)

(A man, a god rather, inside a woman, Through her mouth has his speech, And this has made me such I'll never again be mine after I listen. Ever since she has stolen Me from myself, I'm sure,

Outside myself I'll give myself my pity. Her beautiful features summon Upward from false desire, So that I see death in all other beauty. You who bring souls, O lady, Through fire and water to felicity, See to it I do not return to me.)

Michelangelo, through Vittoria Colonna, learned to seek God above all thoughts of worldly fame, an idea that haunts him from this time on (see pp. 284ff.).

Although first Cavalieri and then Vittoria Colonna attracted Michellangelo's passion, they appealed to very different sides of his nature, as his drawings for them amply testify. Cavalieri remained his friend until death, and Michelangelo also blossomed out with other friends, notably the exiled Florentine banker Luigi del Riccio, who handled his affairs, constantly sent him food, and often got in return poems of one sort or another. Michelangelo, together with Del Riccio, conceived the plan of publishing the poems in a collected edition, only to be frustrated by Del Riccio's death in 1546. Consequently the order and dating of the poems are still not at all certain. They are, as the reader can gather from the passages quoted, passionate, rough like his unfinished sculptures, very far from the elegant petrarchism of the professional literary men of the period. But, as their modern editor, Enzo Noé Girardi, has pointed out:

Michelangelo is without doubt . . . the most immediate and basic interpreter of Renaissance civilization among the [Italian] lyric poets. Unlike all the others, without exception, he is not closed in his own little world: he does not portray a place or a manner, does not celebrate a literary fashion, taste, or style; he does not tell in verse his own personal life, or not it alone. His thoughts are the great thoughts of the century, and of every century: art, beauty, love, death; his drama is the great drama of that era, fought between heaven and earth, flesh and spirit, love of life and cult of death, Plato and Christ. That, writing of these things, he could have written 'better', may well be; but it is worth remembering that no one else, writing 'well', wrote of them at all.

When Vittoria Colonna died, shortly after Luigi del Riccio, Michelangelo was distraught. Condivi, in his record of Michelangelo's friendships, wrote of Vittoria,

of whose divine spirit he was enamored, being in return loved tenderly by her. He still possesses many letters of hers, full of a chaste and most sweet love, such as issued from her heart. He has written to her also many and many sonnets, full of wit and sweet desire. She often returned to Rome from Viterbo and other places, where she had gone for her pastime and to spend the summer, for no other reason than to see Michelangelo; and he bore her so much love that I remember to have heard him say that nothing grieved him so much as that when he went to see her after she passed away from this life he did not kiss her on the brow or face, as he did kiss her hand. Recalling this, her death, he often remained dazed as one bereft of sense.

After the double blow of her death and Del Riccio's, Michelangelo wrote to an old friend:

Having been very unhappy lately, I have been at home, and in going through some of my things a great number of trifles [poems] that I formerly used to send you came to hand, from among which I'm sending you four . . . You will say rightly that I am old and distracted, but I assure you that only distractions prevent one from being beside oneself with grief . . . Reply to me about something, I beg of you.

Brutus

We have seen that Michelangelo, in the period of The Last Judgement. led a richer personal life than ever before, with friends both lively and devout to divert him from his sense of aging and dying. One of these was another Florentine exile, Donato Giannotti, a historian who had been Secretary of State to the last republican government, succeeding Machiavelli. Michelangelo had known Giannotti during the siege, when Giannotti led the defense of San Miniato. He later wrote the Dialogues to which we have referred (p. 183), and according to Vasari it was he, while in the service of the great Cardinal Niccolò Ridolfi (beginning in 1539), who got Michelangelo to carve a bust of Brutus [172]. Ridolfi, after the murder of Duke Alessandro de' Medici in 1537, had gone to Florence with two other Florentine cardinals in a futile attempt to remove the new Medici Duke, Cosimo I, and restore the republic. The military leader of this opposition was Filippo Strozzi, who was beaten miserably in battle and imprisoned; he killed himself in desperation late in 1538. Giannotti, meanwhile, had been writing On the Venetian Republic and On the Florentine Republic. The latter, dedicated to Ridolfi, advocated tyrannicide - perhaps not merely with reference to Alessandro - and Giannotti had the hope of writing a play on the subject of Brutus. The tone struck in his works is that of Machiavelli's Discourses (first published in 1531): Caesar was the exemplum of tyranny, and Brutus the hero of republicanism. When Lorenzino de' Medici horribly murdered the bestial Alessandro he was following a prescribed and approved pattern; in exile in North Italy,

172. Michelangelo, Brutus. 1539-40?

he struck a medal showing himself as Brutus to commemorate the event, and was hailed by others as the Tuscan Brutus.

The *Brutus* must be seen against this background. Begun as a tribute to the republican spirit of Florence by an ardent patriot, it was then abandoned: according to the later epigram attached to the base, because while working on the bust Michelangelo was reminded of the crime and abandoned work. This could be a self-serving Medicean addition, but the inscription does correspond with ideas that were attributed to Michelangelo by Giannotti. In his *Dialogues*, written

sometime after 1545, he records Michelangelo's explanation of why Dante put Brutus and others like him in the lowest pit of Hell – whereas, Giannotti said, 'I would put them in the most honored seats in Paradise.' Michelangelo explained that Brutus was a traitor, of which the lowest kind was the betrayer of divine majesty – like Judas, since for Dante the Roman state was divinely instituted. In the second *Dialogue* Michelangelo is made to say that assassination is an act of arrogance if one cannot be certain that good will result; and even so, he cannot tolerate the idea of achieving good through bad. Thus the inscription may be authentic.

Michelangelo gave the *Brutus* and the Florence *Pietà* [184] to his pupil Tiberio Calcagni, whose work with the flat chisel can be differentiated from Michelangelo's own fine work with the *gradina*. The pose of Brutus is clearly based on Imperial busts like those of Caracalla [173]. Brutus's right profile, turned toward us, is handsome and

173. Roman bust of the Emperor Caracalla

aggressive, reminiscent of the *Rebellious Slave* [105]. As we move around to inspect the full-front and left side of the face, weaknesses, as of character, obtrude. The drapery and details elsewhere are Calcagni's. The bust has a fibula with a profile head, not wholly visible from normal height, which could be a 'secret,' idealized portrait of one of the Florentine patriots. Despite Vasari's claim that Brutus was based on an antique cornelian, it seems to be an ideal invention and not a true portrait. Unique in Michelangelo's works, it also stands apart from portrait busts of the period.

By 1540 Michelangelo had achieved status and riches unknown to previous artists. Whereas during the Sistine period he signed his letters 'Michelangiolo scultore,' now he is merely 'Michelangiolo.' His cares for his family, and especially for his nephew Lionardo. continue unabated: Michelangelo was exceedingly anxious to reestablish the old and - he thought - noble house of Buonarroti Simoni on a high level. In 1548 he denied ever having been a common artisan who kept a shop – his social position, and with him the status of all artists, had risen. We are on the verge of the establishment of Academic art, which Vasari began with the Accademia del Disegno in Florence in 1563. Michelangelo was the symbolic director, along with Duke Cosimo I. Michelangelo apparently even had a taste for fine clothes – he who had once slept without undressing and who later kept his boots on so long that the skin peeled off with the socks (see p. 290). In July 1540 he wrote to his long-suffering nephew (only surviving son of Buonarroto, who had died in 1528):

Lionardo: I received three shirts with your letter and was much amazed that you sent them to me, since they are so coarse that there is not a single peasant here who wouldn't be ashamed to wear them, and even if they had been fine, I wouldn't have wanted you to send them to me, because when I need them I shall send the money . . .

By 1546 he was urging Lionardo to buy an imposing house, preferably in their quarter (Santa Croce). He rejects one proposal because 'it doesn't seem to me to be our kind of street.'

11 Figural Works of the 1540s and 1550s

The Julius Tomb (Finale)

All through the thirties Michelangelo was still troubled with the spectre of the unfinished tomb of Julius II. Late in 1531 the Duke of Urbino canceled the project of 1516 because he did not want to spend more money. Various possibilities were considered - Michelangelo could send his Florentine tomb sculptures to Rome and have the tomb finished by others. He also offered to give back the money and cancel the commission. Clement VII had realized how the unfinished tomb worried Michelangelo, and urged him to complete it, saying it would make him twenty-five years younger. In April of 1532, after Michelangelo had made a quick trip to Rome, a fourth contract was drawn up for a wall tomb in the church of San Pietro in Vincoli, and the Pope was to allow him some two months each year to do the work. Michelangelo promised to provide a new model 'ad suo piacere,' and to deliver six of the unfinished statues from his workshops in Florence and Rome. When he was in Rome in 1532-3, enamored of Cavalieri, he hired an assistant to begin helping him do the remaining statues for the tomb, but we have no idea what was done. We have seen that, according to Condivi, while Michelangelo was supposed

to be working on the cartoon of *The Last Judgement* (c. 1534) he was secretly working on the tomb, but what he was doing we do not know. Presumably nothing more was done later: from Clement's death in 1534 until the end of 1541, when *The Last Judgement* was finally finished, no serious work on the tomb could be undertaken, since Paul III insisted that Michelangelo work only for him.

As soon as *The Last Judgement* was finished, Paul III pressed Michelangelo to decorate a new chapel, the Cappella Paolina (see p. 273). Therefore a new and final tomb project was agreed upon. Early in 1542 the Della Rovere Duke wrote that he would be content with three figures wholly by Michelangelo, the Moses and, presumably, the Slaves now in the Louvre [103-7]. The remaining three statues for this project were to be carved by some worthy master. Michelangelo made a contract with Raffaello da Montelupo in February 1542 to complete the Virgin, Prophet, and Sibyl that he claimed to have blocked out. But in July Michelangelo told the Pope that the two Slaves were unsuitable for the reduced size of the tomb - indeed. their carnality seems out of place in conjunction with Michelangelo's increased piety of this, the Vittoria Colonna period. To replace them he began two figures of the Active and Contemplative Life. A final contract of August 1542 negates the contract of 1532 and agrees to furnish the statues, of which the Moses alone was to be solely by Michelangelo. The figures representing Active and Contemplative Life were supposedly 'almost finished' and could be completed by Raffaello. The Duke, however, insisted on three statues wholly by Michelangelo. and so agreement was finally reached in November. But the delay in ratifying the contract caused Michelangelo agony:

Enough: for the trust of thirty-six years and for giving myself freely to others I deserve nothing else; painting and sculpture, labor and trust have ruined me, and it's still going from bad to worse. It would have been better if in my early years I had set myself to making matches . . .

In another letter he says that 'an excessive honesty, which went unrecognized, has been my ruin.'

Michelangelo's statues were finally installed in the monument in the first two months of 1545. The tomb itself is only moderately impressive, a mixture of several styles and hands [174]. The beautifully carved blocks with *grotteschi*, from the early period (1505–16), seem all but Quattrocentesque, and contrast strongly with the huge volutes that replace the *Slaves*. The upper architecture, stark and frozen, is entirely different, and only specialists care about the inexpressive

statues set in its niches, although the strange effigy of the pope is clearly based on an Etruscan source and was designed by Michelangelo, as were the others. He was particularly displeased with

174. Michelangelo and assistants, tomb of Julius II. Rome, San Pietro in Vincoli. Finished 1547

Raffaello's expressionless *Prophet* and *Sibyl*. Michelangelo closely supervised the decorative details, and Vasari tells us of the master who was carving one of the terminal figures. Michelangelo

guided him by saying: 'Cut away here, make it level there, polish here . . .' until, without realizing what was happening, the man had carved a figure. After it was finished, as the stone-cutter was staring at it in astonishment, Michelangelo inquired: 'Well, what do you think?'

'I think it's fine,' he said, 'and I'm grateful to you.'

'Why's that?'

'Because through you I've discovered a talent I never knew I had.'

In the central niche of the lower story Michelangelo installed the *Moses* [175], probably after cutting away the drapery below the left

175. Detail of illustration 174

knee to make some accommodation to the new, high viewpoint from which we must see the statue (see p. 160). We are told that he still had some work to do on it, but it seems likely that it was already highly polished, since the accompanying figures, done anew at this

time, do not show such a surface. The meaning of this great statue is now wholly different from what was first intended; begun as one of a number of symbolic figures, it now finds a central place in a papal tomb and not only implies all of the force of divinity invested in Moses in the Old Testament but becomes as well a prototype of the New, standing both for Peter and for Julius himself.

Rachel and her sister Leah [176, 177] were the daughters of Laban and wives of Jacob (Genesis 29ff.). Dante characterized them in the *Purgatorio* as representatives of the Active and Contemplative Life, and Condivi tells us that this was Michelangelo's source of inspiration. These are the last statues Michelangelo ever finished. The *Rachel* is the more expressive, elongated in prayer and 'with her face and both her hands raised to heaven so that she seems to breathe love in every part,'

176. Michelangelo, Rachel

177. Michelangelo, Leah

178. Michelangelo, Leah (detail)

as Condivi wrote. Michelangelo clearly thought of her as a representation of Faith (see p. 255). He spiritualized her in convent garb, to the detriment of the stolid, earthy *Leah*, who is apparently proffering a diadem (but according to the old sources is holding a mirror, like Prudence [cf. 178]). *Leah* thus symbolizes Good Works, but perhaps also an aspect of *Caritas* (Love). In a sense the two figures together symbolize the virtue that St Paul called the greatest: love of God and love of mankind. These female figures are far more summary in their finish than any of Michelangelo's earlier works, display stretches of bland, inexpressive carving, and were surely produced with less personal involvement than we normally expect in his sculpture. Nevertheless, there is a calm resignation and sense of spiritual beauty that pervade even these last, minor works. And so, rather miserably, and to the

great dissatisfaction of the Della Rovere, Michelangelo finished the tomb he had begun so exuberantly forty-two years before. It was unveiled in 1547.

In the course of working on the tomb, in early summer of 1544, Michelangelo became seriously ill and was nursed by his friend Luigi del Riccio, the agent of Roberto Strozzi, in the Strozzi palace. Strozzi, then away in France, was another of the *fuorusciti* who left Florence in protest against the rule of the Medici (see p. 263). In gratitude for his hospitality Michelangelo gave Strozzi (or perhaps first gave Del Riccio, who died late in 1546) the two *Slaves*, no longer needed for the tomb. He also had Del Riccio write to Strozzi to remind King Francis I that Michelangelo would erect a statue of the King at his own expense in the piazza if Francis would only liberate Florence. Michelangelo still believed in Dante's ideal of an imperial liberator of his country.

The Pauline Chapel

During the whole of the last phase of the completion of the tomb, Michelangelo was also working on the Pope's next project, two frescoes on the side walls of the new Cappella Paolina. The idea of painting the chapel was probably implicit from its beginning c. 1537, and was already voiced by Paul III before *The Last Judgement* was

179. Cappella Paolina, Vatican

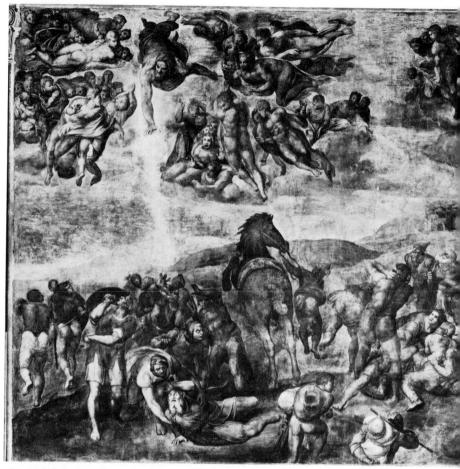

180. Michelangelo, The Conversion of Paul

finished. Michelangelo had to settle the tomb before he began to plan and paint the first of the frescoes, which was probably *The Conversion of Saul (St Paul)* on the left wall [180]. Although urged to begin earlier, Michelangelo simply could not start painting until the final ratification of the tomb contract. As he wrote in the fall of 1542, 'one paints with the head and not with the hands . . . until my affair is settled, I can do no good work.' The execution of the fresco, interrupted by illness and delayed by work on the tomb, extended from late 1542 until mid-1545, when Paul III visited the chapel, presumably to see the completed work.

The idea of frescoes representing Paul III's namesake and his earliest predecessor, Peter, was surely the Pope's. He himself had

special devotion to the feast of Paul's conversion (25 January), which may have had a personal meaning for him as well as reflecting new Counter-Reformatory interests in conversion and salvation. Michelangelo painted Saul old – contrary to the story – perhaps as an

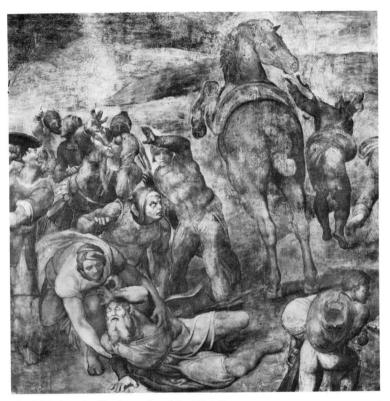

181. Michelangelo, The Conversion of Paul (detail)

idealized reference to the bearded Pope [181]. At first Michelangelo seems to have had the idea of opposing this fresco with a scene of Christ Giving the Keys to St Peter – this is what Vasari thought was to be painted when he published the first edition of his *Lives* in 1550. In Rome, the Giving of the Keys was a favorite papal subject, and became a favored propagandistic theme of the Counter-Reformation. It might be thought a logical counterpart to the Conversion and, like it, represents a divine charge to continue Christ's work on earth.

The story of Paul's conversion is told three separate times, almost identically, in the Acts of the Apostles. Saul, a lawyer of Tarsus, was a great enemy of the Christians and delighted in persecuting them. He described how

I was given letters . . . to our fellow-Jews at Damascus, and had started out to bring the Christians there to Jerusalem as prisoners for punishment; and this is what happened. I was on the road and nearing Damascus, when suddenly about midday a great light flashed from the sky all around me, and I fell to the ground. Then I heard a voice saying to me 'Saul, Saul, why do you persecute me?' I answered 'Tell me, Lord, who you are.' 'I am Jesus of Nazareth,' he said, 'whom you are persecuting.' My companions saw the light, but did not hear the voice that spoke to me. 'What shall I do, Lord?' I said, and the Lord replied 'Get up and continue your journey to Damascus; there you will be told of all the tasks that are laid upon you.' As I had been blinded by the brilliance of the light, my companions led me by the hand, and so I came to Damascus. (Acts 22.5–11)

The story, in part owing to Michelangelo's painting, became a familiar subject in the following years. Michelangelo was following recent artistic tradition in showing a horse, not mentioned in scripture. (He was particularly fond of horses, and owned a beautiful Arab stallion that had been given to him by a friend.) An empty area behind the horse in the fresco signals the spot where Saul in his pride was riding when the lightning struck; around it we see the blinded Saul lying in the foreground, the horse (based on an antique Horse-tamer) bolting to the rear, and the entourage of figures reacting to the event. They create a centrifugal group, roughly circular in plan and tipped up on the rising ground to form an oval. In the sky, another circular but centripetal group surrounds the foreshortened figure of the flying Christ (not mentioned in Paul's account), whose right hand casts the beam of light at Saul's head. In the distant background we see Damascus, a fascinating revelation of Michelangelo's ideas of Near Eastern architecture. This and the companion fresco are Michelangelo's first paintings to show real depth and space comparable to that in other paintings of the Renaissance - and this at a time when so-called Mannerist painters were often eliminating space from their compositions, in part after Michelangelo's example.

By August 1545 the wall for the second fresco had been prepared, but we do not know when Michelangelo began painting. In November of 1545 he wrote Luigi del Riccio that he was thinking of going to Santiago de Compostella – evidently on pilgrimage. The second fresco could have been underway at this time, but Michelangelo again fell ill that winter. The fresco was still not finished when the Pope made a visit in mid-October 1549; on 10 November he died. Perhaps Michelangelo himself influenced the change of subject to *The Crucifixion of Peter*, which also exemplifies a current theme, the Imitation of Christ. Peter was crucified but, according to tradition, so as not to seem truly

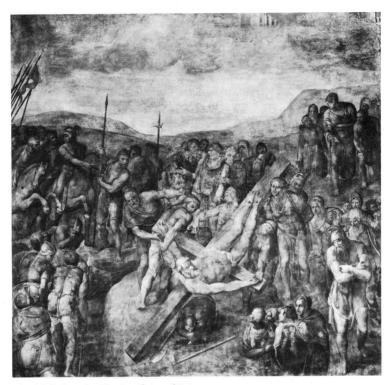

182. Michelangelo, The Crucifixion of Peter

like Christ, he chose to be martyred upside-down [183]. The head of Peter seems to be conceived as an idealized, ironic self-reference. Like its companion, the fresco is a purely figural composition, but without supernatural adjuncts [182]. Peter is shown, unusually, at the time of the actual raising of the cross, leaning up and looking out – not blindly, as Saul does, but engaging the eyes of the visitor. Peter, a mere man, is dying for our sins, as Christ did before him. The message is papal and Counter-Reformatory: I am Peter, the Rock on whom Christ built his Church. Only through it can you find salvation in Him.

Freedberg has beautifully characterized the style of the two frescoes, which is a development from that of *The Last Judgement*:

The earlier fresco, the *Conversion of St Paul*, displays clearly what the *Crucifixion of St Peter* shows still more: a stage of unconcern with *grazia* and the ideas of beauty of form that are associated with it . . . Figures are described as blunt, dense shapes, heavily direct in pose,

and there is no trace in them of a virtuoso display of anatomy . . . The human body is the earthen shell, the *carcer terreno* of a spirit that seems not to possess a private will or even specified identity. This is an abjuring of a whole life's history, and of the aspirations of the time in which it had been made: in the deepest possible sense an anticlassicism, and a negation of the Renaissance.

The figures act like puppets in the hands of God, and the purely artistic aspects of *The Last Judgement* have been replaced by a sense of inevitability and even predestination. This is particularly true of *The Crucifixion of Peter*, where the crucifiers seem to act out of divine necessity without malice or feeling, and the onlookers to accept the martyrdom with resignation. Michelangelo here anticipated the formulations of the Council of Trent in 1562, and the general artistic reaction to the Counter-Reformation that is manifest later in the century. The religious, un-artistic aspect of the frescoes is explained and developed in later poems:

There's no painting or sculpture now that quiets The soul that's pointed toward that holy Love That on the cross opened Its arms to take us. [see p. 286]

But if in the Paolina Michelangelo seems to have put his art wholly at the service of faith, rejecting the physical allure and passion of his earlier style, there is still art in these frescoes, in their novel and influential compositions, and nowhere more than in the softly modulated coloration of *The Conversion of Paul*, which continues that of the Sistine ceiling in violet, blue, and green hues. But the art of these frescoes is above all an intellectual one – Michelangelo himself was quoted in this period as saying that

Art is a music and a melody that the intellect alone can understand, and that with difficulty.

While he was painting *The Crucifixion of Peter*, Michelangelo was asked to reply to the second lecture by Benedetto Varchi, of March 1547, commenting on Michelangelo's supposed assumption that sculpture was superior to painting, as expressed in the sonnet *Non ha l'ottimo artista* (see p. 260). Michelangelo replied ironically as follows:

Master Benedetto: So it may indeed appear that I have received your little book, as I have, I shall answer something to the questions it asks me, although I am not well informed. In my opinion painting is to be considered the better the more it approaches relief, and relief is to be considered the worse the more it approaches painting: and therefore I used to feel that sculpture was the lantern of painting, and that there was the difference between them that there is between the sun and

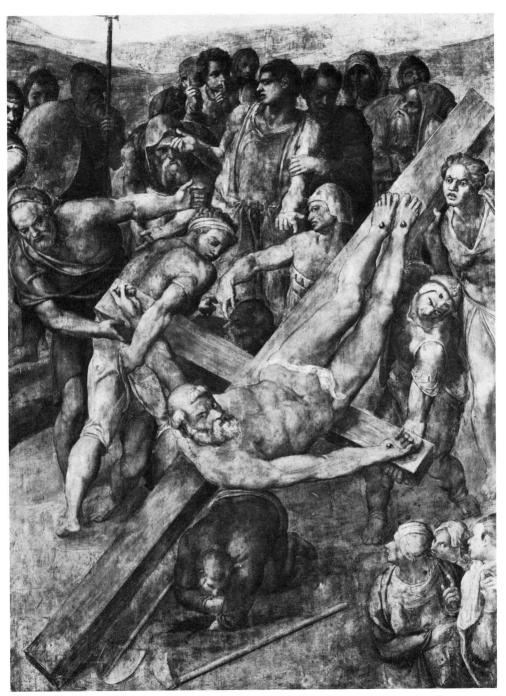

183. Michelangelo, The Crucifixion of Peter (detail)

moon. Now, since I have read the point in your little book where you say that, philosophically speaking, those things that have the same end are the same thing. I have changed my opinion, and say that, if greater judgement and difficulty, obstacles and labor, do not make greater nobility, painting and sculpture are one identical thing; and since it is so concluded, every painter ought to do no less sculpture than painting, and likewise the sculptors as much painting as sculpture. I mean by sculpture what is done by main force in cutting off; what is done by adding is similar to painting; enough that since the one and the other come from the same faculty, that is sculpture and painting, they can make peace together between themselves and leave such disputes behind, for more time goes into them than into making figures. As for the man who wrote that painting was more noble than sculpture . . . my serving maid would have written them better . . . I am not only old but almost one of the number of the dead: so I beg you to accept my excuses . . .

In the fall of 1546 Antonio da Sangallo the Younger died, and Michelangelo reluctantly entered a new career: architect not only of St Peter's but of the Capitol and of the Palazzo Farnese. These, the greatest enterprises of his old age, are in many respects the high points of his entire career (see Chapter 12).

In the later 1540s Michelangelo was increasingly unwell. Beginning in May 1548 he had difficulty urinating, and suffered miserably from kidney stones on and off thereafter. Much of the time he could not work, and his querulous letters to his nephew Lionardo show how irritated and cantankerous he often was. Nevertheless, he was grateful for gifts of wine and cheese, although often his thanks are backhanded (see pp. 309ff.). In mid-1548 he thanked Lionardo for a barrel of pears, 'which numbered eighty-six. I sent thirty-three of them to the Pope; he thought them excellent . . .'

The Florence Pietà

Condivi, writing in the early 1550s, reported that

At present he has in hand a group in marble, which he works at for his pleasure, as one who, full of ideas and powers, must produce something every day. It is a group of four figures, larger than life – a Deposition [184]. The dead Christ is held up by His Mother; she supports the body on her bosom with her arms and with her knees, a wonderfully beautiful gesture. She is aided by Nicodemus above, who is erect and stands firmly – he holds her under the arms and sustains her with manly strength – and on the left by one of the Marys, who,

although exhibiting the deepest grief, does not omit to do those offices that the Mother, by the extremity of her sorrow, is unable to perform. The Christ is dead, all His limbs fall relaxed, but withal in a very different manner from the Christ Michelangelo made for the Marchioness of Pescara [169] or the Pieta [18] . . . It is impossible to speak of its beauty and its sorrow, of the grieving and sad faces of them all,

184. Michelangelo and Tiberio Calcagni, The Deposition of Christ. c. 1547-55

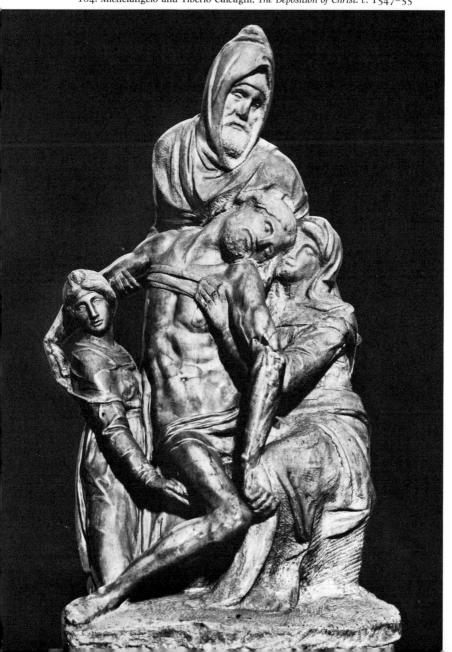

especially of the afflicted Mother. Let it suffice; I tell you it is a rare thing, and one of the most laborious works that he has yet done, principally because all the figures are distinct from each other, the folds of the draperies of one figure not confused with those of the others . . . He intends to give the Deposition from the Cross to some church, and to be buried at the foot of the altar where it is placed.

Vasari, in his first edition of 1550 (written c. 1547), already knew this four-figure group, and mentions the 'Cristo deposto di Croce,' which was evidently the only figure very far advanced at that time. Just when Michelangelo began this group, in the earlier or later 1540s, we do not know. Vasari adds that Michelangelo did the work 'to amuse and occupy himself and also, as he used to say himself, because using the hammer kept his body healthy.' Michelangelo used to work on the sculpture at night, and devised a cap of heavy paper supporting a candle so that he could see what he was carving. Even in old age he was a ferocious worker. A French visitor reported that Michelangelo, even in frail health, could

hammer more chips out of very hard marble in a quarter hour than three young stonecarvers could do in three or four, which has to be seen to be believed, and he went at it with such impetuosity and fury that I thought the whole work must go to pieces, knocking off with one blow chips three or four fingers thick, so close to the mark that, if he had gone even slightly beyond, he ran the danger of ruining everything.

Vasari relates that he was once sent to Michelangelo's house shortly after sunset by Pope Julius III (1550–55) in order to get a drawing, and found Michelangelo working on the *Pietà*:

Michelangelo left his work and met him with a lamp in his hand. After Vasari had explained what he was after, he sent Urbino upstairs for the drawing and they started to discuss other things. Then Vasari's eyes fell on the leg of the Christ on which Michelangelo was working and making some alterations, and he started to look closer. But to stop Vasari seeing it, Michelangelo let the lamp fall from his hand, and they were left in darkness. Then he called Urbino to fetch a light, and meanwhile coming out from the enclosure where he had been working he said:

'I am so old that death often tugs my cloak for me to go with him. One day my body will fall just like that lamp, and my light will be put out.'

Vasari also relates that at some time, apparently late in 1555, Michelangelo

broke it to pieces. He did this either because it was hard and full of emery and the chisel often struck sparks from it, or perhaps because his judgement was so severe that he was never content with anything he did. That this was the case can be proved by the fact that there are few finished statues to be seen of all that he made in the prime of his manhood, and that those he did finish completely were executed when he was young . . . The others, with the exception of Duke Giuliano and Duke Lorenzo, the Night, the Dawn, and Moses, with the other two . . . were all left unfinished. For Michelangelo used to say that if he had had to be satisfied with what he did, then he would have sent out very few statues, or rather none at all. This was because he had so developed his art and judgement that when on revealing one of his figures he saw the slightest error he would abandon it and run to start working on another block, trusting that it would not happen again. He would often say that this was why he had finished so few statues . . . Tiberio [Calcagni] asked Michelangelo why he had broken the Pietà (which was in the house) and wasted all his marvelous efforts. Michelangelo answered that . . . a piece had broken off from the arm of the Madonna . . . as well as other mishaps including his finding a crack in the marble, had made him so hate the work that he had lost patience and broken it; and he would have smashed it completely had not his servant Antonio persuaded him to give it to someone just as it was.

The Florentine *Pietà*, although unfinished, mutilated, and partly completed by the mediocre Calcagni, is one of Michelangelo's most famous works. But Duke Cosimo I de' Medici refused to put it into the Medici Chapel, because it seemed to him of lesser worth than the statues already there. This story reflects on the taste of the time, which was for highly-finished art [cf. 140]. But it also casts a light back onto our own prejudices in favor of the rough, difficult, and enigmatic. One taste is not necessarily better than the other.

The group is pyramidal and frontal, composed of the broken body of Christ being lowered by Nicodemus, with the Magdalen at our left and the Virgin Mary to the right. The Magdalen, finished by Calcagni, is an inexpressive figure that communicates dumbly with the spectator. Mary is roughly blocked out, as is the head of Christ, which sags down onto hers in a moving last farewell [185]. The cowled head of Nicodemus reveals the unfinished features of Michelangelo himself, who serves here as the idealized bearer and burier of Christ. This was recognized by Vasari in 1564, and may be related to the fact that a Nicodemus was supposedly the sculptor of a famous Crucifix in Lucca, the *Volto Santo*. But whereas in the stories of the deposition and entombment Nicodemus is mentioned only in passing, and only by John, the story of Joseph of Arimathea, who buried Christ in his

own tomb, is told by all the gospel writers. Michelangelo's intention to use the group for his own tomb might suggest that the bearded figure is not Nicodemus but Joseph. Nevertheless, Nicodemus, a Pharisee, made a memorable visit to Christ in the night, who said to him:

'In truth, in very truth I tell you, unless a man has been born over again he cannot see the kingdom of God . . .

'God loved the world so much that he gave his only Son, that everyone who has faith in him may not die but have eternal life . . .

'The man who puts his faith in him does not come under judgement . . .' (John 3.1-21)

This passage seems to relate Michelangelo's belief in salvation through faith with the Nicodemus who traditionally carried Christ's body in its shroud in Renaissance *Entombments*. But he did not find the scene in the Bible. The Virgin Mary is never mentioned in these passages, if indeed a particular episode is definable. The closest model for the group is a painting by Filippo Lippi in which Christ is actually being lowered into a tomb, and a later engraving of Michelangelo's group shows it in a landscape before the tomb. There is, therefore, considerable ambiguity about the subject – Deposition, *Pietà*, and Entombment are fused into one iconic image. In his *Life* of Bandinelli, Vasari also says that Michelangelo wanted to be buried at the foot of this sculpture. If so, the significance of the subject would be extended still further as a personal *concetto* – the likeness of Michelangelo, burying Christ in the guise of Nicodemus/Joseph, stands over the grave of the mortal Michelangelo, who hopes to be saved through faith.

In his poetry Michelangelo constantly asks how so old and sinful a man may find salvation. These may be poetic metaphors but they correspond to the spirit of the *Pietà*, which is a typically knotty expression of many of these perennial hopes and fears. They express his anxiety when he felt

si presso a morte, e si lontan da Dio. (*Rime*, 66) (With death so near and God so far away.)

The central figure of Christ is the only one that seems to have been relatively finished; its left arm is broken and repaired, its left leg missing. Originally it crossed the Virgin's thigh, with the foot touching the ground. This motif has echoes all the way back to the *Taddei tondo* [37]. But the implications of the leg slung over Mary's thigh may have become too overtly sexual for Michelangelo to tolerate – in any event, he removed it and it has rarely been missed. The twisted, limp body of Christ recalls ancient sculptures of Menelaus with the body of Patroclus, one of which, in Florence, Michelangelo particularly

admired. The body of Christ twists into a memorable *serpentinata* pose related to that of the *Dying Slave* [103] but also reminiscent of the first *Pietà* [18]. A study probably made for Sebastiano c. 1534 [171] already shows a related pose. These comparisons with some of Michelangelo's most physical and sensuous works show that even around 1550, aged seventy-five, he had not entirely abandoned his youthful sculptural ideal. On the other hand, only the torso still attracted him in this way, and as he worked on the other parts – whatever material problems there may have been – he clearly grew dissatisfied. The verticality of the group is predominant, compared to earlier *Pietà*s. Christ seems to twist and slip down between the others. As Tolnay wrote, the action of Nicodemus above, who lowers Christ and embraces Mary, 'unites the Mother and Son in a kind of ultimate *sposalizio* . . . [185]. This spiritual marriage is the essence of the

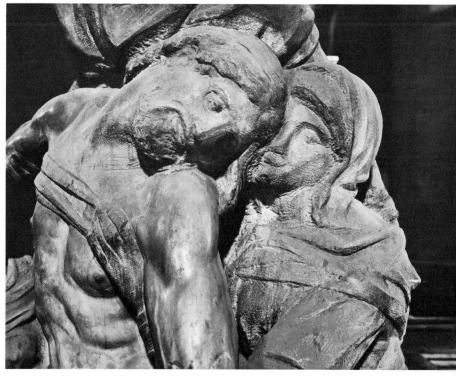

185. Detail of illustration 184

concetto.' The central group of Christ and Mary carries a powerful emotional impact, despite its wounds and unfinished areas. Still, the group is at least as interesting as autobiography as it is as a work of art.

Just a year before he destroyed the *Pietà* he wrote a famous sonnet that reveals one aspect of his new religious point of view:

Giunto è già 'l corso della vita mia, con tempestoso mar, per fragil barca, al comun porto, ov'a render si varca conto e ragion d'ogni opra trista e pia.

Onde l'affettüosa fantasia che l'arte mi fece idol e monarca conosco or ben com'era d'error carca e quel c'a mal suo grado ogn'uom desia.

Gli amorosi pensier, già vani e lieti, che fien or, s'a duo morte m'avvicino? D'una so 'l certo, e l'altra mi minaccia.

Né pinger né scolpir fie piú che quieti l'anima, volta a quell'amor divino c'aperse, a prender noi, 'n croce le braccia. (*Rime*, 285)

(My course of life already has attained, Through stormy seas, and in a flimsy vessel, The common port, at which we land to tell All conduct's cause and warrant, good or bad, So that the passionate fantasy, which made Of art a monarch for me and an idol, Was laden down with sin, now I know well, Like what all men against their will desired. What will become, now, of my amorous thoughts, Once gay and vain, as toward two deaths I move, One known for sure, the other ominous? There's no painting or sculpture now that quiets The soul that's pointed toward that holy Love That on the cross opened Its arms to take us.)

This poem was sent to Vasari on 19 September 1554 with the following lines:

Master Giorgio, dear friend: You will surely say I am old and crazy to want to produce sonnets, but since many say I am in my second childhood, I wanted to act the part . . .

At about the time of this poem and of the destruction of the *Pietà*, Michelangelo drew in chalk several Crucifixes; not the live, *Laocoön*-like Christ of the Vittoria Colonna *Crucifix* [169], but pitiful and dead on the cross, with Mary and John. One, perhaps the last of the series, becomes almost a *Pietà* as the numbed figures approach and touch the body [186]. Michelangelo's hand now falters, the lines are indistinct, and outlines are often drawn over several times, giving a

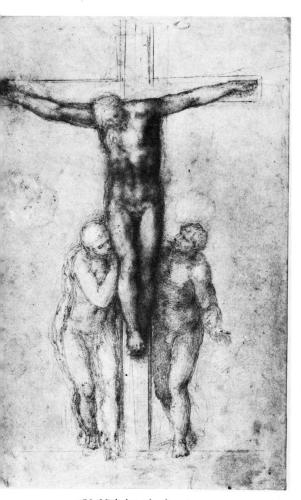

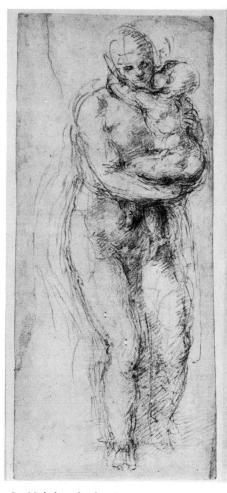

187. Michelangelo, drawing of a standing *Madonna*

blurred, mystical look that has been very appealing to modern eyes. A moving example of this shaky, old-age style is a very late standing *Madonna*, in chalk, enormously sculptural in its implications [187]. In this, perhaps the last of his figural compositions, there is still a rich display of rhythm and color despite the signs of feeble age. Panofsky has said of these works that finally 'the dualism between the Christian and the classical was solved. But it was solution by way of surrender.'

The Rondanini Pietà

Vasari relates that once Michelangelo had broken up the Pietà,

it was now necessary for him to find another block of marble, so that he could continue using his chisel every day; so he found a far smaller block containing a *Pietà* already roughed out and of a very different style.

The figure of Christ in this *Pietà*, begun perhaps in the mid-1540s, may be reflected in a painting by Taddeo Zuccari of *c*. 1560 [188]. Michelangelo then proceeded to destroy and recarve the group, creating the mere whisper of another, standing, *Pietà* [189]. He was working on this mutilated fragment on 12 February 1564, six days before his

188. Taddeo Zuccari, The Deposition of Christ. c. 1560

death, as we learn from his follower Daniele da Volterra: 'Michelangelo worked all Saturday . . . standing up, studying that torso of a *Pietà*.' The *Rondanini Pietà*, so-called from the Roman palace where it long stood, is a strangely curved Gothicizing work that has led commentators to try to define a late, Medievalizing tendency in Michelangelo's art and thought. Certainly his attitude toward art had changed drastically – no longer was he the God-like creator of divine forms. But this final statue is the result of old-age debility, and although it is

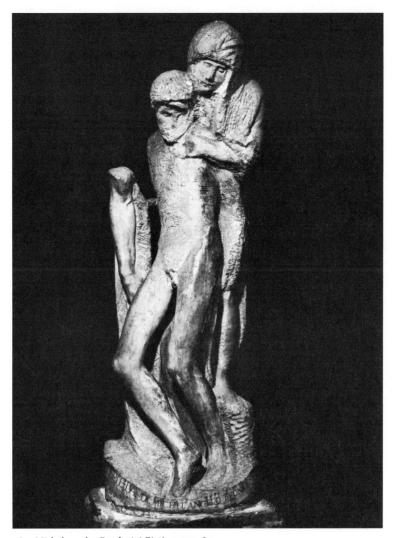

189. Michelangelo, Rondanini Pietà. 1555–64

strangely moving, its interest is chiefly autobiographical. Unlike Michelangelo's other unfinished works, this is hardly a potential work of art. It is a record of the old man's solitary need to express something more in stone, his beloved enemy. More and more isolated – in 1556 he wrote 'all my friends are dead' – beleaguered at St Peter's, almost unable to write or draw, he was still obsessed with his original passion to create from stone. The Gothic, formless, anti-physicality of this wreck is unbearably pathetic.

Vasari gives us a description of the Michelangelo he knew in the 1550s and 1560s:

I must record that Michelangelo's constitution was very sound, for he was lean and sinewy . . . he could always endure any fatigue and had no infirmity, save that in his old age he suffered from dysuria and gravel . . . As he grew old he took to wearing buskins of dog-skin on his legs, next to the skin; he went for months at a time without taking them off, then when he removed the buskins often his skin came off as well. Over his stockings he wore boots of cordovan. fastened on the inside, as a protection against damp. His face was round, the brow square and lofty, furrowed by seven straight lines, and the temples projected considerably beyond the ears, which were rather large and prominent. His body was in proportion to the face, or perhaps on the large side; his nose was somewhat squashed. having been broken . . .; his eyes can best be described as being small. the colour of horn, flecked with bluish and vellowish sparks. His evebrows were sparse, his lips thin (the lower lip being thicker and projecting a little), the chin well formed and well proportioned with the rest, his hair black, but streaked with many white hairs and worn fairly short, as was his beard, which was forked and not very thick.

12 The Roman Architecture

The Piazza del Campidoglio

Early in 1536 Emperor Charles V made a ceremonial visit to Rome. The Pope, Paul III Farnese, did his best to ornament the recently ravaged city, but Rome had no central square in which to receive and impress so great a dignitary. The obvious place to have such a ceremonial reception was on the Capitoline Hill, the focus of ancient Roman Triumphs. In those times the Capitol supported the chief temple of the state religion, dedicated to Jupiter Optimus Maximus. There, too, were kept the Roman state archives, and various sacred relics like the Wolf. In the later Middle Ages the hill became a center of Rome's political life. But Rome herself had shrunk; the old focus of the hill, the forum to the southeast, was now only a cow-pasture amid ruins. So the newer buildings faced what was left of Rome, in the opposite direction. A palace for the Senator, an office newly created in 1144, was begun in the twelfth century above the ruins of the Tabularium. A palace for the Conservators of Rome was built into the ruins of the great temple in the fifteenth century [190]. Sixtus IV, in the Quattrocento, donated some famous antiquities to the people of Rome, and henceforth one of the functions of the Capitol was to house a public art museum, perhaps the first since antiquity, which was patriotic and even imperial in its connotations.

190. View of the Capitoline Hill, Rome. c. 1554-60

191. Engraved plan of Michelangelo's project for the Capitoline Hill. 1567

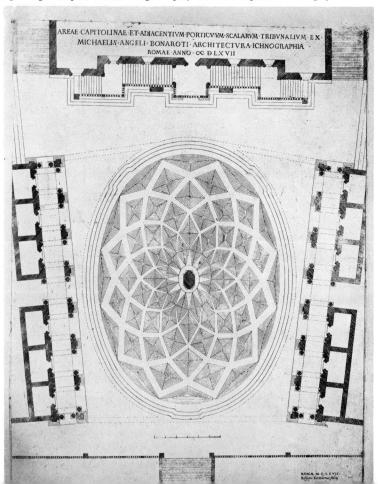

So stood affairs when Paul III decided to do something about the Capitol - too late for Charles V, who was entertained elsewhere. Paul determined to move the famous equestrian statue of Marcus Aurelius - the only monumental bronze of its kind to survive antiquity - to the empty piazza before the Palazzo del Senatore, and set it up early in 1538, facing the normal approach from Rome. Michelangelo had opposed this move, but having been made a citizen of Rome on the Capitol on 10 December 1537, a great honor, he soon set about designing a new base for the statue. And perhaps at this time he made preliminary plans for a new piazza around it. Almost nothing of the new project was built before Michelangelo died; we know that details remained to be designed in the later 1550s, and after his death the new architects made some important changes. Nevertheless, thanks to the preservation of this design in engravings [191, 192], the scheme was erected more or less according to his wishes, although finished only in the mid-seventeenth century.

192. Engraved view of Michelangelo's project for the Capitoline Hill. 1569

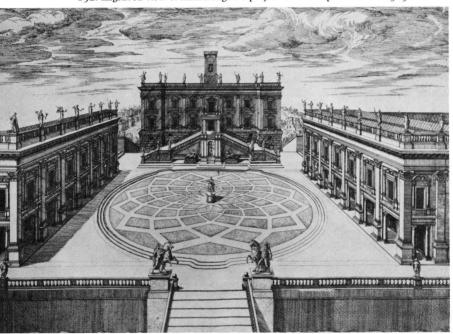

Michelangelo's base for the symbolic statue seems to imply the oval area that he eventually described around it. At the right he planned a new façade for the old Palazzo dei Conservatori and, to balance it, a similarly canted palace opposite. These new façades,

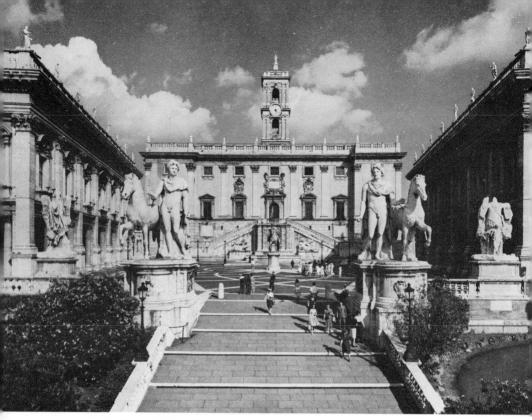

193. The Piazza del Campidoglio

with a modestly refurbished Senator's palace as the backdrop, defined a trapezoidal space that was so enclosed as to seem like a kind of open-air room — a piazza salone, as it is called in Italy [193]. The approach was by a ramp leading into the narrow end of the trapezoid, and the contrast between the narrow entrance and the irregular, semi-triangular space with a central statue on an oval prominence creates a dynamic tension between central and diffuse, oval and triangle. The egg-shaped segment of the oval, rising up to support the Emperor, recalls the old idea of the Capitol as the center of the world — the umbilicus mundi. The august bronze symbolizes Rome's Imperial might, and as time went on more trophies of the glorious past were added — Horse-tamers (Dioscuri), trophies, and other relics symbolizing power and authority. So the Capitol is not just a piece of city-planning but a conscious aggregate of references to the dignity and beauty and power of Rome, ancient and modern.

The novel center of the piazza employs what was then an unusual form, the oval. Michelangelo, who may have invented a compass for

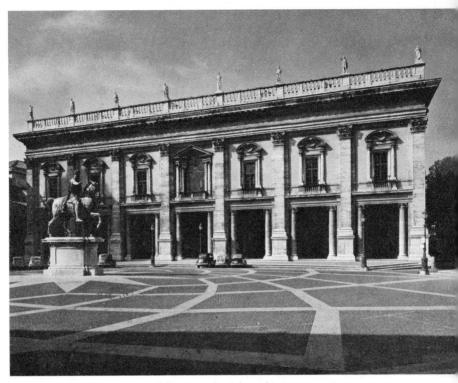

194. Michelangelo and Giacomo della Porta, the Palazzo dei Conservatori

inscribing ovals, used it here to unite an irregular space – both centralizing and longitudinal – to emphasize the centrality of the statue and still to encompass the façades of the three palaces, two identical but not parallel, one divergent. It is brilliantly successful. The oval was to be decorated with a complex geometric design related to ancient cosmological schemes. Like so many of Michelangelo's forms, the oval came into its own as an architectural space only in the following century, when Bernini and Borromini preferred it for their chapels and churches.

The most novel and exciting aspect of Michelangelo's design, apart from its whole conception, which is unique, is the design of the Palazzo dei Conservatori [194]. This was later echoed in the opposite palace, whose function was purely esthetic – hence its long-delayed construction. Michelangelo conceived an architectural screen in front of the palace that would acknowledge its two-story structure yet achieve a new unity. In order to do this he articulated his new ground-floor loggia with a lintel instead of the usual arches, supported by

Ionic columns. The bays are divided by an order of colossal Corinthian pilasters that rise through both stories to support a magnificent entablature surmounted by a balustrade and statuary. The open, trabeated loggia below carries on the idea of the Quattrocento arcade in novel terms [cf. 190]. Above, the walled-in *piano nobile* is given windows whose gables are supported by colonnettes – thus there are three gradations of the orders, as uncanonical as the colossal order, which is unprecedented in a secular context.

Despite the fascination of such details, it is the intimate yet monumental grandeur of the Capitol, the unity of diverse parts, the focus within divergent systems – oval, trapezoid, longitudinal – which make this an almost holy space, the most resonant and impressive piece of city-planning ever built.

The Palazzo Farnese

In the design of the Palazzo dei Conservatori, Michelangelo may have used ideas he had formulated for the great Palazzo Farnese, the largest private palace in Rome, which Antonio da Sangallo designed for Paul III but left incomplete at his death in 1546. At this time Michelangelo was very unwillingly made Architect, and although he quickly turned over the management of the Farnese to the young architect Vignola, he made a number of decisive designs for the palace - first for the cornice [195], designed by March 1547, which was higher and grander than other palace cornices. Michelangelo designed it, not as the crown of the top floor alone, but in proportion to the bulk of the whole palace. This unified sense of design is what we notice first at the Conservatori [194]. When completing the courtyard of the Farnese, Michelangelo also hit upon a similar device to that of the Conservatori: Sangallo had begun a handsome arcade on the ground floor that he continued above on the piano nobile. But there an ambiguity crept in, for whereas some of the arcades were left open, others were walled in, resulting in the anomalous device of a window set within an arch - an opening in a walled-up opening. To avoid continuing this problematic system on the top story, which was to be wholly enclosed, Michelangelo scrapped the arcade entirely in favor of a simple wall divided into bays by clustered pilasters [196]. The window he designed is unique, but drawings show that it was developed in the later 1550s by reusing a drawing for the Palazzo dei Conservatori and freely letting his imagination play over it until he achieved a new design. The result has a gable that rides over the window like an eye-

195. Michelangelo's cornice for the Palazzo Farnese, Rome

196. Detail of Michelangelo's upper story of the courtyard of the Palazzo Farnese

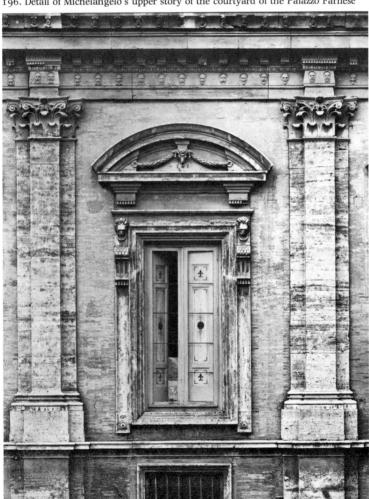

brow, unsupported. The frame itself seems to have slipped down, and frames another, more normal set of moldings. Here, executed crisply in local Roman travertine, we see an example of Michelangelo's capriciousness – the belief in chimerical design that Vasari and others attributed to him. All of these designs can be seen to grow out of his Florentine architecture, but with new monumentality, in different materials and scale.

St Peter's

After Sangallo died the task of building new St Peter's – begun by the hated Bramante in 1506 (see p. 91) – passed to the aging and reluctant Michelangelo. His appointment enraged Sangallo's followers, but Michelangelo was firmer than ever in his affairs, made sure that he was in complete command of the Fabbrica (Office of Works), and made his position impregnable by accepting no salary. In consequence he was actually able to cancel Sangallo's elaborate plans and to pull down what Sangallo had built that he did not want. Sangallo's expensive wooden model, an elaborate and ungainly compromise, was clearly no improvement on Bramante's design [197]. We first learn of Michelangelo's point of view in a famous letter to a member of the Fabbrica, to be dated early in 1547:

It cannot be denied that Bramante was skillful in architecture, as much as anyone from the time of the ancients up to now. He established the first plan of St Peter's, not full of confusion but clear and neat, with ample light and isolated on all sides, so that it did no harm to anything in the Palace and was considered a beautiful thing, as is still clear today, so that any who have deviated from Bramante's aforesaid arrangement, as Sangallo did, have deviated from the truth; and anyone with unprejudiced eyes can see whether it is so in his model. In the first place, the circle he puts outside cuts off all the light from Bramante's plan, and not only this, it has no light itself, and so many dark hiding places between the upper and lower parts that it is arranged conveniently for an infinity of mischief, such as hiding outlaws, coining false money, getting nuns with child and other mischief, such that when, in the evening, the aforesaid church would be locked, it would take twenty-five men to hunt out whoever might be lying hidden inside . . . on the outside . . . the Pauline Chapel, the Seal rooms, the Rota, and many other buildings would have to be demolished, and I do not think even the Sistine Chapel would remain intact . . . This is what I feel, without any emotion, because winning [the commission] would be the greatest loss to me. And if you can get the Pope to understand this, you will give me pleasure, because I don't feel well.

a. Bramante, 1506

b. Bramante-Peruzzi, 1514-20

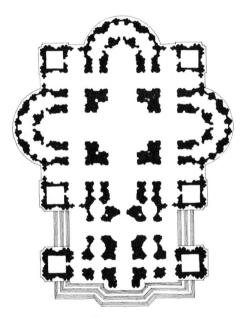

c. Sangallo, 1539

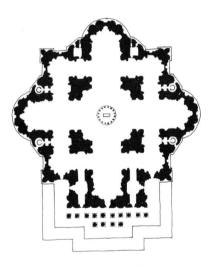

d. Michelangelo, 1546-64

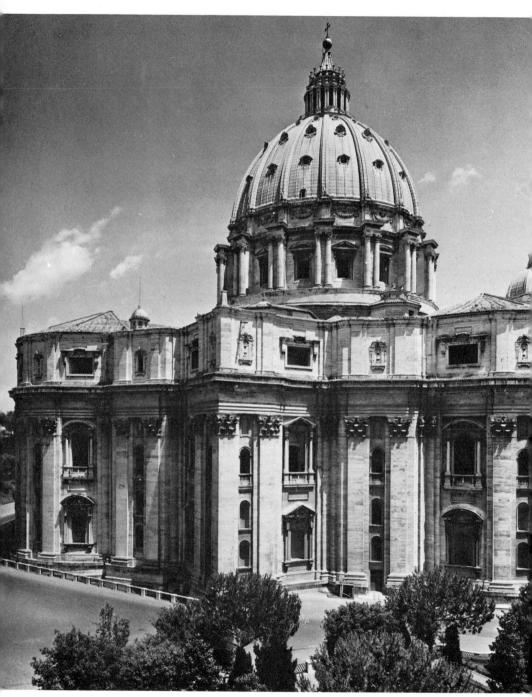

198. St Peter's: view from the Vatican gardens

The old basilica, begun by Constantine, remained partially standing until early in the seventeenth century. But at the west end (St Peter's is occidented), Bramante had begun an enormous centrally-planned structure to support a dome over the grave of St Peter (see p. 91). Vasari stated that his idea was to place the dome of the Pantheon over the Basilica of Maxentius. When Michelangelo reluctantly took over in 1547, the crossing piers were built and some of the arms of the Greek cross were vaulted. Thus Michelangelo's concern was essentially confined to the outer and upper parts of the design, its perimeter and dome, which he changed radically. Even the Bramante plan he so admired was complex, and Michelangelo with master strokes simplified the interior by reducing the peripheral areas to a great square of vaults around the Greek cross already begun, not only a clarification of design but a vast saving of expense [197].

Because of the state of construction, Michelangelo's most obvious contribution was its exterior cloak of architectural revetment, which like the Capitoline palaces utilized a colossal pilaster order [198]. It was already designed by the fall of 1547, when a small wooden model was finished. The exterior order alternates between wider and narrower bays, following the necessary windows lighting the interior. This marvelously sculptural cloak of travertine expresses the interior form on the exterior, and moves now decisively around the sharp corners of the square, now smoothly around the apses. The entablature above is broken, as if to encourage us to read the giant order as thrusting upward – and in a sense it does, and our eye jumps to the continuation of this upward thrust on the drum and dome above. Michelangelo planned to have above the broken cornice, not the ornamented attic we now see, but a smooth band of wall hiding the vaults, penetrated only by arched windows.

Above this he planned a dome, which was at first based on ideas derived from Brunelleschi's great pointed dome in Florence. Michelangelo wrote to his nephew on 30 June 1547 for its measurements – he seems to have been particularly interested in the relationship between the height of the dome and that of the lantern. But only in 1557 was the drum we now see finished and the construction of the dome at hand. In 1557 he made a clay model of the dome, and in 1558–61 an elaborate wooden model was constructed on his directions. The drum is influenced by Bramante's design, but has a powerful set of thrusting columns as buttressing, not single but paired, echoing the paired pilasters below. Michelangelo's final plan for the dome was hemispherical, with a large lantern above [199]. This design was modified, probably chiefly for engineering reasons, into the more pointed profile we now see [198]. It was the work of Giacomo della

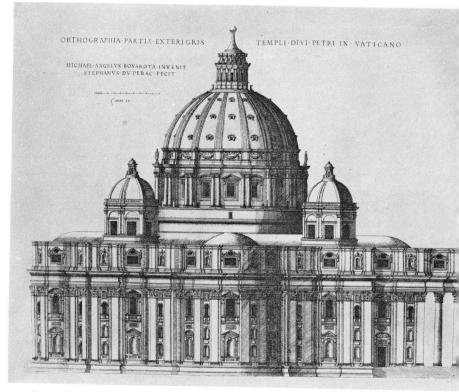

199. Engraving by E. Duperac after Michelangelo's project for the completion of St Peter's. Elevation. $c.\ 1569$

Porta, who built it in 1588-90 - the affairs of St Peter's are long. Nevertheless, as we look at the church from the flank or rear we still get a fair idea of what Michelangelo had in mind - despite the attic and profile of the dome. As for the smaller domes, Michelangelo presumably wanted four, but left no designs for them or for the façade. Della Porta built the two smaller domes we now see, and in the early seventeenth century Pope Paul V totally destroyed the crystalline centrality of Michelangelo's (and Bramante's) church by adding a long nave and façade that tend to hide the dome and give the church a Counter-Reformatory aspect that Michelangelo's design did not have. Nevertheless, apart from the scale, which was decided by Bramante's four central piers, Michelangelo's contribution was decisive. His concept of the flank articulation was sculptural and unifying, organic as no Renaissance church had been. By simplifying the plan, excising ambulatories and towers, he was able to admit direct light in greater quantity than any of the previous designs allowed.

The dome, although modified from his design, is the greatest ever built and became symbolic not merely of religious functions but was adopted by men in the Age of Reason to crown their halls of justice. As Ackerman pointed out, 'if Michelangelo had not reluctantly become an architect the domes of St Paul's and of the Washington Capitol could not have been the same, and the Capitol surely would have had another name.'

During this late period of his architectural mastery, Michelangelo had infinite troubles, delays, and irritations. He was aging, suffered on and off from the stone, and often could not work. Most of his supervision of St Peter's had to be done at second hand; the members of the *Fabbrica* were often hostile, and Sangallo's followers continually tried to get back in power. We see an example of what he was up against in his letters to Vasari in 1557 about a mistake in building one of the apses:

As the model, such as I make for everything, was exact, this mistake [should not have happened] but it happened through my not being able to go there often enough, owing to old age, and whereas I believed that the said vault would now be finished, it will not be finished until the end of this winter, and if one could die of shame and grief I should not be alive . . .

His problems were complicated by the rapid succession of popes: his friend Paul III died late in 1549, to be succeeded by Julius III (1550–55). This was a relatively productive period, despite severe famine beginning in 1551. But by 1554 Michelangelo was rumored to be in his second childhood, and the intrigues multiplied. (In 1557 Michelangelo wrote Vasari: 'I'm getting off the point, because I have lost my brains and my memory, and writing is great trouble for me, because it is not my art.') Julius was followed by Marcellus II, hostile but short-lived, and by Paul IV Carafa (1555–9), a strict reformer and the enemy of Renaissance art, including Michelangelo's *Last Judgement* (see p. 253). A fruitless war with Spain slowed expenditures, and even Paul's succession by a great builder, Pius IV Medici (1559–65). did not accomplish the construction of the dome; Michelangelo continued to have troubles with the *Fabbrica*, as shown in the following letters. The first was to the *Fabbrica*:

You are aware I told Balduccio that he should not send his lime if it wasn't good. Now having sent poor stuff, which must be taken back without any question, one may believe that he had made an agreement with whoever accepted it. This is a great favor to those whom I threw out of the aforesaid construction for a similar reason, and whoever accepts bad materials is only making friends with those whom I

have made my enemies. I think there must be a new conspiracy. Promises, tips, and presents corrupt justice. So I request you from now on, in the name of that authority I have from the Pope, never to accept anything that is not fit to use, even if it comes from Heaven, so that I may not seem to have favorites, as I have none in fact.

The second was sent on 13 September 1560, to the Cardinal Pio da Carpi:

your . . . lordship has said that the construction of St Peter's could not be going worse than it was going, a thing that really grieved me a great deal, because you have not been told the truth; and besides, I desire more than all other men, as I ought, that it should go well. And if I don't deceive myself, I believe I can truthfully assure you that, with regard to the work being done now, it could not be going better. But since perhaps my own interest and my old age can easily deceive me, and thus unwillingly harm or prejudice the above-mentioned construction, I propose to ask permission from His Holiness, our lord, as soon as I can, to withdraw . . . I wish to entreat as I am now doing that your most illustrious and most reverend lordship may please to free me from this vexation, which by command of the Popes, as you know, I have willingly been in without payment for seventeen years. In which time one may plainly see how much has been done through my labor on the aforesaid construction. If I can effectively beg your permission to give up the work, you could never do me a greater single kindness . . .

Neither St Peter's nor the Capitol was close to completion in 1564, when Michelangelo died.

San Giovanni dei Fiorentini

In the friendless atmosphere of Rome Michelangelo was increasingly tempted to accept the offers of Duke Cosimo to return to Florence. These entreaties, proffered over and again through Vasari, were repeated by the Duke himself. Michelangelo answered that he would love to come to Florence to end his days, but could not for fear of wasting all his efforts at St Peter's, which 'would be a disaster for St Peter's, a disgrace for myself, and a grievous sin.'

The Florentines had long wanted to build a national church in Rome, for which expensive foundations were built on the Tiber bank in the 1520s, when money ran out without anything being built above

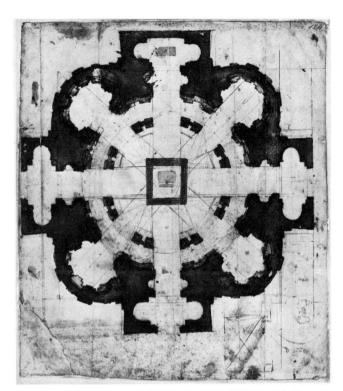

200. Michelangelo, final plan for San Giovanni dei Fiorentini, Rome

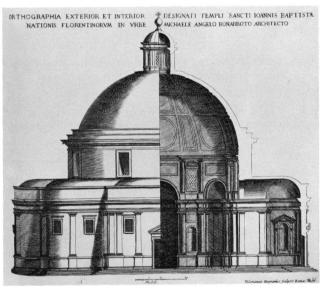

201. Engraving by V. Régnard after Michelangelo's wooden model for San Giovanni dei Fiorentini

ground. In 1559 Michelangelo was asked to provide new drawings, and on 1 November of that year wrote the Duke:

The Florentines have several times before had the strongest wish to set up a church of St John here in Rome. Now, hoping in your lordship's time to have more facilities for it, they have decided on it and . . . asked and begged me several times for a design . . . I have already made several drawings for it, suitable to the site that the abovementioned commissioners have given me for this work. They . . . have chosen the one that would be most imposing; this will be redrawn and copied more neatly, which I cannot do on account of old age . . .

It grieves me in these circumstances to be so old and so at odds with life that I can promise little to the aforesaid construction personally; yet while staying in my house I shall make an effort to do what may be asked of me on behalf of your lordship...

These plans show how far Michelangelo was from senility [200]. The drawings are particularly moving since he could no longer make single straight lines, and so modeled in masses. The wooden model based on this drawing shows how, in the ten years that had elapsed, his ideas had progressed from the richness of St Peter's and the Capitol to a new, Pantheon-like simplicity [201]. Michelangelo's project would have required a different set of foundations, and his expensive designs were not carried out or even begun; the church that was eventually built follows the old plan.

The Porta Pia

One project, however, was more or less built in these years. Pius IV was an admirer of Michelangelo's and a great builder. To ornament a newly straightened street he commissioned Michelangelo to design a gate in the city wall – the Porta Pia, built in 1561–5 [202]. Michelangelo began with a drawing for a garden portal – they were normally quite fanciful – and again improvised around it. The result is as capricious a design as can be imagined. The central gate is complex and powerful, the outlying ornaments odd and willful. Some of the ornaments may have been dredged up from Michelangelo's repertory by assistants, since Michelangelo's surviving drawings record only the design of the central portal. Unlike previous gates, the Porta Pia faces inward. It is a conscious part of a city-planning scheme that depended on new straight streets and vistas, an idea taken up more extensively by Sixtus V (1585–90), who also built the dome of St Peter's. The idea of a city gate as a work of art may even be Pius's,

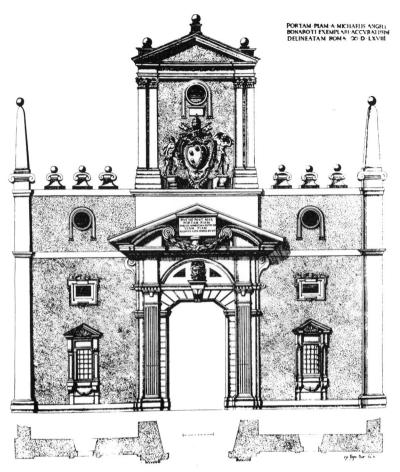

202. Engraving after Michelangelo's design for the Porta Pia, Rome. 1568

but Michelangelo was involved with a new concept of the city at the Capitol and may have proposed this as well.

Architecture became Michelangelo's chief old-age means of expression. Architectural design aroused none of the unconscious anxieties that so frustrated his later sculptural projects, and the abstract repertory of architectural forms became personal and sculptural in his hands. He changed Renaissance architecture in larger ways as well: what had been an organization of parts in Bramante's practice became sculptural, organic wholes. This achievement was not finally appreciated until the following century, when Borromini, taking

Michelangelo as an inspiration, produced the greatest expression of the style we call Baroque. Michelangelo became in the end not merely a designer of genius, inventing new membering and details, but a God-like molder of space and mass, a worthy successor to the architects of ancient Rome. Thus his achievement in architecture is comparable to his earlier sculpture and painting – but perhaps even greater: many of us today would echo Bernini, who revered Michelangelo's architecture above all his other creations, saying that 'since architecture is pure disegno, Michelangelo was a divine architect.'

13 Death and Transfiguration

We have seen that Michelangelo suffered increasingly from what may be called simply old age: he was almost eighty-nine when he died. His later years were saddened by the deaths of younger friends, not only Vittoria Colonna and Luigi del Riccio, but his faithful servant Urbino. He wrote Vasari in February 1556:

Master Giorgio, dear friend: I can write only with difficulty, but still as an answer to yours I shall say something. You know that Urbino is dead, which for me was a very great mercy of God, but my heavy hurt and infinite sorrow. The mercy is that, as in his life he kept me alive, dying he taught me to die, not against my will but welcoming death. I had him twenty-six years and found him most loyal and faithful, and now that I had made him rich and expected him to be a staff and refuge for my old age, he has been taken from me, and no hope is left me but to see him again in Heaven. And of this God has given a sign through the happiness with which he met death, and he was much more distressed than in his own dying at leaving me alive in this traitorous world . . .

In July of 1556 he wrote his nephew Lionardo:

Lionardo: I did not acknowledge the *trebbiano*, as I was pressed when I received it – that is to say, thirty-six flasks. It's the best you've ever sent me, for which I thank you, but I'm sorry you put yourself to this

expense, particularly as I've no longer anyone to give it to, since all my friends are dead.

When a Spanish army threatened Rome in October of that year Michelangelo made the last of his 'flights,' which is mentioned in another letter to Lionardo:

More than a month ago, finding that the work on the construction of St Peter's had slowed down, I decided to go as far as Loreto, as an act of devotion; so, being a little tired when in Spoleto, I stopped a bit to rest, with the result that I couldn't follow up my intention, since a man was sent specially for me to say I had to return to Rome . . .

He wrote to Vasari in December that 'less than half of me has returned to Rome, because peace is not really to be found save in the woods.'

Late in the winter of 1557 Michelangelo wrote to Duke Cosimo in Florence that in another year he would be able to accept his kind invitation to come to live in Florence; but by May things were worse because of the error in vaulting at St Peter's (see p. 303), and he asks for another full year before coming. In June he wrote Lionardo:

As for how I am, I am ill in body, with all the ills that the old usually have; with the stone, so that I cannot urinate; in my side and in my back, to such an extent that often I cannot climb the stairs; and the worst is that I am filled with pains . . . I pray God to help and counsel me, and if I got really bad, that is, in a dangerous fever, I would send for you at once. But don't think about it and don't set about coming if you don't have a letter from me to come.

In December he wrote him:

In my last I wrote you about a house, because if I can get free here before I die, I would like to know I have a nest there for me and my troop alone, and in order to do this I am thinking of turning what I have here into money . . .

Early in 1561 he wrote:

Lionardo: I had twelve marzolini cheeses from you a few days ago; which were excellent and most delicious and for which I thank you. I have not acknowledged them before, because I wasn't able to and because writing, being old as I am, writing [sic] is very irksome to me. I think that's all. As to your coming here now, it's not convenient . . .

By this time many of his letters had to be dictated – a letter of June 1563 states: 'I haven't replied before, because I can't use my hand to write.' But he was still full of fire; on 21 August 1563 he wrote:

Lionardo: I see from your letter that you are trusting certain envious, paltry fellows, who are writing you many lies, since they cannot twist

or rob me. They are a gang of gluttons, and you are so silly you consider them trustworthy on my affairs, as if I were a child. Remove them from your presence, since they are envious scandalmongers and evil livers. As for being miserable because of the way I am being looked after and the other things you write me, I tell you I couldn't be living better, nor more faithfully looked after in everything; as for being robbed by the one I think you mean, I tell you I have people I can trust and be at peace with in the house. So attend to living, and don't think of my affairs, because I know how to watch out for myself if I have to, and am not a child. Keep well.

His last letter was written on 28 December 1563:

Lionardo: I had your last letter with twelve most excellent and delicious marzolini cheeses, for which I thank you. I'm delighted at your well-being; the same is true of me. Having received several letters of yours recently and not having replied, I have omitted to do so, because I can't use my hand to write; therefore from now on I'll get others to write and I'll sign . . .

We have seen that within a week of his death he was still hacking away on the *Rondanini Pietà*. Before he died he evidently burned a number of drawings, particularly those of the façade of San Lorenzo, to the great displeasure of Duke Cosimo, who wanted them for his collection. Vasari tells of Michelangelo's death:

Michelangelo's nephew Lionardo wanted to go to Rome the following Lent, for he guessed that his uncle had now come to the end of his life; and Michelangelo welcomed this suggestion. When, therefore, he fell ill with a slow fever he at once made Daniele [da Volterra] write telling Lionardo that he should come. But, despite the attentions of his physician . . . his illness grew worse; and so with perfect consciousness he made his will in three sentences, leaving his soul to God, his body to the earth, and his material possessions to his nearest relations. Then he told his friends that as he died they should recall to him the sufferings of Jesus Christ. And so on 17 February [actually 18 February], in the year 1563 according to Florentine reckoning (1564 by the Roman), at the twenty-third hour he breathed his last and went to a better life . . .

Michelangelo was followed to the tomb by a great concourse of artists, friends, and Florentines; and he was honourably buried in the church of Santi Apostoli, in the presence of all Rome. His Holiness expressed the intention of having a personal memorial and sepulchre erected for him in St Peter's itself.

Although he travelled with the post, his nephew Lionardo arrived after all was finished. Duke Cosimo had meanwhile resolved to have the man whom he had been unable to honor while he was living brought to Florence after his death and given a noble and costly burial; and after the Duke had been told of the happenings in Rome, Michelangelo's body was smuggled out of Rome by some merchants, concealed in a bale so that there should be no tumult to frustrate the Duke's plan. Before the corpse arrived, however, Florence received the news of Michelangelo's death and at the request of the acting head of their academy, who at that time was the Reverend Don Vincenzo Borghini, the leading painters, sculptors, and architects assembled together and were reminded that under their rules they were obliged to solemnize the obsequies of all their brother artists.

A great catafalque was constructed in San Lorenzo, a funeral oration was delivered by Benedetto Varchi, and a funeral book was published – honors previously reserved for emperors. Michelangelo was buried in Santa Croce, the church of his old neighborhood, and given a tomb – not surmounted by the *Pietà* as he had once wished – designed by Vasari, with a bust of the artist and statues representing Painting, Sculpture, and Architecture mourning his death [203].

To write of Michelangelo's influence on the art of later times would require a book as long as this one. Perhaps no other artist was so essential for the formation of the romantic idea of the inspired genius. On the other hand, of all important Renaissance artists, Michelangelo was one of a very few to come from a good social background. This dignity, increased by his own accomplishment and manner, helped raise the station of artists to a level they had never before enjoyed; it also helped spawn the Florentine Academy and its successors all over the world – for better or worse.

His example as a sculptor and painter, sometimes baleful in the later Cinquecento, also served stronger spirits like Annibale Carracci (1560–1609) and Peter Paul Rubens (1577–1640) to renew the art of painting and create the Baroque style. Although Giovanni Bologna learned much from Michelangelo, sculpture veered into other directions under Bernini, and it was not until Rodin in the last century that sculpture again became, in a special sense, Michelangelesque. Michelangelo's formative influence on the architecture of Borromini has been mentioned (p. 308). But there were other great contemporaries who increasingly had their partisans - Raphael is arguably more important for subsequent painting than Michelangelo, and the influence of Titian was profound. Everyone realized that, great as he was, Michelangelo had not explored all artistic problems. But whenever artists have considered the mastery of the nude figure, in action or repose. as a primary artistic goal, they have inevitably found Michelangelo an inspiration.

Full references are given in the Bibliography, pp. 321-5.

Bibliographical Note

The most compendious modern treatment of Michelangelo's life and works is found in Tolnay's five volumes (1943–60). Although some of his discussions are necessarily out of date, this is the basic work. Tolnay catalogues the drawings, prints documents, and has many comparative illustrations. (A sixth volume, on architecture and poetry, is still lacking.) Georg Brandes's *Life and Times*, although now over half a century old, is still stimulating reading; Adrian Stokes has tried to explore Michelangelo's psychology. For architecture, Ackerman's monograph is unsurpassed. Frederick Hartt's books on Michelangelo combine beautiful illustrations with an impassioned, personal text, often containing new suggestions.

Source materials for the study of Michelangelo are slowly being made available in modern editions. For the purposes of this volume, it is enough to cite Ramsden's excellent translation of the letters, complete with many valuable appendices on related matters, and with a sensitive, partisan Introduction on the life of Michelangelo. Creighton Gilbert's translation of the poetry is the most trustworthy. I am indebted to the various catalogues of drawings, especially Wilde's. Vasari's *Life* is given in both versions with notes and index in Barocchi's five-volume edition. (The quotations here are from Bull's translation.) I used the Holroyd translation of Condivi, slightly emended. I owe much to Pope-Hennessy's incisive discussion of the sculpture, to Freedberg's sensitive description of Michelangelo's style as a painter, and to Einem's monograph, which although addressed to a more scholarly audience is the best single volume on Michelangelo's art. Tolnay

(1964) is stimulating and enlightening on Michelangelo's artistic ideals and theory; the reader should also see the informative survey by Blunt.

Artistic background can be pursued in the Pelican History of Art, but there is no volume on Quattrocento painting or on Cinquecento sculpture. Social and cultural questions are investigated by Burke. The notes that follow will cite the more specialized literature; the reader must keep in mind that there is always basic material to be found in Tolnay and the other volumes cited above. I have tried to keep the English-reading public in mind in the following notes, since there is now a vast literature in our language, but some reference to foreign studies was unavoidable.

Full references are given in the Bibliography, pp. 321-5.

Notes for Further Reading

INTRODUCTION

The literature is vast. Schevill is the popular history of Florence; cf. Rubinstein for Medicean Florence, Cochrane for the period after 1527, and Spini for Michelangelo's political ideas and ideals. For art, cf. Panofsky (1965) and, as general texts on Renaissance art, Hartt (1970) and Gilbert (1972). For the Platonic Academy, see Kristeller (1965).

CHAPTER I

Michelangelo and Ghirlandaio: See Marchini.

Early drawings: Sensitively discussed by Weinberger.

Medici garden: Chastel exploded the Vasarian myth of a proto-Academy, but obviously something happened there. For Michelangelo and Quattrocento sculpture, see Seymour (1966) and Lisner (1967).

Battle relief: I quote from Clark (1956) and Gombrich. For the Renaissance philosophy of Man, see Kristeller (1961).

Madonna of the Steps: See Calì and Wind (1960, p. 79, note); for the Madonna super petram, Posner (1970).

Crucifix: Discovered by Lisner (1964). For Michelangelo's supposed apprenticeship with Benedetto da Maiano, see Lisner (1967).

Lost Hercules: Chatelet-Lange gives a new, believable version.

Savonarola: Weinstein offers a full treatment.

Sleeping Cupid: See Norton.

CHAPTER 2

Rome: Pastor is invaluable for Renaissance patronage.

Bacchus: Wind (1968) discusses the 'mystery.'

Pietà: For the meaning of sacred images in the Renaissance, see Trexler. Painting: Documents for the unidentified painting were discovered by Mancusi-Ungaro. The so-called *Manchester Madonna*, designed but not painted by Michelangelo, is more obviously a work of this date. For the Entombment, see Levey and Smart.

Piccolomini statuettes: Mancusi-Ungaro has a full discussion.

CHAPTER 3

Marble David: Seymour (1967) has a full treatment. The placement is discussed by Levine.

Bronze David: See Boeck.

Leonardo: The best introduction is still that of Clark (1967), which I quote; cf. Wilde (1953a).

Doni Madonna: There has been endless discussion of the iconography of this work. One of the most interesting is that of Eisler (1961), who sees the background as a stadium and the nudes as athletes of antique virtue - a concept that can be reconciled with my text; cf. also D'Ancona.

Maniera: Brilliantly discussed by Shearman, although I do not agree that there was a European, or even Italian, period dominated by the style. Cf. also *The Renaissance and Mannerism*.

Taddei tondo: See Smart.

Bruges Madonna: Mancusi-Ungaro has new documents.

Battle cartoon: A fundamental contribution by Wilde (1944), which I quote, has withstood later attacks; cf. also Gould (1966).

CHAPTER 4

Julius tomb: Panofsky (1937) is still basic reading; cf. *idem* (1962) and (1964). Frazer's discovery has been announced in lectures and is in press. *Laocoön*: See Brummer.

CHAPTER 5

Sistine Chapel: See Seymour (1972) for general information, bibliography, and selected critical papers. For the Chapel before Michelangelo, Ettlinger. For Michelangelo's decorative scheme, Wilde (1958), and Sandström in Seymour (1972). My analysis is indebted to Sinding-Larsen and to Wind (1960); cf. also Hartt (1950). My interpretation of the break in work of 1510 is based on Wilde's ideas (1953, p. 23; cf. Freedberg, note 17, p. 468).

Belvedere Torso: See Brummer.

Sebastiano: I am indebted to a lecture by Michael Hirst; cf. Wilde (1953), Gould (1967), and, for the 'dark manner,' Posner (1972).

CHAPTER 6

Tomb project of 1513: See the note on the Julius tomb under Chapter 4 above. For Michelangelo and Neoplatonism in general, I follow Garin.

Moses: See Rosenthal.

Risen Christ: cf. Eisler (1969).

Florentine *Slaves*: I follow Wilde's (1954) controversial discussion; the chief work may, however, have been done in the 1530s, and the statues are too unfinished to give firm stylistic clues.

The unfinished: See the survey by Brunius.

CHAPTER 7

Medici Chapel sculptures: I am indebted to Gilbert's interpretation (1971); see also the politico-religious comments by Hartt (1957), and Panofsky's Neoplatonic interpretation (1962; cf. also 1964). For the archeological aspects, in addition to Wilde (1955), see Posner (1973). The idea of the *Day* and *Night* being originally for a double tomb is found in Kriegbaum as well as Wind (1963).

Medici Madonna: Kris, pp. 198-9.

Victory: See Wilde (1954).

Hercules: Wilde's conclusions (1954) are challenged, I believe correctly, by others including Panofsky (1962).

CHAPTER 8

In addition to Ackerman, see Wolf and, for theory, Summers.

CHAPTER 9

Michelangelo's republicanism: See the important article by Spini.

Leda: Wind (1968); cf. Wilde (1957).

Cavalieri: I cite Gilbert (1965). For Michelangelo's personality in Renaissance context, see Wittkower (1963).

Ganymede and Tityus: Panofsky (1962) is more convinced than I of Michelangelo's wholehearted Neoplatonism (cf. Garin).

CHAPTER IO

Last Judgement: Tolnay (V), perhaps too vigorously, advocates the theory that a Resurrection was first planned for the wall; cf. Redig de Campos.

Vittoria Colonna: I quote Clark (1956). For the iconography of the Vittoria Colonna *Crucifix*, see Haussherr.

Poetry: I quote Girardi (1964, Introduction). Cf. idem (1965).

Brutus: For the political background, see Gordon.

Status of Michelangelo: cf. Burke and Wittkower (1963).

CHAPTER II

Tomb of Julius II: For possible changes in the Moses at this time, see Rosenthal.

Florentine *Pietà*: Stechow discusses the problem of Nicodemus or Joseph of Arimathea. For the 'slung leg,' see Steinberg. (It is noteworthy in this context that the copies or reconstructions of the *Pietà* show both of Christ's feet touching earth, i.e., not truly slung.)

Late works: I quote Panofsky (1962). For Michelangelo's relationship with Paul IV and Pius IV, see the important study by De Maio.

CHAPTER 12

In addition to Ackerman, see now Hedberg.

CHAPTER 13

Obsequies: See Wittkower (1964).

Bibliography

- Ackerman, James S., *The Architecture of Michelangelo*, rev. ed. Harmondsworth, 1970. (For the complete catalogue of works, see ibid., II, London, 1964.)
- Barocchi, Paola, Michelangelo e la sua scuola. I disegni di Casa Buonarroti e degli Uffizi, Florence, 1962, 2 vols. I disegni dell'archivio Buonarroti, Florence, 1964.
- -, see also Vasari.
- Battisti, Eugenio, 'I "coperchi" delle tombe medicee.' Arte in europa. Scritti di storia dell'arte in onore di Edoardo Arslan, Milan, 1966.
- Blunt, Anthony, Artistic Theory in Italy, 1450–1600, Oxford, 1956.
- Boeck, Wilhelm, 'Michelangelos Bronze-David und die Pulszky-Statuette im Louvre,' Mitteilungen des kunsthistorischen Instituts in Florenz, VIII, 1959.
- Brandes, George, Michelangelo. His Life. His Times. His Era (1924), trans. Heinz Norden, London, 1963.
- Brummer, Hans H., *The Statue Court in the Vatican Belvedere* (Acta Universitatis Stockholmiensis, Stockholm Studies in the History of Art, 20), Stockholm, 1970.
- Brunius, Teddy, 'Michelangelo's non finito,' Contributions to the History of Art (Figura, 6), Uppsala, 1967.
- Burke, Peter, Culture and Society in Renaissance Italy, 1420–1540 (Studies in Cultural History, ed. J. R. Hale), London, 1972.
- Calì, Maria, 'La "Madonna della Scala" di Michelangelo il Savonarola e la crisi dell' umanesimo,' *Bollettino d'arte*, LII, 1967.

Cellini, Benvenuto, *The Autobiography*, trans. George Bull, Harmondsworth, 1956.

Chastel, André, Art et humanisme à Florence au temps de Laurent le Magnifique Paris, 1959.

Chatelet-Lange, Liliane, 'Michelangelos Herkules in Fontainebleau,' *Pantheon*, XXX, 1972.

Clark, Kenneth, The Nude, London, 1956.

-, Leonardo da Vinci, 2nd ed. Harmondsworth, 1967.

Cochrane, Eric, Florence in the Forgotten Centuries 1527–1800 . . ., Chicago and London, 1973.

Condivi, Ascanio, Vita di Michelangelo Buonarroti, ed. E. Spina Barelli, Milan, 1964.

D'Ancona, Mirella Levi, 'The Doni Madonna by Michelangelo: An Iconographic Study,' Art Bulletin, L. 1968.

De Maio, Romeo, 'Michelangelo e Paolo IV.,' Reformata reformanda. Fest-gabe für Herbert Jedin zum 17. Juni 1965, I, Münster, 1965.

Dussler, Luitpold, Die Zeichnungen des Michelangelo, Berlin, 1959.

Einem, Herbert von, Michelangelo, London, 1973.

Eisler, Colin, 'The Athlete of Virtue: the Iconography of Asceticism,' De artibus opuscula XL. Essays in Honor of Erwin Panofsky, New York, 1961.

-, 'The Golden Christ of Cortona and the Man of Sorrows in Italy,' II, Art Bulletin, LI, 1969.

Ettlinger, L. D., The Sistine Chapel before Michelangelo . . ., Oxford, 1965.

Freedberg, Sydney J., *Painting in Italy:* 1500 to 1600 (Pelican History of Art), Harmondsworth, 1970.

Garin, Eugenio, 'Michelangelo Thinker,' *The Complete Work of Michelangelo*, ed. M. Salmi, London, 1965.

Gilbert, Creighton, Complete Poems and Selected Letters of Michelangelo, translated with foreword and notes by Creighton Gilbert, 2nd ed. New York, 1965.

- -, 'Texts and Contexts of the Medici Chapel,' Art Quarterly, XXXIV, 1971.
- -, History of Renaissance Art, New York, n.d. [1972].

Girardi, Enzo Noé, *Studi sulle rime di Michelangelo*, Milan, 1964. (Cf. his article in English in *The Complete Work of Michelangelo*, ed. M. Salmi, London, 1965.)

-, see also Michelangelo.

Gombrich, Ernst, Symbolic Images . . ., London, 1972.

Gordon, D. J., 'Giannotti, Michelangelo and the Cult of Brutus,' *Fritz Saxl*, 1890–1948: A Volume of Memorial Essays..., ed. D. J. Gordon, London, 1957.

Gould, Cecil, *Michelangelo, Battle of Cascina* (Charlton Lectures on art delivered at the University of Newcastle upon Tyne), Newcastle upon Tyne, 1966.

-, The Raising of Lazarus by Sebastiano del Piombo, London, 1967.

Hartt, Frederick, 'Lignum Vitae in Medio Paradisi: The Stanza d'Eliodoro and the Sistine Ceiling,' Art Bulletin, XXXII, 1950.

- -, 'The Meaning of Michelangelo's Medici Chapel,' Essays in Honor of George Swarzensky Chicago, 1951.
- -, Michelangelo, New York, London, 1965 [painting]; The Complete Sculpture, New York, 1968; The Drawings of Michelangelo, New York, 1970.
- -, A History of Italian Renaissance Art . . ., New York, 1969.
- Haussherr, Reiner, Michelangelos Kruzifixus für Vittoria Colonna . . . (Wissenschaftliche Abhandlungen der Rheinisch-Westfälischen Akademie der Wissenschaften, 44), Opladen, 1971.
- Hedberg, Gregory, 'The Farnese Courtyard and the Porta Pia: Michelangelo's Creative Process,' *Marsyas*, XV, 1970–72.
- Holroyd, Charles, Michael Angelo Buonarroti, 2nd ed. London, New York, 1911.
- Kriegbaum, Friedrich, 'Michelangelo und die Antike,' Münchner Jahrbuch der bildenden Kunst, III–IV, 1952–3.
- Kris, Ernst, Psuchoanalytic Explorations in Art, New York, 1952.
- Kristeller, Paul Oskar, 'The Philosophy of Man in the Italian Renaissance,' Renaissance Thought . . ., New York, Evanston, London, 1961.
- -, 'The Platonic Academy of Florence,' Renaissance Thought II, New York, Evanston, London, 1965.
- Levey, Michael, Cecil Gould, et al., Michelangelo's Entombment of Christ . . ., London [1970].
- Levine, Saul, 'The Location of Michelangelo's *David*: The Meeting of January 25, 1504,' *Art Bulletin*, LVI, 1974.
- Lisner, Margit, 'Michelangelos Crucifix aus S. Spirito in Florenz,' Münchner Jahrbuch für bildende Kunst, XV, 1964.
- -, 'Das Quattrocento und Michelangelo,' Stil und Überlieferung in der Kunst des Abendlandes (Akten des 21, Internationalen Kongresses für Kunstgeschichte in Bonn 1964), II, Berlin, 1967.
- Mancusi-Ungaro, Harold R., Jr, Michelangelo: The Bruges Madonna and the Piccolomini Altar, New Haven and London, 1971.
- Marchini, Giuseppe, 'The Frescoes in the Choir of Santa Maria Novella,' *Burlington Magazine*, XCV, 1953.
- Michelangelo Buonarroti, Rime, ed. Enzo N. Girardi, Bari, 1967.
- -, see also Gilbert and Ramsden.
- Nelson, John C., 'The Poetry of Michelangelo,' Developments in the Early Renaissance, ed. B. S. Levy, Albany, 1972.
- Norton, Paul, 'The Lost Cupid of Michelangelo,' *Art Bulletin*, XXXIX, 1957. Panofsky, Erwin, 'The First Two Projects of Michelangelo's Tomb of Julius II,' *Art Bulletin*, XIX, 1937.
- -, Studies in Iconology, 2nd ed. New York and Evanston, 1962.
- -, Tomb Sculpture, New York, 1964.
- -, Renaissance and Renascences in Western Art, 2nd ed. Stockholm, 1965.
- Pastor, Ludwig von, *The History of the Popes* . . ., London, 1923–53 (many vols.).
- Pope-Hennessy, John, *Italian High Renaissance and Baroque Sculpture*, 2nd ed. London and New York, 1970.

- Posner, Kathleen W.-G., 'Notes on S. Maria dell'Anima,' Storia dell'arte, VI, 1970.
- -, 'Raphael's Transfiguration and the Legacy of Leonardo,' Art Quarterly, XXXV, 1972.
- -, 'Comments on the Medici Chapel . . .,' Burlington Magazine, CXV, 1973. Ramsden, E. H., Letters of Michelangelo, translated, edited, and annotated by E. H. Ramsden, London and Stanford, 1963, 2 vols.
- Redig de Campos, Dioclecio, Il giudizio universale di Michelangelo, Milan, 1964.
- The Renaissance and Mannerism (Studies in Western Art, II), Acts of the Twentieth International Congress of the History of Art, Princeton, 1963.
- Rosenthal, Earl, 'Michelangelo's Moses, dal di sotto in sù,' Art Bulletin, XLVI, 1964.
- Rubinstein, Nicolai, *The Government of Florence under the Medici*, Oxford, 1966.
- Schevill, Ferdinand, Medieval and Renaissance Florence, New York, 1963, 2 vols.
- Seymour, Charles, Jr, Sculpture in Italy: 1400 to 1500 (Pelican History of Art), Harmondsworth, 1966.
- -, Michelangelo's David: a Search for Identity, Pittsburgh, 1967.
- -, Michelangelo: The Sistine Chapel Ceiling, New York, 1972.
- Shearman, John, Mannerism, Harmondsworth, 1967.
- Sinding-Larsen, Staale, 'A Re-reading of the Sistine Ceiling,' Acta ad Archaeologiam et Artium Historiam Pertinentia (Institutum Romanum Norvegiae), IV, 1969.
- Smart, Alastair, 'Michelangelo: The Taddei "Madonna" and the National Gallery "Entombment", Journal of the Royal Society of Arts, CXV, 1967.
- Spini, Giorgio, 'Politicità di Michelangelo,' Atti del Convegno di Studi Michelangioleschi, Rome, 1966. (Also in Rivista storica italiana, LXXVI, 1964.)
- Stechow, Wolfgang, 'Joseph of Arimathea or Nicodemus?', Studien zur toskanischen Kunst. Festschrift . . . L. H. Heydenreich . . ., Munich, 1964.
- Steinberg, Leo, 'Michelangelo's Florentine "Pietà": the Missing Leg,' Art Bulletin, L, 1968.
- Steinmann, Ernst, Die Sixtinische Kapelle, Munich, 1905, 2 vols.
- -, and R. Wittkower, Michelangelobibliographie 1510–1926 (Römische Forschungen der Bibliotheca Hertziana, 1), Leipzig, 1927 (reprinted Hildesheim, 1967).
- Stokes, Adrian, Michelangelo, New York, 1955.
- Summers, David, 'Michelangelo on Architecture,' Art Bulletin, LIV, 1972.
- Tolnay, Charles de, Michelangelo, Princeton, 1943-60, 5 vols.
- -, The Art and Thought of Michelangelo, New York, 1964.
- Trexler, Richard C., 'Florentine Religious Experience: The Sacred Image,' Studies in the Renaissance, XIX, 1973.
- Vasari, Giorgio, La vita di Michelangelo, ed. Paola Barocchi (Documenti di Filologia, 5), Milan and Naples, 1962, 5 vols.
- -, The Lives of the Artists, trans. George Bull, Harmondsworth, 1965.

- Weinberger, Martin, Michelangelo the Sculptor, London, New York, 1967, 2 vols.
- Weinstein, Donald, Savonarola and Florence . . ., Princeton, 1970.
- Wilde, Johannes, 'The Hall of the Great Council of Florence,' *Journal of the Warburg and Courtauld Institutes*, VII, 1944 (reprinted in *Renaissance Art*, ed. C. Gilbert, New York, 1970).
- -, and A. E. Popham, The Italian Drawings of the XV and XVI Centuries . . . at Windsor Castle, London, 1949.
- -, Italian Drawings in . . . the British Museum. Michelangelo and his Studio, London, 1953.
- -, 'Michelangelo and Leonardo,' Burlington Magazine, XCV, 1953a.
- -, Michelangelo's 'Victory' (Charleton Lectures on Art, 36), Oxford, 1954.
- -, 'Michelangelo's Designs for the Medici Tombs,' Journal of the Warburg and Courtauld Institutes, XVIII, 1955.
- -, 'Notes on the Genesis of Michelangelo's Leda,' Fritz Saxl 1890–1948. A Volume of Essays . . . , ed. D. J. Gordon, London, 1957.
- -, 'The Decoration of the Sistine Chapel,' Proceedings of the British Academy, XLIV, 1958.
- Wind, Edgar, 'Michelangelo's Prophets and Sibyls,' Proceedings of the British Academy, LI, 1960.
- -, Art and Anarchy, London, 1963.
- -, Pagan Mysteries in the Renaissance, London, 1968.
- Wittkower, Rudolf and Margot, Born Under Saturn, London, 1963.
- -, The Divine Michelangelo, London, 1964.
- Wolf, Peter M., 'Michelangelo's Laurenziana and Inconspicuous Traditions,' *Marsyas*, XII, 1964–5.

List of Illustrations

Frontispiece. Daniele da Volterra, head of Michelangelo. Bronze. Florence, Galleria Buonarroti. (Alinari)

- I. Domenico Ghirlandaio and assistants, *The Birth of St John the Baptist*. Fresco. c. 1491. Florence, Santa Maria Novella, Tornabuoni Chapel. (Alinari)
- 2. Michelangelo, drawing after Masaccio's *Tribute Money*. Pen over chalk. *c.* 1489–90. Munich, Graphische Sammlungen.
- 3. Masaccio, *The Tribute Money* (detail). Fresco. c. 1427. Florence, Santa Maria del Carmine, Brancacci Chapel. (Alinari)
- 4. Ottavio Vannini, *Lorenzo il Magnifico Surrounded by his Artists* (detail). Fresco. 1635. Florence, Pitti Palace, Museo degli Argenti. (Alinari)
- 5. Michelangelo, *Battle* relief. Marble. 1491–2. Florence, Galleria Buonarroti. (Alinari)
- 6. Bertoldo di Giovanni, *Battle* relief. Bronze. c. 1475? Florence, Bargello. (Alinari)
- 7. Nicola Pisano, *The Damned*. Detail of marble pulpit of 1260. Siena, Cathedral. (Alinari)
- 8. Donatello, *Pazzi Madonna*. Marble. c. 1430?. Berlin, Staatliche Museen. (Museum photo)
- Michelangelo, The Madonna of the Steps. Marble. c. 1491. Florence, Galleria Buonarroti. (Alinari)
- 10. Michelangelo (?), Crucifix. Painted wood. c. 1492? Florence, Galleria Buon-arroti. (Soprintendenza alle Gallerie, Florence)
- II. Anonymous, *Hercules*. Bronze statuette. c. 1505? London, Victoria and Albert Museum. (Museum photo)

- 12. Niccolò dell'Arca, Angel Bearing Candelabrum. Marble. 1470–73. Bologna, San Domenico, Arca di San Domenico. (Alinari)
- Michelangelo, Angel Bearing Candelabrum. Marble. 1495. Bologna, San Domenico, Arca di San Domenico. (Alinari)
- 14. Michelangelo, *Bacchus*. Marble. c. 1496–8. Florence, Bargello. (Luigi Artini, Florence)
- 15. Maerten van Heemskerck, view of the sculpture garden of Jacopo Galli, Rome. Drawing. 1532–5. Berlin, Staatliche Museen. (Museum photo)
- 16. Michelangelo, Bacchus (detail). (Brogi)
- 17. Michelangelo, Bacchus (detail). (Alinari)
- 18. Michelangelo, Pietà. Marble. 1497–1500. Rome, St Peter's. (Alinari)
- 19. German, fifteenth century, Pietà. Assisi, San Rufino. (Alinari)
- 20. Michelangelo, Pietà (detail). (Ernest Nash)
- 21. Michelangelo and assistant, *Entombment*. Oil and tempera. c. 1500? London, National Gallery. (Gallery photo)
- 22. Donatello, David. Bronze. c. 1440? Florence, Bargello. (Anderson)
- 23. Michelangelo, drawing for marble and bronze *Davids*. Pen. 1502. Paris, Louvre, Cabinet des Dessins. (Museum photo)
- 24. After Michelangelo, bronze David. Paris, Louvre.
- 25. Michelangelo, *David*. Marble. Colossal size. 1501–4. Florence, Galleria dell'Accademia. (Soprintendenza)
- Nicola Pisano, Fortitude (Hercules). Detail of marble pulpit finished 1259.
 Pisa, Baptistery. (Anderson)
- 27. Palazzo della Signoria, Florence: view showing a copy of Michelangelo's *David* in the original position, and in center Bandinelli's *Hercules and Cacus*. (Alinari)
- 28. Michelangelo, David (detail). (Alinari)
- 29. Leonardo da Vinci, cartoon for a *Madonna with St John and St Anne*. Charcoal, heightened with white. c. 1500? London, National Gallery. (Gallery photo)
- 30. Michelangelo, drawing of a *Madonna with St Anne*. Pen. c. 1501–2? Oxford, Ashmolean Museum. (Museum photo)
- 31. Michelangelo, study of heads (detail). Pen. c. 1501–2? Oxford, Ashmolean Museum. (Museum photo)
- 32. Michelangelo, drawing of a *Madonna and St Anne* and other subjects. Pen over black chalk. c. 1505? Paris, Louvre, Cabinet des Dessins. (Museum photo)
- 33. Michelangelo, *Doni Madonna*. Oil on panel. 1503–4. Florence, Uffizi. (Alinari)
- 34. Michelangelo, study for the *Doni Madonna*. Red chalk. Florence, Galleria Buonarroti. (Soprintendenza)
- 35. Michelangelo, Doni Madonna (detail). (Alinari)
- 36. Luca Signorelli, Virgin and Child. Oil on panel. Florence, Uffizi. (Alinari)
- 37. Michelangelo, *Taddei tondo*. Marble. c. 1504. London, Royal Academy. (Photo Studios Ltd)
- 38. Michelangelo, *Pitti tondo*. Marble. c. 1503–5. Florence, Bargello. (Soprintendenza)

- 39. Michelangelo, *Bruges Madonna*. Marble. 1503–5. Bruges, Notre Dame. (Gabinetto Fotografico Nazionale)
- 40. Peter Paul Rubens, free copy of the central section of Leonardo's Battle of Anghiari. Paris, Louvre, Cabinet des Dessins. (Museum photo)
- 41. Wilde's reconstruction of the Great Hall of the Palazzo della Signoria, Florence, at the time of the frescoes planned by Michelangelo and Leonardo.
- 42. Michelangelo, drawing of a battle scene (after Leonardo?), and of an Apostle. Pen. 1504–5. London, British Museum. (Museum photo)
- 43. Aristotile da Sangallo, copy of the central section of Michelangelo's cartoon for *The Battle of Cascina*. Grisaille on panel. 1542? Holkham Hall, Norfolk. (Courtauld Institute of Art)
- 44. Michelangelo, study for a figure for *The Battle of Cascina*. Black chalk, heightened with white. *c.* 1504. Vienna, Albertina. (Bildarchiv d. Ost. Nationalbibliothek)
- 45. Michelangelo, study for a figure for *The Battle of Cascina*. Pen and brush, heightened with white. c. 1504. London, British Museum. (Museum photo)
- 46. Antonio and Piero del Pollaiuolo, *The Martyrdom of St Sebastian*. Painting on panel. c. 1475? London, National Gallery. (Gallery photo)
- 47. Drawing after Michelangelo's project of 1513 for the tomb of Julius II. Florence, Uffizi. (Soprintendenza)
- 48. Roman sarcophagus. Marble. Rome, Vatican Museums. (Museum photo)
- 49. Antonio del Pollaiuolo, tomb of Sixtus IV. Bronze. 1484–93. Rome, Vatican, Grotte Vaticane. (Anderson)
- 50. Agesandros, Polydoros, and Athenodoros of Rhodes, *Laocoön*. Marble. Hellenistic-Roman period. Rome, Vatican Museums. (Alinari)
- Michelangelo, St Matthew. Marble. 1504–8. Florence, Galleria dell'Accademia. (Soprintendenza)
- 52. Wilde's reconstruction of the altar wall of the Sistine Chapel before Michelangelo's Last Judgement.
- 53. Michelangelo, sketch for the decoration of the Sistine ceiling. Pen over lead-point; black chalk. 1508. London, British Museum. (Museum photo)
- 54. Sandström's reconstruction of the scene implied in illustration 53.
- 55. Michelangelo, sketch for the decoration of the Sistine ceiling. Pen and black chalk. 1508. The Detroit Institute of Arts. (Courtesy of the Detroit Institute of Arts)
- Bernardo Pinturicchio, vault over the high altar of Santa Maria del Popolo, Rome. Fresco. c. 1508. (Alinari)
- 57. Michelangelo, Sistine ceiling as decorated: view from the high altar. (GFN)
- 58. Michelangelo's illusionistic architecture on the Sistine ceiling drawn as if actually three-dimensional (after Sandström).
- 59. Scheme of Michelangelo's decorations on the Sistine ceiling.
- 60-66. Michelangelo, Sistine ceiling:
 - 60. Zechariah. (GFN)
 - 61. Jonah. (GFN)
 - 62. The Creation of Eve. (Alinari)
 - 63. Ezekiel. (GFN)
 - 64. Cumaean Sibyl. (GFN)

- 65. The Death of Haman. (GFN)
- 66. Moses and the Serpent of Brass. (GFN)
- 67. Michelangelo, detail of poem satirizing his painting with a caricature of himself. Pen. Florence, Casa Buonarroti. (Pineider)
- 68-9. Michelangelo, Sistine ceiling:
 - 68. First pair of nudes, left of The Drunkenness of Noah. (Alinari)
 - 69. Second pair of nudes, on the right side of The Sacrifice of Noah. (Alinari)
 - Apollonios son of Nestor, the Belvedere Torso. c. 50 B.C. Rome, Vatican Museums. (Alinari)
- 71-6. Michelangelo, Sistine ceiling:
 - 71. Nude over the Persian Sibyl. (GFN)
 - 72. Nude over Jeremiah. (Alinari)
 - 73. Nude opposite illustration 72. (Alinari)
 - 74. Nude over the Libyan Sibyl. (Alinari)
 - 75. Delphic Sibyl. (Alinari)
 - 76. Libyan Sibyl. (GFN)
 - 77. Michelangelo, drawing for the Libyan Sibyl. Red chalk. c. 1511. New York, Metropolitan Museum of Art. (The Metropolitan Museum of Art, Joseph Pulitzer Bequest, 1924; museum photo)
- 78-84. Michelangelo, Sistine ceiling:
 - 78. Judith and Holofernes. (GFN)
 - 79. David and Goliath. (GFN)
 - 80. The Drunkenness of Noah. (Alinari)
 - 81. The Flood. (Alinari)
 - 82. The Flood (detail). (Alinari)
 - 83. The Temptation and Expulsion from Paradise. (GFN)
 - 84. The Creation of Eve. (Alinari)
 - 85. Jacopo della Quercia, *The Creation of Eve.* Istrian stone. 1430–34. Bologna, San Petronio. (James Beck)
 - 86. Michelangelo, Sistine ceiling: The Creation of Adam. (Alinari)
 - 87. Michelangelo, study for *Adam*. Red chalk. London, British Museum. (Museum photo)
- 88-95. Michelangelo, Sistine ceiling:
 - 88. The Creation of Adam (detail). (Alinari)
 - 89. The Separation of Land from Water. (Alinari)
 - 90. The Creation of the Sun and Moon. (Alinari)
 - 91. The Separation of Light from Darkness. (GFN)
 - 92. The Creation of Eve (detail). (Anderson)
 - 93. The Creation of Adam (detail). (Alinari)
 - 94. Jesse. (GFN)
 - 95. Details of two lunettes. (GFN)
 - 96. Raphael, *The School of Athens* (detail). Fresco. c. 1511. Rome, Vatican, Stanza della Segnatura. (Anderson)
 - Sebastiano del Piombo, Lamentation. Oil on canvas. 1514. Viterbo, Museo Civico. (Alinari)
 - 98. Sebastiano del Piombo, *The Resurrection of Lazarus*. Oil on canvas. 1517–19. London, National Gallery. (Gallery photo)

- 99. Sebastiano del Piombo, *The Flagellation of Christ.* Fresco. c. 1520. Rome, San Pietro in Montorio. (Alinari)
- 100. Michelangelo, anatomical drawing. Red chalk, metal point. c. 1516? Windsor Castle. (Reproduced by gracious permission of H.M. the Queen: photo: A. C. Cooper)
- 101. Michelangelo, drawing for the Genius of the Libyan Sibyl and of Slaves for the Julius tomb. Red chalk, pen. 1511-12. Oxford, Ashmolean Museum. (Museum photo)
- 102. Copy after Michelangelo, frontal view of the project of 1513 for the tomb of Julius II. Berlin, Kupferstichkabinett. (Museum photo)
- 103 and 104. Michelangelo, *Dying Slave*. Marble. c. 1514. Paris, Louvre. (Museum photos)
- 105 and 106. Michelangelo, *Rebellious Slave*. Marble. c. 1514. Paris, Louvre. (Museum photos)
- 107. Michelangelo, Moses. Marble. c. 1515. Rome, San Pietro in Vincoli. (GFN)
- 108. Donatello, St John the Evangelist. Marble. c. 1410. Florence, Museo dell'Opera del Duomo. (Brogi)
- 109. Michelangelo, Moses (detail). (Alinari)
- 110. San Lorenzo, Florence, showing the unfinished façade. At right, the Medici Chapel by Michelangelo (lower dome). (Alinari)
- III. Michelangelo, wooden model for the façade of San Lorenzo. 1519. Florence, Galleria Buonarroti. (Alinari)
- 112. Michelangelo, The Risen Christ. Marble. c. 1518–21. Rome, Santa Maria sopra Minerva. (GFN)
- 113. Michelangelo, drawing for *The Risen Christ*. Pen; red and black chalk. London, Brinsley Ford Collection. (John R. Freeman)
- 114. Wilde's sketch of the tomb project of 1516.
- 115. Michelangelo, Young Slave. Marble. 1520-23? Florence, Galleria dell'Accademia. (Soprintendenza)
- 116. Michelangelo, Atlas. Marble. 1520–23? Florence, Galleria dell'Accademia. (Soprintendenza)
- 117. Michelangelo, Awakening Slave. Marble. 1520–23? Florence, Galleria dell'Accademia. (Alinari)
- 118. Michelangelo, Bearded Slave. Marble. 1520-23? Florence, Galleria dell'Accademia. (Alinari)
- 119. Filippo Brunelleschi, Old Sacristy of San Lorenzo, Florence: interior. 1421 ff. (Paolo Monti)
- 120. Michelangelo, Medici Chapel, San Lorenzo, Florence: interior showing the altar and tomb of Giuliano de' Medici 1519-33. (Alinari)
- 121. After Michelangelo, drawing for a Medici tomb. Black chalk; pen. Paris, Louvre, Cabinet des Dessins. (Museum photo)
- 122. Michelangelo, sketch for a double tomb. Pen. 1520–21. London, British Museum.
- 123. Michelangelo, Medici Chapel, tomb of Giuliano de' Medici: Night. (Alinari)
- 124. Michelangelo, drawing of molding with inscription relating to the tomb of Giuliano de' Medici. Pen. c. 1524. Florence, Casa Buonarroti. (Soprintendenza)

- 125-6. Michelangelo, Medici Chapel:
 - 125. Giuliano de' Medici. (Alinari)
 - 126. Lorenzo de' Medici. (Alinari)
 - 127. Michelangelo, *Ideal Head*. Red chalk. Oxford, Ashmolean Museum. (Museum photo)
- 128-32. Michelangelo, Medici Chapel:
 - 128. Tomb of Giuliano de' Medici: Day. (Alinari)
 - 129. Tomb of Giuliano de' Medici: Night (detail). (Alinari)
 - 130. Tomb of Lorenzo de' Medici: Dusk. (Alinari)
 - 131. Tomb of Lorenzo de' Medici: Dawn. (Alinari)
 - 132. Frieze of masks. (Alinari)
 - 133. Michelangelo, *Medici Madonna*. Marble. 1521–34. Florence, San Lorenzo, Medici Chapel. (Alinari)
 - 134. Michelangelo, cartoon of a Madonna. Black and red chalk; wash. Florence, Casa Buonarroti. (Soprintendenza)
 - 135. Michelangelo, drawing for the *Bruges Madonna*. Pen. c. 1503? Vienna, Albertina.
 - 136. Michelangelo, Medici Madonna (detail). (Brogi)
 - 137. Bartolommeo Ammannati, Victory. Marble. c. 1540. Florence, Bargello.
 - 138. Michelangelo, *Victory*. Marble. 1527–30? Florence, Palazzo Vecchio. (Soprintendenza)
 - 139. Michelangelo, Victory (detail). (Brogi)
 - 140. Vincenzo Danti, Honor Triumphant over Falsehood. Marble. c. 1562. Florence, Bargello. (Alinari)
 - 141. Giovanni Bologna, *Florence Victorious over Pisa*. Marble. 1565–70. Florence, Bargello. (Brogi)
 - 142. Michelangelo, clay model, probably for *Hercules and Cacus. c.* 1528. Florence, Galleria Buonarroti. (Alinari)
 - 143-4. Michelangelo, Medici Chapel:
 - 143. Tomb of Lorenzo de' Medici. Marble. (Alinari)
 - 144. Detail. (Alinari)
 - 145-6. Michelangelo, Biblioteca Laurenziana:
 - 145. Reading room. (Einaudi)
 - 146. Vestibule. (Alinari)
 - 147. Michelangelo, drawings for the stairs of the vestibule. Pencil, pen, red chalk, wash. Florence, Casa Buonarroti. (Soprintendenza)
 - 148. Michelangelo, Biblioteca Laurenziana: stairs. (Alinari)
 - 149. Michelangelo, fortification design. Pencil, pen, red chalk, wash. Florence, Casa Buonarroti. (Brogi)
 - 150. Rosso Fiorentino (?) after Michelangelo, *Leda*. Oil on canvas. Early 1530s. London, National Gallery. (Gallery photo)
 - 151. Michelangelo, drawing for the head of *Leda*. Red chalk. Florence, Casa Buonarroti. (Alinari)
 - 152. Jacopo Pontormo after Michelangelo, *Venus and Cupid*. Oil on canvas. Florence, Uffizi. (Brogi)
 - 153. Michelangelo, Apollo. Marble. c. 1530. Florence, Bargello. (Alinari)
 - 154. Giovanni Bologna, *Apollo*. Bronze statuette. c. 1578. Florence, Palazzo Vecchio, Studiolo. (Alinari)

- 155. Michelangelo, drawing of Andrea Quaratesi. Black chalk. 1532. London, British Museum. (Museum photo)
- 156a. Michelangelo, drawing of Tityus. Black chalk. 1532. Windsor Castle. (Reproduced by gracious permission of H.M. the Queen)
- 156b. Detail of 156a.
 - 157. Copy after drawing by Michelangelo, *Ganymede*. Black chalk, pen. Windsor Castle. (Reproduced by gracious permission of H.M. the Queen)
 - 158. Michelangelo, drawing of the *Resurrection of Christ*. Black chalk. c. 1533. London, British Museum. (Museum photo)
 - 159. Michelangelo, sketch for The Last Judgement. Black chalk. c. 1534. Florence, Casa Buonarroti. (Soprintendenza)
 - 160. View of the Sistine Chapel with The Last Judgement. (Alinari)
 - 161. Michelangelo, The Last Judgement. Fresco. 1534-41. Rome, Vatican City, Sistine Chapel. (GFN)
- 162-7. Michelangelo, The Last Judgement:
 - 162. Detail. (Alinari)
 - 163. Detail. (GFN)
 - 164. Detail. (Alinari)
 - 165. Detail. (Alinari)
 - 166. Detail. (GFN)
 - 167. Detail. (GFN)
 - 168. Luca Signorelli, *The Last Judgement* (detail). Fresco. 1500–1504. Orvieto, Cathedral. (Alinari)
 - 169. Michelangelo, drawing of *Crucifix* for Vittoria Colonna. Black chalk. London, British Museum. c. 1539. (Museum photo)
 - 170. Michelangelo, drawing of *Pietà* for Vittoria Colonna. Pencil. By 1546. Boston, Isabella Stewart Gardner Museum. (Museum photo)
 - 171. Michelangelo, drawing of torso for Sebastiano's *Pietà* now in Ubeda, Spain. Black chalk. c. 1534. Florence, Casa Buonarroti. (Soprintendenza)
 - 172. Michelangelo, Brutus. Marble. 1539-40? Florence, Bargello. (Soprintendenza)
 - 173. Roman bust of the Emperor Caracalla. Marble. Naples, Museo Nazionale. (Anderson)
 - 174. Michelangelo and assistants, tomb of Julius II. Marble. Finished 1547. Rome, San Pietro in Vincoli. (Alinari)
 - 175. Detail of illustration 174. (Alinari)
 - 176. Michelangelo, Rachel. (Alinari)
 - 177. Michelangelo, Leah. (Alinari)
 - 178. Michelangelo, Leah (detail). (GFN)
 - 179. Cappella Paolina, Vatican. (GFN)
 - 180. Michelangelo, *The Conversion of Paul.* Fresco. Rome, Vatican, Cappella Paolina. (Anderson)
 - 181. Michelangelo, *The Conversion of Paul* (detail). (GFN)
 - 182. Michelangelo, *The Crucifixion of Peter*. Fresco. Rome, Vatican, Cappella Paolina. (GFN)
 - 183. Michelangelo, *The Crucifixion of Peter* (detail). (GFN)

- 184. Michelangelo and Tiberio Calcagni, *The Deposition of Christ*. Marble. c. 1547–55. Florence, Cathedral. (Anderson)
- 185. Detail of illustration 184. (Anderson)
- 186. Michelangelo, drawing of the *Crucified Christ*. Black chalk. London, British Museum. (Museum photo)
- 187. Michelangelo, drawing of a standing *Madonna*. Black chalk. London, British Museum. (Museum photo)
- 188. Taddeo Zuccari, *The Deposition of Christ*. Oil on panel. c. 1560. Rome, Galleria Borghese. (Anderson)
- 189. Michelangelo, *Rondanini Pietà*. Marble. 1555–64. Milan, Castello Sforzesco. (Fototeca Unione)
- 190. View of the Capitoline Hill, Rome. c. 1554–60. Paris, Louvre, Cabinet des Dessins.
- 191. Engraved plan of Michelangelo's project for the Capitoline Hill. 1567.
- 192. Engraved view of Michelangelo's project for the Capitoline Hill. 1569.
- 193. The Piazza del Campidoglio. (Leonard von Matt)
- 194. Michelangelo and Giacomo della Porta, the Palazzo dei Conservatori. (John Vincent)
- 195. Michelangelo's cornice for the Palazzo Farnese, Rome. (Anderson)
- 196. Detail of Michelangelo's upper story of the courtyard of the Palazzo Farnese. (Anderson)
- 197. Plans for St Peter's (after Ackerman).
- 198. St Peter's: view from the Vatican gardens. (Leonard von Matt)
- 199. Engraving by E. Duperac after Michelangelo's project for the completion of St Peter's. Elevation. c. 1569. (Photo: The Metropolitan Museum of Art, Harris Brisbane Dick Fund, 1941)
- 200. Michelangelo, final plan for San Giovanni dei Fiorentini, Rome. Florence, Casa Buonarroti. (Soprintendenza)
- 201. Engraving by V. Régnard after Michelangelo's wooden model for San Giovanni dei Fiorentini.
- 202. Engraving after Michelangelo's design for the Porta Pia, Rome. 1568.
- 203. Giorgio Vasari, Tomb of Michelangelo. 1564-75. Florence, Santa Croce. (Bust and figure *Painting*, Battista Lorenzi; Sculpture, Valerio Cioli; Architecture, Giovanni Bandini; fresco of Pietà, Battista Naldini.) (Anderson)

Acknowledgements

I am grateful to the owners of copyrights for allowing me to quote, at times extensively, from the following books: Kenneth Clark, The Nude, London, John Murray, 1956, and Leonardo da Vinci, 2nd ed. Harmondsworth, Penguin Books, 1956; Benvenuto Cellini, The Autobiography, trans. George Bull, Harmondsworth, Penguin Books, 1956; Sydney J. Freedberg, Painting in Italy: 1500 to 1600 (Pelican History of Art), Harmondsworth and Baltimore, Penguin Books, 1970; Creighton Gilbert and Robert N. Linscott, Complete Poems and Selected Letters of Michelangelo (The Modern Library), New York, N.Y., Random House, 1965: John Pope-Hennessy, Italian High Renaissance and Baroque Sculpture, 2nd ed. London and New York, Phaidon, 1970; Giorgio Vasari, The Lives of the Artists. trans. George Bull, Harmondsworth, Penguin Books, 1965. The publishers of The Letters of Michelangelo, translated, edited, and annotated by E. H. Ramsden (Peter Owen, London, and Stanford University Press, Stanford), 1963, 2 vols., have graciously permitted me to publish excerpts from the following letters: 6, 33, 52, 86, 134, 156, 159, 161, 195, Draft 6, 406, 419, 464, 480.

Index

Numerals in **bold face** indicate extended discussions. An asterisk (*) indicates a quotation. Illustrations are shown by their numbers in brackets.

```
academic drawing, 81
                                        Ammannati, Bartolommeo, 59, 202,
Accademia Fiorentina, 260
                                          218; Victory, 202-3 [137]
Acheron, Last Judgement, 245
                                        Amor sacro e profano, 236
Ackerman, James, 10, 217*, 303*
                                        Andrew, St, Last Judgement, 245
active-passive pairs in Michelangelo's
                                        Angel Holding Candelabrum, 33 [13]
  work, 137, 155, 189, 268, 271-2
                                        angels: see Michelangelo (angels)
Acts, New Testament, 275
                                        antique art, study of, 19, 22, 56-9,
Adam:
                                          88, 89-91, 151, 169, 178, 184;
                                          see also Michelangelo (and an-
 Last Judgement, 248
 Creation of, Sistine ceiling, 117, 119,
                                          tiquity)
  136-7 [86-8, 93]
                                        Antonio [da] Urbino, 282-3, 309
 and Eve, Temptation, Sistine ceiling,
                                        ape, symbolism, 151-2
  113, 117, 134 [83]
                                        Apocalypse of St John, 242
                                        Apollo ('David'), 169, 227-8 [153]
Agesandros, Polydoros, and Atheno-
                                        Apollo Belvedere, 36, 85
  doros of Rhodes, Laocoon, 89-90
                                        Apostles, Twelve:
  [50]
Agostino di Duccio, 52
                                         statues commissioned by the Flo-
Alberti:
                                          rence Cathedral, 61, 85, 92-4, 97
                                         projected for Sistine ceiling, 100-
 family, 12
 Leon Battista, 12, 24; De Statua, 24;
                                          105 [53-5]
  Treatise on Painting, 84
                                        architecture:
Albizzi family, 12
                                         ancient, 216, 308
                                         Michelangelo's, 177-8, Chapters 8
Aldrovandi, Gianfrancesco, 32-3
Alexander VI Borgia, 36
                                          and 12
                                        Aretino, Pietro, 232
Alia, Sistine ceiling, 142
All-Saints' Day, 120, 242, 249
                                        Arezzo, 15
```

Aristotelianism, 22 Arno river, 80, 167, 208 Athens, Parthenon, metopes, 23 Augustine, St, 28, 114 Augustinian Order, 49

Bacchus, 38-43 [14-17] Baglioni, Malatesta, 223 Bandinelli, Baccio, Hercules and Cacus, 58-9, 97, 208 [27] baptism, symbolism, 69 baroque style, 308, 312 Bartholomew, St. Last Judgement, 245. 248-9 Battisti, Eugenio, 190 Battle of Anghiari: see under Leonardo Battle cartoon: see Battle of Cascina and cartoon Battle of Cascina, 61, 74-84, 85, 92, 97, 121, 132, 162, 204, 242 [43-5]Battle of Centaurs, 22-5, 26, 28, 29, 31, 80, 81 [5] Beatrice, 255 Belvedere Torso, 122, 125, 192 [70] Bembo, Pietro, Gli asolani, 155 Benedetto da Maiano, 29-30 Benivieni, Domenico, Scala della vita spirituale . . ., 28 Bernardine of Siena, St. 28, 45 Bernini, Gianlorenzo, 132, 184, 188, 193, 295, 308*, 312 Bertoldo di Giovanni, 20, 22, 24, 31 Battle relief, 22, 24 [6] Hercules (formerly ascribed), 31 [11] Biagio (Blaise), St, Last Judgement, 245 Bibbiena, Cardinal Bernardo, 146-7 Bilhères de Lagraulas: see Villiers de Fezenzac Boccaccio, 11, 23-4, 32 Bologna, 32-4, 95-7, 120 conquered by Julius II in 1506, 95

33-4 [12-13]
S. Petronio, 95, 97; portal sculpture by Jacopo della Quercia, 134 [85]
Borghini, Don Vincenzo, 312
Borgia:

S. Domenico, Arca di S. Domenico,

family, 36 Cesare, 85

Borromini, Francesco, 295, 307, 312 Botticelli, Sandro, 34, 68, 100 Primavera, 13 Bramante, Donato, 86, 91, 92, 99, 216, 298, 301, 302, 307 [197] Bronzino: Venus, Cupid, Folly, and Time, 227 Venus and Cupid, 227 Bruchsal, Schloss, stair, 219 Bruges Madonna, 61, 73-4, 169, 199-200 [39, 135] Brunelleschi, Filippo, 11, 162, 209. 215, 301 [110, 119] Brutus, 263-5 [172] Buonarroti Simoni, family of Michelangelo, 12-13, 30 Buonarroti: Buonarroto, brother of Michelangelo, 226 Lionardo, brother of Michelangelo, Dominican, 30 Lionardo di Buonarroto, nephew of Michelangelo, 266, 280, 309-12 Ludovico, father of Michelangelo. 15-17, 42, 48, 228 Burckhardt, Jacob, 216*

Caesar, Julius, 263 Calcagni, Tiberio, 265, 281, 283 [172, 184] Capponi: Neri, 78 Piero, 78 Caprese, 15 Caracalla, bust of, 265 [173] caritas, 272 Carracci, Annibale, 312 Carrara, marble quarries, 43, 161, 163 cartoon (full-scale preparatory drawing), 74 ff., 77, 80-84, 92, 199, 224, 226, **240–42**, 268 [134] Cascina: see Battle of Cascina Castiglione, Baldassare, The Courtier, 155, 188 Catherine, St, Last Judgement, 245, 252 Cavalieri, Tommaso de', 204, 229-36, 246, 262, 267 lost portrait-drawing of, 233

busts, portrait, 265

column, symbol of Fortitude, 54 Cellini, Benvenuto, Autobiography, conclave, 100 17*, 20*, 81-2*, 83, 175, 220 Condivi. Ascanio, Life of Michelangelo, on sculptural technique, 56*, 94 16, 20*, 22*, 25, 28, 29*, 30*, charity (caritas), 272 31*, 32*, 34*, 38*, 41, 42, 48*, Charles V, emperor, 220, 222, 223, 68*, 86, 86-7*, 87, 89*, 91, 95*, 291, 293 96*, 97, 99*, 105*, 119-20*, Charles VIII, king of France, invades 120*, 147, 152, 158*, 163*, 222*, Italy, 32, 52 223, 232-3*, 239*, 240*, 242-3*, Charon, Last Judgement, 245, 250 256*, 262-3*, 271, 271-2*, 280chisel, 201, 204, 265 81* Christ: contrapposto, 31, 56, 167, 227 Ancestors of, Sistine ceiling, 105-6, Conversion of Paul, Cappella Paolina, 109, 119, 142 [94-5] 274-8 [180-81] crucifixion, 116 Copernicus, 9 entry into Jerusalem, 109 Corpus Domini, 46 Giving the Keys, projected fresco for Cosmas and Damian, Sts, Medici Cappella Paolina, 275 Chapel, 193 life of, cycle in Sistine Chapel, 100-Council of Trent, 240, 278 Counter-Reformation, 178, 240, 255, Last Judgement, 245-6, 248-9, 252 277-8, 302 Passion, 28, 116 Cross, wood of, 28, 114 resurrection, 110, 113, 116 Crucified Christ, drawings, 286-7 Risen, 165, 167-9, 227-8 [112-[186] Crucifix: virgin birth, 113-15 wood, 29-30 [10] See also Crucifix; Madonna; Resurrecdrawing for Vittoria Colonna, 256tion 9, 286 [169] Church, Christian (Catholic), 28, 151, Crucifixion of Peter, Cappella Paolina, 248, 254 277-8 [182-3] reform, 240; see also Counter-Cuio, Captain, 179 Reformation Cumaean Sibyl, Sistine ceiling, 114-Cimabue, 11, 12 15, 130 [64] Clark, Kenneth, 24*, 56*, 76*, 84*, Cupid, Sleeping, 34-5, 36, 38 classic style: see High Renaissance Daniel. Sistine ceiling, 123 Daniele da Volterra, 288, 311 Clement VII Medici (Giulio de' Medici), bust of Michelangelo [frontispiece] 22, 145, 165, 170, 178, 181, 201, Dante, 11, 12, 32-3, 255, 265, 273 208, 212, 214, 219, **220–21**, 222, 223, 227, 228, 239-40, 267-8 Convivio, 183 Divine Comedy, 45*, 253*, 271 flight to Orvieto in 1527, 214, Danti, Vincenzo: 220-2I Honor Triumphant, 206 [140] Brief ordering Michelangelo to work Treatise, 147 only for him, 227 David: Bull on Medici Chapel, 201 lost bronze statue, 52-4, 61 [23-4] Cletus, pope, Sistine Chapel, 100 [52] marble statue, 41, 51-61, 76-7, Colonna, Vittoria, Marchioness of 97, 137, 152, 207, 208, 221, 229 Pescara, 231, 254-63, 268, 281, [23, 25, 27-8]; marble copy of, 58 309 [27] colossal order, 296, 301 See also Apollo colossal statuary, 51 ff., 89

David and Goliath, Sistine ceiling, 106, Eve: 118, 131 [79] Last Judgement, 248 Dawn, Medici Chapel, 185, 193, 201, Creation of, Sistine ceiling, 113-15, 202 [131] 117, 123, 134 [62, 84, 92] Day, Medici Chapel, 184 ff., 190-93 Ezekiel, 114*, 242-3*, 250* [128] Sistine ceiling, 114, 130 [63] Deianira: see Battle of Centaurs Delacroix, Eugène, 76 Fabbrica di S. Pietro, 298, 303 Della Porta, Giacomo, 301-2 [194, Faith: 1981 justification through, 255 ff. Della Rovere: personification, 272 family, 151, 161, 163, 165, 169, Fall of Rebel Angels, proposed fresco 178, 240, 267-8, 273; see also for Sistine Chapel, 239-40, 252 Julius II Farnese, Cardinal Alessandro: see coat of arms, 109 Paul III Cardinal Giuliano: see Julius II Faun, lost marble head, 20–21 [4] Francesco Maria, Duke of Urbino, Febo del Poggio, 232 161, 267 Ficino, Marsilio, 13, 22 Delphic Sibyl, Sistine ceiling, 128 [75] Filarete, 24 Del Riccio, Luigi, 242, 262-3, 273, Finding of Moses, Sistine Chapel, 100, 276, 309 117[52]Deposition of Christ (Pietà), marble Flood, Sistine ceiling, 117, 118, 132 group, 280 ff. [184-5] [81-2]Dies Irae, 250 Florence, 11 ff.; see also Michelangelo Dionysus, cult of, 42 (residence) Dioscuri (Horse-tamers), 36, 276, 294 Accademia del Disegno, 266, 312 Doge of Venice, 51 Accademia Fiorentina, 260 Donatello, 11, 20, 24, 26, 51-2 apprenticeship of artists, 17 David, bronze statue, 52, 61 [22] bank failures of 1339, 12 St John Evangelist, marble statue, Bianchi, 259 158 [108] book publishing, 28 Judith and Holofernes, bronze group, capitalism, 12 Casa Buonarroti, 97 Pazzi Madonna, marble relief, 26 [8] churches: Donati, Manno, 80 S. Croce, 15, 97, 259, 312 Doni: Cathedral: dome, 301; façade com-Angelo, 67, 70 petition, 22; Operai, 52, 61; Madonna, 50, 66-70, 83, 128, 169 Apostles: see Apostles, Twelve; Her-[33-5]cules, Agostino di Duccio, 52; Dürer, Albrecht, 32 Prophet program, 51-2, 58, 61; Dusk, Medici Chapel, 193 [130] Prophet, Donatello, 51 S. Lorenzo, 162 [110]; cloister, 214; Earth, projected statue in Medici façade project, 162-7 [111]; Chapel, 184 Medici Chapel, architecture, 209-Eliud, Sistine ceiling, 142 12 [110, 120, 132, 144]; dome, entombment of Christ, 283-4 181 [110]; tombs, 177-202, 211. painting begun by Michelangelo, 227 [120–33, 136, 143]; Library 48-50, 65 [21] (Biblioteca Laurenziana), Erasmus, 255 212-19 [145-8]; Old Sacristy, Este, Duke Alfonso I d', 223-4 177, 181, 209, 211 [119] Etruscan art, 184 S. Marco, 19, 32; library, 214

projected equestrian statue for S. M. del Carmine, Brancacci Chapel, Florence, 273 Tribute Money, 19-20 [3] Francisco de Hollanda, Dialogues, S. M. Novella, Tornabuoni chapel, 255, 278* I7 [I] Frazer, Alfred, 88 S. Miniato, earthworks, 222 Freedberg, Sydney, 119*, 123-4*, S. Spirito, Hospital, 29 226*, 254*, 277-8* Constitution, 51 fresco technique, 17, 118, 242 democratic institutions, 12, 34, 51 ff., 77 Galli, Jacopo, 38-41, 43, 49, 73 Duchy of, 192 art collection, 41 [15] flood of 1333, 12 bank, 48-9 fortifications, 222-3 [149] suburban villa, 42 Gonfaloniere, 51, 221 Ganymede, copy of drawing for Cavagovernment: see Medici; Savonalieri, 235-6 [157] rola: Florence (republic) Genesis, scenes from, Sistine ceiling: Great Council, 34 see under individual titles Guelph party, 12, 78 genius, idea of, 312 guilds: cloth, 12; painters', 12 Ghirlandaio, Domenico, 16-19, 49, Humanism, 13, 22, 24; see also 66, 67, 84, 118 [1] Neoplatonism and Platonism drawings, 19 Loggia dei Lanzi, 58 Giannotti, Donato, 263-4 Medici garden, 19 ff., 28 Dialogues, 175, 183, 264-5 money, 12 On the Venetian Republic, On the painters, 12 Florentine Republic, 263 palaces: Gilbert, Creighton, 183-4*, 188, 231 Medici (Riccardi), 22, 52; see also Giorgione, 144, 227 Florence (Medici garden) della Signoria (Vecchio), Council Giotto, 11, 12, 19, 22 Giovanni Bologna, 207, 208, 228, 312 Hall. 34, 58, 76 ff. [41]; Audience Apollo, 228 [154] Hall, inscription, 246; mural com-Florence Victorious over Pisa, 207 petition between Leonardo and Michelangelo, 61, 74-84 [41]; [141] Giovanni da Pistoia, 119 Salone dei Cinquecento, 206-7; Girardi, Enzo N., 262* Studiolo, 206-7, 228 God Creating the Sun and Moon, piazza della Signoria, 58, 160, 273 Sistine ceiling, 116, 138 [90] [27]; see also Florence (Loggia dei God Separating Light from Darkness, Lanzi and palaces: della Signoria) Sistine ceiling, 116, 132, 138 [91] and Pisa, 76, 78 God Separating the Waters, Sistine plague, 12, 35 ceiling, 116, 138 [89] republic, 51, 58, 208, 221-3; fall of, in 1512, 161; fall of, in 1530, golden age, 115 goldfinch, symbolism, 71-2 Gombrich, Ernst, 25* siege of 1530, 222-3, 263 aradina, 265; see also chisel Signoria, 77, 208 Granacci, Francesco, 16, 118 snowfall of 1494, 31, grotte, grotteschi, 103 via Ghibellina, 97 Guelphs. 12, 78 Fortitude (personification), 54, 57 Francesca, mother of Michelangelo, Hadrian VI, pope, 178 Haman, Death of, Sistine ceiling, 106, 116, 131 [65] Francis I, king of France, 169

Heaven, personification, 184 Julius II della Rovere, 36, 61, 85 ff., Helios (Sol), 245-6 91-2, 94-6, 97, 99 ff., 120, 148-Hellenistic sculpture, 56; see also 9, 152, 158 antique art and titles of individual Brief of March 1508, 99 statues bronze memorial statue (destroyed), Henry VIII, king of England, 240 Heraclitus, in School of Athens, 144 effigy in Julius tomb, 269 [174] [96] heirs to: see Della Rovere (family) Hercules: tomb in S. Pietro in Vincoli, 10, 177, as Fortitude, 54, 57 [26] 240; project of 1505, 61, 85-92, marble statue (lost), 30-31, 52 [cf. 92-3, 97, 105, 108, 122, 125, 129, 130, 143, 152, 157 [47, uncarved project for Piazza della 101]; project of 1513, 148-61, Signoria in Florence, 97, 160, 170, 240 [101-7, 109] (see also 207-8, 221, 228 [142]; see also Slaves; Moses); project of 1516, Bandinelli 163, 169 ff., 178, 202-6, 227, High Renaissance style, 34, 41, 51 ff., 267 [114]; project of 1532, 240, 62 ff., 74, 131 267-8; project of 1542, 189, 193, Hippodameia, Lapith princess, 23-4 268-73 [174-8] (see also under Hollanda, Francisco de, Dialogues, individual statues) 255, 278* Julius III del Monte, 282, 303 horns, symbolism, 158 justification through faith, 255 ff. Horse-tamers, antique statuary group, 36, 276, 294 Kings, Book of, 100 Humanism, 13, 22-5; see also Neo-Kris, Ernst. 201* platonism; Rome (Humanism) Lamentation: see Pietà ignudi, Sistine ceiling, 121-5, 151-2, Laocoön, 50, 93, 125, 152, 178, 286 155, 204 [68-9, 71-4] [50] Isaiah, Sistine ceiling, 113, 122 discovery, 89-91 Lapiths, 23-4 Jacob, 271 Last Judgement, fresco, Sistine Chapel, Iacopo della Quercia, 33, 46, 134 [85] 42, 121, 239-54, 268, 273, 278, Jerusalem, Solomon's Temple, 100 303 [160-67] Iesse: repainted, 252 Sistine ceiling, 142 [94] Laura, 54, 255 tree of, 108-9, 113 Lawrence, St., Last Judgement, 245, 248 Jesuit Order, confirmation of, 240 Leah, Julius tomb, 271-2 [175, John the Baptist: 177-8] Last Judgement, 247-8 Leda: lost marble statue, 34 antique statue, 192, 224 John, St, Evangelist: lost painting, 223-6, 233 [150-51] Gospel, 284* left-right symbolism, 56 Revelation, 242 Leo X Medici, 149-51, 161, 163, Jonah, Sistine ceiling, 106, 110-13, 167, 178, 188, 208, 209 116, 130 [61] visit to Florence in 1515, 162 Joseph of Arimathea, 283-4 Leonardo da Vinci, 29, 34, 52, 61, Joyce, James, Ulysses, 191* 62-7, 74-84, 146, 174, 216, Judas Iscariot, 265 221-2* Judith and Holofernes, Sistine ceiling, influence on Michelangelo, 62 ff., 106, 118, 131 146

Man of Sorrows, 169, 246, 259 influence on Raphael, 70-71 Marcellus II Cervini, 303 Battle of Anghiari, 61, 76-7, 79 Marco da Siena, 204 cartoon of Madonna with St John and Marcus Aurelius, ancient bronze St Anne, 62-3 [29] monument, 293-4 [190, 192, Mona Lisa, 67 193] notebooks, 30 Mariano da Genazzano, Fra, 49 sketch of (?), 64 [31] Mary, mother of Christ: Treatise on Painting, 74-5* attributes, 28 Leto, 224, 235 as new Eve, 113-15, 248 Levine, Saul, 58 lactans, 28, 196 'Liberal Arts': see Slaves and Julius II Last Judgement, 247-8, 255 (tomb) Florence Pietà, 280-84 [185] Libro . . . della . . . scala del Paradiso, 28 Libyan Sibyl, Sistine ceiling, 128-9, as Sibyl, 28, 74 super petram, 28, 45, 73 148 [76-7] Linus, pope, Sistine ceiling, 100 [52] See also Madonna Masaccio, 11, 19, 20 Lippi, Filippo, Entombment, 284 Tribute Money, 19 [3] Lomazzo, G. P., 204* Matthew, St, 61, 85, 92-4, 97 [51] Loreto, 310 Gospel, 105, 108, 110*, 246-7* love, sacred and profane, 236; see Medici: also Neoplatonism bank, 12 Luther, Martin, 240 Chapel: see under Florence (churches: Lutherans, 220, 240 S. Lorenzo) dynasty, 58, 188 Machiavelli, Niccolò, 76, 221 family: rise to power, 12; garden law constituting militia, 79 near S. Marco, 19 ff., 28; govern-Discourses, 263 ment of Florence, 12, 161, 221, Prince, 188 273; expulsion in 1495, 32, 34, Madonna: 58; return to power in 1512, 161; Julius tomb, 151, 269-70 [174] palace: see under Florence (palaces); drawing, 287 [187] tombs: see under Florence (churwith St Anne, drawings, 64 ff. [30, ches: S. Lorenzo) Duke Alessandro, 228-9, 263 Bruges, 61, 73-4, 169, 199-200 Catherine, 178 [39, 135] Cosimo, Pater Patriae, 12, 162 Doni, 50, 66-70, 83, 128, 169 Cosimo, Duke, 192, 227, 263, 266, [33-5]283, 304, 306, 310, 311-12 lactans, 28, 196 Francesco I, 206 Medici, 185, 196-202 [133, 136] Giovanni: see Leo X Pitti, 73, 128 [38] Giuliano di Piero (d. 1478), 22; of the Steps, 26-8, 29, 45, 72, 74, tomb, 178; see also under Florence 196 [9] (churches: S. Lorenzo: Medici Taddei, 70-73, 199, 284 [37] Chapel) See also Deposition; Mary; Pietà Giuliano di Lorenzo, Duke of Ne-Madonnas, round, 61, 62 mours, 22, 161, 178, 188; tomb Magdalen, Florence Pietà, 283 statue, 181 ff. [120, 125] Malatesta, Galeotto, 80 Giulio: see Clement VII maniera, 70, 206; see also Mannerism Mannerism, 70, 84, 129, 131, 169, Lorenzino, 263-4 Lorenzo di Pierfrancesco, 34, 38 201, 204-6, 208, 226, 228, 253, Lorenzo di Piero, 'il Magnifico,' 12, 276

20-21, 22, 29, 38, 68, 151, 178, 188; see also under Florence (churches: S. Lorenzo: Medici Chapel): collection of antique art, 19-20, 22; collection of manuscripts, 214: household, 22, 29 Lorenzo di Piero, Duke of Urbino. 161, 178, 188, 211; tomb statue, 181 ff. [126, 143] Piero di Cosimo, 12 Piero di Lorenzo, 31-2, 42-3 Medici Madonna, 185, 196-202 [133, 136] Menelaus with Patroclus, ancient marble group, 284 Michelangelo Buonarroti: accident in 1541, 242 anatomy, study of, 29, 83; see also Michelangelo (and the nude) angels, representations of, 28, 33-4, 121 [13] and antiquity, 21-2, 24, 28, 31, 34-5, 38-9, 50, 93, 122-5, 136, 151, 152, 167, 184, 192, 193, 196, 200, 246, 252, 265, 284-5 apprenticeship to Ghirlandaio, 16 ff., 49 Architect of St Peter's, 240, 280, 296 ff.; Chief Architect, Sculptor, and Painter to the Vatican Palace. 241 architecture, 177-8, Chapters 8 and assistants, 118, 148, 161, 167, 169, 174, 175, 179, 181, 224, 232, 233, 265, 306 autobiographical qualities in his art, 53-4, 61; see also Michelangelo (self-portraits and personality) burial, 311-12 catafalque in S. Lorenzo, Florence, 312 citizen of Rome in 1537, 293 city-planning, 291 ff., 306 ff. compass for inscribing ovals, 294-5 Dante, knowledge of, 32-3, 264-5 death, 311-12 description, 290 dissections, 30 drawings, 9, 17-19, 21, 50, 52-4, 56, 64-5, 73, 81-2, 87, 92, 93,

101-3, 108, 119, 129, 136, 147, 148, 152, 168, 181, 184-5, 189, 196-200, 217, 222, 225, 233-6, 239, 241-2, 246, 256-9, 262, 267, 282, 285, 286-7, 289, 296-8, 311 [2, 23, 31, 32, 34, 42, 43, 44, 45, 47, 53, 55, 67, 77, 87, 100, 101, 102, 113, 121, 122, 124, 127, 132, 135, 147, 149, 151, 155, 156, 157, 158, 159, 169, 170, 171, 186, 187, 200]; see also cartoon; drawings for Sebastiano, 144-7, 259 [171] family background, 12, 15-16 family interests, 30, 266 father, 15-17, 42, 48, 228 and Florence, 11 ff. friends, 16, 262-3, 289, 309; see also Cavalieri; Colonna; Condivi; Del Riccio; Giannotti; Soderini; Vasari: etc. Governor-General of the fortifications of Florence (1528-9), 222 hardships of life, 42-3 homosexuality, 229-33 horses, love of, 276 houses: in Florence, purchased in 1508, 97, 310; see also Michelangelo (workshop); in Rome, 151 illnesses, 273, 280, 303, 309 ff. influences: on later artists, 202-3, 204-7, 224, 226-7, 312; rivalry with Leonardo, 74 ff.; influence of Leonardo, 64 ff. letters, 9, 30, 42 (July, August 1497. June 1509), 42-3 (Oct. 1512), 43 (July 1497), 89 (Jan. 1506), 91 (May 1506), 92 (July 1508, Dec. 1523), 96 (August 1507), 96-7 (Nov. 1507), 105 (Dec. 1523), 118 (Jan., June 1509), 118-19 (Oct. 1509), 119 (July 1510), 142 (Dec. 1523), 146-7 (May/June 1520), 148 (Oct., Nov. 1512), 151 (July 1516), 160 (June, August 1515), 161 (Sept., Nov. 1515, Sept. 1516, Oct. 1512), 165 (April, July 1518), 167 (Dec. 1518, March 1520), 175 (July 1523), 179 (Jan. 1524, May 1525), 181 (April 1523), 212 (Nov. 1523,

6, 230-31, 232, 233, 249, 255, Jan. 1524), 217 (Sept. 1555), 229 256-8, 260-62, 278, 284, 286 (Jan. 1533), 229-30 (July 1533), 230 (July 1533), 232 (Sept. 1533, [67] Sept. 1534), 236-7 (July 1533). 237 (Sept. 1534), 242 (March 1541), 263 (March 1547), 266 portraits) (July 1540, April 1547), 268 (Oct./Nov. 1542), 274 (Oct./Nov. 1542), 276 (Nov. 1545), 280 (May 1548), 286 (Sept. 1554), 298 (early 1547), 303 (May Bologna, Oct. 1557), 303-4 (1548/9?), 304 (Sept. 1560), 309 (Feb. 1556), 309-10 (July 1556), 310 (Oct., Dec. 1556, June, Dec. 1557, early 1561, June 1563), 310-11 (August 1563), 311 (Dec. 1563) mannerism: see Mannerism marble carving, 16, 24, 28-9; see also Michelangelo (technique: relief; and technique: sculptural) marble: purchases, 30, 42; see also under individual commissions; quarrying, 43, 89, 161, 163, 164-5. 178 in Medici household, 22 memory, visual, 68 model: wooden, for S. Lorenzo, 163 ff. [111]; for tomb project of 1532, 267; for vault of St Peter's, 303; clay, for dome of St Peter's, 301; wooden, for Laurenziana stairs, 218; wooden, for St Peter's, 298, 301; wooden, for S. Giovanni dei Fiorentini, 306; see also Michelangelo (sculpture) models, male, 225 Neoplatonism, 13, 22, 56, 125, 155, 158, 229 ff., 232, 235-6 and the nude, 24, 56 ff., 121 ff., 167-9, 252 ff.; see also Michelangelo (anatomy) painter, 48, 61, 67 ff., 242 ff., 274 ff. personality, 91-2, 95, 125, 137,

143-7, 148-9, 155, 163-5, 175,

178-9, 191-2, 229 ff.; see also

poetry, 9, 10, 13, 42, 53-4, 119,

125, 155, 181, 192-3, 204, 225-

Michelangelo (terribilità)

pilgrimages, 276, 310

portraiture, 96, 152, 193, 231, 265: see also Michelangelo (selfreligion, 76, 249, 254 ff., 278, 284, republicanism, 34, 208 residence and travel (in chronological order): Venice, Oct. 1494, 32; 1494, 32-4; Florence, 1495/6, 34; Rome, June 1496. 35: Carrara, Dec. 1497, 43; Rome, March 1498, 43; Florence, May 1501, 50-51; Rome, March 1505, 85; Carrara, April 1505, 86, 89; Rome, Dec. 1505, 89; Florence, April 1506, 91-2; Viterbo, Sept. 1506, 95; Florence, Sept. 1506, 95; Bologna, Nov. 1506, 95; Florence, March 1508, 97; Rome, April 1508, 97-9; Bologna, Sept., Dec. 1510, 120; Florence, spring 1515, 160; Rome, April 1515, 160; Florence and Carrara, July 1516, 161, 163, 167; Carrara, April 1521, 178; Rome, Dec. 1523, 212; Venice, Sept.-Nov. 1529, 222-3; Rome, 1531-4, 227, 229; Rome, April 1532, 267; Rome, Sept. 1534, 202, 237, 240; Spoleto, Oct. 1556, 310 sculpture, models for, 53, 56, 181, 207-8 [142]; see also Michelangelo (technique) self-portraits, 119, 249, 277, 283-4 social position, 15-16, 266 subject matter, 253-4; see also Michelangelo (and the nude) technique: painting, 67, 118, 120; relief. 24, 26, 72-3; sculptural, 34, 46, 56, 94, 171-4, 190 ff., 201, 204, 265, 270-72, 282 terribilità, 94-5, 158, 254 training, early, 16-22, 28, 28-30 travel: see Michelangelo (residence and travel) treatise on proportion, planned, 147 unfinished works, 174-5, 192-3, 201, 260-61, 282-4, 288-9

will, 311 papacy: works: see Michelangelo (drawings; Great Schism, 11 letters; poetry); see also in general See also Rome alphabet under title for individual Papal States, 85, 95 paintings and statues, under place for paragone (comparison of painting and architecture and frescoes sculpture), 74-5, 278-80 workshop in Florence, 163, 165, Passion, 28, 116 167 instruments of, 168 Mini, Antonio, 224, 233 Last Judgement, 245 Minos, Last Judgement, 245 Paul, St: modeling (vs. carving), 24 Epistles, 255, 272 Montelupo, Raffaello da, 268, 270 statue projected for Julius Tomb pro-Moses: ject of 1505, 157-8 marble statue, 41, 86, 157-60, Conversion of, Cappella Paolina, 188, 240, 270-71 [107, 109 274-8 [180-81] 175] Paul III Farnese, **240**–**41**, 252*, 268, life of, Sistine Chapel, 100-101 274-5, 276, 280, 291, 293, 296, and Serpent of Brass, Sistine ceiling, 298, 303 106, 116, 131 [66] Paul IV Carafa, 253, 303, 311 Mouscron, Alexandre, 73 Paul V Borghese, 302 mouse, symbolism, 184 Peace of Lodi (1454), 32 Perugino, Pietro, 100 Nativity of Christ, Sistine Chapel, 100 Assumption, Sistine Chapel, 100. [52] 24I-2 [cf. 159] Neoplatonism, Florentine, 13, 22, 25, Pescara, Marchioness of: see Colonna. 229 ff.; see also Michelangelo (Neo-Vittoria platonism) Peter, St, 91, 100, 301 Nero, Golden House of, 103 Crucifixion of, Cappella Paolina, Neumann, Balthasar, 219 277-8 [182-3] Niccolò dell'Arca, 33-4 Last Judgement, 247-8 Angel [12] Petrarch, 11, 32, 231, 255 Nicholas V Parentucelli, 91 Rotta l'alta colonna (sonnet), 54 Night, Medici Chapel, 137, 184 ff., Triumphs, 184 190-93, 201, 202, 224-6 [123, Petronius, St, marble statuette, 33 129 Piccolomini, Cardinal Francesco (Pius Noah: III), 50, 73 scenes from life of, Sistine Chapel. altar, Siena Cathedral, 50, 61, 73 Pico della Mirandola, Giovanni, 158* Drunkenness of, 117, 132, 134 [80] Pierre de Rohan, 52 Sacrifice of, 122 Pietà: subject, 28, 43 ff., 258-9. See also Flood 280 - 86statue in St Peter's, 43-8, 50, 64, oil painting, technique, 67 74, 83, 259, 285 [18, 20] Orvieto, 220-21 statue in Florence, 265, 280-86 Cathedral, Last Judgement by Signo-[184-5]relli, 252 [168] oval plan, 293-5 Rondanini, Milan, 288-9, 311 [189] for Vittoria Colonna, 256, 258-9 Ovid, 23-4 [170] Palm Sunday celebrations, 110 Pietrasanta, marble quarries, 165 Panofsky, Erwin, 158, 235, 287* pietra serena, 178, 181, 209, 211, 214

Pinturicchio, Bernardo, 103 vault decoration, S. M. del Popolo [56] Pio da Carpi, Cardinal Rodolfo, 304 Pisa, 161, 165, 167 conquered by Florence in 1364, 78 conquered by Florence in 1509, 76 lost to Florence in 1494, 76, 78 Pisano, Nicola: Hercules, Pisa pulpit, 57 [26] Siena pulpit, 24 [7] Pitti: Bartolommeo, 73 Madonna, 73, 128 [38] Pius III: see Piccolomini, Cardinal Francesco Pius IV Medici, 303 platonic love, 236; see also Neoplatonism and Michelangelo (Neoplatonism) Platonism, Florentine, 13; see also Neoplatonism and Michelangelo (Neoplatonism) Pliny the Elder: description of Laocoon, 89-90 on canon of Polykleitos, 147 on the unfinished, 193 Plotinus, 13 Plutarch, 224 Poliziano, Angelo, 22, 24, 29*, 32 Pollaiuolo: Antonio, 24, 30; tomb of Sixtus IV, 89 [49] Antonio and Piero, Martyrdom of St Sebastian, 83 [46] Pontormo, Jacopo, 226-7 Venus and Cupid [152] Pope-Hennessy, John, 29*, 94*, 171*, 192* Popes, Sistine Chapel, 100 Prato, sack by Medici in 1512, 161 Prigioni, 169, 172-3; see also Slaves primatus papae, 100 Prisoners, Julius tomb: see Slaves Proculus, St, statuette, 33 Prophets: Iulius tomb, 268, 270 [174] Sistine ceiling, 105-6, 108 ff., 130-31, 158; see also Sibyls and individual prophets

symbolism, 69-70

Protagoras, 24* Protestantism, 220, 240, **255** Prudence (personification), 272 Psychomachia (Prudentius), 25 Pulci, Luigi, 175

Ouaratesi, Andrea, 233 [155]

Rachel, Julius tomb, 271-2 [175-6] Raffaello da Montelupo, 268, 270 Rape of Deianira: see Battle of Centaurs Raphael, 63, 70, 86, 92, 105, 143-6, 151, 162, 312 Madonna of the Meadow, 70 School of Athens, 144 [96]; see also Rome (palaces: Vaticano: Stanza della Segnatura) Transfiguration, 146 Rembrandt van Rijn, 174 Resurrection, drawings, 201-2, 226, 239 [158] Riario, Cardinal Raffaele, 34, 36, 38, 41, 43, 49 statue for, 38, 42-3 Ridolfi, Cardinal Niccolò, 263 Risen Christ, statue, 165, 167-9, 227, 228 [112-13]; see also Resurrection Rivers, Medici Chapel, 181 Rodin, Auguste, 312 rogus, imperial, 88 romantic idea of genius, 312 Rome: Basilica of Maxentius and Constantine, 301 Capitol, 36, 240, 280, 291-6, 306 - 7Castel Sant'Angelo, 220 churches: S. Agostino, 49-50 SS. Apostoli, 311 S. Giovanni dei Fiorentini, 304-6 [200-201] S. M. sopra Minerva, 167; see also Risen Christ S. M. del Popolo, vault by Pinturicchio, 103 [56] St Peter's: Old, 36, 301; choir of Nicholas V, 91; New, 91, 92, 289, 311; Michelangelo's completion, 298-304, 310 [197-9]; attic,

301-2; dome, 301-3, 306 [198]; Fabbrica, 298, 303; lantern, 301; little domes, 302; Pietà: see under Pietà S. Pietro in Vincoli, Julius tomb: see under Julius II S. Silvestro al Ouirinale, cloister, 255 column of Trajan, 151 Horse-tamers, 36, 294 Humanism, 41-2, 85 Monument to Victor Emmanuel II. Museo Capitolino, 291, 295 Nero's Golden House, 103 palaces: Cancelleria, 36 Capitoline, 280, 291-6, 304 dei Conservatori, 291-6 [190-94] Farnese, 280, **296–8** [195–6] Galli, 41 [15] Riario (Cancelleria), 36 Rondanini, 288 del Senatore, 291, 294 [190-93] Vaticano, 100, 298; Belvedere, gallery, 91, 178 (see also Apollo Belvedere; Laocoön; Torso Belvedere; etc.); Museums, 88; Cappella Paolina, 268, 273-8, 298 [179-83]; Sistine Chapel, 17, 298; ceiling, 17, 82, 83, 99-143, 144, 158, 170, 223, 252-3, 254 [104, 160]; changes of style within, 108, 120, 121-42; color, 142-3, 254, 278; iconography, 106-18; choir screen, 113-14; Last Judgement: see Last Judgement; Quattrocento frescoes, 100-101, 105, 239-42, 245, 246; Stanza della Segnatura, 105, 143-4 [96] Pantheon, 301, 306 papal curia, 38 piazza del Campidoglio, 291-6 Porta Pia, 306-8 [202] Renaissance, 36 Sack, 214, 220, 254 symbolism, 291 ff., 294-5 Tabularium, 291 temple of Jupiter Optimus Maximus, threatened by Spanish troops in 1556, 310

villa Madama, 220 rosarv. 249 Rossellino, Antonio, 52 Rubens, Peter Paul, 76, 132, 312 [40] Sadoleto, Jacopo, Phaedrus, 42 Samson and a Philistine, projected statue, 208 Sandström, Sven [54] Sangallo: Antonio da, Jr. 280, 296, 298, 303 Aristotile da, 79 [43] Francesco da, 196 Giuliano da, 86, 90-91, 92, 95, 162 Sansovino, Andrea, 52 Christ, 77 Sansovino, Jacopo, 163, 165 Santiago de Compostella, 276 sarcophagi, Roman, 22, 88 [48] satvrs, 42 Saul of Tarsus: see Paul, St. Savonarola, Fra Girolamo, 32, 34, 51, 77, 132 Sebastian, St, 152 Last Judgement, 245 Sebastiano Luciani (del Piombo), 144-7, 179, 202, 227, 242, 285 Flagellation of Christ, 147 [99] Lamentation (Pietà), 145, 259 Pietà, Ubeda, 259 Resurrection of Lazarus, 146 [98] Seven Sorrows of the Virgin, 43 Seymour, Charles, 54* sfumato, 64 Shakespeare, William, 9, 230 Shearman, John, 169*, 204* Sibuls: Julius tomb, 270 [174] Sistine ceiling, 105-6, 113-15, 128-9 Siena, Cathedral, Piccolomini altar. 50, 61, 73 Signorelli, Luca, 67, 68, 69, 100 Madonna and Child, 68-9 [36] Orvieto frescoes, 252 [168] Silenus, 42 Sistine Chapel: see under Rome (palaces: Vaticano) Sixtus IV della Rovere, 36, 89, 99, 100-101

villa Galli. 42

Urbino, Antonio [da], 282-3, 309 tomb, 89 [49] Sixtus V Peretti-Montalto, 306 Valdés, Juan de, 255 Slaves: projected for Julius tomb, 129 [47, Valori, Baccio, 227 Vannini, Ottavio, Lorenzo il Magnifico Surrounded by his Artists [4] for tomb of 1513 (Louvre), 151-5, Varchi, Benedetto, Discourses, 246, 157, 169, 171, 192, 285 [101, 260, 278-80, 312 Vari, Metello, 167 for tomb project of 1516 (Florence). Vasari, Giorgio, 217, 221*, 226, 304, 169-75, 201 [115-18] 309, 310-12 [203] Sleeping Cupid, 34-5, 36, 38 Lives, 41*, 72*, 94*, 284; Life of Soderini, Pietro, Gonfaloniere of Michelangelo, 16, 19-20, 28, 33, Florence, 51, 61, 77, 93, 95*, 97, 45, 46-8*, 52*, 56*, 57-8, 58, 161, 207* 59*, 63-4*, 68*, 69, 92, 160*, Solomon's Temple at Jerusalem, 100 163, 184*, 201*, 212*, 223-4*, snowman for Piero de Medici, 31-2 227*, 240, 252, 253-4*, 254*, stairways, 218-19 270*, 282*, 282-3*, 283, 288*, Strozzi: 290*, 301, 311 family, 30 Vatican: see under Rome (palaces) Filippo, 263 Vauban, 222 Maddalena, 67 Venice, Doge, 51 Roberto, 273 Venus and Cupid, lost cartoon, 226-7 style: see High Renaissance, maniera, Mannerism, baroque, etc. Vergil, Eclogues, 114-15* Verrocchio, 30, 46 Taddei: Versailles, 31 Taddeo, 70, 73 Vesperbild: see Pietà [19] Madonna, 70-73, 199, 284 [37] Victory, 169, 191, 202-6, 208, 221 terribilità, 94, 158, 254 [138-9] Theatine Order, 255 Vignola, Jacopo Barozzi da, 296 Tiber river, 36 Villiers de Fezenzac, Cardinal Jean Titian, 227, 312 (Bilhères de Lagraulas), 43 Tityus, drawing for Cavalieri, 226, Virgin Mary: see Mary and Madonna 235-6 [156] Virgo lactans, 28, 196 Tolnay, Charles de, 285* Virtues, Cardinal, 54 tomb of Julius II: see under Julius II Viterbo, 221 tondi, 68 ff.; see also Madonna Volto Santo, 283 Tornabuoni family, chapel, 17 [1] Torrigiano, Pietro, 20 Wilde, Johannes, 78* Torso Belvedere, 122, 125, 192 [70] Würzburg, Schloss, stairway, 219 travertine, 301 Turkey, Sultan of, 95 Zechariah, Sistine ceiling, 106, 108tyrannicide, 58, 229, 263-5 10, 119, 121, 130, 142 [60] Zeus, 235 Zuccari, Taddeo, Deposition, 288 [188] Urbano, Pietro, 167, 169, 233